TROLLS

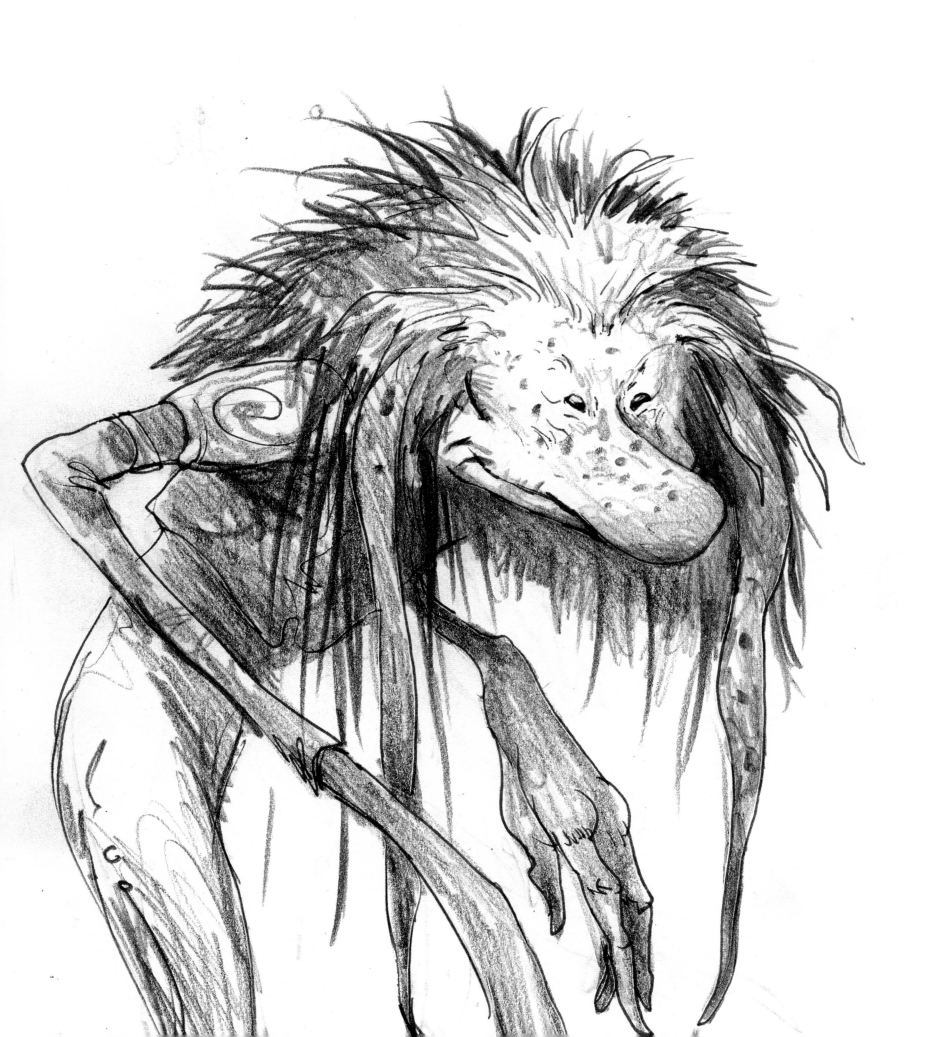

Brian Froud's TROLLS

Brian & Wendy Froud

Abrams, New York

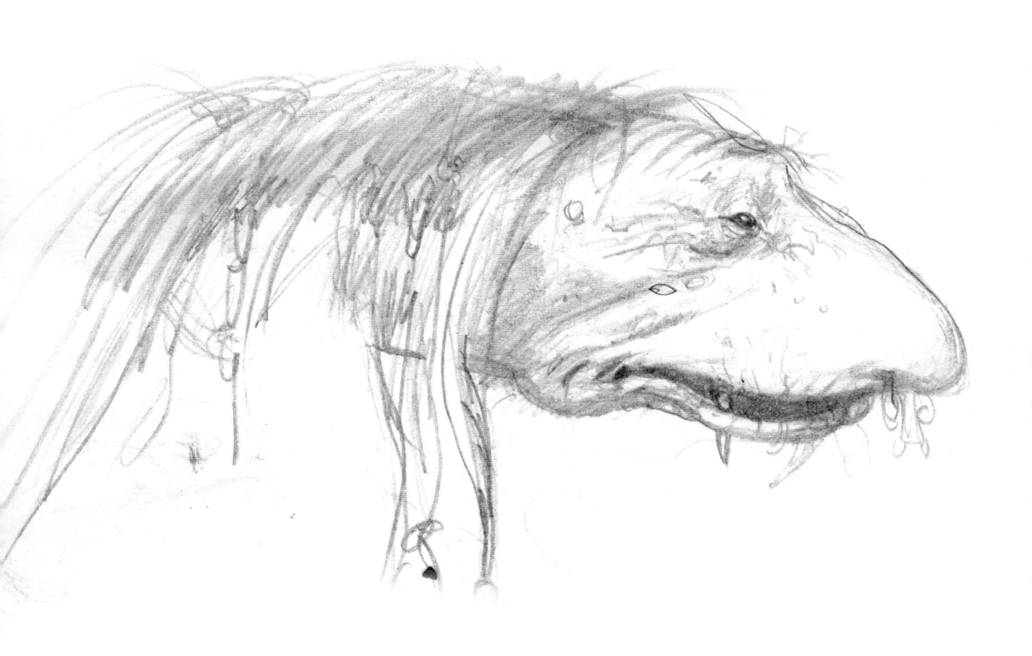

Beneath the rock—the trolls sleep;

Amongst the trees—the trolls watch;

Under the bridge—the trolls wait;

Up the mountain—the trolls sing;

In the storm—the trolls howl.

And at the threshold of night
— the trolls come.

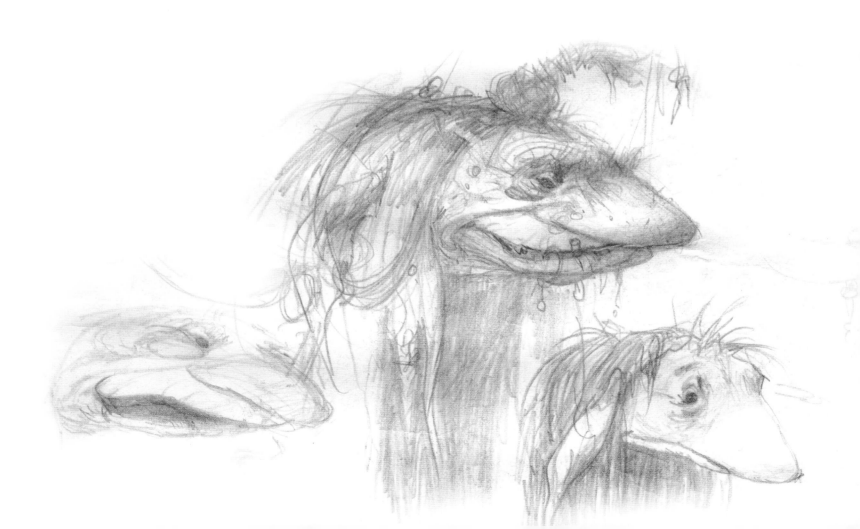

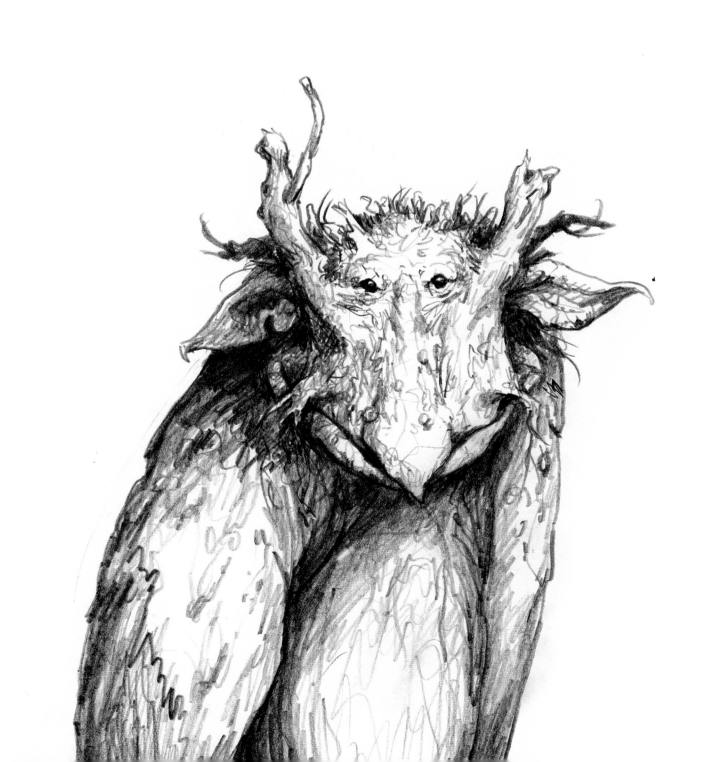

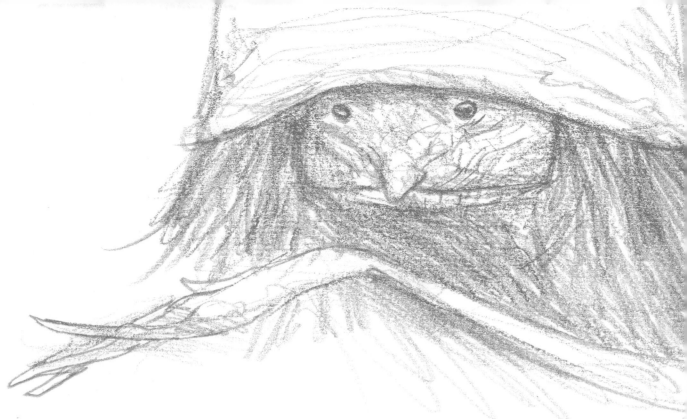

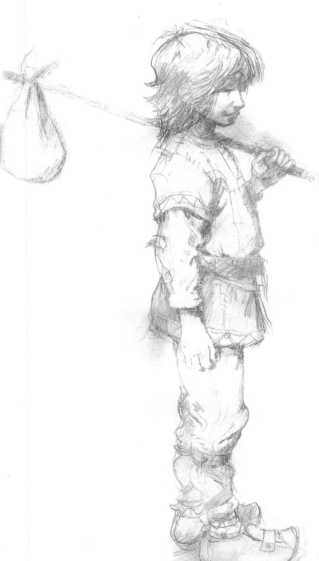

E VER SINCE I CAN REMEMBER, I HAVE BEEN FASCINATED by beings beyond our normal experience, inhabiting nature. What mighty creature dwells in the wood? What musty man hides behind the tree? Whose glittering eye peers from the dark crevice? Who sleeps under the silent hill and what huddles in the dank darkness under the bridge? In short, what sort of invisible spirits inhabit our visible world and what do they look like?

My paintings of trolls answer some of these questions. The troll images are animated landscapes, for they are a direct, emotional response to what I see and what I sense of the spiritual energy of the land.

Mother Earth has myriad children. Closest to her heart are the trolls. Their diverse forms echo the undulations and protrusions of nature. Their tree-bole legs, branchlike arms, rooty hands, and gnarly faces all inform us of their origins.

Not only do they live in the hidden places of the earth and walk on the earth but also they are of the earth itself. Trolls live not just under bridges but are themselves a bridge, for they come from nature and so support the way back to the heart of nature. Our dealings with them are conversations with the land and we must listen to what they have to tell us.

Years ago, as we embarked on the film *The Dark Crystal*, Jim Henson visited me in my home in Devon, England. He was intrigued and enchanted by the wild landscape, rugged tors, tumbling streams, and moss-laden trees. Jim said to me, "Make the movie feel like this." And so began the transformation from land and nature to art; beginning with pencil and paint and moving on to metal, fabric, fur, latex, and all of the various and sundry elements we used to create and people the world that became the enduring classic *The Dark Crystal*.

The last conversation Jim Henson and I had before his death was about collaborating on another film. It was to be about trolls. This book is, in essence, the film we never got to make.

Brian Froud

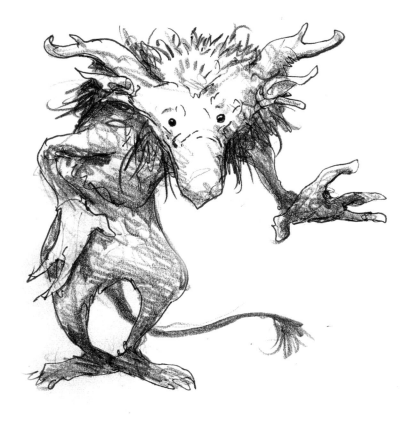

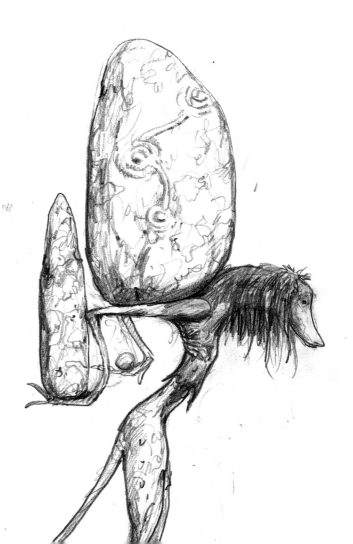

BRIAN AND I ARE LUCKY ENOUGH TO LIVE IN A PLACE where the edges and borders are easily blurred and the next step you take may just place you firmly in a world beyond our own. Don't get me wrong—we don't live in the Otherworld, but we can sense it and feel it, and sometimes, but only just, we can see it. The thing you might not know, the thing that makes this important, is that you live there too. You just don't realize it yet. The border between this world and that is only a step away, no matter who you are or where you live. We want to help you take that first step, so hold our hands and follow us on our journey. We won't lose you along the way and we'll make sure you're home in time for dinner.

Trolls: What does that name conjure up in your imagination? Three billy goats trip-trapping over a bridge with the bad thing lurking beneath it . . . or a large, dim-witted creature, ungainly and slow, the perfect target to be tricked by a wily human . . . or perhaps a wicked ogre crouching in the woods, just waiting to gobble up unwary children? Yes, this is how humans often think of trolls. They've had a lot of bad press over the years. Mind you, that's not to say that some trolls aren't just like that . . . but, really? Here's the truth about trolls: They are many things, and most of those things are good and wise and funny. But trolls, above all, are an intrinsic part of nature and the earth itself. Trolls are the keepers of wisdom. Trolls are the earth's storytellers.

Some of the tales the trolls tell are as old as time, and some are as new as this morning, but all of them are as varied as the trolls themselves. Trolls exist in the rocks and the trees, the hills and valleys, the mossy places and the barren windswept mountains. They listen to the songs the earth sings, the tales the hills and valleys tell, and the stories the rocks and trees whisper. They carry those songs and tales with them, passing them on, linking each and every story into the only story, the never-ending tale of everything. Storytelling is as much a part of their lives as eating and drinking. Tales are nourishment. Tales are lifeblood, and a troll without a tale isn't really a troll at all.

Brian and I have been listening to the stories the trolls tell for many years now, waiting for the right time to gather them together and put them into a book. We've had help along the way. We've met fellow travelers who are willing to share what they know. Now let me tell you a tale:

We recently met a young woman who came searching for us with much to tell and even more to share. Rosie came from a city quite close to us with something she had kept secret since her childhood. A girl in her late teens, Rosie shyly held out an old (very old indeed) bundle of leather, tied with cord and bulging with loose pieces of parchment covered in writing and drawings. It also held quite a few strange objects. Troll objects. As we looked at these odd bits of

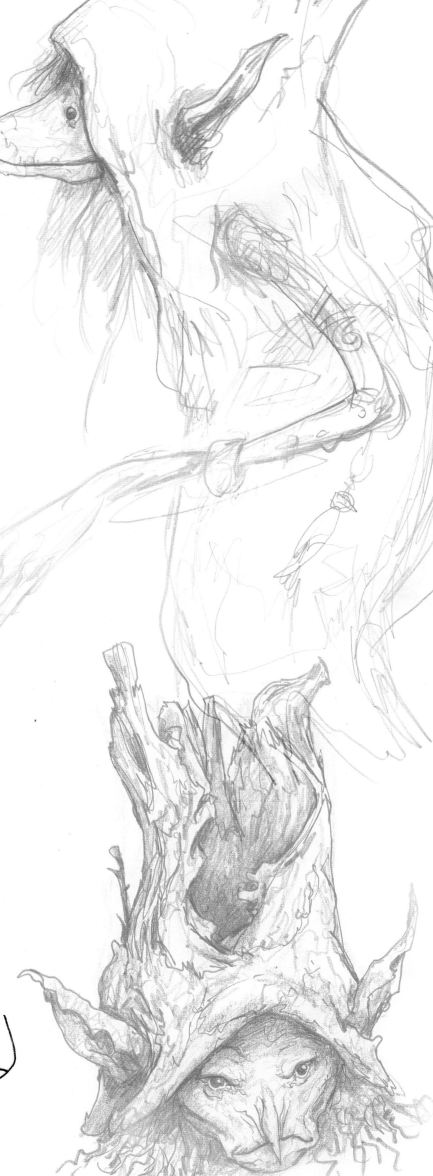

stick and bone, feathers and wood, we began to understand what they
were, and how they fit together with the stories and information we
already possessed. The drawings were rough and the writing almost
unintelligible, but the two of us, with Rosie's help, unraveled the
mysteries the bundle held. Scattered throughout the pages of this
book are our interpretations of what we found: the writings and
drawings of Will, the Red-Haired Boy, a character whom you will
learn about in this book and one who plays an important role in our
tales. He collected much information and carried secrets and magic
back to the human world . . . but that's all part of this book. And if
it isn't in this book? Well then, that's a tale yet to tell.

So journey with us. Meet the trolls we've come to know and
love (most of them, that is—there are always a few who are never
going to be lovable) and listen to their tales through paintings,
drawings, tales, story fragments, and troll facts.

The world of the trolls is rich and varied, sometimes simple
but, more often than not, quite complex. Take your time and let the
journey unfold. Who knows where it may lead you? Finally, in the
words of one of the trolls, we leave you with this:

*A troll tail, a troll tale, long and winding, full of twists and turns. A tail, a tale
a long time in the telling, a long time in the growing. We carry our tales with us.
We tell our tales and tell our tails. The stones and bones and wood and feathers
are each a part of the telling, each a part of the long Remembering of the tale.
We gather the pieces of the Rememberings and hang each one on our tail, each one
in its place and in its time and in its certainty of experience. Listen: We have untold
tales to tell and many tails to tell them.*

*In the days that came before, in the days that came almost before any-
thing, the trolls began the Remembering. We are solitary beings, living our lives as
the stones live their lives, a long time in a single place, a long time for a single
thought. We grow waterfalls, we carry forests on our backs. We make our houses
of the leavings of the heaving of the earth itself. Our songs are heard by all and
recognized by no one but ourselves. Long and low, they rumble just beneath the
surface of the world, following the energy within the rocks, following the spirit
trails that weave and spiral within the earth. Our songs tell the spirit tale. Our
tails hold the Remembering. Stone and bone and wood and feather: stones for the
longest tales, bones for the tales of passing, wood for the tales of birthing,
and feathers for the tales of laughter, for sometimes we do laugh.*

*When the time of the Remembering comes, when the Gathering becomes
now, we move. Each must come to the place of the Remembering. Each one hears
the song, hears the calling, and follows the spirit line. The spirit lines are many,
but each one leads to another. Each one leads us to the Gathering where we tell
our tales. Our precious tails. From the corners and the edges and the inner and
the outer of the world, we come to the Remembering, our tails following behind
us, like shadows, like the Rememberings themselves. We are a proud race of beings
and we live a very long time indeed.*

Wendy Froud

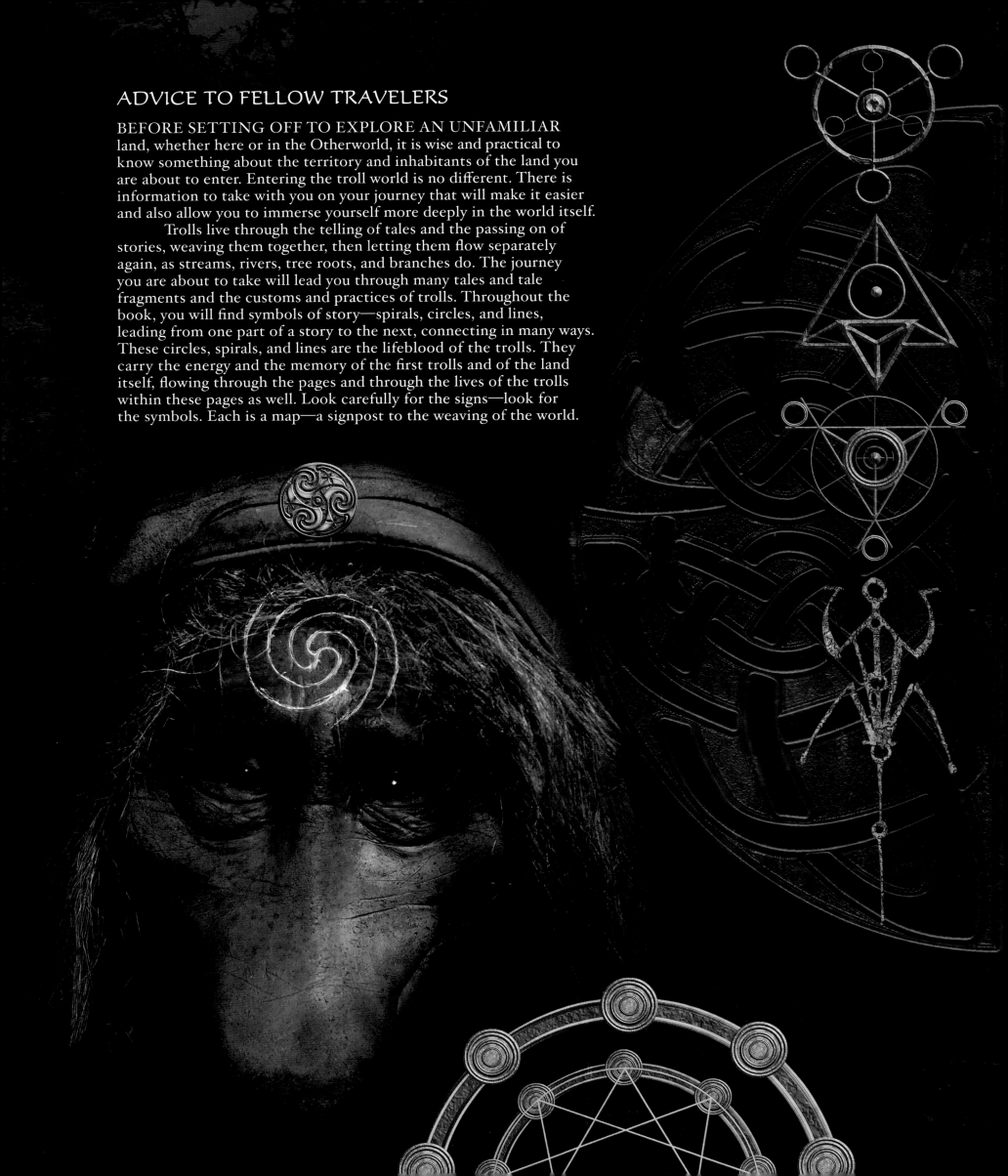

ADVICE TO FELLOW TRAVELERS

BEFORE SETTING OFF TO EXPLORE AN UNFAMILIAR
land, whether here or in the Otherworld, it is wise and practical to
know something about the territory and inhabitants of the land you
are about to enter. Entering the troll world is no different. There is
information to take with you on your journey that will make it easier
and also allow you to immerse yourself more deeply in the world itself.

Trolls live through the telling of tales and the passing on of
stories, weaving them together, then letting them flow separately
again, as streams, rivers, tree roots, and branches do. The journey
you are about to take will lead you through many tales and tale
fragments and the customs and practices of trolls. Throughout the
book, you will find symbols of story—spirals, circles, and lines,
leading from one part of a story to the next, connecting in many ways.
These circles, spirals, and lines are the lifeblood of the trolls. They
carry the energy and the memory of the first trolls and of the land
itself, flowing through the pages and through the lives of the trolls
within these pages as well. Look carefully for the signs—look for
the symbols. Each is a map—a signpost to the weaving of the world.

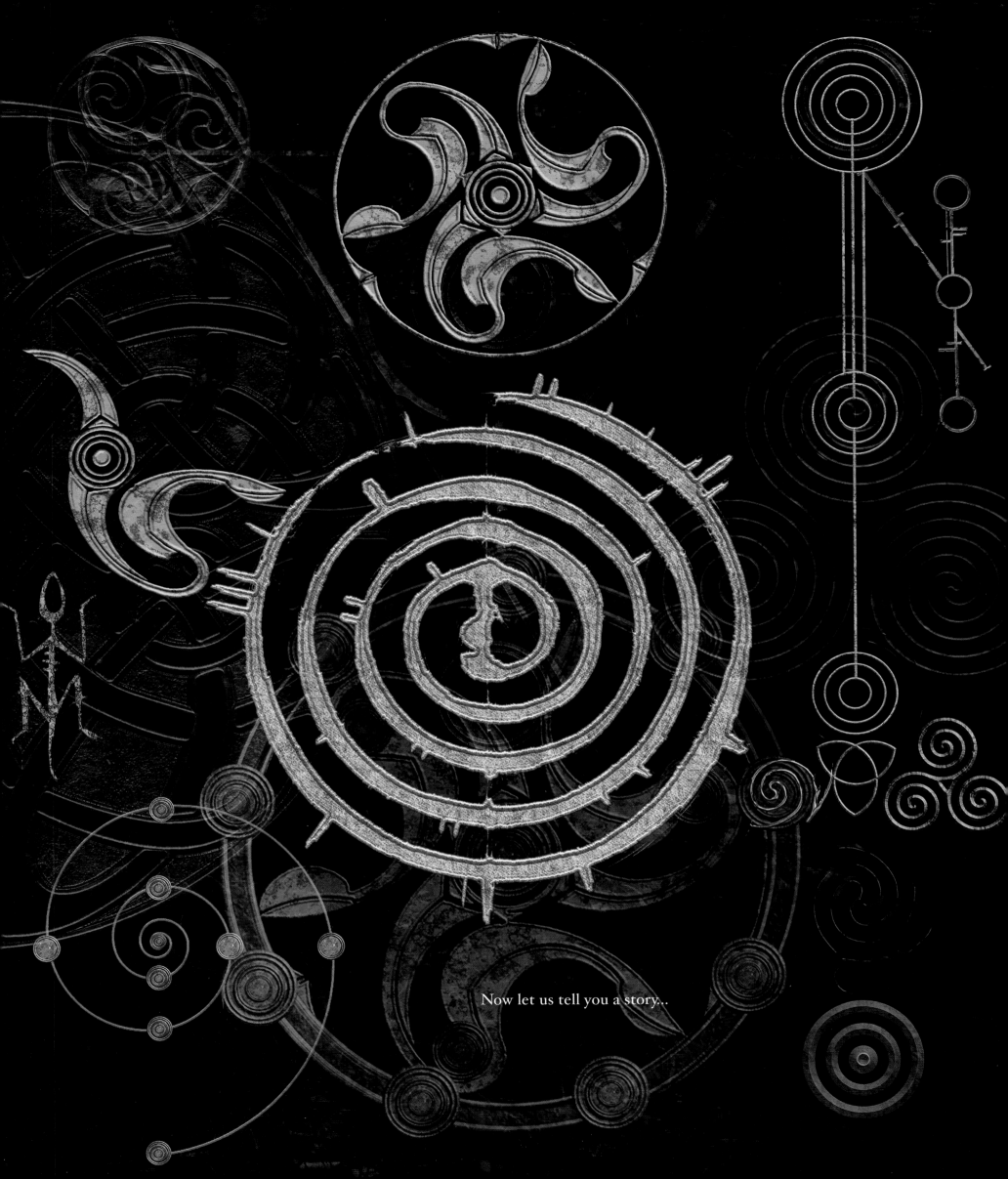

Now let us tell you a story...

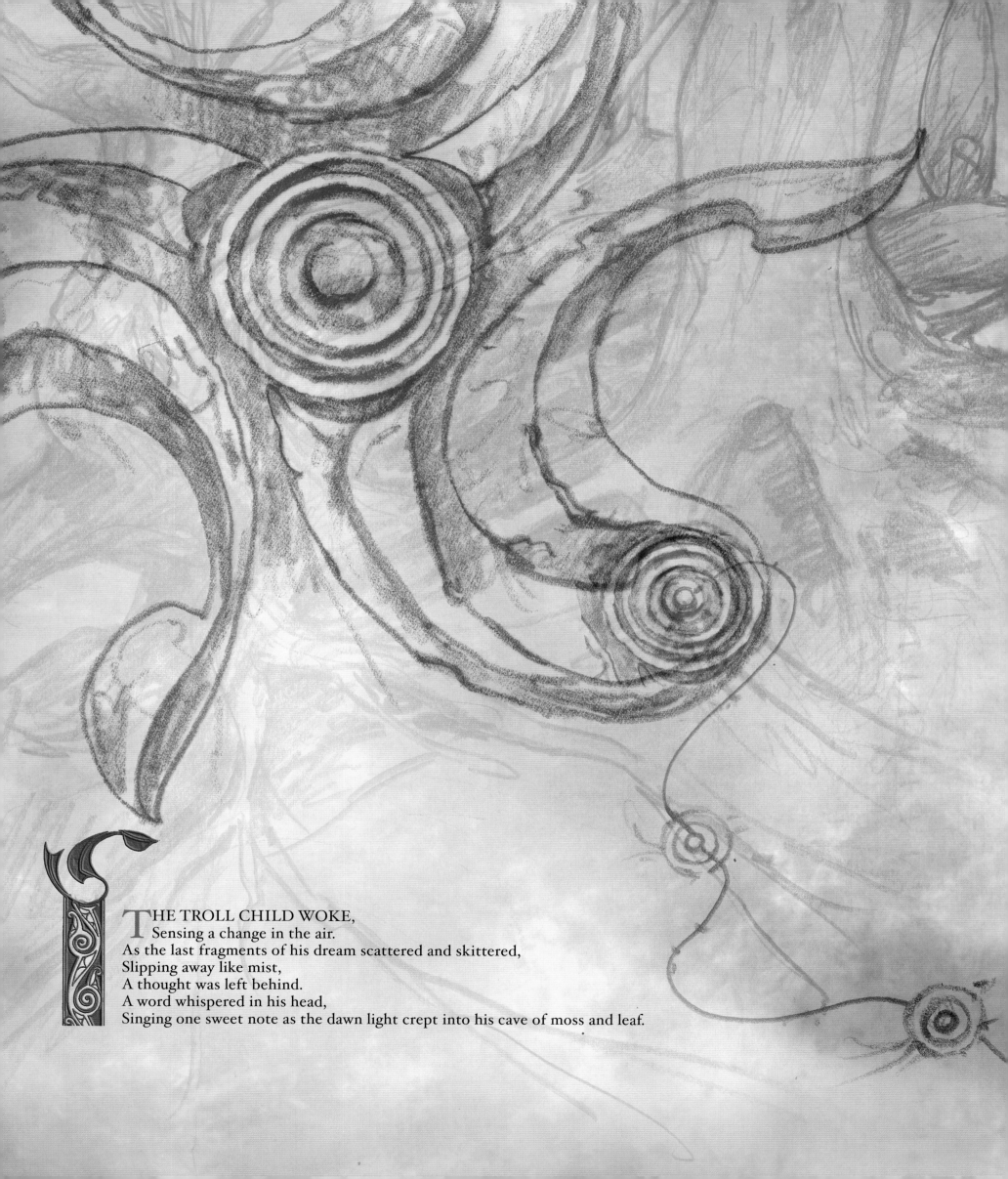

THE TROLL CHILD WOKE,
Sensing a change in the air.
As the last fragments of his dream scattered and skittered,
Slipping away like mist,
A thought was left behind.
A word whispered in his head,
Singing one sweet note as the dawn light crept into his cave of moss and leaf.

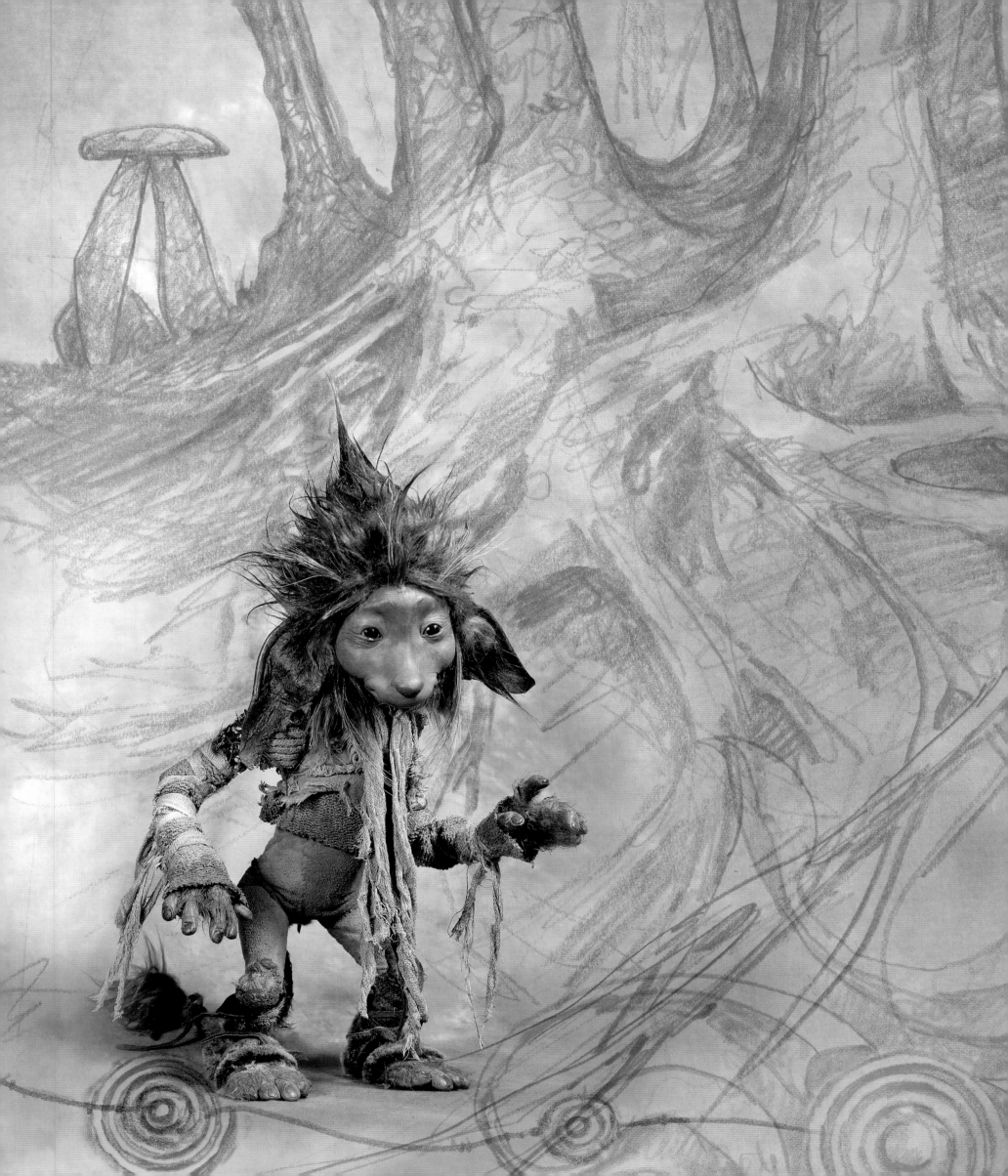

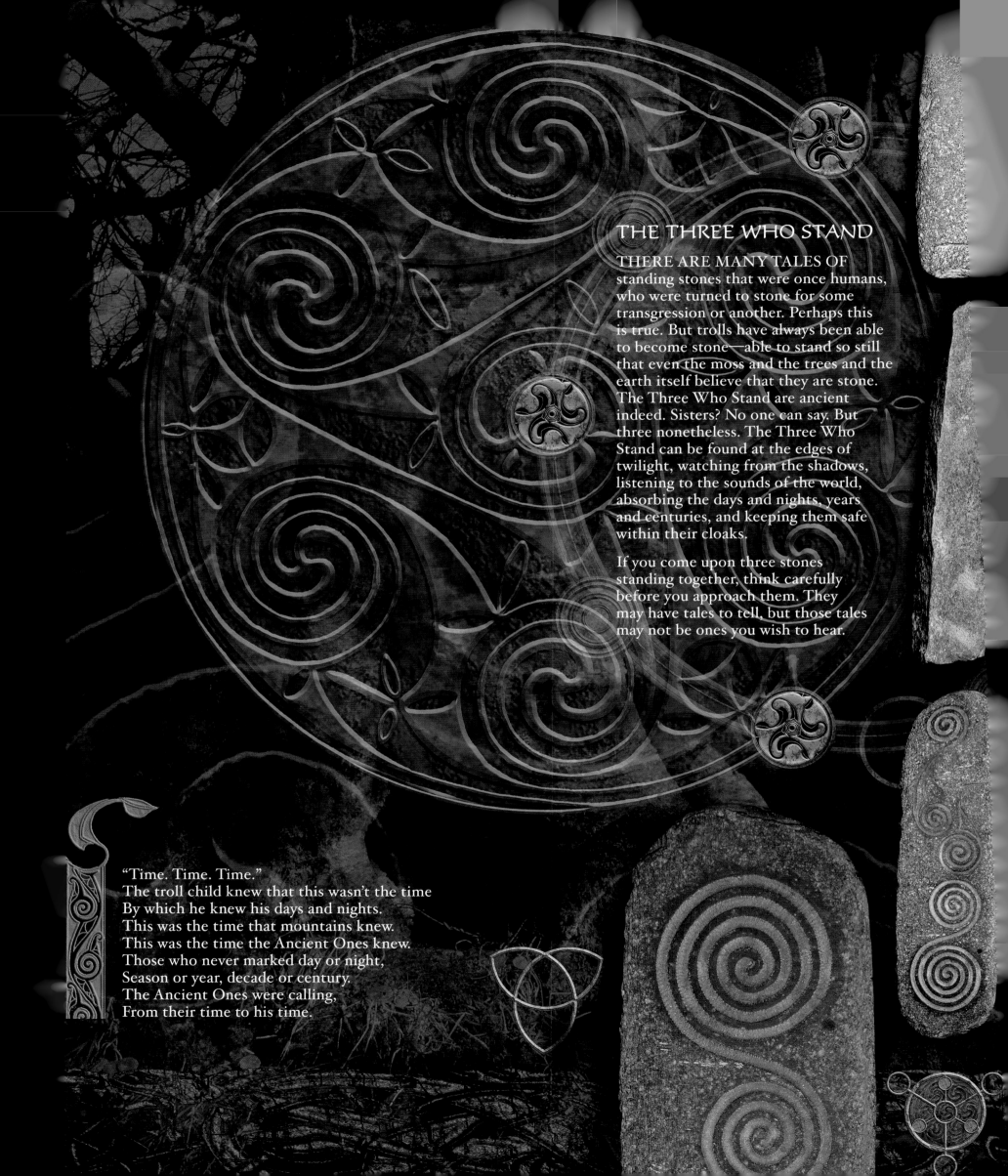

THE THREE WHO STAND

THERE ARE MANY TALES OF standing stones that were once humans, who were turned to stone for some transgression or another. Perhaps this is true. But trolls have always been able to become stone—able to stand so still that even the moss and the trees and the earth itself believe that they are stone. The Three Who Stand are ancient indeed. Sisters? No one can say. But three nonetheless. The Three Who Stand can be found at the edges of twilight, watching from the shadows, listening to the sounds of the world, absorbing the days and nights, years and centuries, and keeping them safe within their cloaks.

If you come upon three stones standing together, think carefully before you approach them. They may have tales to tell, but those tales may not be ones you wish to hear.

"Time. Time. Time."
The troll child knew that this wasn't the time
By which he knew his days and nights.
This was the time that mountains knew.
This was the time the Ancient Ones knew.
Those who never marked day or night,
Season or year, decade or century.
The Ancient Ones were calling,
From their time to his time.

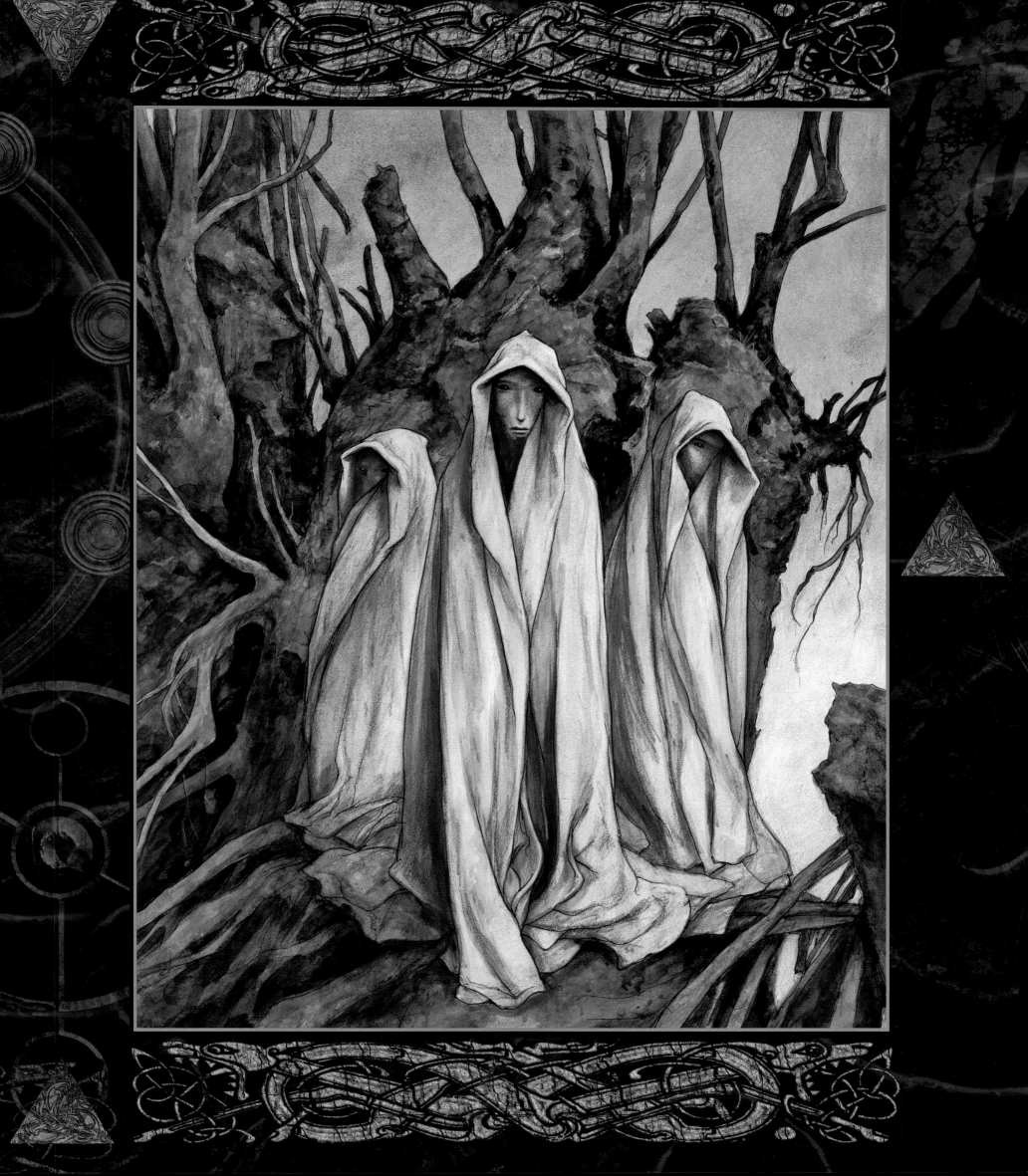

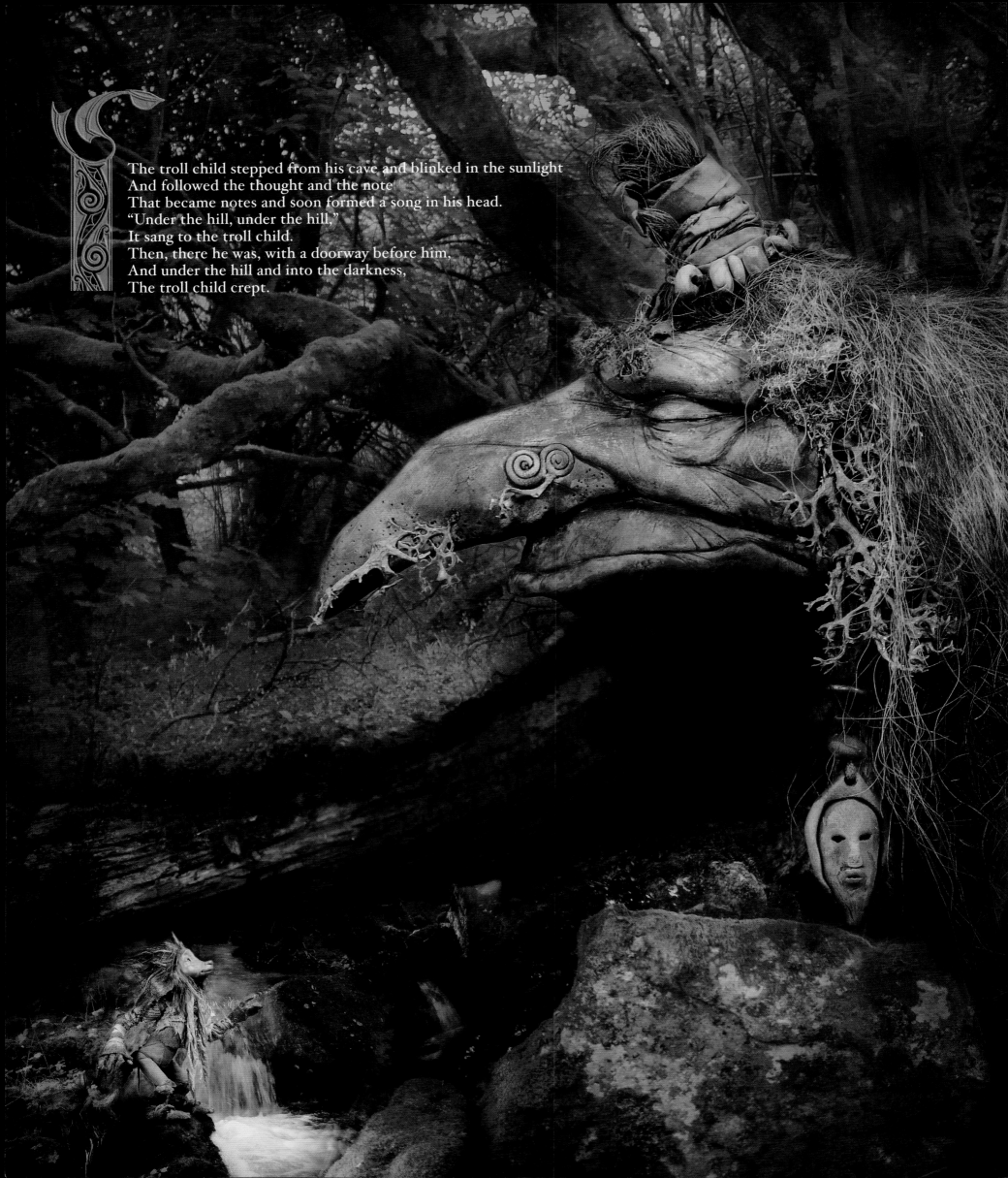

The troll child stepped from his cave and blinked in the sunlight
And followed the thought and the note
That became notes and soon formed a song in his head.
"Under the hill, under the hill,"
It sang to the troll child.
Then, there he was, with a doorway before him,
And under the hill and into the darkness,
The troll child crept.

When we walk on the bones of the landscape,
We walk on the Ancient ones themselves.
If we stop and listen,
we can hear their dreams.

THE ANCIENT ONES

THE KEEPERS OF WISDOM ARE A
shadowy presence, living in the twilight world
of all time as one. The past, present, and future
are woven together in spirals and turnings that
speak to and through the Ancient Ones. In
story and song and Remembering, the Ancient
Ones send these spirals and wheels of know-
ing into the world, where they flow through the
landscape, circling the hills, dancing their ener-
gy dance through the world, leaving traces that
even dull humans can sometimes feel. And so
humans are drawn to the rocks and the hills and
the tors. They stand one stone upon another
and build, create, and, in more ways than they
will ever know, are touched by the Ancient Ones
and the troll tales that weave the world.

He saw the eyes shining,
Like flames in the darkness,
A hand reached toward him and beckoned
With fingers so old and so gnarled
That the troll child was certain a strong wind would snap them.
The face of the Ancient One peered from the gloom
Older than time, older than thought.

"Come closer, child," the Ancient One said.
"Now that you stand there, ask me a question."
"Why am I here?" the troll child asked.
"You heard me calling you, thought, note, and song,"
The Ancient One whispered.
"Who are you?" the troll child asked.
"Look at me, child, you know the answer.
Ask me another."

"Who are WE?" the troll child asked.
"Oh, that is better." The Ancient One smiled.
"That is the question worth asking.
We are the Tale Keepers,
We are the voices of stone and bone, wood and feather.
The voices of earth and water, fire and air."

"How long have we been this?" the troll child asked.
"Since the beginning of the beginning, child."
"And how long will we be this?" he asked again.
"Until the end of the end, my little one.
But until that time, until the end of all things,
We will find and keep and tell the tales."

"How do we remember them?" the troll child asked.
"We gather in circles and share our Rememberings.
We tie them to our tails, child.
We weave them and knot them and make them secure.
The stones we knot for the oldest of tales, those of the earth,
Long and slow and old as time.
The bones we secure for the tales of passing, those of the water.
Swift and fluid, here and gone.
The wood we bind on for the tales of living, those of the fire.
Bright and warm, passion-filled and consuming.
The feathers we tether lightly for the tales of laughter, those of the air.
Bringers of joy, healers of sorrows."

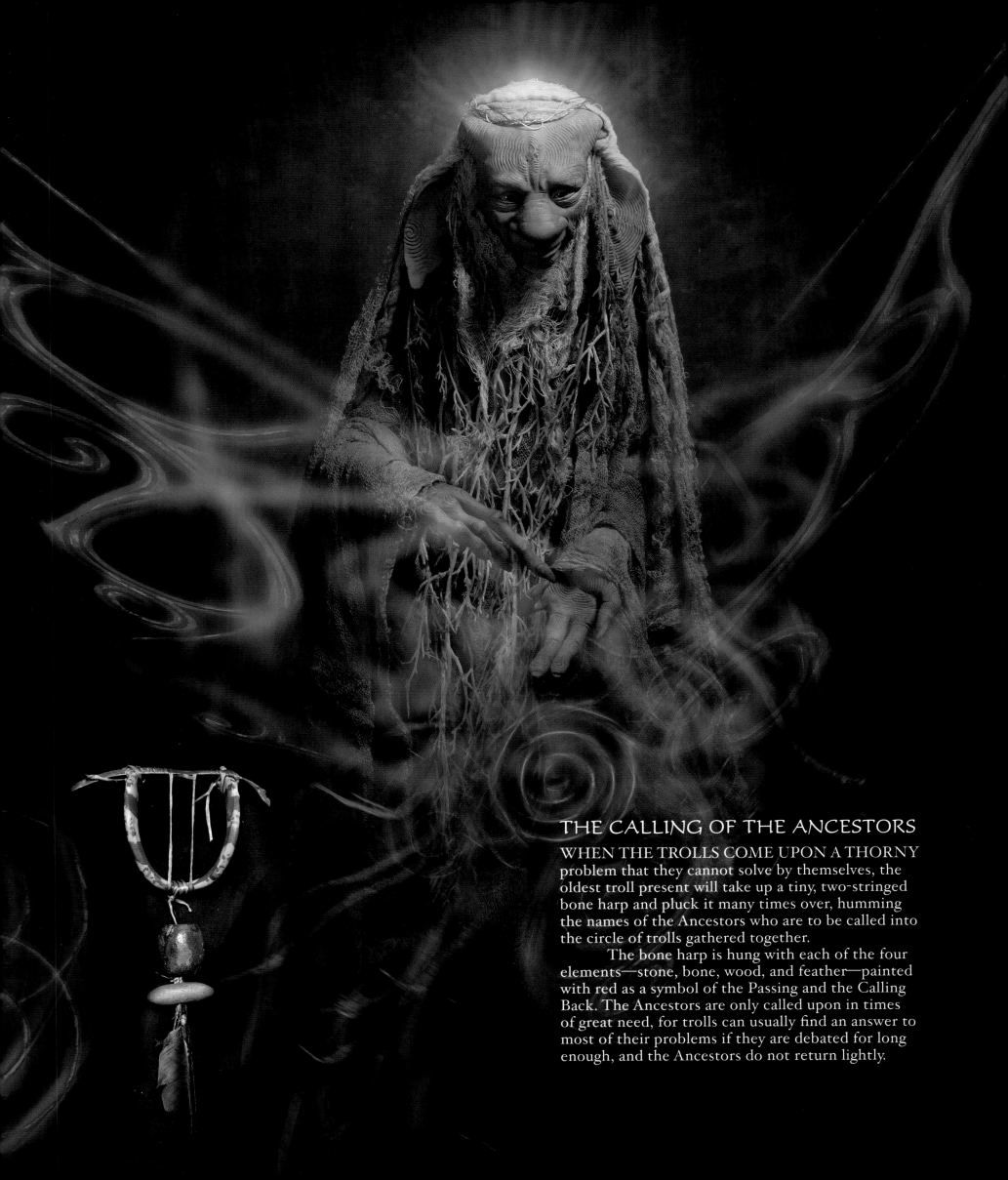

THE CALLING OF THE ANCESTORS

WHEN THE TROLLS COME UPON A THORNY problem that they cannot solve by themselves, the oldest troll present will take up a tiny, two-stringed bone harp and pluck it many times over, humming the names of the Ancestors who are to be called into the circle of trolls gathered together.

The bone harp is hung with each of the four elements—stone, bone, wood, and feather—painted with red as a symbol of the Passing and the Calling Back. The Ancestors are only called upon in times of great need, for trolls can usually find an answer to most of their problems if they are debated for long enough, and the Ancestors do not return lightly.

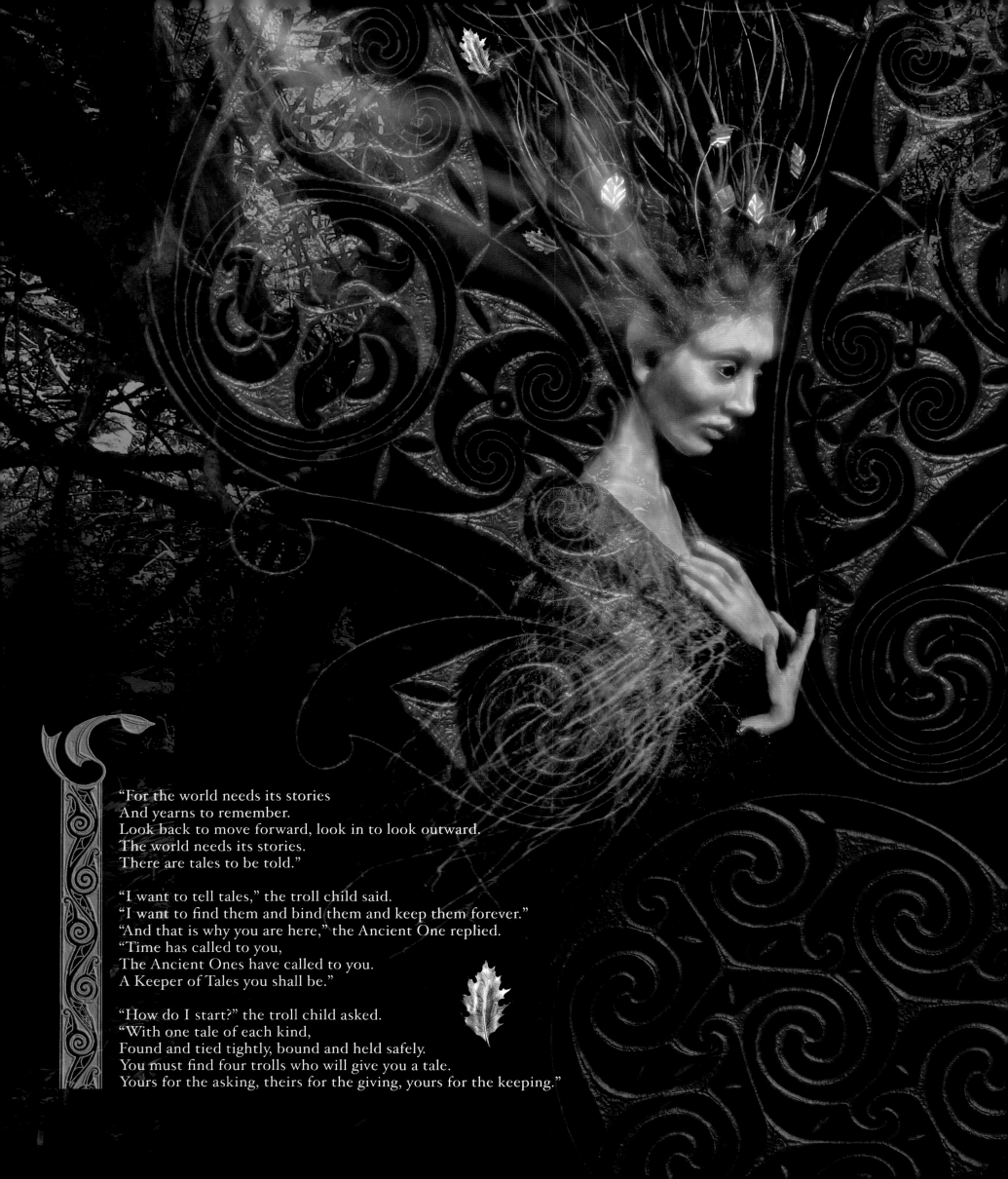

"For the world needs its stories
And yearns to remember.
Look back to move forward, look in to look outward.
The world needs its stories.
There are tales to be told."

"I want to tell tales," the troll child said.
"I want to find them and bind them and keep them forever."
"And that is why you are here," the Ancient One replied.
"Time has called to you,
The Ancient Ones have called to you.
A Keeper of Tales you shall be."

"How do I start?" the troll child asked.
"With one tale of each kind,
Found and tied tightly, bound and held safely.
You must find four trolls who will give you a tale.
Yours for the asking, theirs for the giving, yours for the keeping."

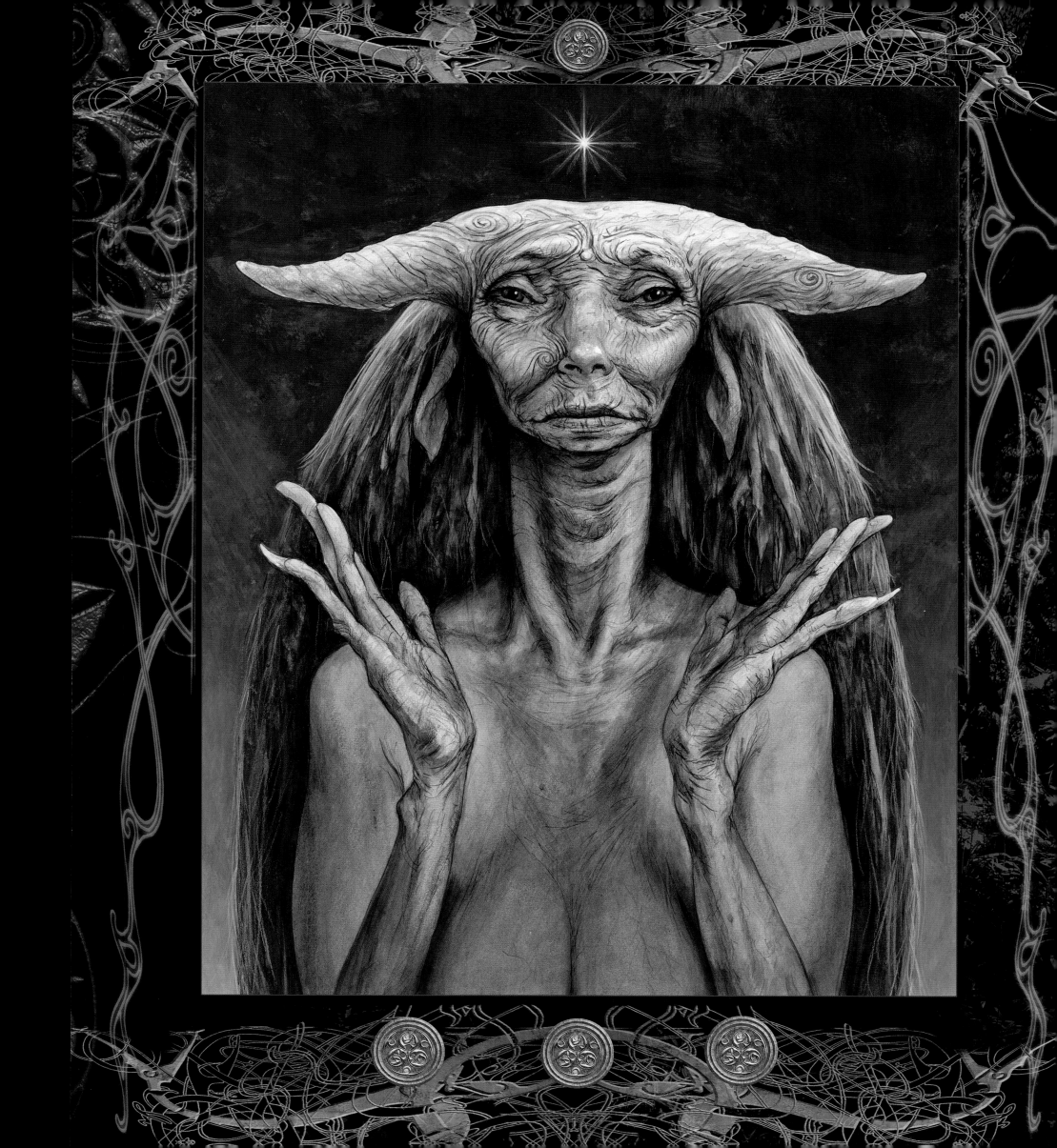

THE DANCE OF SIGILS

NOT ALL TROLLS CARRY TALES, either on their tails or in their heads. Some trolls, usually the small and slightly human ones, convey messages by doing a Sigil Dance. The troll will strike poses that are easily recognizable, to tell an extremely short tale—usually about a food source. At times they become so involved in the pose that they need to be led away home by an exasperated partner. Sigil Dancing is frowned upon as being a rather extreme form of communication.

"Whom do I ask? " said the troll child.
"Whom do you know?" said the Ancient One.
"I know Mistress Od, and I know Gendy Tom,
And I know the Hen twins. But they have no tales."
"Whom do you know who lives for the telling of tales?"
"I know Old Alfing, who lives in the hedge
And never stirs from his den of twigs.

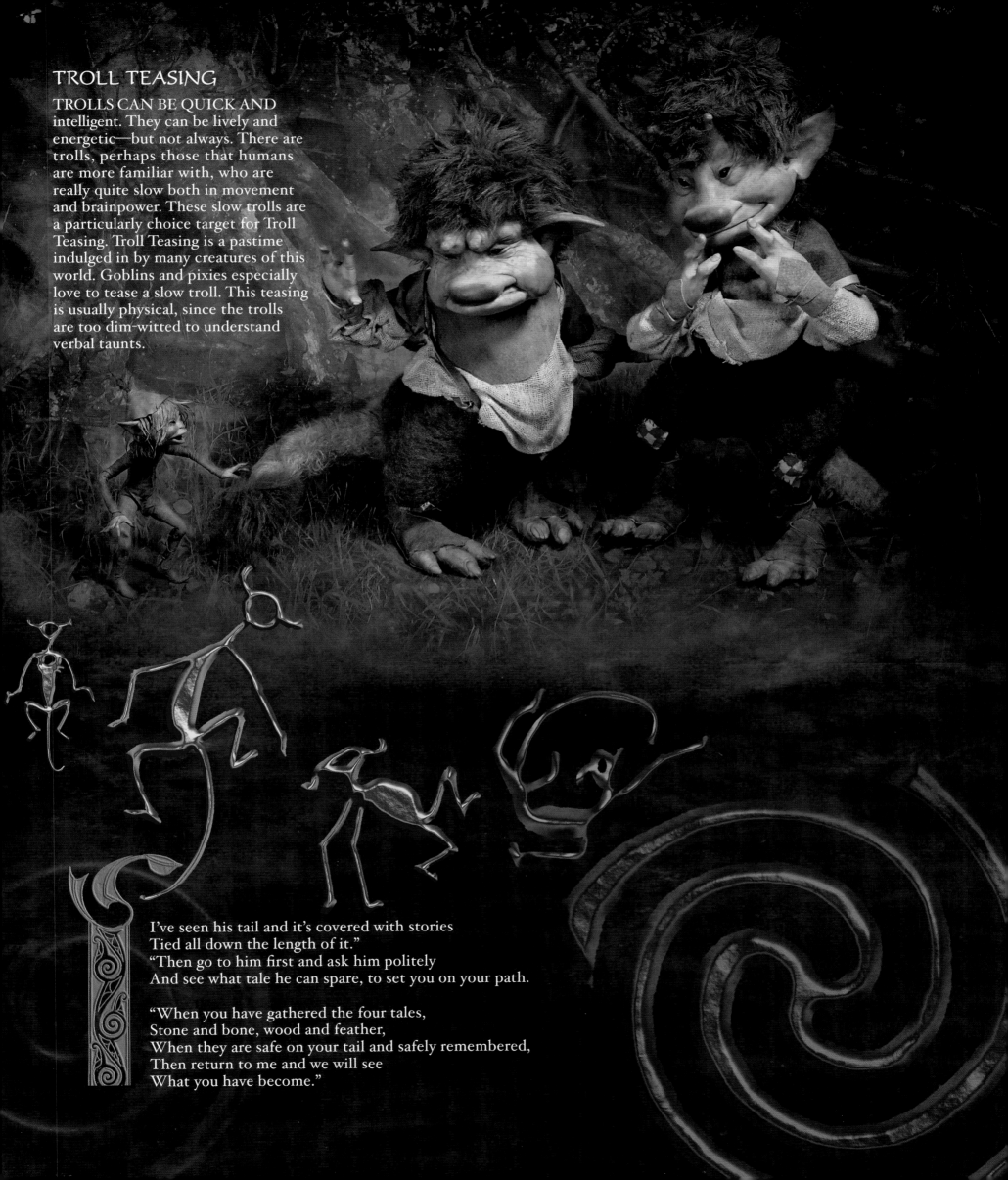

TROLL TEASING

TROLLS CAN BE QUICK AND intelligent. They can be lively and energetic—but not always. There are trolls, perhaps those that humans are more familiar with, who are really quite slow both in movement and brainpower. These slow trolls are a particularly choice target for Troll Teasing. Troll Teasing is a pastime indulged in by many creatures of this world. Goblins and pixies especially love to tease a slow troll. This teasing is usually physical, since the trolls are too dim-witted to understand verbal taunts.

I've seen his tail and it's covered with stories
Tied all down the length of it."
"Then go to him first and ask him politely
And see what tale he can spare, to set you on your path.

"When you have gathered the four tales,
Stone and bone, wood and feather,
When they are safe on your tail and safely remembered,
Then return to me and we will see
What you have become."

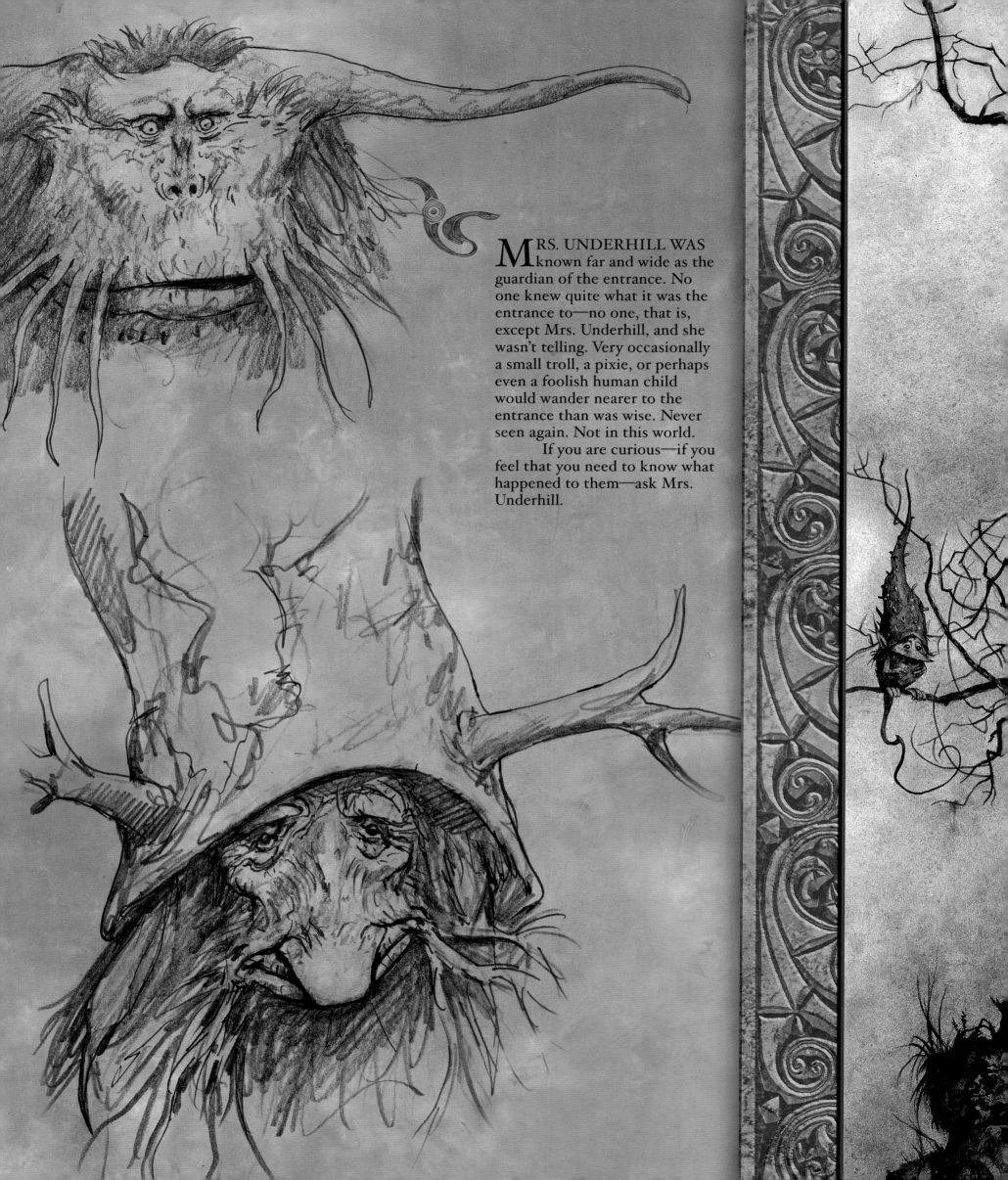

MRS. UNDERHILL WAS known far and wide as the guardian of the entrance. No one knew quite what it was the entrance to—no one, that is, except Mrs. Underhill, and she wasn't telling. Very occasionally a small troll, a pixie, or perhaps even a foolish human child would wander nearer to the entrance than was wise. Never seen again. Not in this world.

If you are curious—if you feel that you need to know what happened to them—ask Mrs. Underhill.

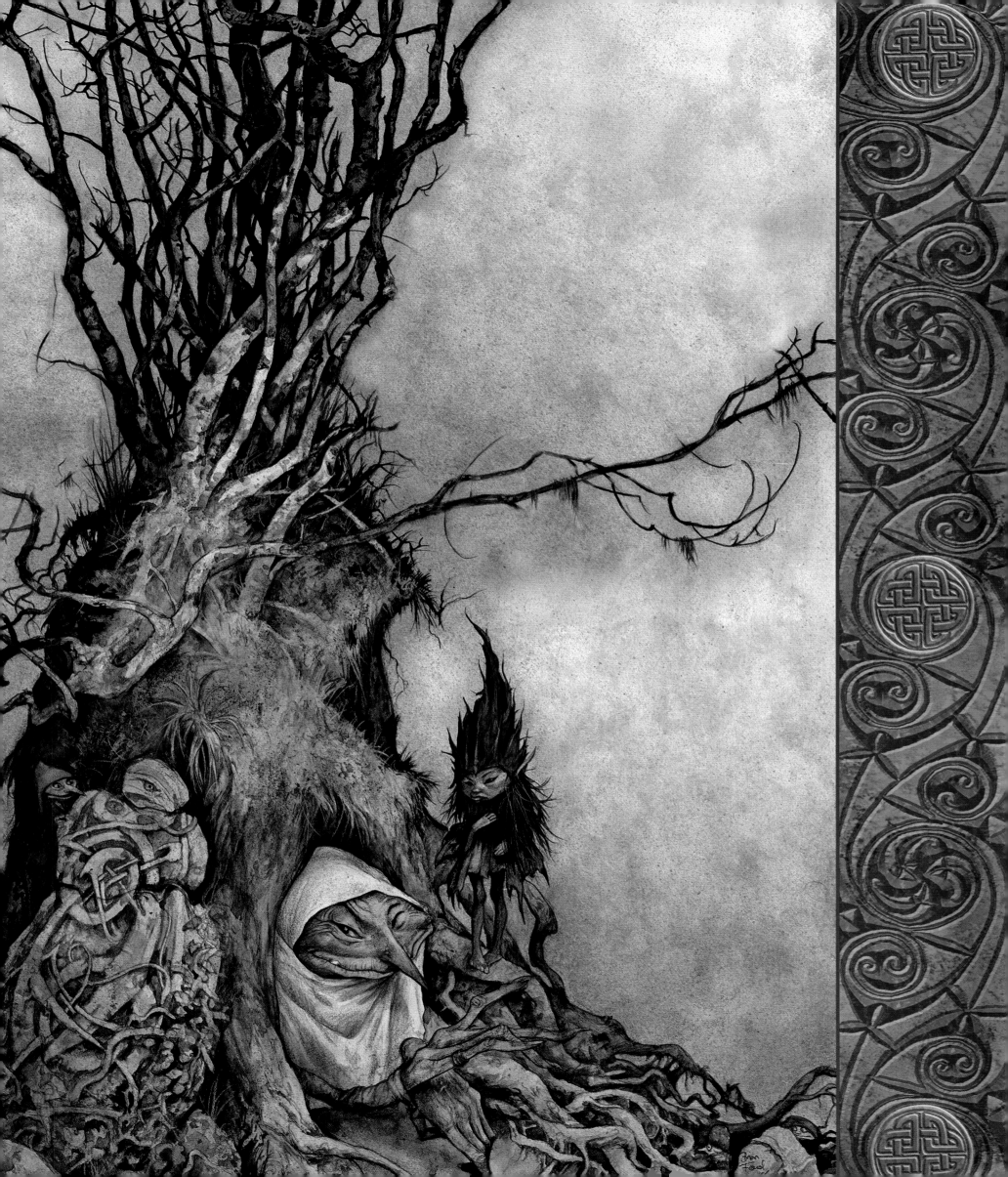

So the troll child walked
Through the forest he knew, to the edge of the moorland,
To a hedge and a hill and a bundle of twigs.
Under the twigs sat Old Alfing the troll.

"Harrooo, Old Alfing!
Old Alfing, wake up!" shouted the troll child.
Old Alfing stirred and shifted,
Stretched and awoke.
"Please, Old Alfing, tell me a tale.
I'm off on a journey and need to start somewhere,
And I thought of you."

Old Alfing replied in a voice like the droning of bees,
"A tale for the asking, the giving, the keeping?
I might have a tale I could spare for a troll child.
No, not that one. Perhaps this is the better.
Ah, this is the one. The tale I will give you,
For telling and keeping, the tale I can spare and the tale that you need."

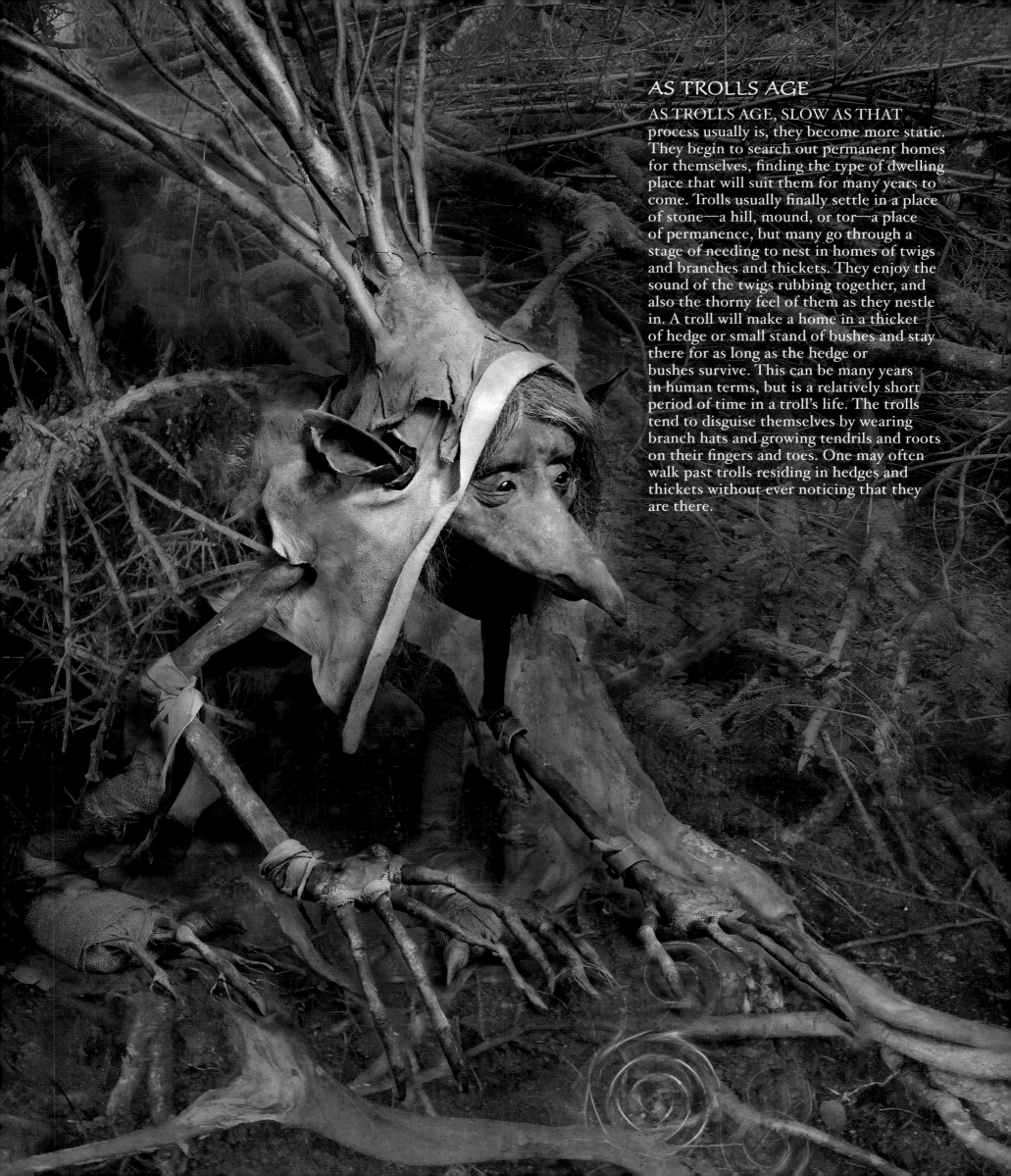

AS TROLLS AGE

AS TROLLS AGE, SLOW AS THAT process usually is, they become more static. They begin to search out permanent homes for themselves, finding the type of dwelling place that will suit them for many years to come. Trolls usually finally settle in a place of stone—a hill, mound, or tor—a place of permanence, but many go through a stage of needing to nest in homes of twigs and branches and thickets. They enjoy the sound of the twigs rubbing together, and also the thorny feel of them as they nestle in. A troll will make a home in a thicket of hedge or small stand of bushes and stay there for as long as the hedge or bushes survive. This can be many years in human terms, but is a relatively short period of time in a troll's life. The trolls tend to disguise themselves by wearing branch hats and growing tendrils and roots on their fingers and toes. One may often walk past trolls residing in hedges and thickets without ever noticing that they are there.

The Tale of Wood
The Troll Bride

ONCE THERE WAS A BEAUTIFUL troll maiden who lived amongst the rowan trees on the banks of the Teign. She had golden red hair, white skin, and the green, green eyes of the forest. Her voice was sweet and her manner gentle and kind. One day a young man, wandering along the bank of that river, came upon the maiden, so fair, so lovely that she took his breath away. He asked her name.

"Hannah Kestor," she replied.

"But that is a troll name," said the young man.

"Well, that is because I am a troll maiden," said Hannah.

"Oh no," said the man. "I know what a troll looks like and it doesn't look like you. You are the most beautiful maiden I have ever seen—not a monstrous creature like a troll."

"All the same," she said, "I am a troll—and now, since you know mine, what is your name?" asked the troll maiden.

"Jon Fairweather," he replied.

"Well, that is certainly a human name," said Hannah, "and you are certainly a human, but none the worse for that."

So Jon fell in love with her and in jest called her his little troll mate and asked her to come away with him and be his bride.

"I gladly will," said Hannah Kestor, "for I love you as well, but you must remember that I am a troll and not as other women."

"I'll remember," promised Jon, thinking all the time that she was joking with him to make him love her even more. "I love you all the more for your loving jests and your sense of fun. I cannot give you much in the way of wealth, but I have a smallholding in the heart of the forest. It is poor, and in the lean times such as these it does not produce much, but it will be yours to make of what you will when we are wed." Hannah told him not to worry, for as long as they loved each other, she would bring him abundance and plenty, and with that he took her hand in his and together they jumped over the Teign and declared themselves married.

Jon Fairweather took his troll bride back to his smallholding. It was indeed a sorry place of nettles and weeds, with not a fruit tree in leaf or blossom or flower in sight. "Oh, Hannah," said Jon. "I am ashamed to bring you here to this place. It is so very poor."

Hannah smiled at him and said again, "As long as we love each other, I will bring you abundance and plenty. Just wait and see what the change of season brings." With that, he

swept her into his arms and carried her into the house and loved her all the night long.

In the morning, as the dawn light crept into the room, Jon looked at his love asleep on the bed next to him. He woke her with a kiss, and as she rose from the bed and turned to look at the dawn coming in through the window, she tossed her long golden-red hair aside and Jon saw, to his horror, that where her back should be, where her beautiful back should be, there was a hollow space filled with dry twigs. His beautiful bride was indeed a troll. Jon jumped up and, gathering his clothes, ran out of the house and into the forest. He ran and ran farther than he had ever wandered before—anywhere far away from the woman, the troll, who had tricked him so cruelly.

From that day on, Hannah was left in the house alone—abandoned and bereft. What could she do? She had told him (but never shown him) that she was a troll. She had given her love and given up her troll life, and now she must stay, for she could not go back to the Teign and the trees and the wild moor.

Hannah walked through the house and into the garden, so overgrown and neglected. She touched an old apple tree, stroking its bare branches and singing softly to the withered leaves. As if the tree could hear her (as indeed it could), it bent toward her and wrapped itself around her, holding her tight as she wished her Jon were there to do. Hannah went from tree to tree, touching, murmuring, singing. As she went, each tree burst into flower and leaf, and as she walked, the grass beneath her feet became green and lush and flowers of every description began to bloom in her footsteps.

As the days passed, Hannah knew that she was with child from that first and only night of love that she and her husband had shared. And as the child grew within her, she remembered that the night they had shared had indeed been one of love—that this child had come from love and not from fear, from a union of two hearts that had loved. Hannah knew that she could love this child enough for both of them if she must.

All that long summer Hannah lived in the garden, tending, talking, singing to the life that grew there and within her. The garden flourished in such abundance that the birds and wild animals from far over the moor came and lived in it as well, peacefully and happily, for there was food enough for all and beauty enough to make the heaviest heart lighter.

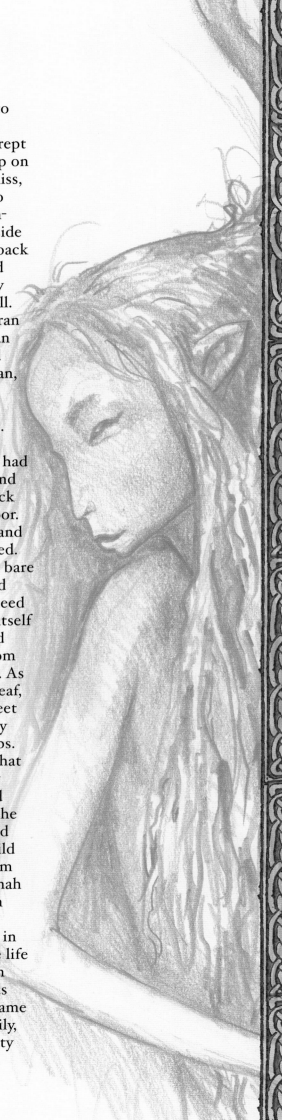

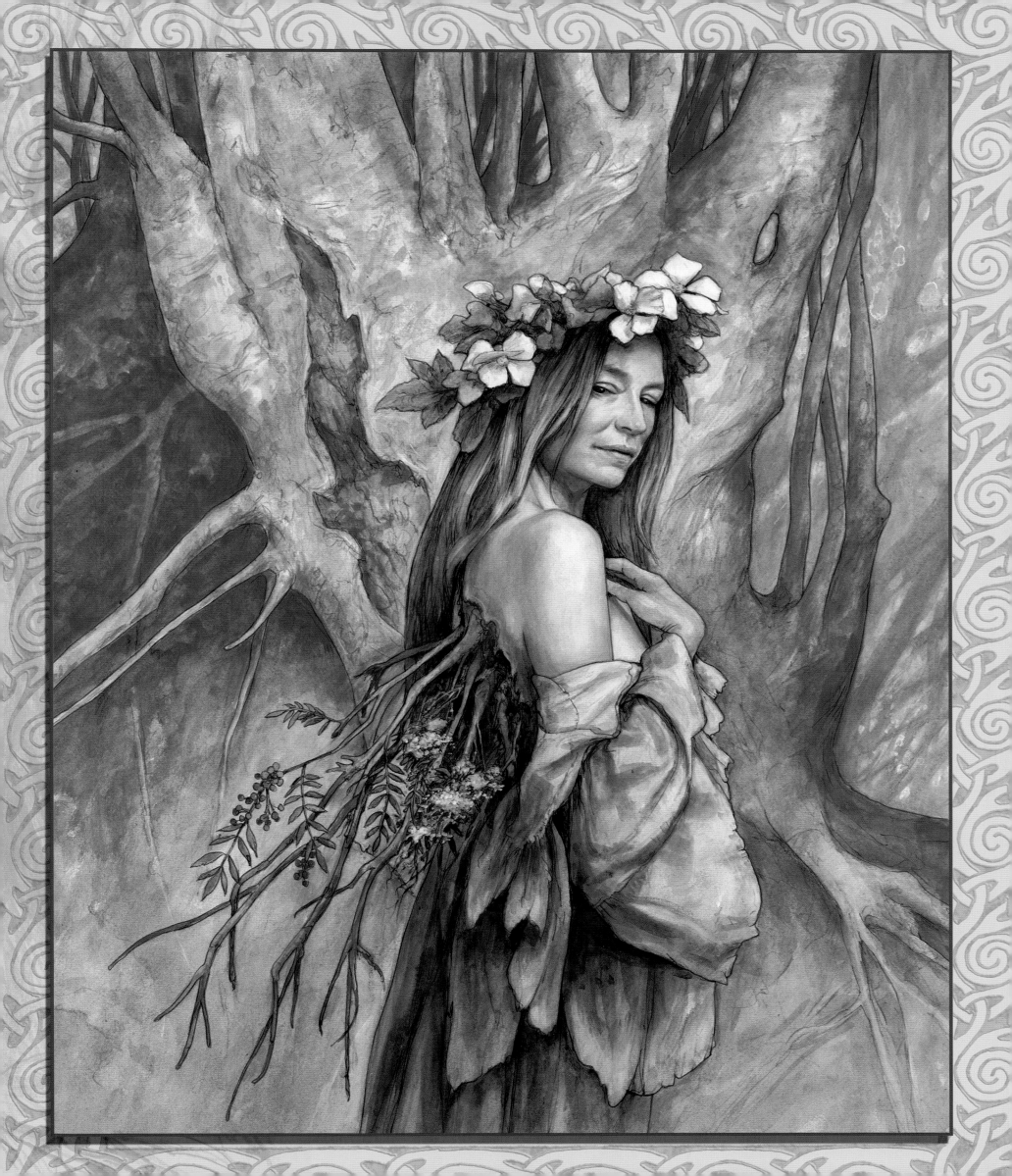

And what of Jon? He wandered like a lost soul, scrabbling for food and drinking from the streams that flowed over the moorland. He saw no one. He was lost in sorrow and fear and guilt, for his feelings for Hannah had not vanished in that dawn light. Not completely. Jon finally came to a tall tor in the middle of a wild and ancient wood. He had never seen this wood before, for it was much, much farther away than he had ever traveled. His wanderings had taken him to the very edge of the moor or perhaps the very middle of a world that was much larger than he had imagined. He sank to the ground and fell into a deep sleep near the bottom of the tor at the edge of a deep pool that was filled by a thin waterfall cascading from the top of the granite boulders.

The sound of the water lulled him deeper and deeper into sleep, and as he slept, he dreamed and in his dream he heard a voice. "Why do you wander on the moor and in the forest when you have a wife waiting and weeping for you at home?" Jon told the voice that his wife was a monster who had deceived him most cruelly. "Did she not tell you that she was a troll?" the voice asked, and Jon answered that yes, she had told him. "And did she not say that she was not as other women?" And again Jon said yes. "And did she not promise to love you for her whole lifetime, and did you not promise to love her in return?" Once again he confessed that she did promise this and that indeed so did he. "Well then, how can you run from true love?" the voice asked.

"How do you know so much about this troll maiden?" Jon asked in return.

"Look up and tell me what you see."

Jon looked up and up to the very top of the waterfall and saw that it cascaded over the tip of the nose of the most enormous troll he had ever seen. The troll looked down at him and said, "How do I know? Because I am the troll maiden's grandmother. I have watched her grow and flourish and become the beautiful and loving woman that you took for your wife. I have seen her sacrifice her home and her troll family to become your bride and your love. Would you abandon her because she is different? Her differences may bring you more happiness than you can imagine." Jon Fairweather hung his head in shame, for he did truly love his little troll mate. "Return to her and see what bounty she has given you."

And with that, Jon awoke from his dream and looked up to the very top of the waterfall that cascaded over the tip of great boulders, which indeed did look very much like the nose of an enormous and ancient troll woman. He remembered his dream and his shame and his love and he ran out of the wood and over the moor and back to his smallholding so very far away.

As Jon approached he could see that his house and the garden surrounding it were not at all as they had been when he brought Hannah there a season ago. The house was neat and clean, the thatch new, and the whitewashed walls sparkled in the sun. But the garden . . . the garden was beyond his imagining. It was filled with the most beautiful flowers and grasses and fruit trees that he had ever seen, and sitting under an apple tree in the middle of the beautiful garden was his beautiful troll wife.

Jon Fairweather fell to his knees and placed his head in her lap. "Hannah, my own, my dearest. Can you ever forgive my fear and my foolishness and take me once again for your loving husband and be my little troll mate for all of our lives?"

Hannah stood up and turned her back on him. She pulled her long, red-golden hair aside and said, "Look at my back and tell me again that I am your little troll mate for all our lives."

Jon, kneeling, looked at her back and then he stood and touched the twigs that grew out of it. He touched them lovingly and kissed the dry and bare tips, and as he did this, they burst into leaf and flower and berry all at the same time and Hannah's back became a graceful rowan tree with glossy green leaves and red, red berries on it. Jon kissed the leaves and said at once, "You are my beautiful troll mate for all our lives."

Hannah turned and kissed him and said, "Soon we will be a family and you will have a troll child to love as well."

And so they did. Their troll son had leafy hair and the green, green eyes of the forest and lips as red as the rowan berries. Jon Fairweather rejoiced in him. Jon and Hannah and their troll son were the happiest of families and loved one another for their differences and celebrated their togetherness and all was well.

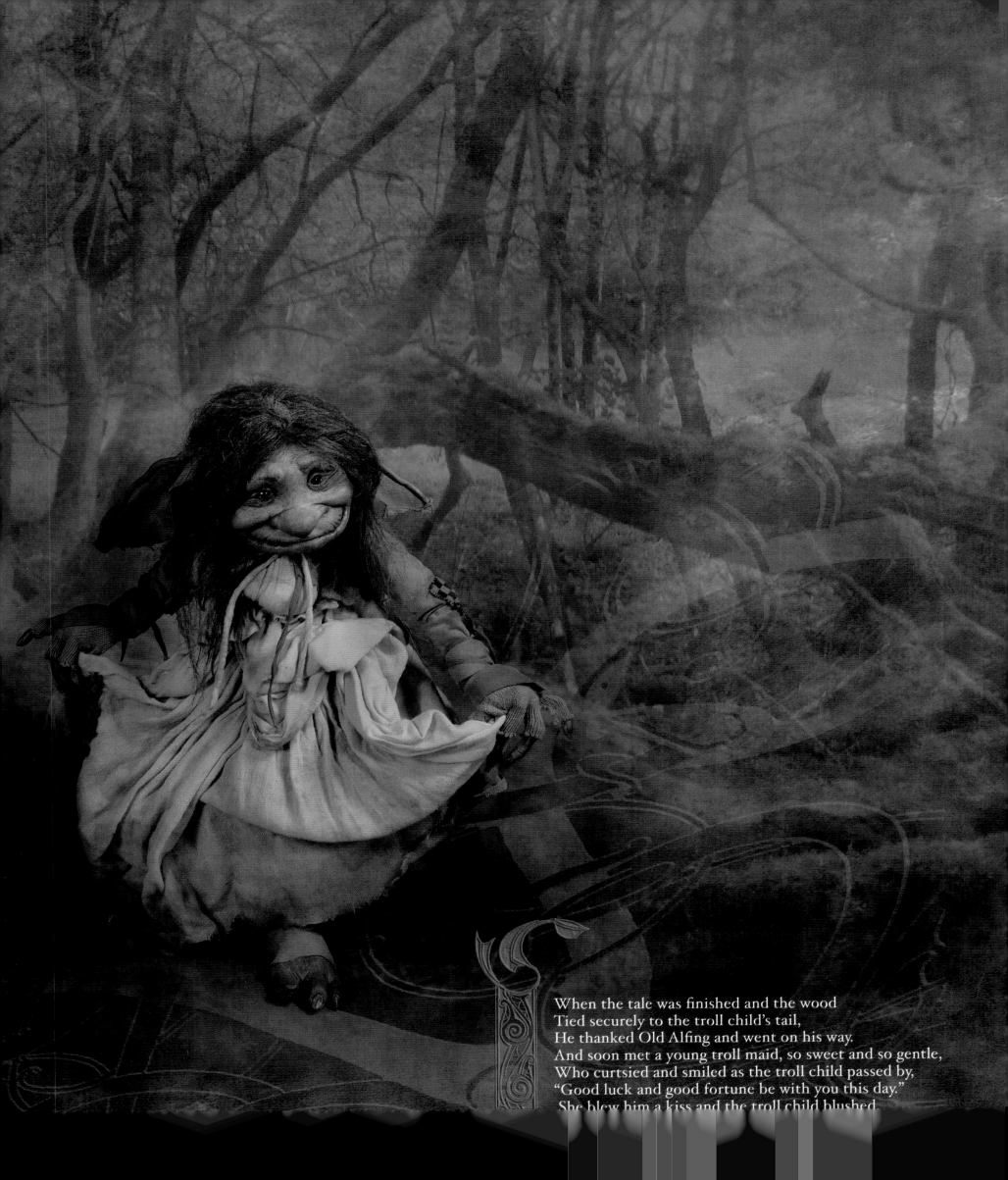

When the tale was finished and the wood
Tied securely to the troll child's tail,
He thanked Old Alfing and went on his way.
And soon met a young troll maid, so sweet and so gentle,
Who curtsied and smiled as the troll child passed by,
"Good luck and good fortune be with you this day."
She blew him a kiss and the troll child blushed.

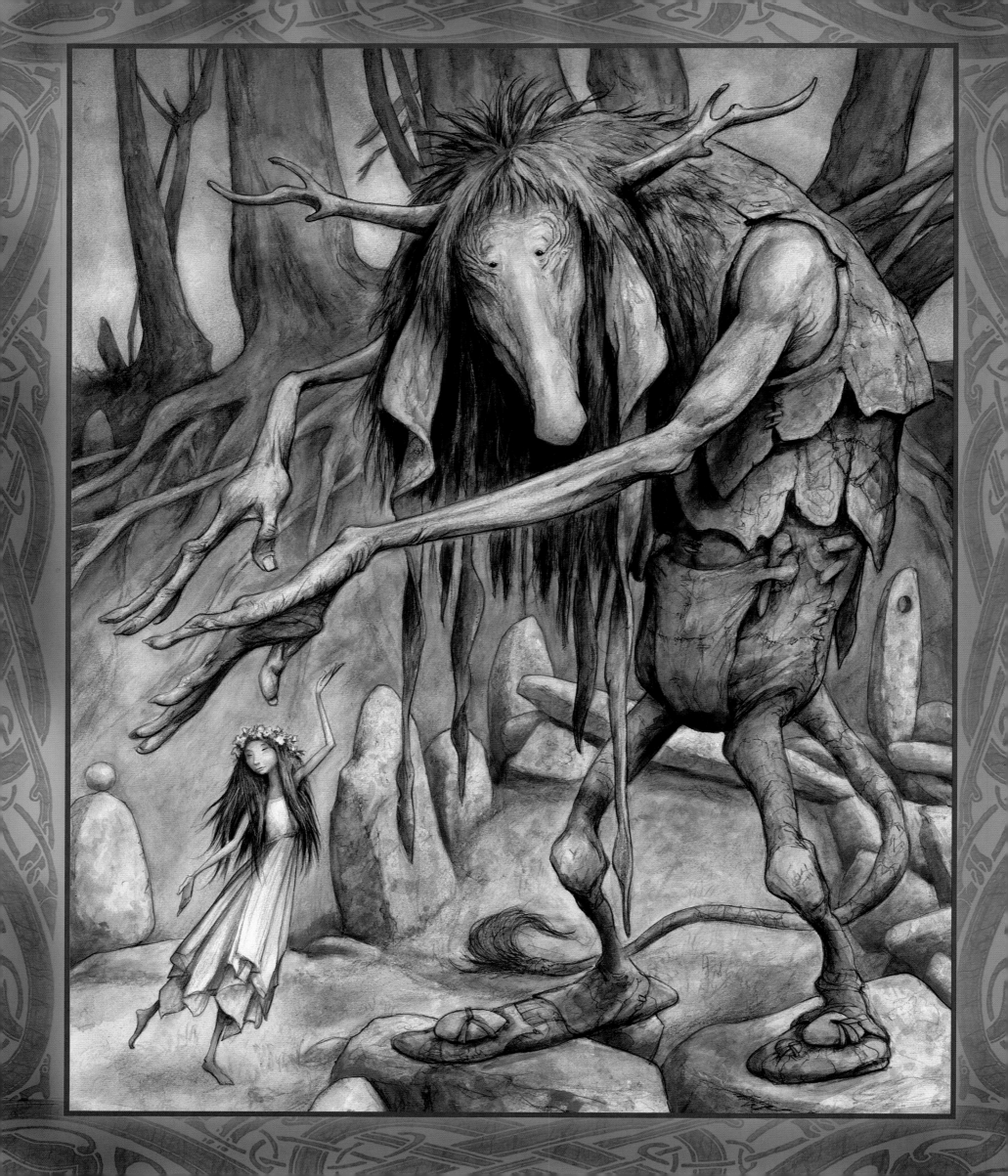

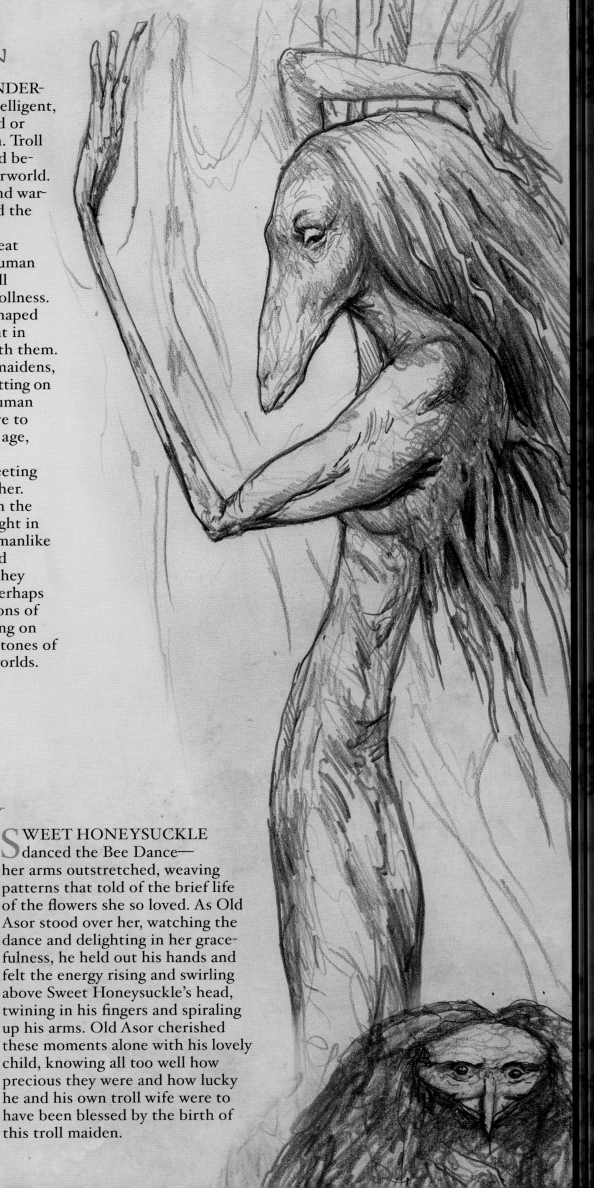

THE BEAUTY OF TROLL WOMEN

TROLL WOMEN ARE THE WISE AND WONDER-
ful beings of this world. They are strong and intelligent,
steadfast and canny. They can be extremely kind or
terribly cruel—and sometimes they can be both. Troll
women are born knowing the pathways over and be-
neath the hills, the ways in and out of the Otherworld.
They can be guides and wise women, witches and war-
rior women. They are the holders of dreams and the
keepers of home and hearth. Usually.

Every once in a while, every once in a great
while, a troll woman is born in the shape of a human
or almost a human with only a small tail or small
branches growing from her back to mark her trollness.

When humans see these lovely human-shaped
troll women, they wonder at their beauty, delight in
their strangeness, and sometimes fall in love with them.
When trolls look at these human-shaped troll maidens,
they see a sorrow and a passing and a life lived flitting on
the borders between the worlds. These lovely human
troll women do not live long troll lives. They live to
what humans may think to be an extremely old age,
but for a troll is but the blink of an eye.

The trolls rejoice and grieve for these fleeting
creatures, who are neither one thing nor the other.
As they delight in watching a butterfly flutter in the
air or a bee dance above a flower, the trolls delight in
caring for and watching over these delicate, humanlike
creatures. Trolls guard them and guide them and
nurture them as much as possible, knowing as they
do that the troll maidens will soon fade away, perhaps
taken to live as human wives in the border regions of
the world or perhaps to spend short lives dancing on
the hills or haunting the bridges and stepping-stones of
streams and rivers that flow between the two worlds.

SWEET HONEYSUCKLE
danced the Bee Dance—
her arms outstretched, weaving
patterns that told of the brief life
of the flowers she so loved. As Old
Asor stood over her, watching the
dance and delighting in her grace-
fulness, he held out his hands and
felt the energy rising and swirling
above Sweet Honeysuckle's head,
twining in his fingers and spiraling
up his arms. Old Asor cherished
these moments alone with his lovely
child, knowing all too well how
precious they were and how lucky
he and his own troll wife were to
have been blessed by the birth of
this troll maiden.

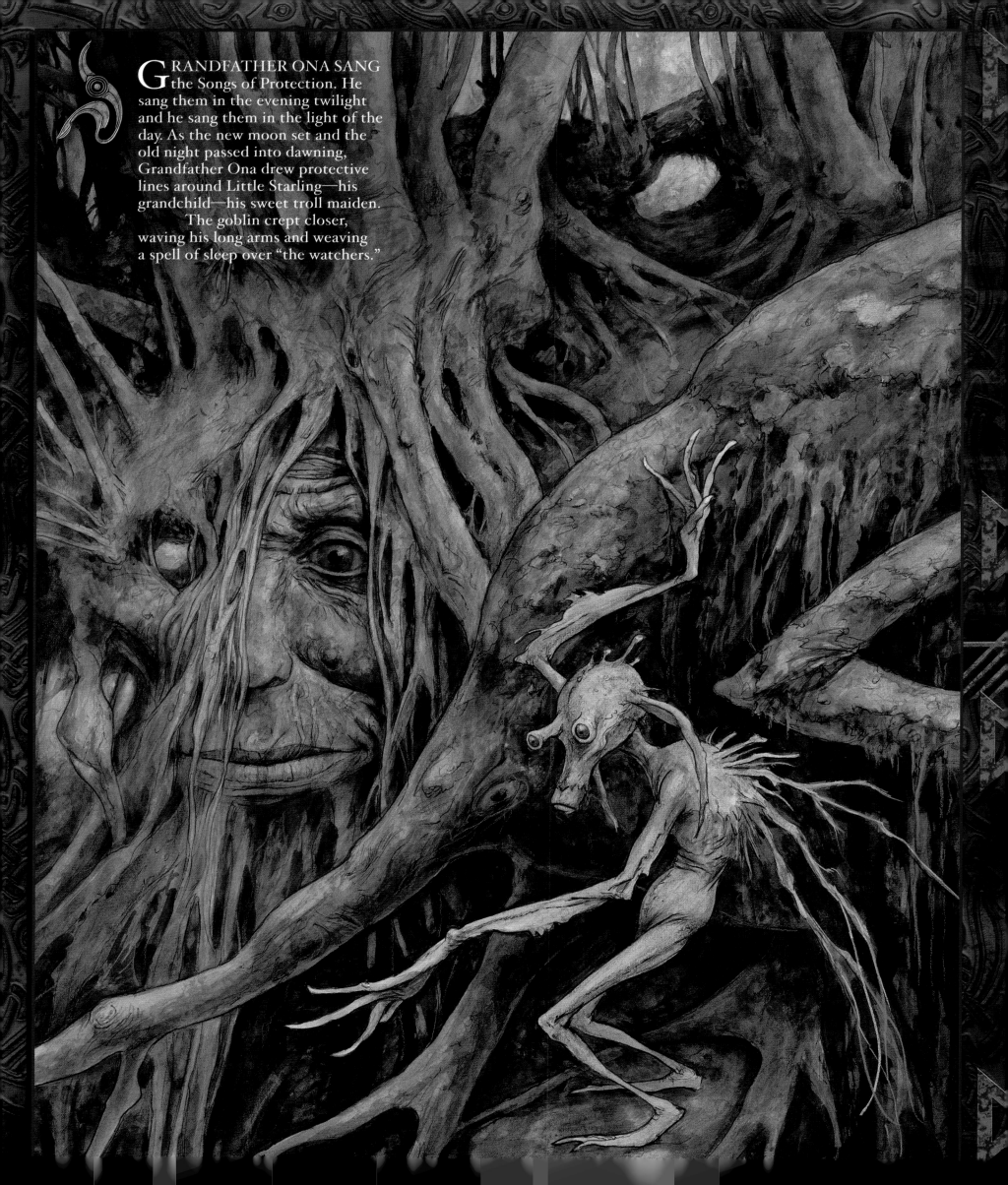

GRANDFATHER ONA SANG the Songs of Protection. He sang them in the evening twilight and he sang them in the light of the day. As the new moon set and the old night passed into dawning, Grandfather Ona drew protective lines around Little Starling—his grandchild—his sweet troll maiden.

The goblin crept closer, waving his long arms and weaving a spell of sleep over "the watchers."

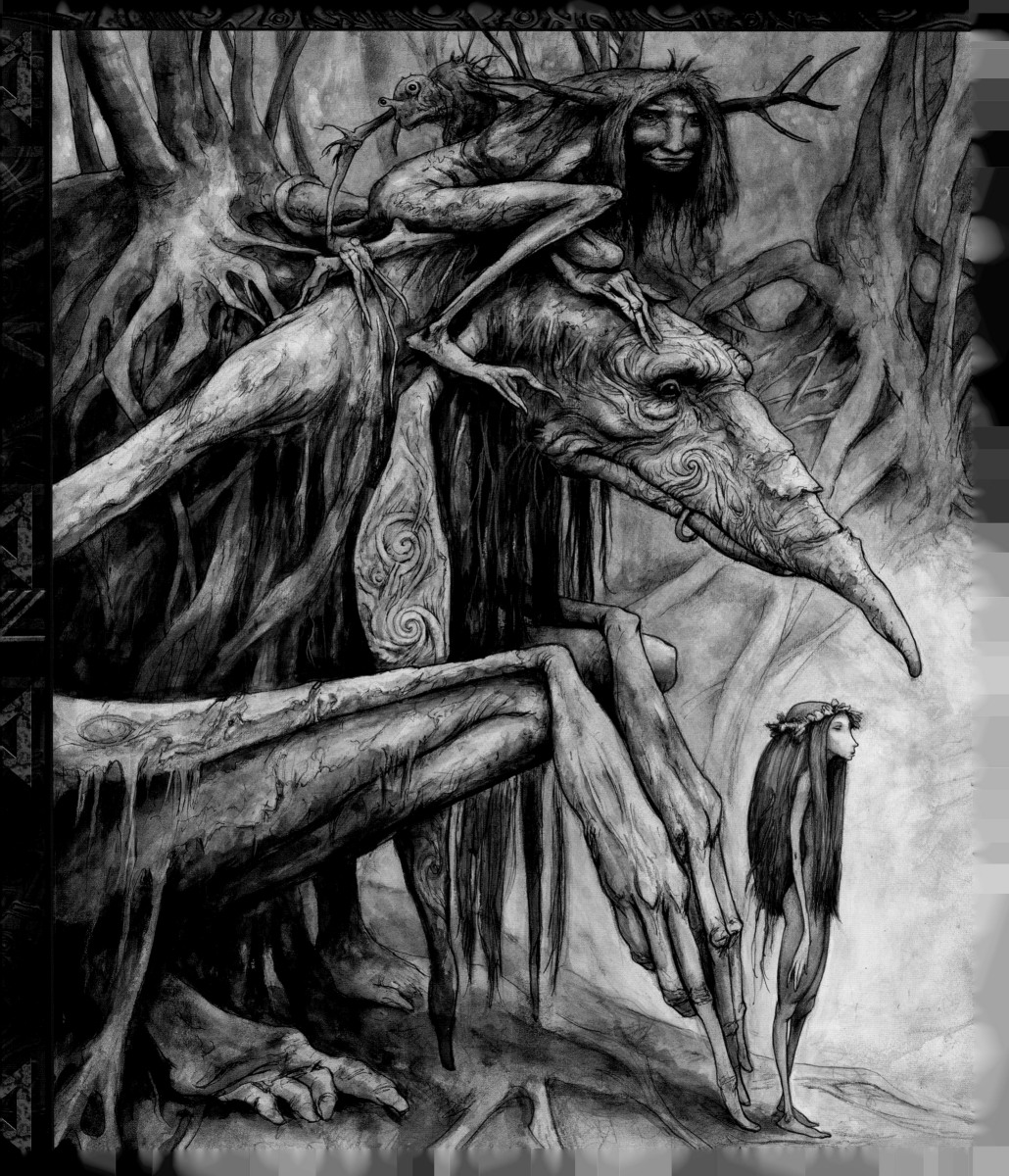

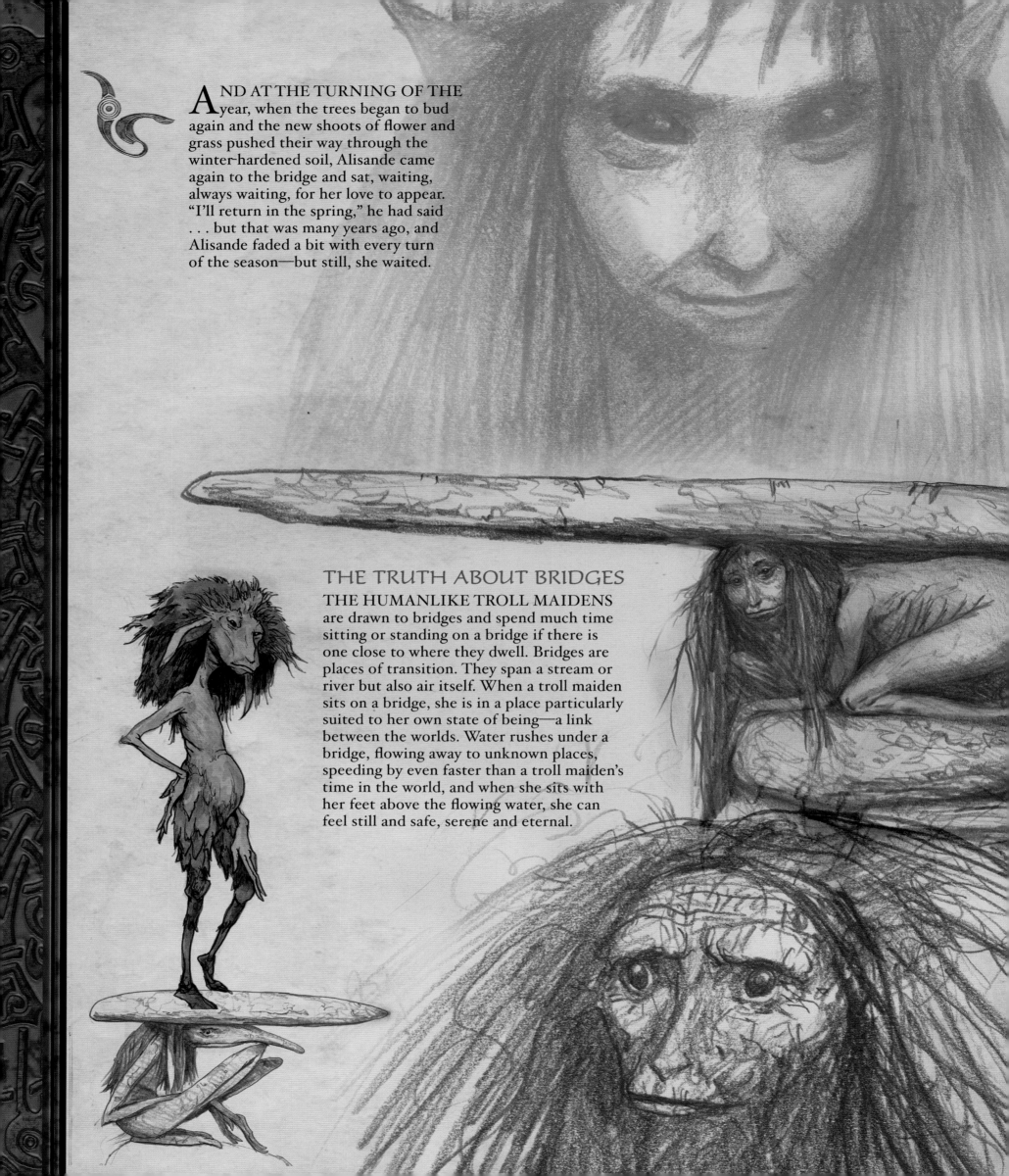

AND AT THE TURNING OF THE
year, when the trees began to bud
again and the new shoots of flower and
grass pushed their way through the
winter-hardened soil, Alisande came
again to the bridge and sat, waiting,
always waiting, for her love to appear.
"I'll return in the spring," he had said
. . . but that was many years ago, and
Alisande faded a bit with every turn
of the season—but still, she waited.

THE TRUTH ABOUT BRIDGES

THE HUMANLIKE TROLL MAIDENS
are drawn to bridges and spend much time
sitting or standing on a bridge if there is
one close to where they dwell. Bridges are
places of transition. They span a stream or
river but also air itself. When a troll maiden
sits on a bridge, she is in a place particularly
suited to her own state of being—a link
between the worlds. Water rushes under a
bridge, flowing away to unknown places,
speeding by even faster than a troll maiden's
time in the world, and when she sits with
her feet above the flowing water, she can
feel still and safe, serene and eternal.

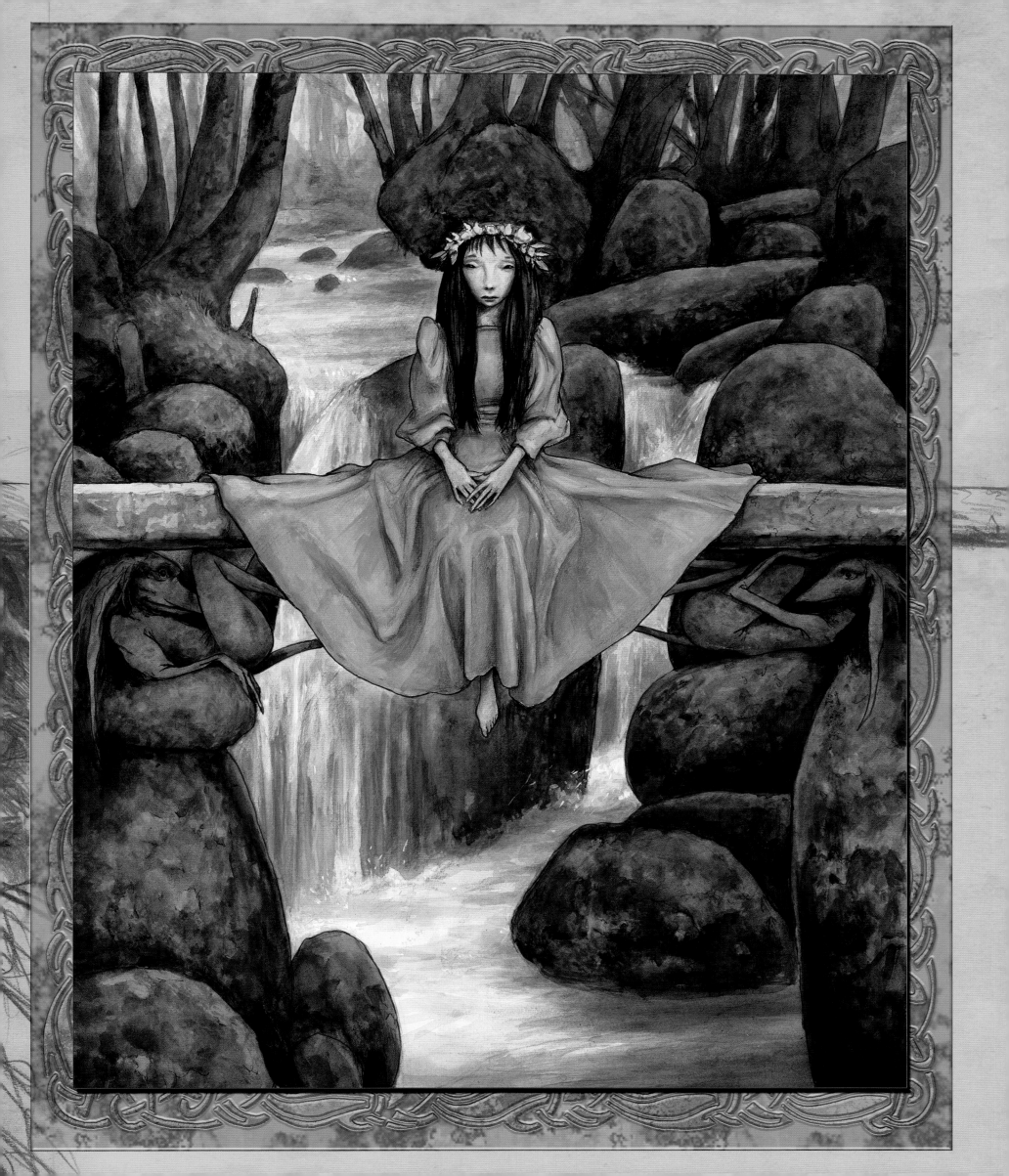

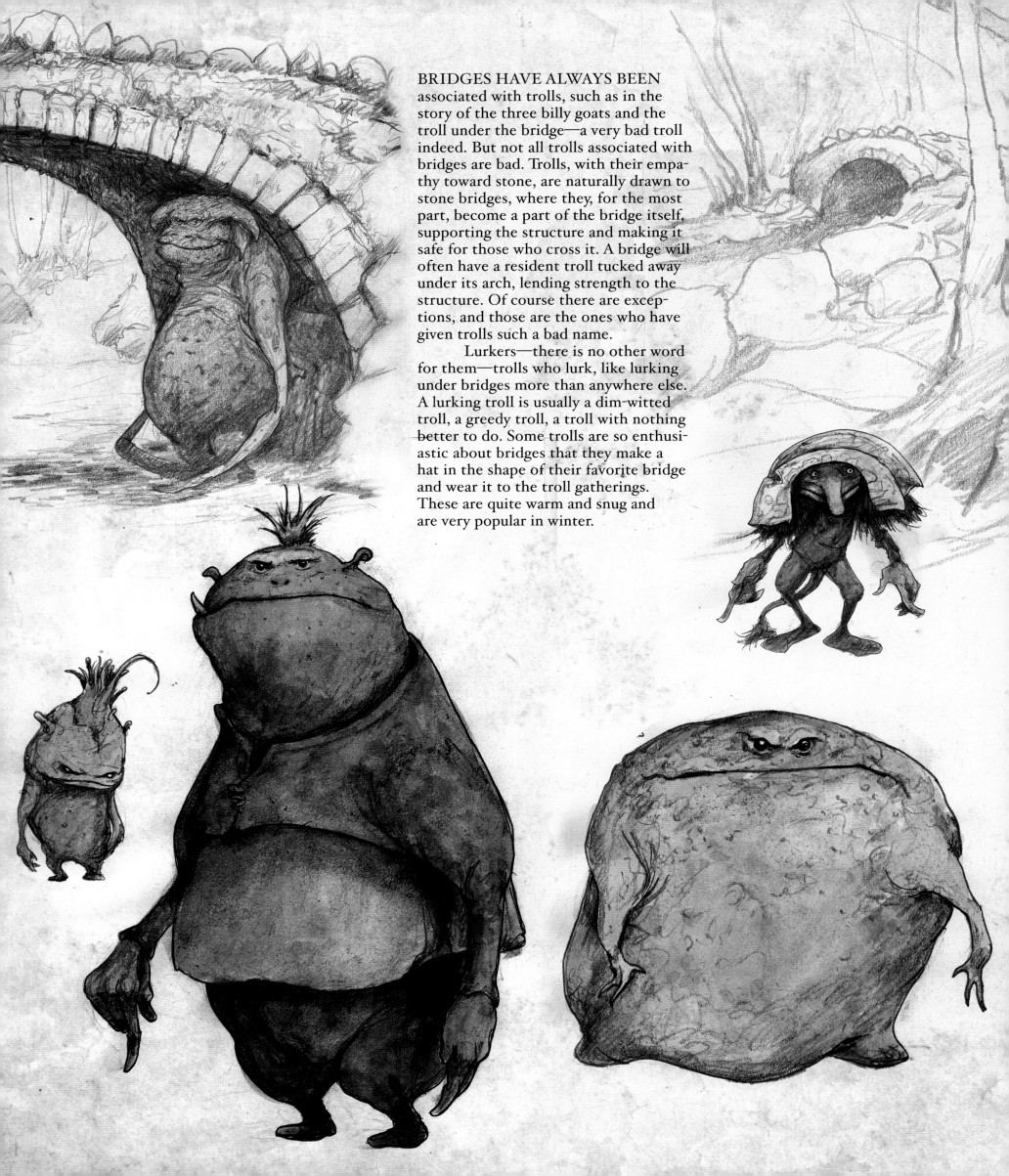

BRIDGES HAVE ALWAYS BEEN associated with trolls, such as in the story of the three billy goats and the troll under the bridge—a very bad troll indeed. But not all trolls associated with bridges are bad. Trolls, with their empathy toward stone, are naturally drawn to stone bridges, where they, for the most part, become a part of the bridge itself, supporting the structure and making it safe for those who cross it. A bridge will often have a resident troll tucked away under its arch, lending strength to the structure. Of course there are exceptions, and those are the ones who have given trolls such a bad name.

Lurkers—there is no other word for them—trolls who lurk, like lurking under bridges more than anywhere else. A lurking troll is usually a dim-witted troll, a greedy troll, a troll with nothing better to do. Some trolls are so enthusiastic about bridges that they make a hat in the shape of their favorite bridge and wear it to the troll gatherings. These are quite warm and snug and are very popular in winter.

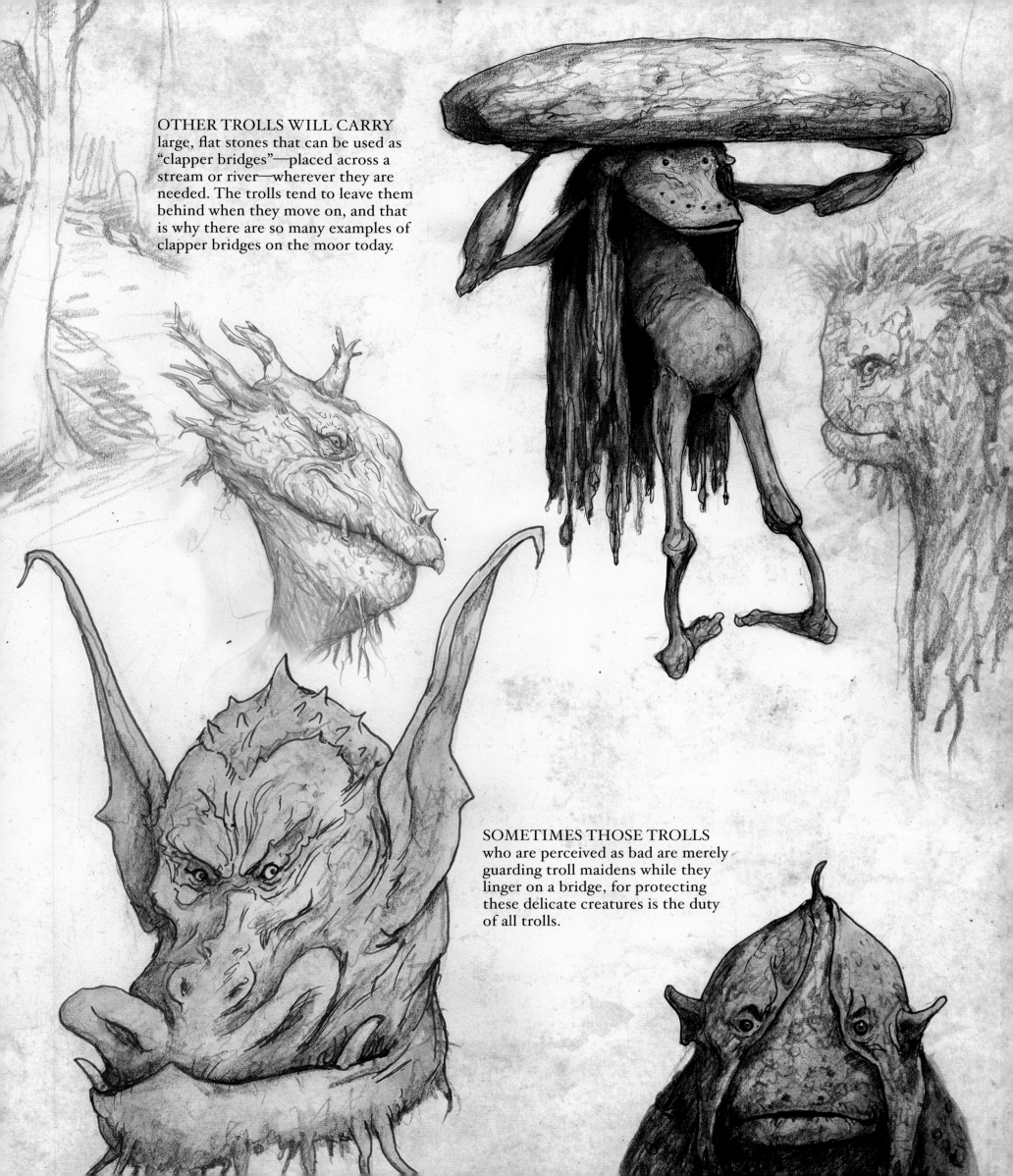

OTHER TROLLS WILL CARRY large, flat stones that can be used as "clapper bridges"—placed across a stream or river—wherever they are needed. The trolls tend to leave them behind when they move on, and that is why there are so many examples of clapper bridges on the moor today.

SOMETIMES THOSE TROLLS who are perceived as bad are merely guarding troll maidens while they linger on a bridge, for protecting these delicate creatures is the duty of all trolls.

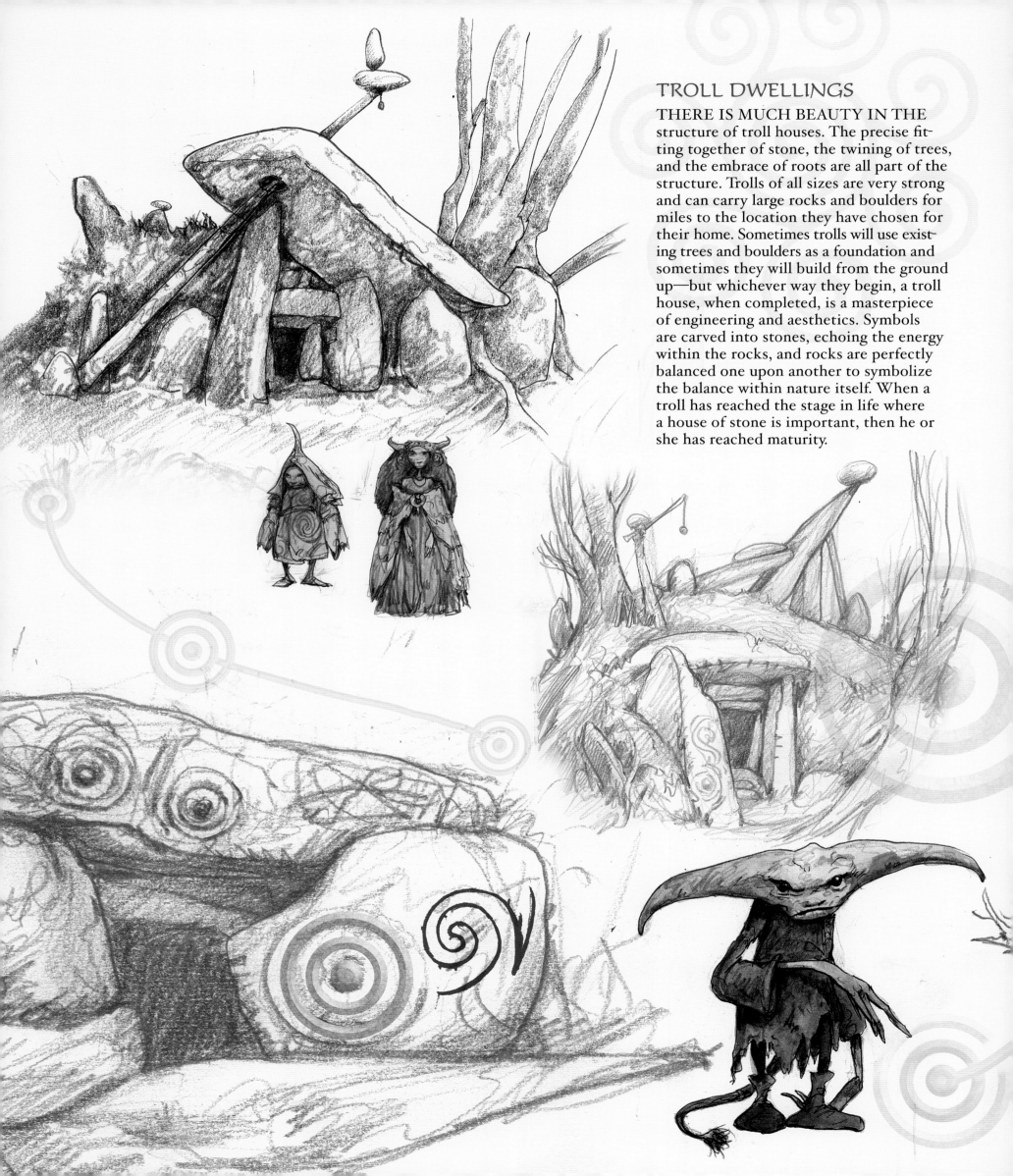

TROLL DWELLINGS

THERE IS MUCH BEAUTY IN THE structure of troll houses. The precise fitting together of stone, the twining of trees, and the embrace of roots are all part of the structure. Trolls of all sizes are very strong and can carry large rocks and boulders for miles to the location they have chosen for their home. Sometimes trolls will use existing trees and boulders as a foundation and sometimes they will build from the ground up—but whichever way they begin, a troll house, when completed, is a masterpiece of engineering and aesthetics. Symbols are carved into stones, echoing the energy within the rocks, and rocks are perfectly balanced one upon another to symbolize the balance within nature itself. When a troll has reached the stage in life where a house of stone is important, then he or she has reached maturity.

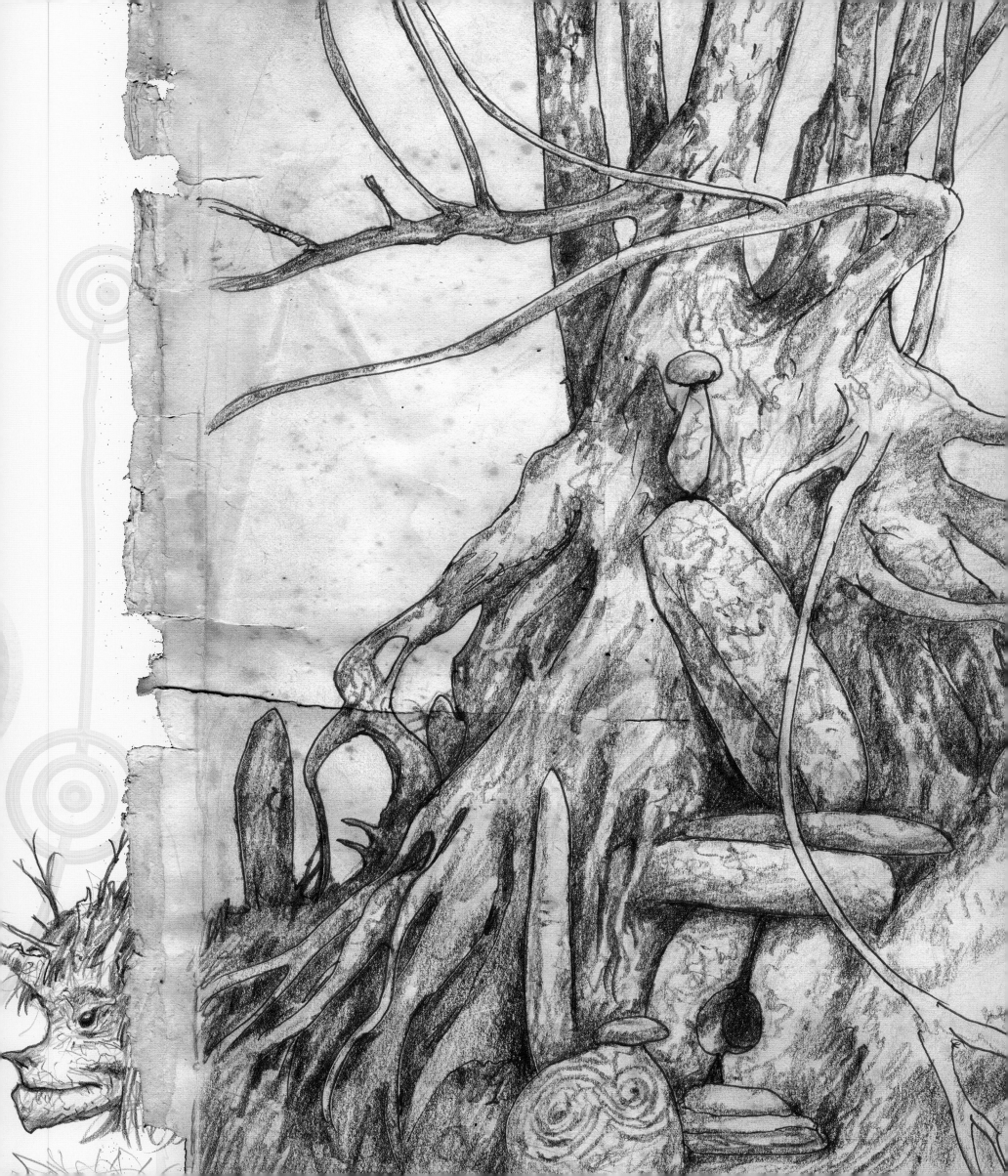

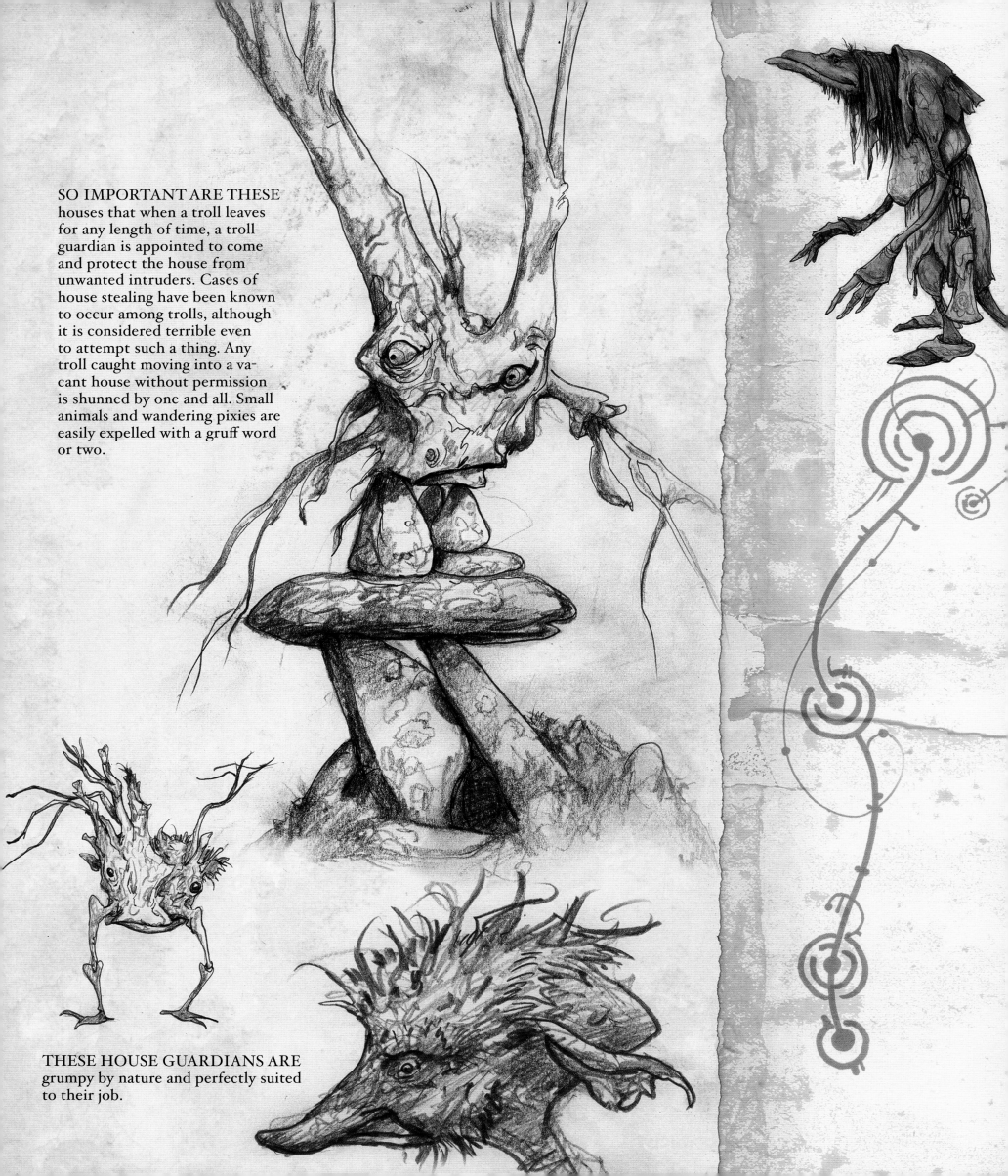

SO IMPORTANT ARE THESE houses that when a troll leaves for any length of time, a troll guardian is appointed to come and protect the house from unwanted intruders. Cases of house stealing have been known to occur among trolls, although it is considered terrible even to attempt such a thing. Any troll caught moving into a vacant house without permission is shunned by one and all. Small animals and wandering pixies are easily expelled with a gruff word or two.

THESE HOUSE GUARDIANS ARE grumpy by nature and perfectly suited to their job.

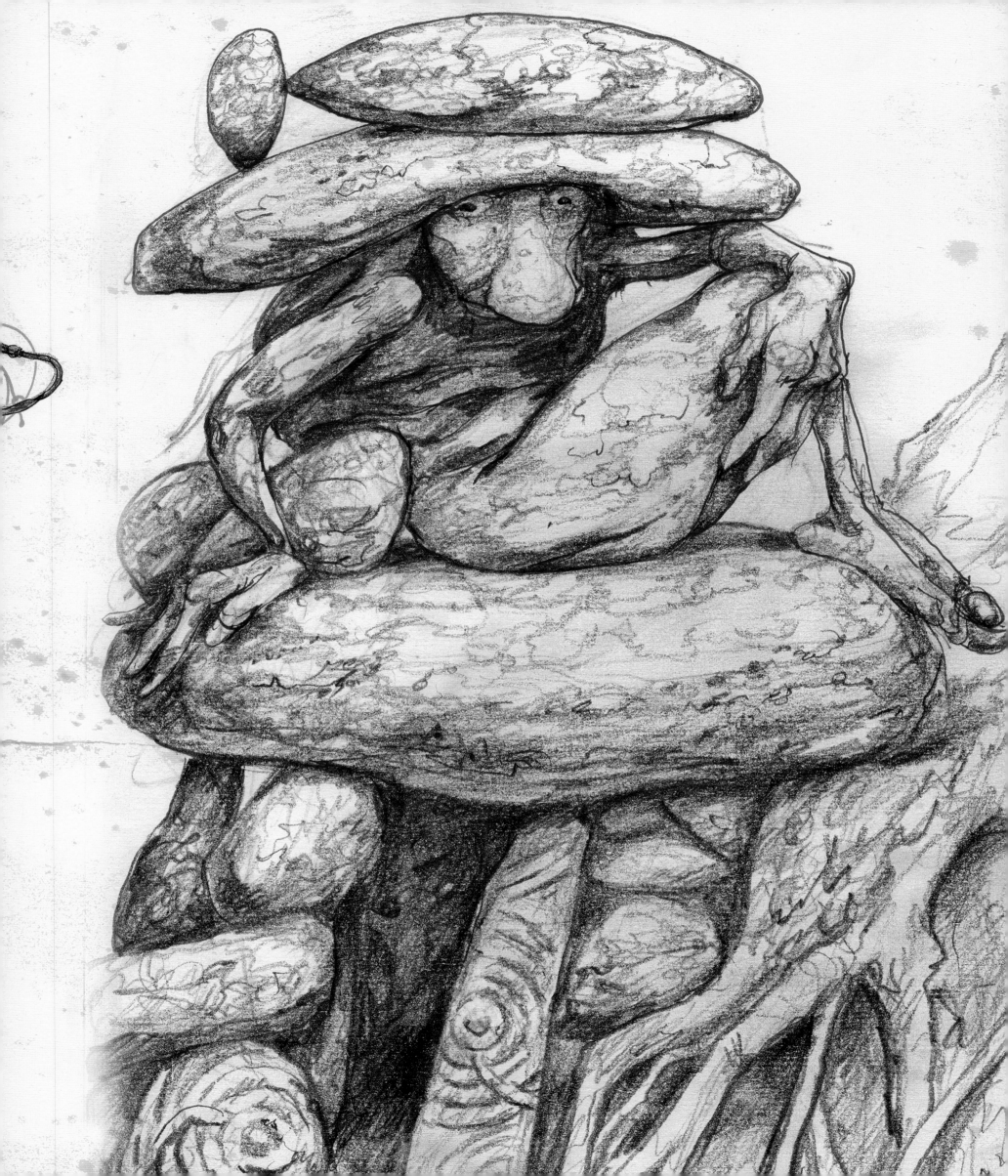

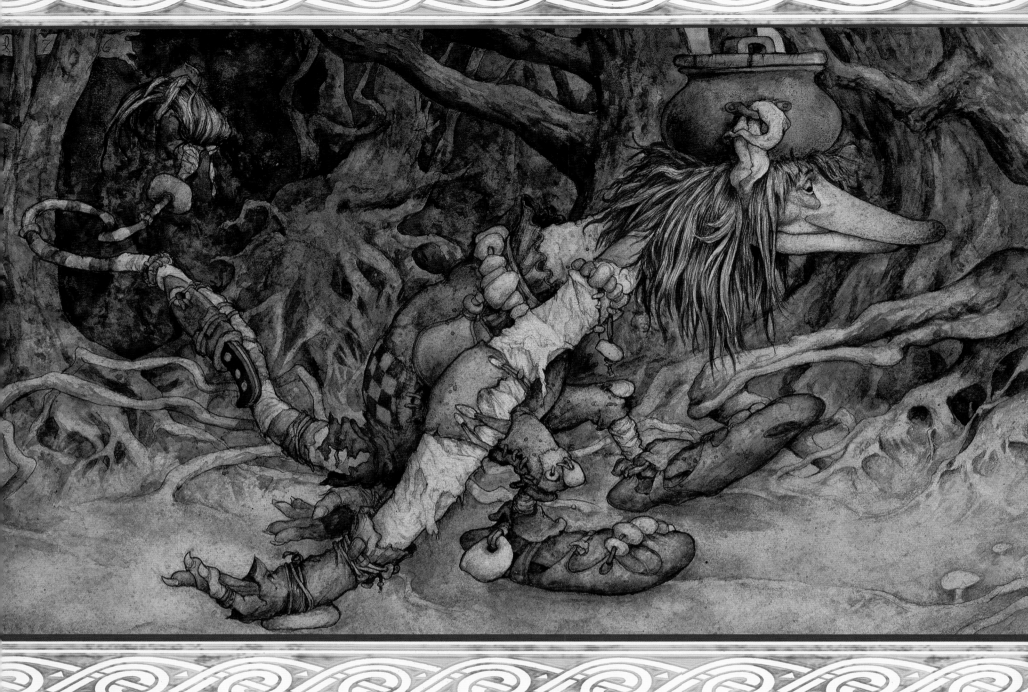

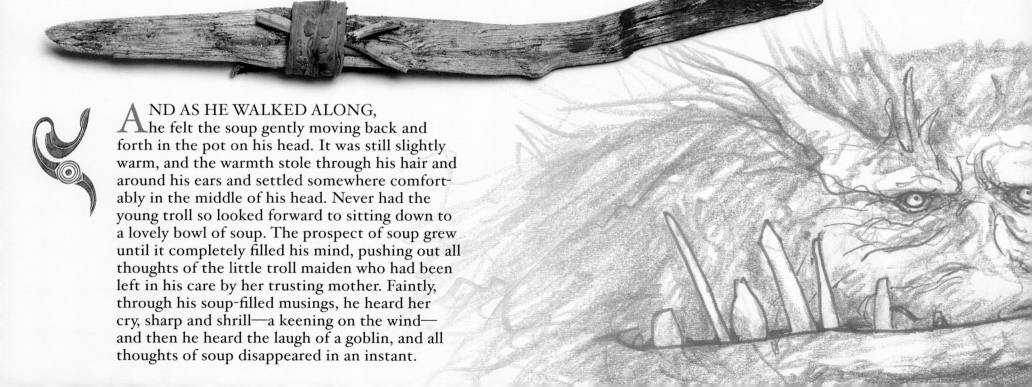

AND AS HE WALKED ALONG,
he felt the soup gently moving back and
forth in the pot on his head. It was still slightly
warm, and the warmth stole through his hair and
around his ears and settled somewhere comfort-
ably in the middle of his head. Never had the
young troll so looked forward to sitting down to
a lovely bowl of soup. The prospect of soup grew
until it completely filled his mind, pushing out all
thoughts of the little troll maiden who had been
left in his care by her trusting mother. Faintly,
through his soup-filled musings, he heard her
cry, sharp and shrill—a keening on the wind—
and then he heard the laugh of a goblin, and all
thoughts of soup disappeared in an instant.

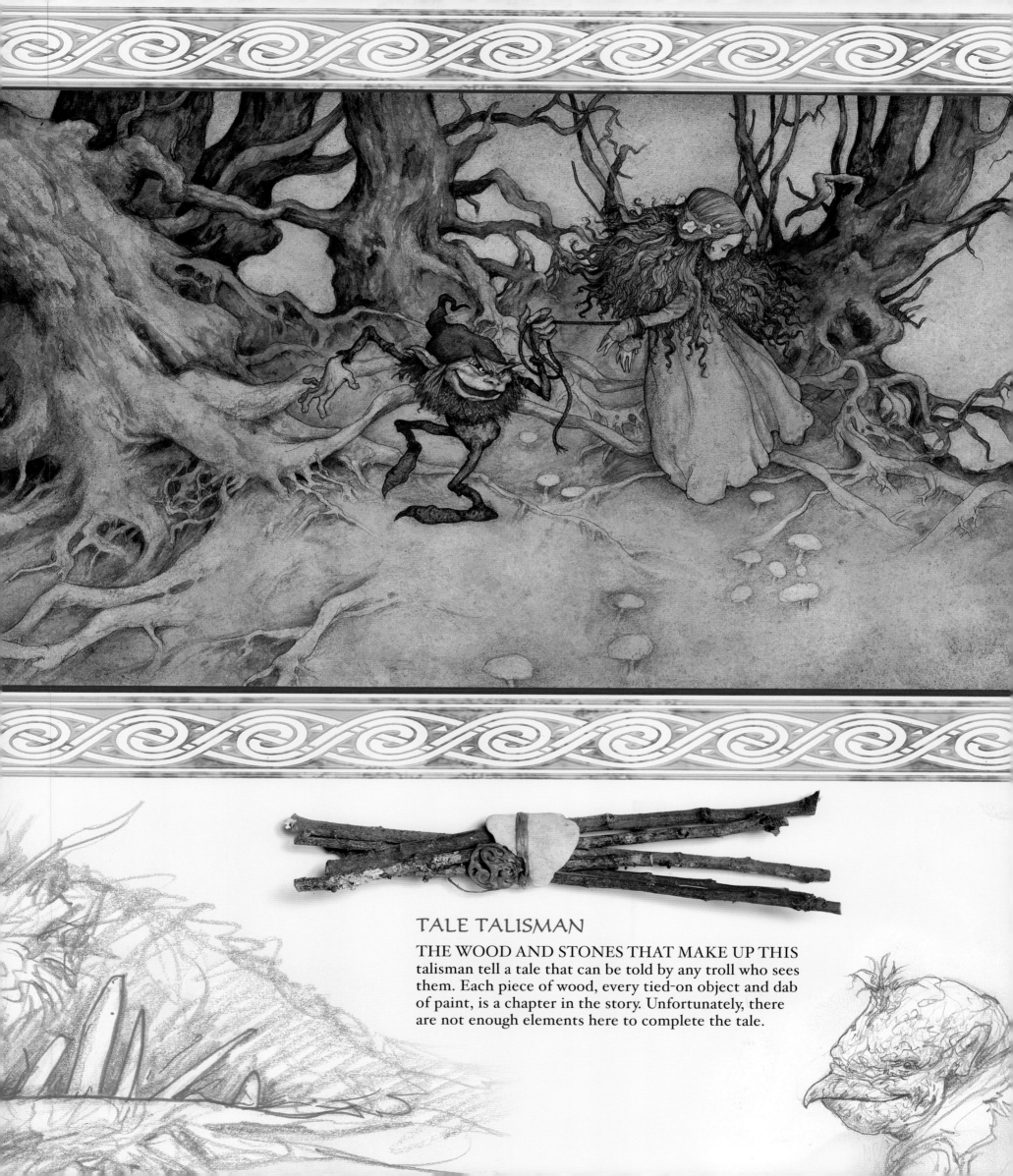

TALE TALISMAN

THE WOOD AND STONES THAT MAKE UP THIS
talisman tell a tale that can be told by any troll who sees
them. Each piece of wood, every tied-on object and dab
of paint, is a chapter in the story. Unfortunately, there
are not enough elements here to complete the tale.

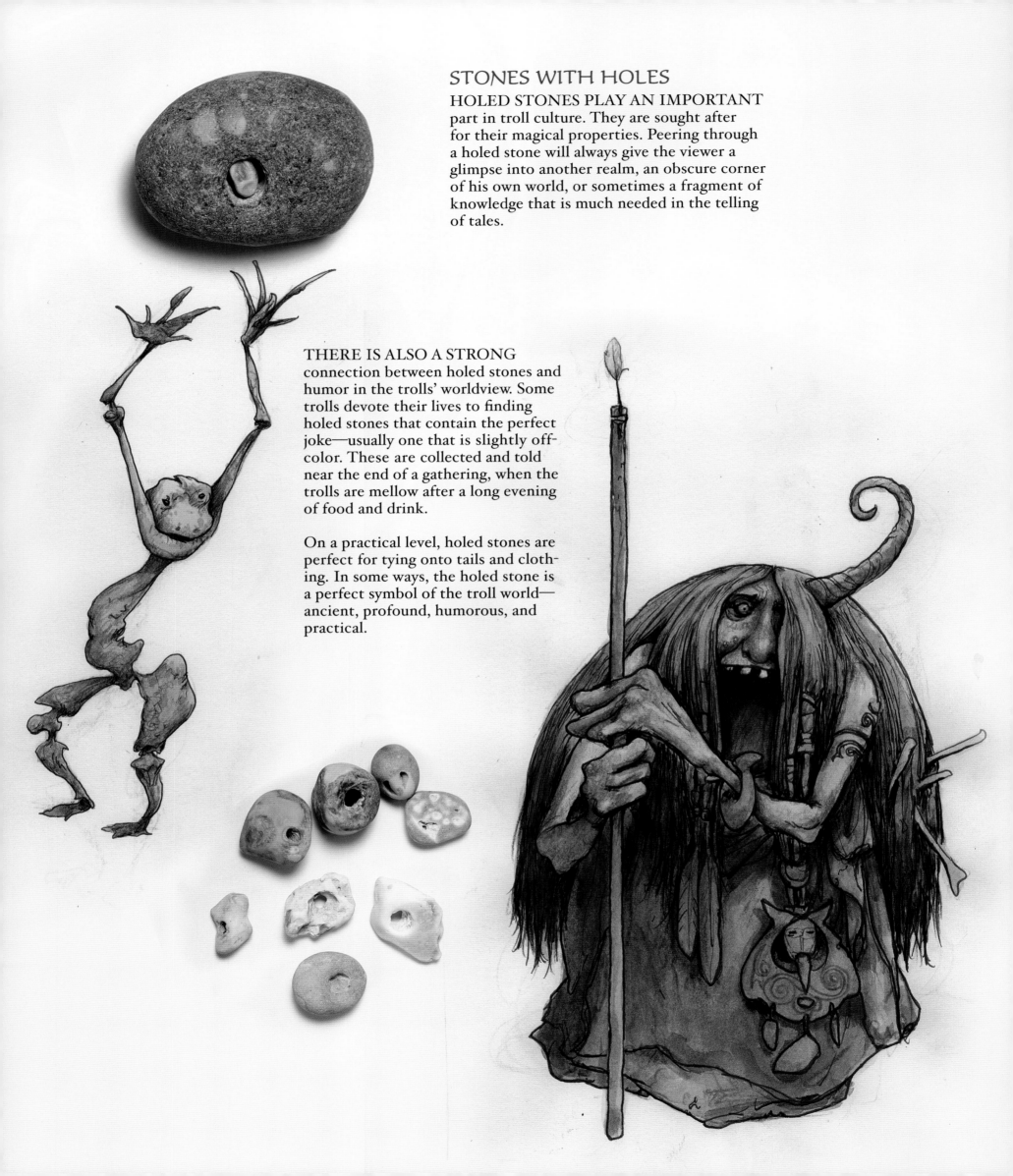

STONES WITH HOLES

HOLED STONES PLAY AN IMPORTANT part in troll culture. They are sought after for their magical properties. Peering through a holed stone will always give the viewer a glimpse into another realm, an obscure corner of his own world, or sometimes a fragment of knowledge that is much needed in the telling of tales.

THERE IS ALSO A STRONG connection between holed stones and humor in the trolls' worldview. Some trolls devote their lives to finding holed stones that contain the perfect joke—usually one that is slightly off-color. These are collected and told near the end of a gathering, when the trolls are mellow after a long evening of food and drink.

On a practical level, holed stones are perfect for tying onto tails and clothing. In some ways, the holed stone is a perfect symbol of the troll world—ancient, profound, humorous, and practical.

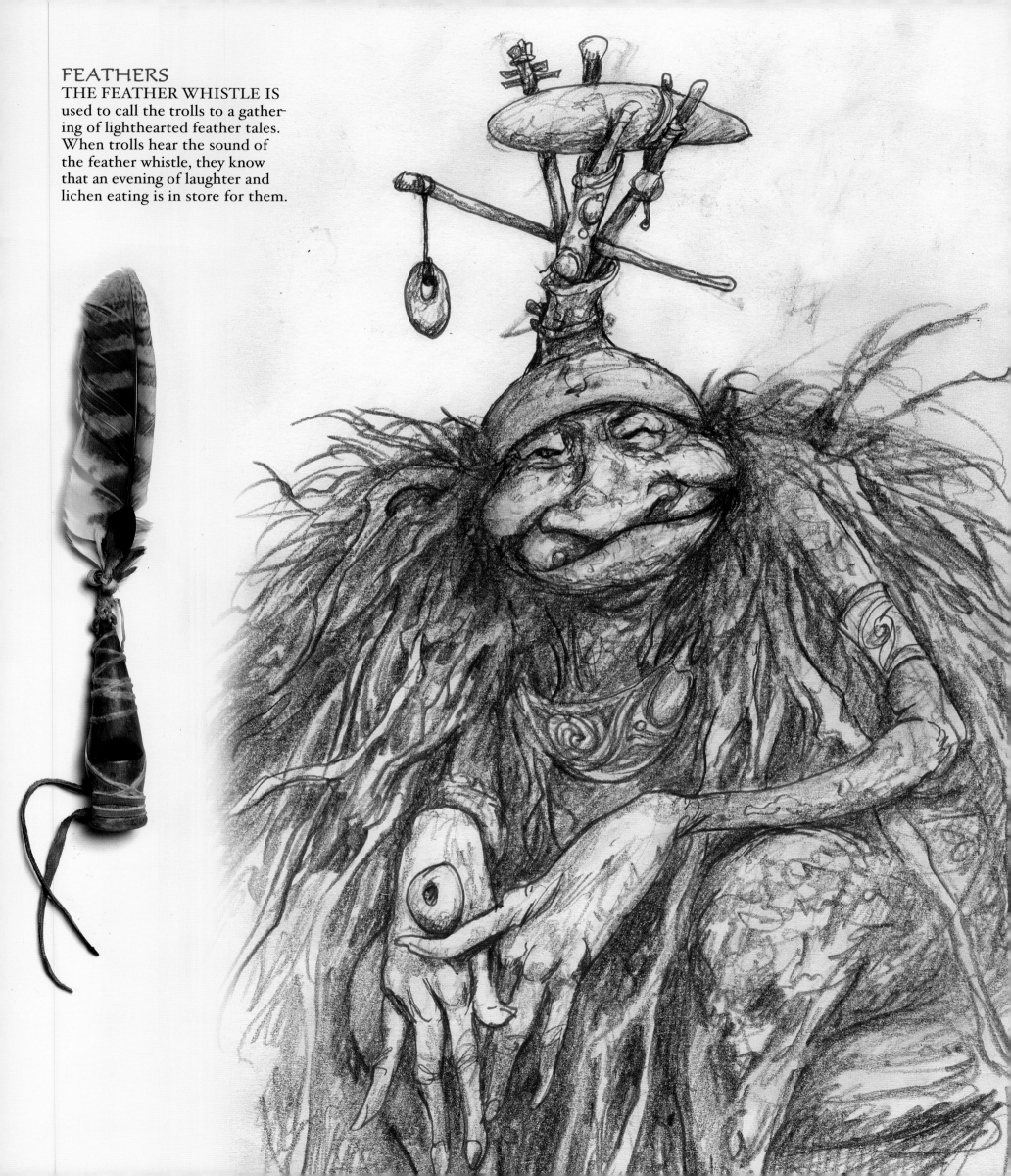

FEATHERS

THE FEATHER WHISTLE IS used to call the trolls to a gathering of lighthearted feather tales. When trolls hear the sound of the feather whistle, they know that an evening of laughter and lichen eating is in store for them.

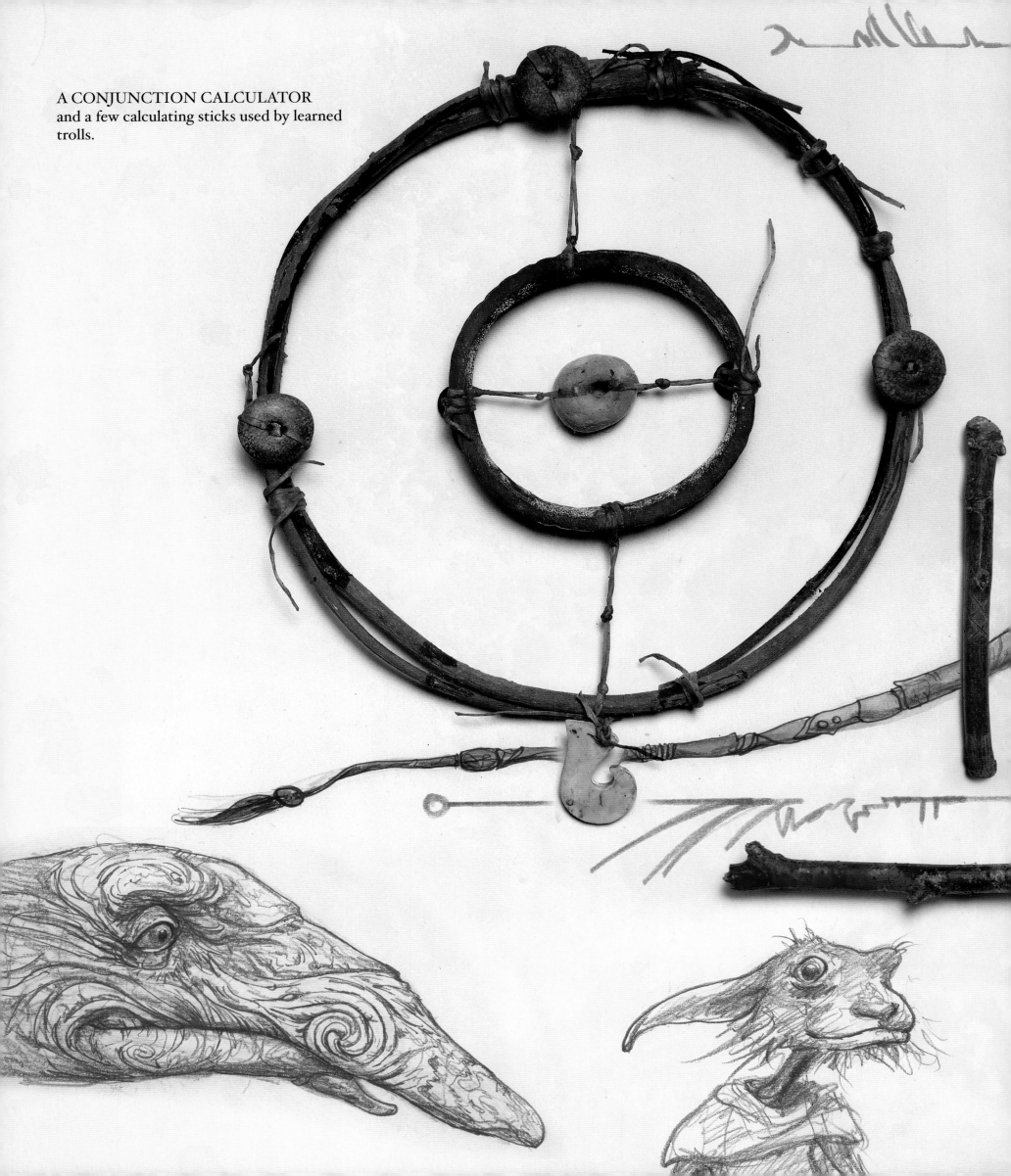

A CONJUNCTION CALCULATOR
and a few calculating sticks used by learned
trolls.

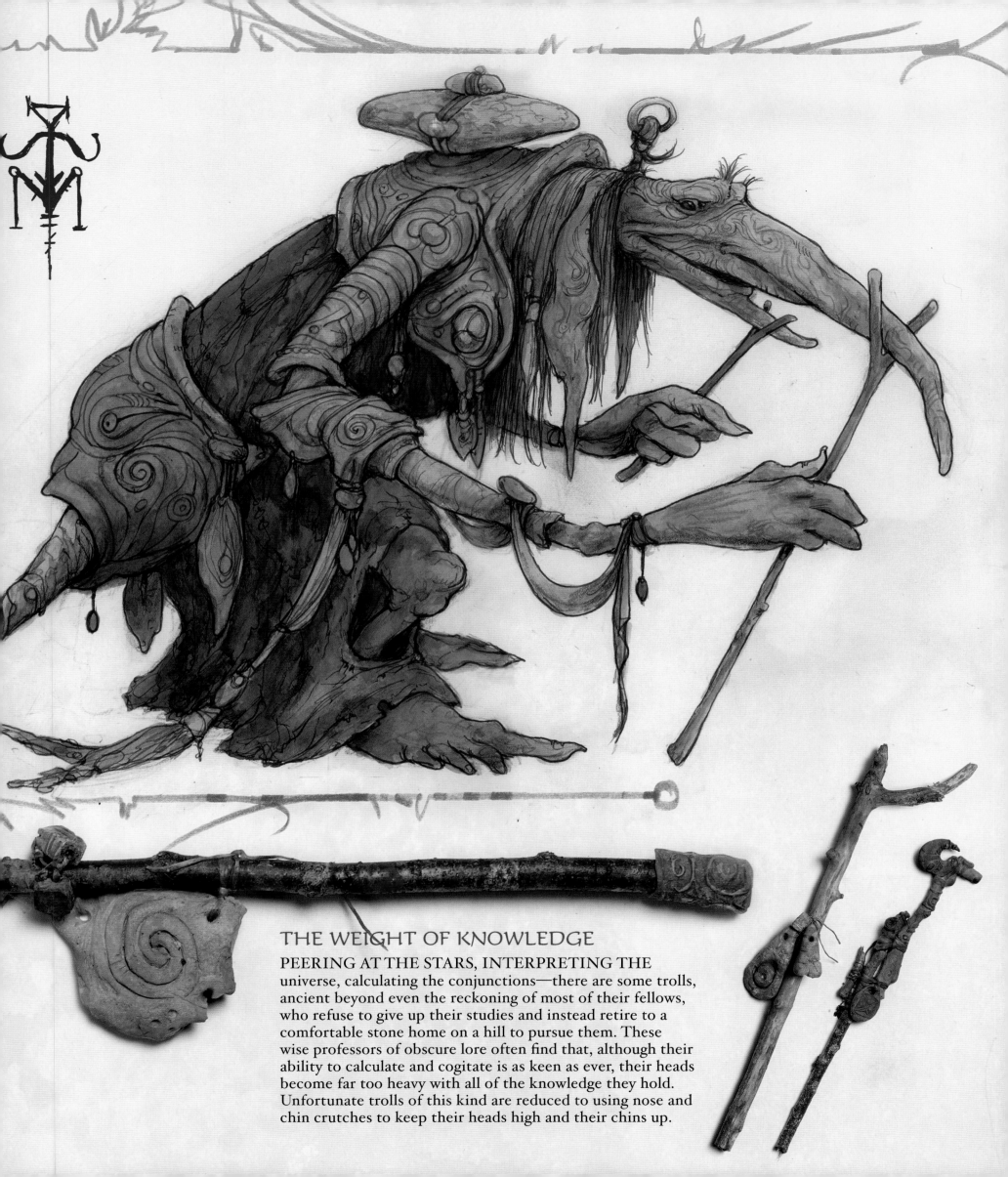

THE WEIGHT OF KNOWLEDGE

PEERING AT THE STARS, INTERPRETING THE
universe, calculating the conjunctions—there are some trolls,
ancient beyond even the reckoning of most of their fellows,
who refuse to give up their studies and instead retire to a
comfortable stone home on a hill to pursue them. These
wise professors of obscure lore often find that, although their
ability to calculate and cogitate is as keen as ever, their heads
become far too heavy with all of the knowledge they hold.
Unfortunate trolls of this kind are reduced to using nose and
chin crutches to keep their heads high and their chins up.

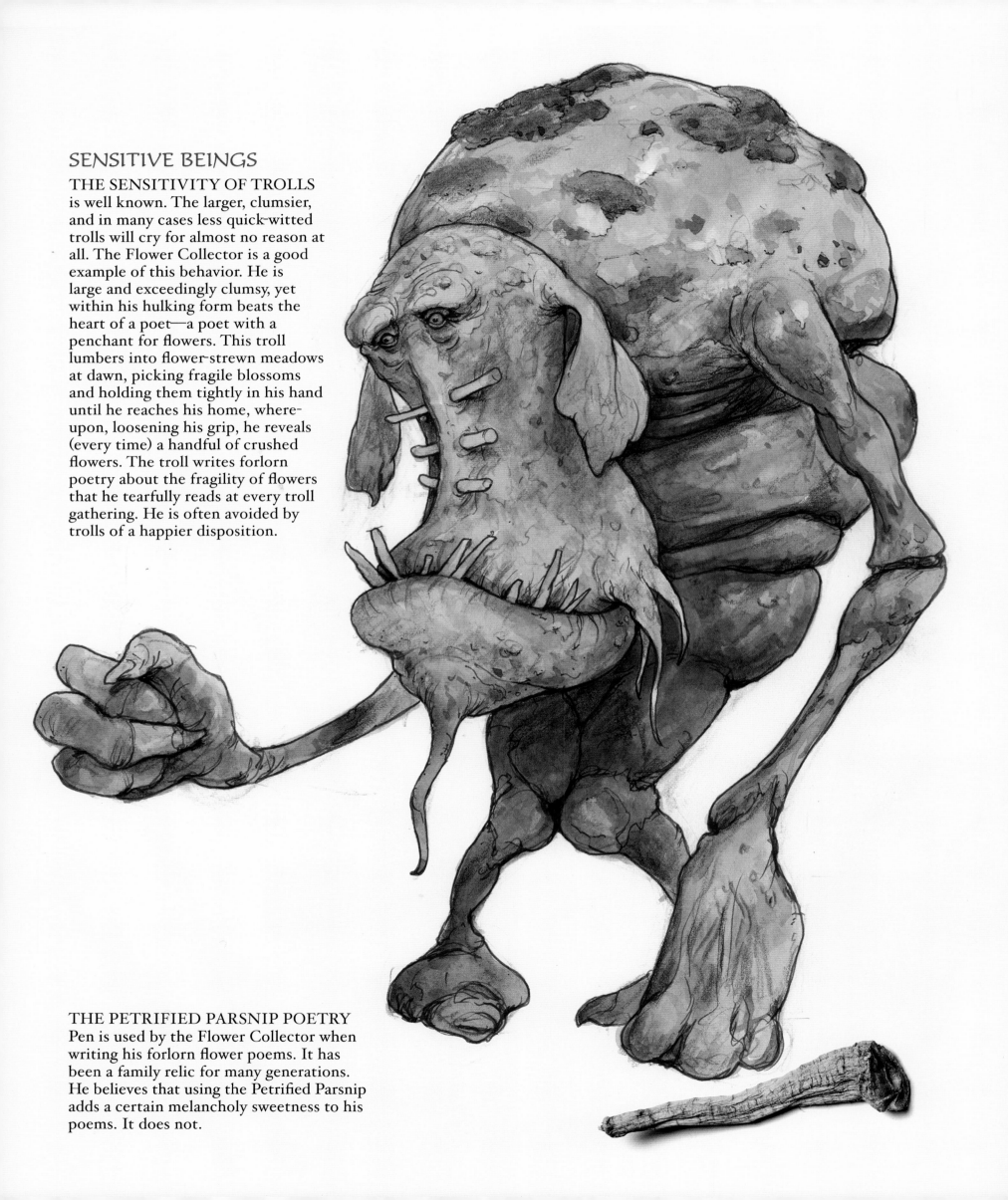

SENSITIVE BEINGS

THE SENSITIVITY OF TROLLS is well known. The larger, clumsier, and in many cases less quick-witted trolls will cry for almost no reason at all. The Flower Collector is a good example of this behavior. He is large and exceedingly clumsy, yet within his hulking form beats the heart of a poet—a poet with a penchant for flowers. This troll lumbers into flower-strewn meadows at dawn, picking fragile blossoms and holding them tightly in his hand until he reaches his home, where-upon, loosening his grip, he reveals (every time) a handful of crushed flowers. The troll writes forlorn poetry about the fragility of flowers that he tearfully reads at every troll gathering. He is often avoided by trolls of a happier disposition.

THE PETRIFIED PARSNIP POETRY Pen is used by the Flower Collector when writing his forlorn flower poems. It has been a family relic for many generations. He believes that using the Petrified Parsnip adds a certain melancholy sweetness to his poems. It does not.

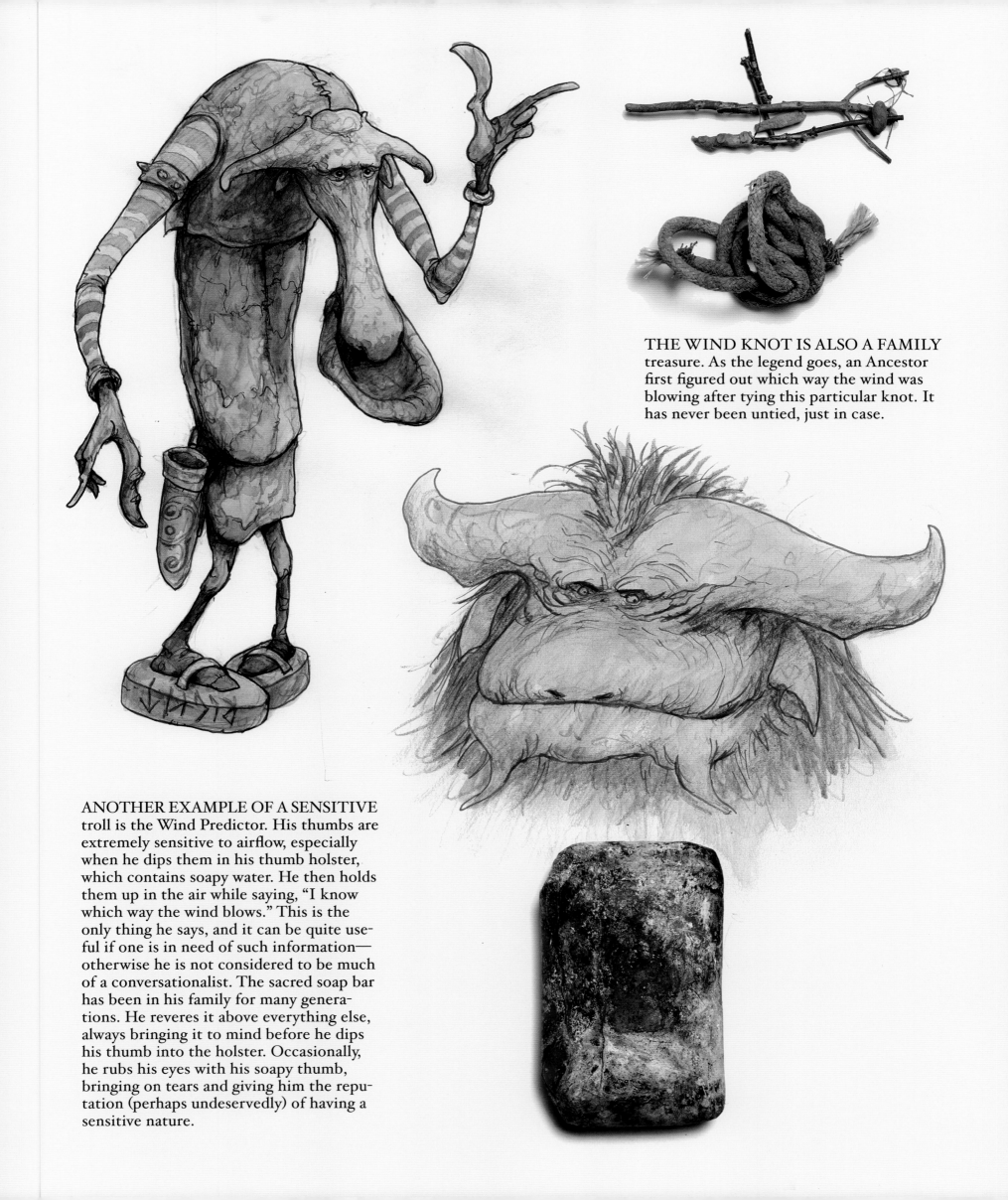

THE WIND KNOT IS ALSO A FAMILY treasure. As the legend goes, an Ancestor first figured out which way the wind was blowing after tying this particular knot. It has never been untied, just in case.

ANOTHER EXAMPLE OF A SENSITIVE troll is the Wind Predictor. His thumbs are extremely sensitive to airflow, especially when he dips them in his thumb holster, which contains soapy water. He then holds them up in the air while saying, "I know which way the wind blows." This is the only thing he says, and it can be quite useful if one is in need of such information—otherwise he is not considered to be much of a conversationalist. The sacred soap bar has been in his family for many generations. He reveres it above everything else, always bringing it to mind before he dips his thumb into the holster. Occasionally, he rubs his eyes with his soapy thumb, bringing on tears and giving him the reputation (perhaps undeservedly) of having a sensitive nature.

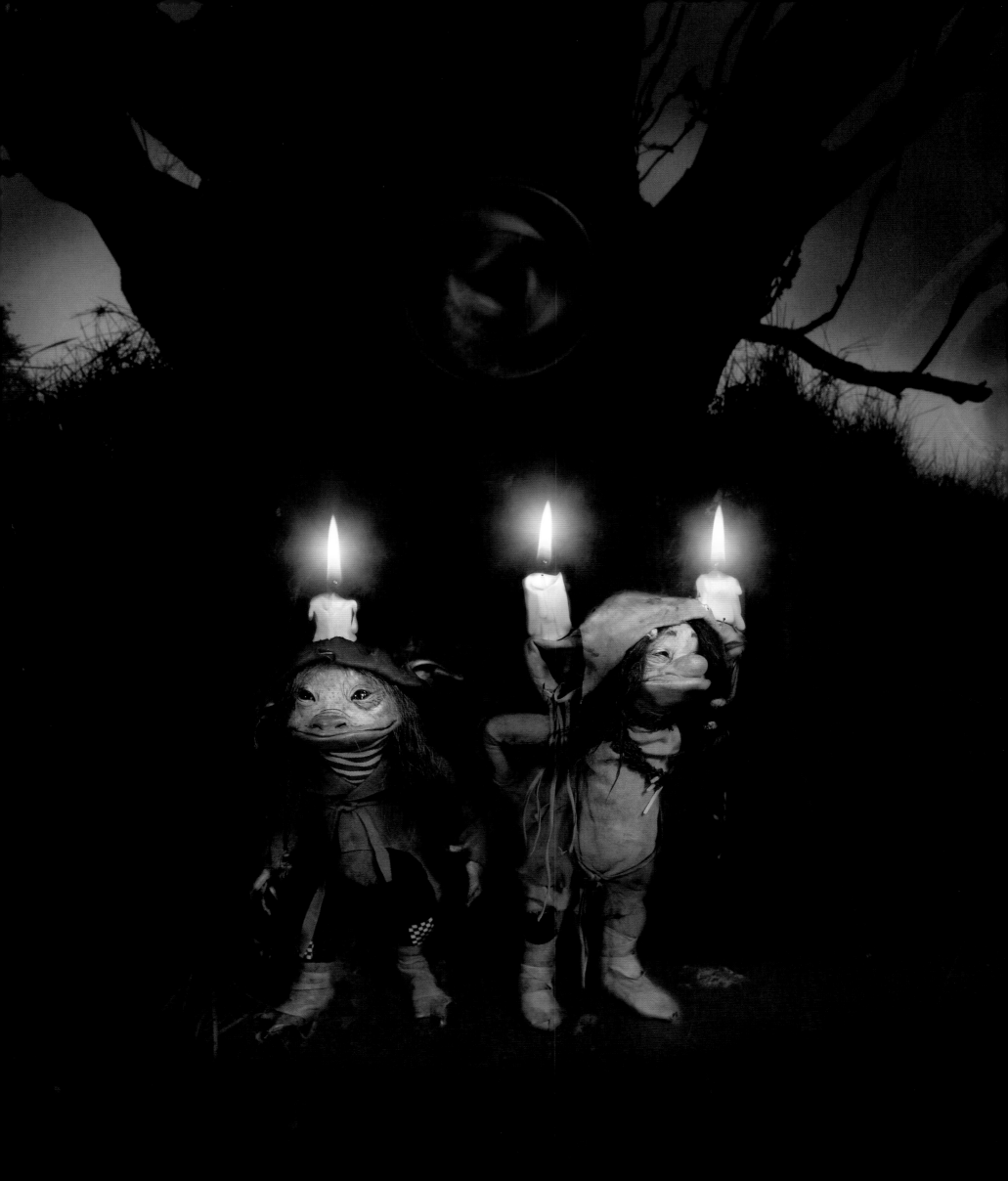

WAYWARD ILLUMINATION

THERE HAVE ALWAYS BEEN TALES OF FOLK
led astray on the moors by following ghostly lights in
the darkness. These lights are notorious for leading
whoever follows them into bogs and marshes.
While some of these lights may be the work of
mischievous pixies, marsh gas, or other phenomena,
they are often no more than simple trolls, wending
their way home by candlelight, unaware of the
havoc they might be causing.

WELL, THERE'S THE TALE OF OUR TERRIBLE NOISES IN THE NIGHT
When we walks on our way with our candles all alit up,
Wherever we goes, we hears strange things and noises and such
A-following on from behind.
We never sees a thing, but then we never turns around,
We're that a-scared and a-frighted.
So we always lights our candles and we always hears the noises
And we always tries to shake them off in the bogs.
Then sometimes we hears a wailing and screaming
And the noises goes away.
We lives a terrible life and no mistake.

The troll child stepped onto the moorland,
The open land, the land of grass and gorse,
Of heather and bluebells, of hills and tors
And rocks and trolls.
For the trolls are everywhere
Moorland and forest, on tor and under hill
Large and small, tiny and huge,
Trolls are everywhere—if you have the eyes to look
And the heart to see.

But which troll to ask next?
Which troll had a tale to spare, and the right tale at that?
Finally, he came to a tall tor, a great tumble of rocks.

The troll child wandered and searched,
Pondered and worried.
Perched on the top of a high hill
Surrounded by white thorn in blossom
And bluebells that carpeted the lowland around it,
There sat a troll.

The troll of the tor watched the troll child from his tumble of rocks.
He looked with one eye that was large as a flink of cows,
He opened a mouth that was big as a drove of bullocks,
He said in a voice that was loud as a clowder of cats,
"Who are you, little troll, and what do you want?"
"A tale, please, sir, a tale for the telling, a tale for the keeping,
If you would be so kind."

"A tale," said the troll, "a tale for the keeping.
Maybe this is the tale." He rumbled and hummed.
"No, not that one I think; too grim for the morning,
Too fierce for the bluebells.
A feather tale I will tell you to lighten your heart.
A tale of laughter to quicken your feet and straighten your path."

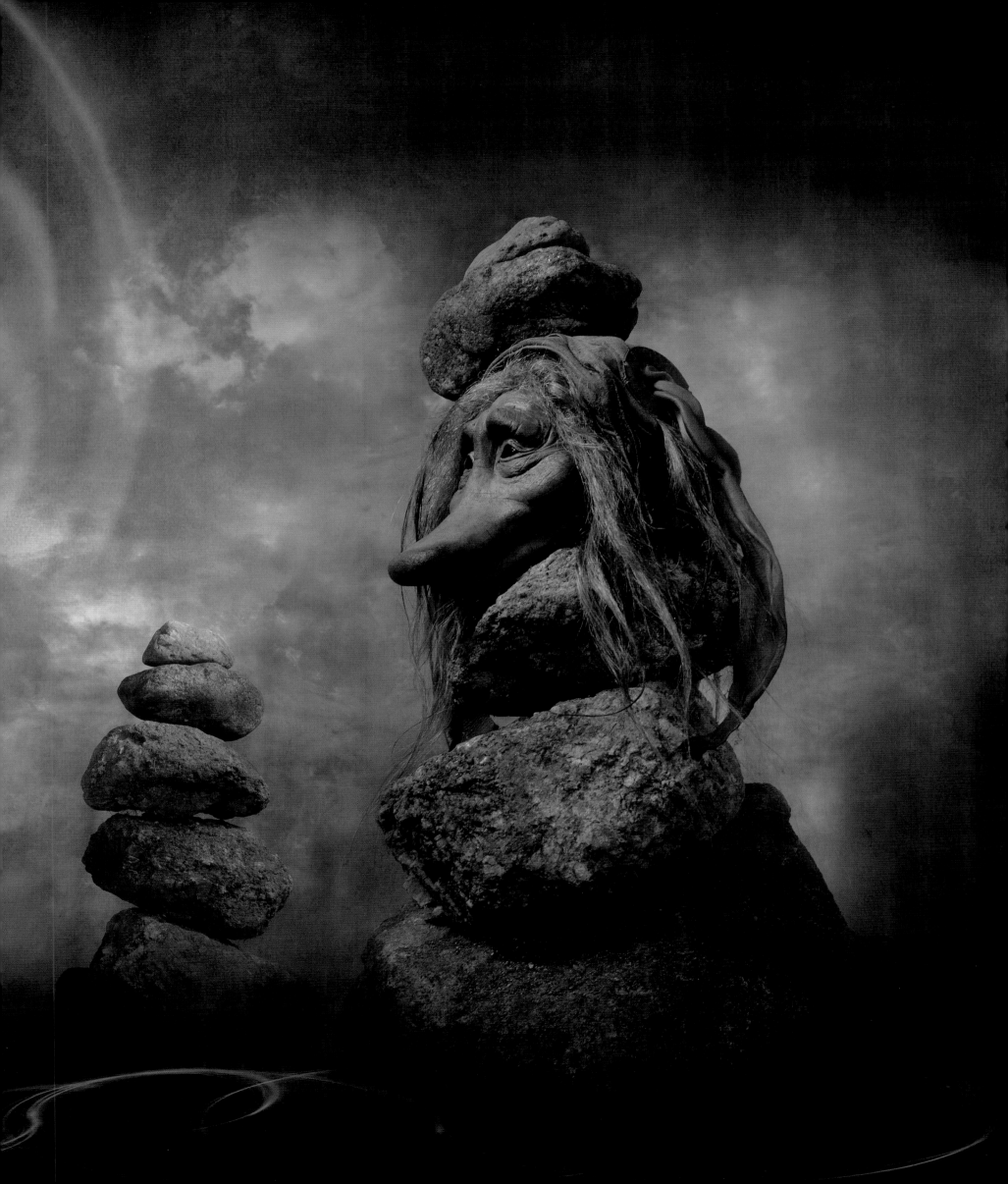

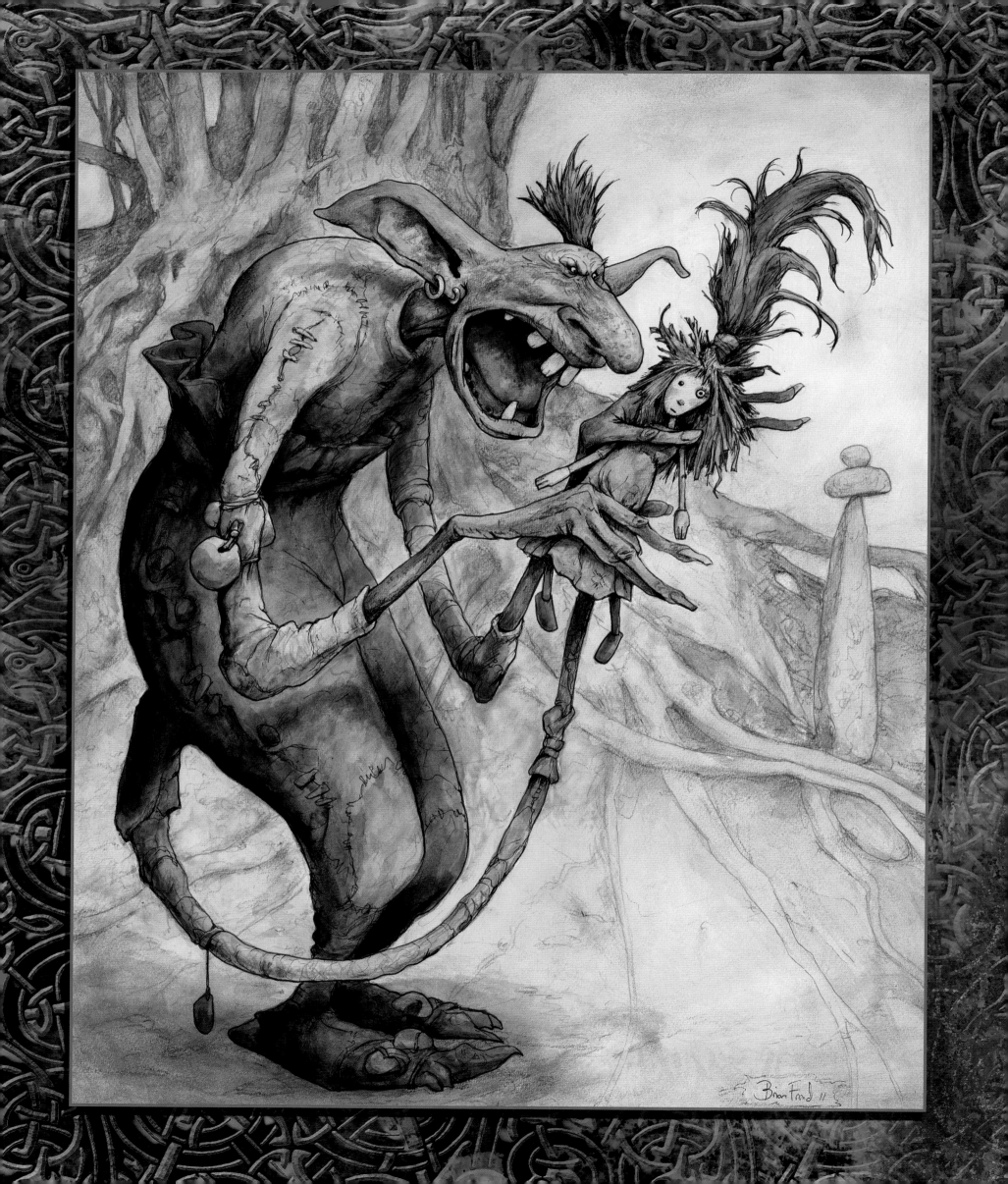

The Tale of Feathers
The Bad Troll

THERE ONCE WAS A BAD TROLL. Now, there's bad and there's bad, and this troll was the kind of bad that gives trolls a bad name. This troll was the worst possible kind of bad. This troll was a troll eater. Trolls, admittedly, do on occasion like to snack upon a knight or less often a damsel and least often of all, a child, but . . . the one thing trolls very, very rarely do indeed is eat other trolls. Well, this was one of those rare trolls.

Every few days this troll would go to his special secret hut in the forest and brew himself up a mighty barrel of beer, let it ferment for a day or two, and then drink it all down in one huge gulp. After having imbibed this strong drink, the troll would develop an enormous hunger—a hunger for troll meat. He would wander and weave his way home from the beer hut, sniffing the air and listening for the sounds of small, hapless trolls making their way in the dark at the end of the day to their snug caves. The bad troll was big and the bad troll was strong and the bad troll was fast, and more often than not he would reach out and grab an unsuspecting troll by the tail and pop him into his mouth all in one bite, and that would be that. Then, adding insult to injury, the bad troll would sing his "I've just eaten a tasty troll" song as he stumbled home with his stomach full and his head spinning a bit from the beer.

All the trolls in his part of the world were afraid of him, and who wouldn't be? He was a menace and no mistake. And there was one more bad thing about this troll—well, probably many more bad things, but this is the one that goes with the tale: He was in love with a lady troll and this love was of the unrequited sort. The bad troll was left all flustered and trembling whenever he saw his lady walking nearby, for she would just turn up her troll nose at him and laugh as she skipped away out of his reach. The bad troll didn't know if he wanted to wed her or eat her. When he was sober, it was a wedding he hankered after, but when he was in his cups, it was the taste of her sweet troll flesh that made him shiver with longing.

Now, this troll lady was smart—as smart as the bad troll was stupid. For yes, he was bad and stupid. All the trolls for many miles around came to the lady troll for advice on various aspects of their lives, and she dished out good common sense where and when it was needed. The trolls certainly needed advice about what to do

with the bad troll who was terrorizing their neighborhood so efficiently. The lady, of course, had a stake in this, since she was well aware of how her life hung in the balance given the bad troll's designs on her person. She gathered the trolls together, and having thought long and hard, she hatched a plot. It would need bravery and cunning and a lightness of foot that most of the trolls sadly lacked. Of the twenty or so trolls who gathered that day, only one of them was quick enough on his feet to suit the purpose of the scheme the lady had plotted. This troll was young and scrawny and gangly—all arms and legs— but his feet were fast and his hands were sure and his heart was brave enough when the troll lady smiled on him. What she promised him remained a secret between the two of them, but five minutes alone behind the blackberry bushes was sufficient to make him take on the task.

First a potion was made to slip into the bad troll's beer just before he drank it—a potion that would make him so drunk and stupid that he wouldn't know his tail from a trivet. Next, some clothing borrowed from the good lady herself and a hank of hair that she obligingly sacrificed for the cause, some paint for good measure, and the plan was ready. Potion, paint, and costume in hand, the fleet-footed troll crept near the beer hut and waited until he could hear the bad one stumping through the forest, humming a drinking song as he approached. At the sound, the fleet-footed troll quickly slipped into the hut, lifted the top off the beer barrel, and poured in the potion. Then he hid and waited.

The bad troll hummed his way into the hut, and, loosening his belt in readiness for the drink and the feast to follow, he lifted the barrel, opened his mouth, and drank it all down in one gulp. Oh, how good it was—how perfectly tasty and thirst quenching. How it made him long for troll flesh, and especially the flesh of the lady troll he so desired. As he stumbled out of the hut and began weaving his way down the path, he staggered. He listed to one side and then the other and, staggering again, fell flat on his face in a drunken stupor. Quick as a flash, the fleet-footed troll rolled him over and pulled his tail out straight behind him. Now, luckily, this particular troll was also a bit of an artist. With all the skill he could muster, he dressed the bad troll's

tail up in the clothes and the hair and painted a beautiful lady troll face on a bare bit of tail. Lo and behold, there, stretched out and behind the bad troll, was the lady troll herself, all ready and willing and waiting to be eaten. Once again the fleet-footed troll hid behind the hut and waited.

The bad troll woke up, still tipsy as a turnip but back on his feet and hungry for his treat. He heard a small cough behind him—a lady's cough. He turned his head and peered over his shoulder— and there she was! She lay on the ground, all coy and shy—nothing to say, smiling sweetly. The bad troll couldn't believe his luck. He gathered her up in his great, strong arms, opened his mouth, and ate her up. And over his tongue, behind his teeth, and down his throat went his tail, from top to bottom, gone in one gulp.

He stood there, swaying from side to side. Something was wrong. It was the sweetest, tastiest treat he had ever eaten, but . . . something was wrong. And in his small troll brain, all fuddled with drink, he knew he should stop and consider this situation—should think on the wrongness and figure it out. But he couldn't resist the temptation of the tastiest thing he had ever eaten, and saying to himself, "I know I shouldn't— oh well, just the one," he opened his mouth as wide as he could and ate himself up, right to the top of his head.

And that was the end of the bad troll, and that is the end of the tale.

And as the tale ended,
The last words ringing and bouncing
From rock to rock,
The troll laughed and laughed.
The sound was like a whole hersil of sheep,
An affliction of starlings, a chime of wrens,
And a boogle of weasels—
All at the same time.
The rocks shifted and crumbled,
The tor cracked and lifted,
And buried five sheep, a cow,
And two ponies beneath it.
The troll rolled on his back and snored.
He had laughed himself to sleep.
The troll child thought,
As he tied the feather to his tail,
Laughter brings joy to some and tears to others.
And I think I must remember that.

THE SWEET ROLLER

IN TIMES OF TROUBLE or sorrow, trolls wait with anticipation for the appearance of the Sweet Roller. He comes when trolls are at low ebb, scattering handfuls of sweet, rolled bracken tops amongst them. These are quickly gathered up and eaten, restoring hope and balance to a troll gathering. Trolls with more than one nose or mouth are at a distinct advantage when gathering up these treats.

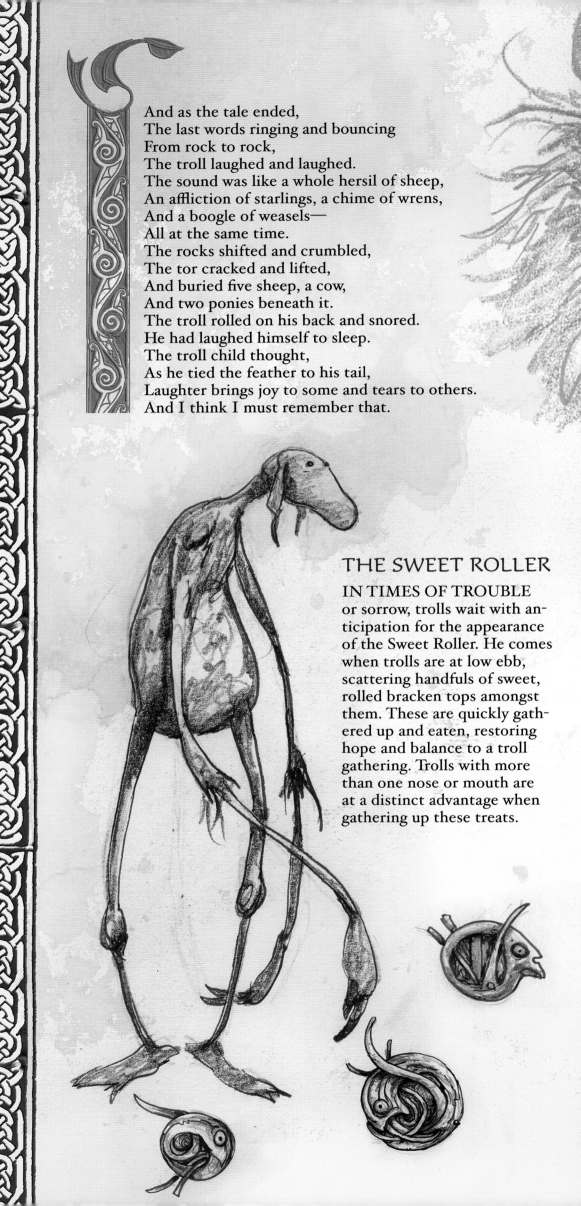

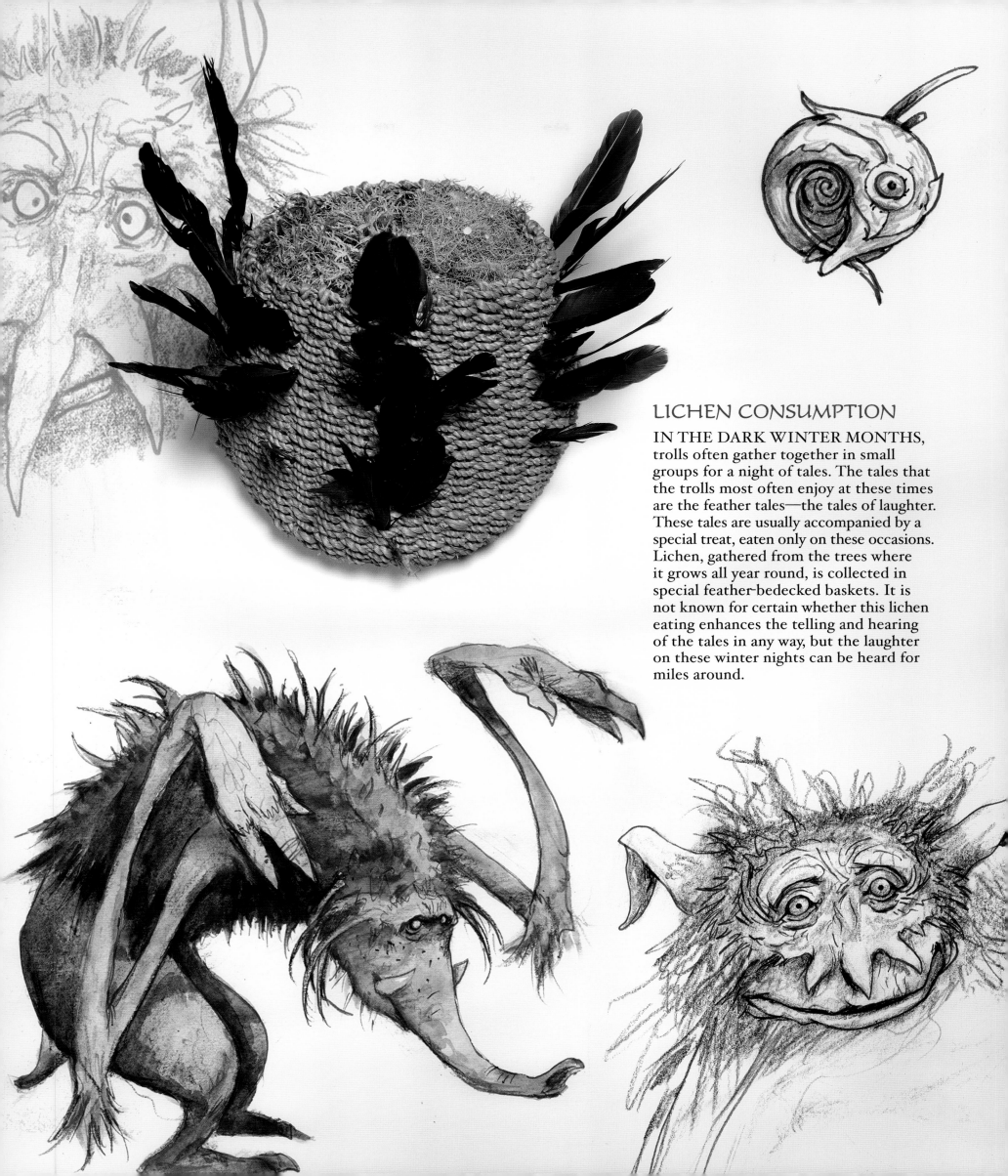

LICHEN CONSUMPTION

IN THE DARK WINTER MONTHS, trolls often gather together in small groups for a night of tales. The tales that the trolls most often enjoy at these times are the feather tales—the tales of laughter. These tales are usually accompanied by a special treat, eaten only on these occasions. Lichen, gathered from the trees where it grows all year round, is collected in special feather-bedecked baskets. It is not known for certain whether this lichen eating enhances the telling and hearing of the tales in any way, but the laughter on these winter nights can be heard for miles around.

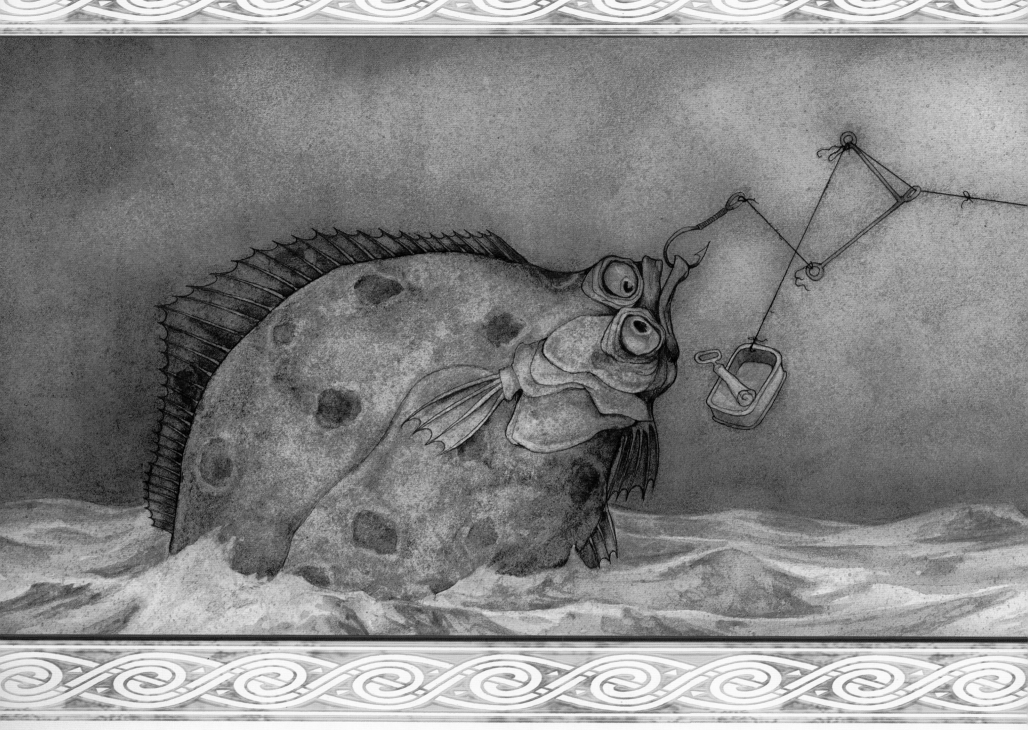

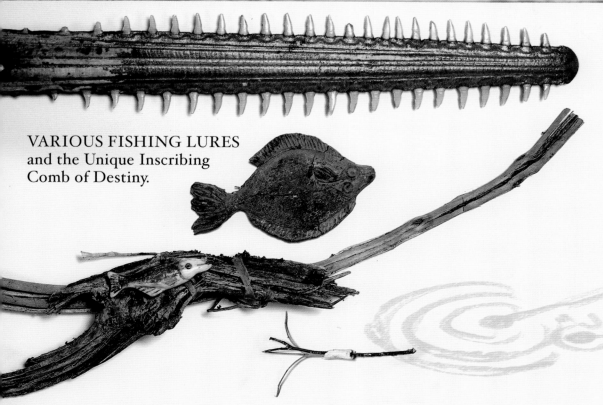

VARIOUS FISHING LURES
and the Unique Inscribing
Comb of Destiny.

SEA TROLLS

TROLLS WHO LIVE ALONG THE
seashore have a special relationship
with the tides and the sand. The sand is
a perfect blank canvas for the inscribing
of symbols, energy lines, and mystical
Rememberings. Unfortunately, often
the most complex and important
inscriptions are washed away before
they can be shared with other
interested trolls. Individual trolls
have been known to inscribe the
same pattern every day for many
years, in the vain hope that the
tide would not come in and wash
it away. This hasn't happened yet.

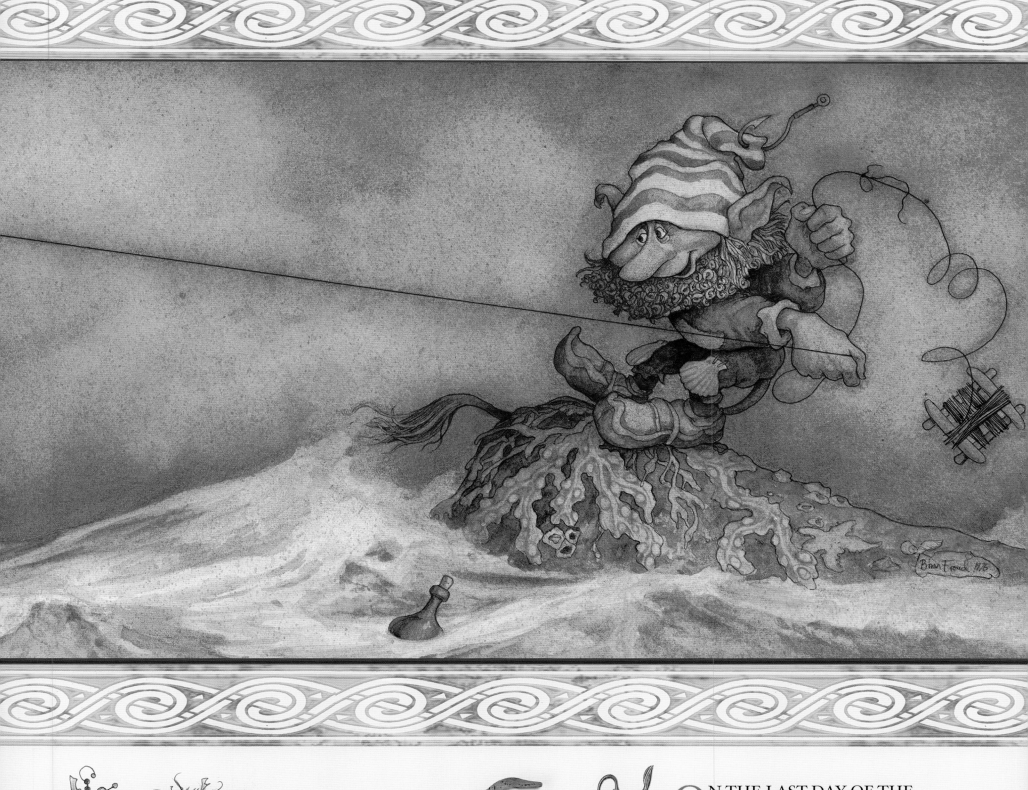

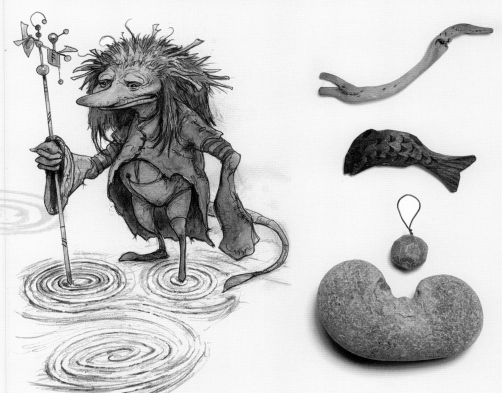

O N THE LAST DAY OF THE last month in the Year of the Flounder, Tiny Eelo gathered up his fishing equipment, his line and reel, his lure and bait, his float and hook, and set off for the slippery, seaweed-covered rocks on the very edge of the Trembling Peninsula. It was a day that Tiny Eelo would remember for the rest of his life.

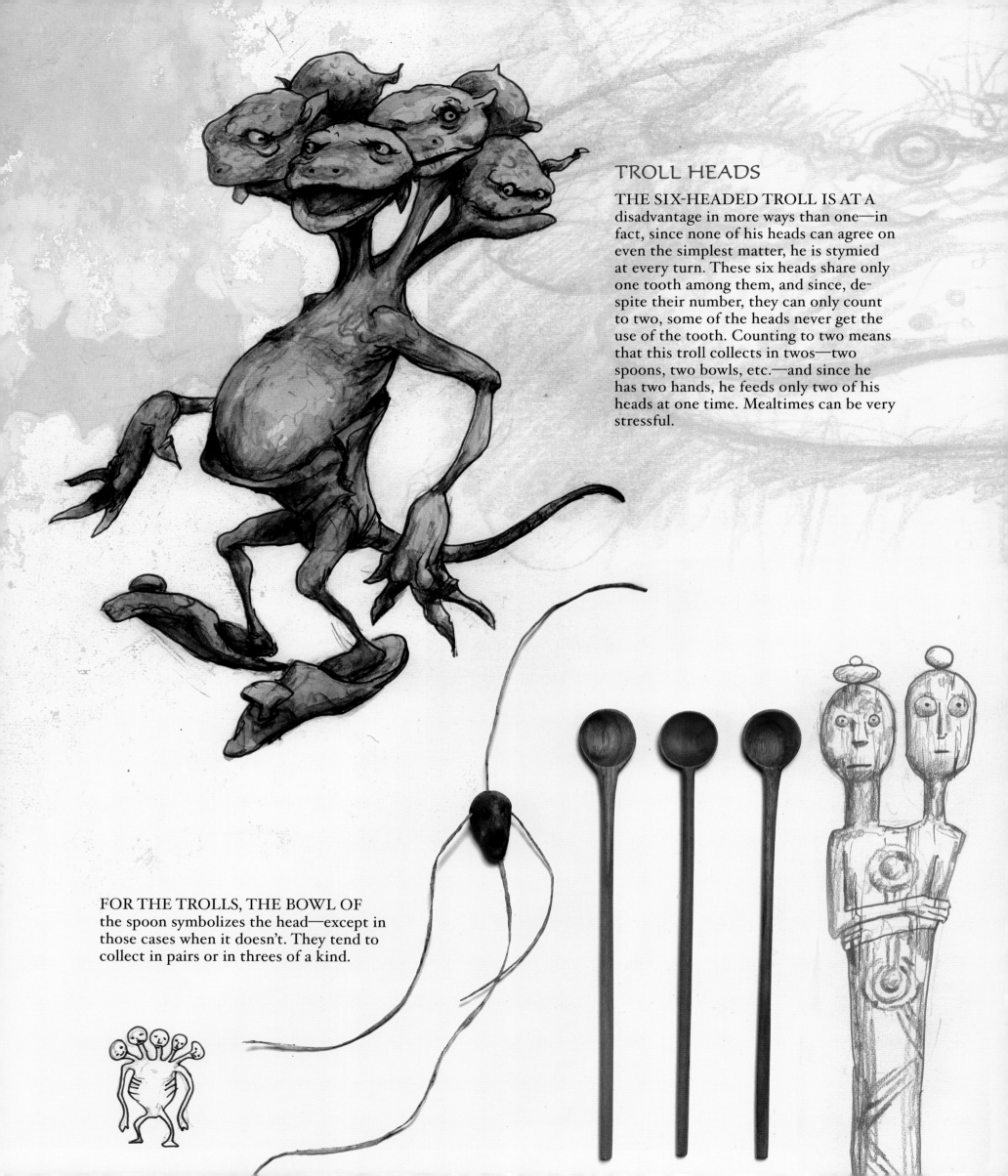

TROLL HEADS

THE SIX-HEADED TROLL IS AT A disadvantage in more ways than one—in fact, since none of his heads can agree on even the simplest matter, he is stymied at every turn. These six heads share only one tooth among them, and since, despite their number, they can only count to two, some of the heads never get the use of the tooth. Counting to two means that this troll collects in twos—two spoons, two bowls, etc.—and since he has two hands, he feeds only two of his heads at one time. Mealtimes can be very stressful.

FOR THE TROLLS, THE BOWL OF the spoon symbolizes the head—except in those cases when it doesn't. They tend to collect in pairs or in threes of a kind.

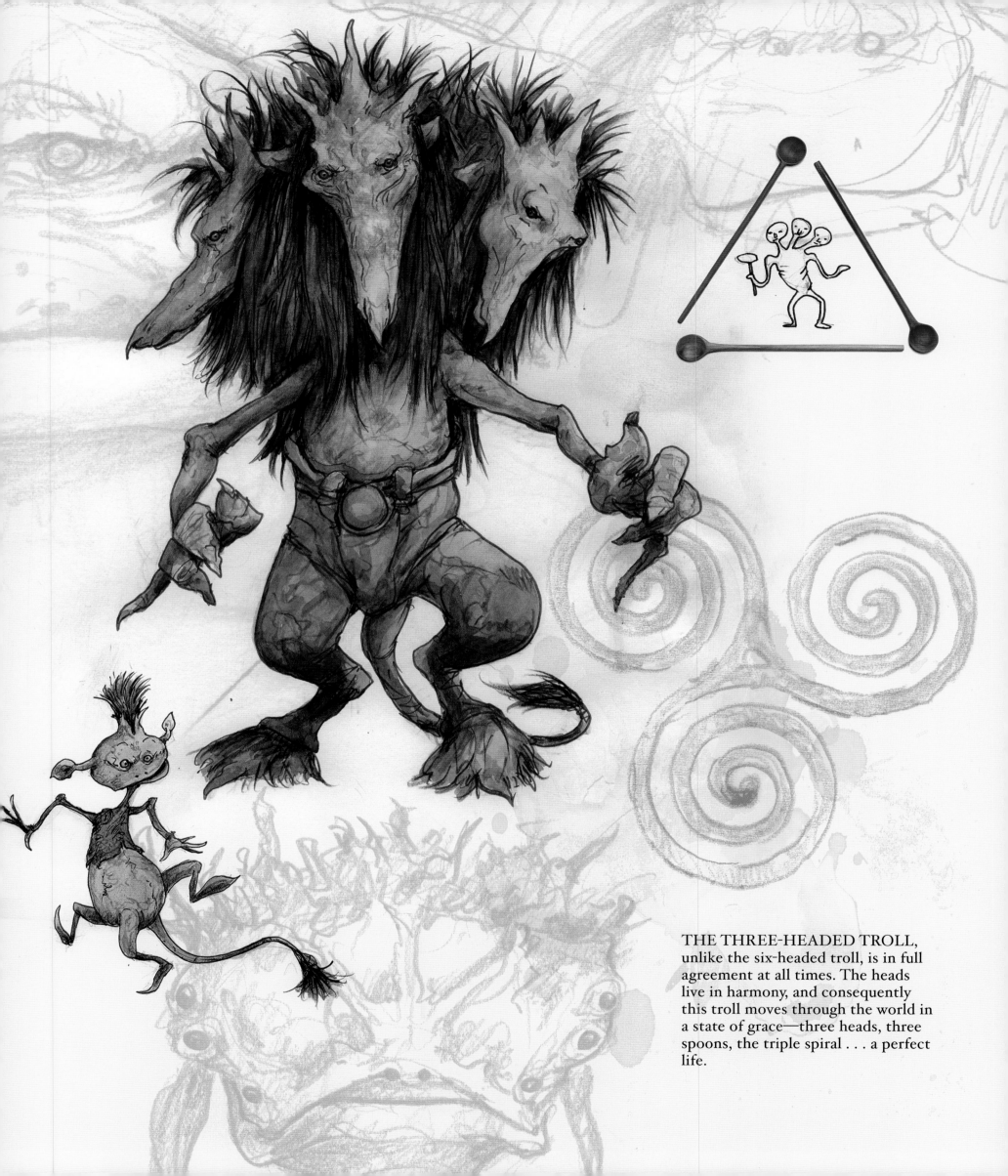

THE THREE-HEADED TROLL, unlike the six-headed troll, is in full agreement at all times. The heads live in harmony, and consequently this troll moves through the world in a state of grace—three heads, three spoons, the triple spiral . . . a perfect life.

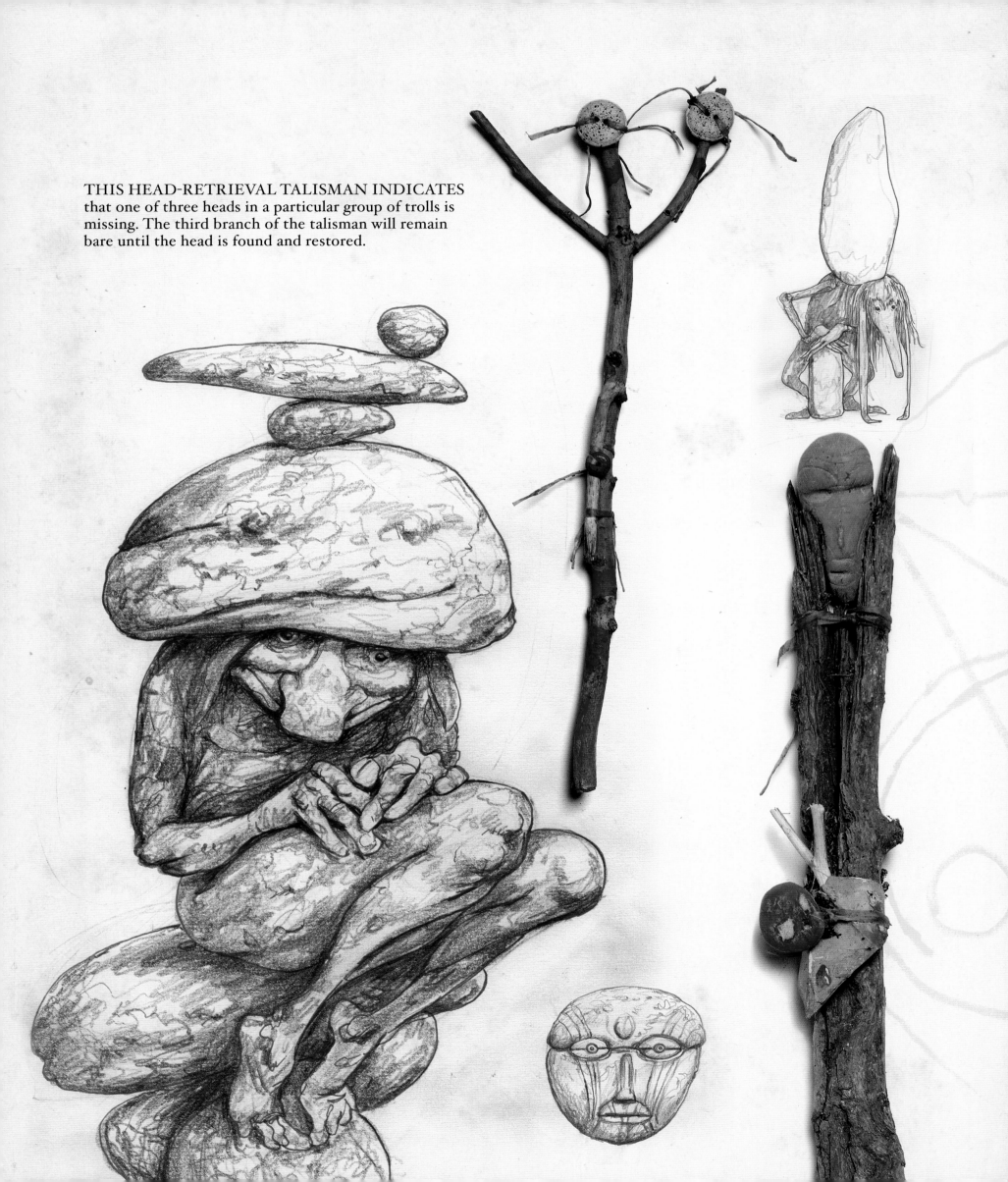

THIS HEAD-RETRIEVAL TALISMAN INDICATES that one of three heads in a particular group of trolls is missing. The third branch of the talisman will remain bare until the head is found and restored.

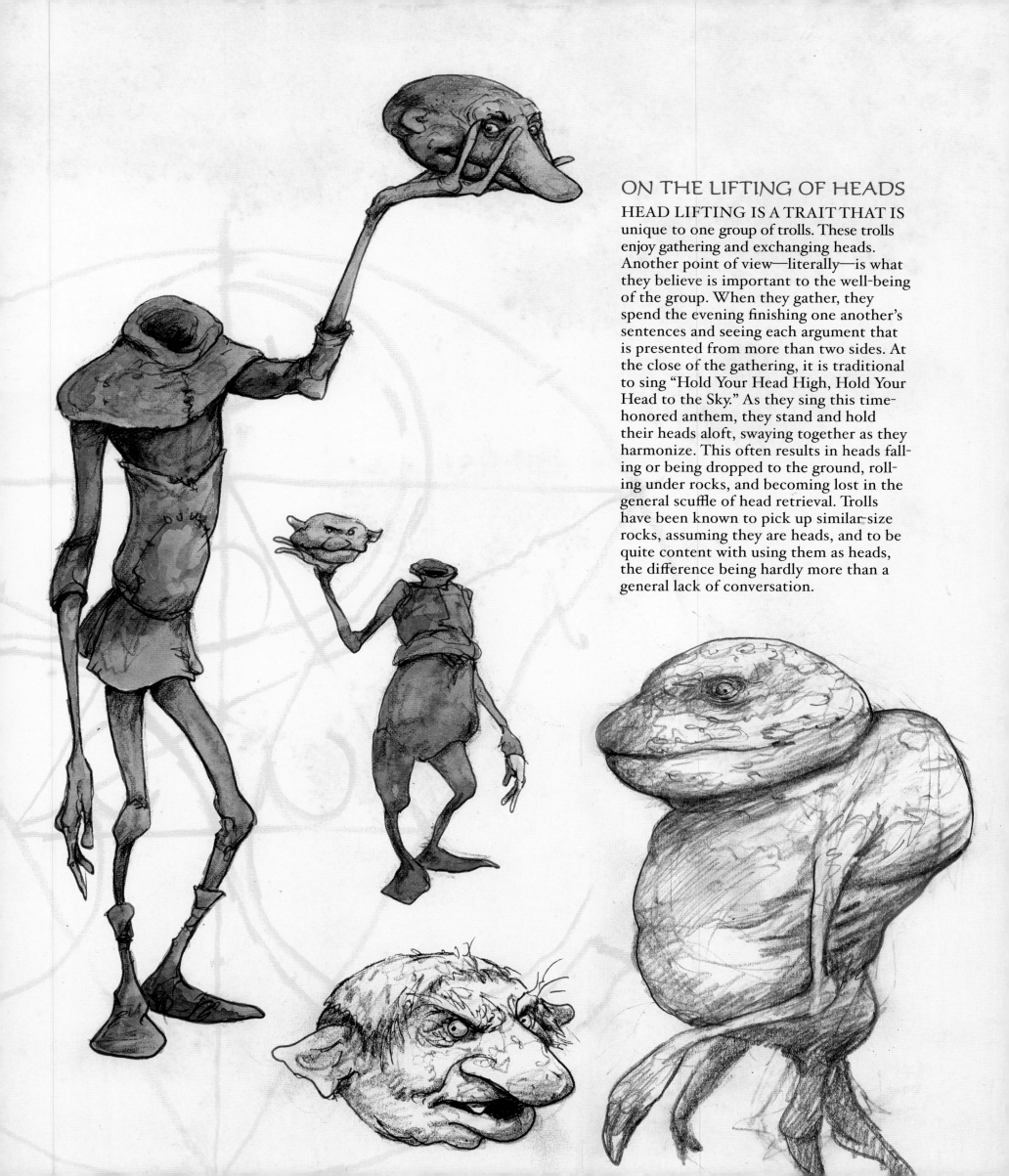

ON THE LIFTING OF HEADS

HEAD LIFTING IS A TRAIT THAT IS unique to one group of trolls. These trolls enjoy gathering and exchanging heads. Another point of view—literally—is what they believe is important to the well-being of the group. When they gather, they spend the evening finishing one another's sentences and seeing each argument that is presented from more than two sides. At the close of the gathering, it is traditional to sing "Hold Your Head High, Hold Your Head to the Sky." As they sing this time-honored anthem, they stand and hold their heads aloft, swaying together as they harmonize. This often results in heads falling or being dropped to the ground, rolling under rocks, and becoming lost in the general scuffle of head retrieval. Trolls have been known to pick up similar-size rocks, assuming they are heads, and to be quite content with using them as heads, the difference being hardly more than a general lack of conversation.

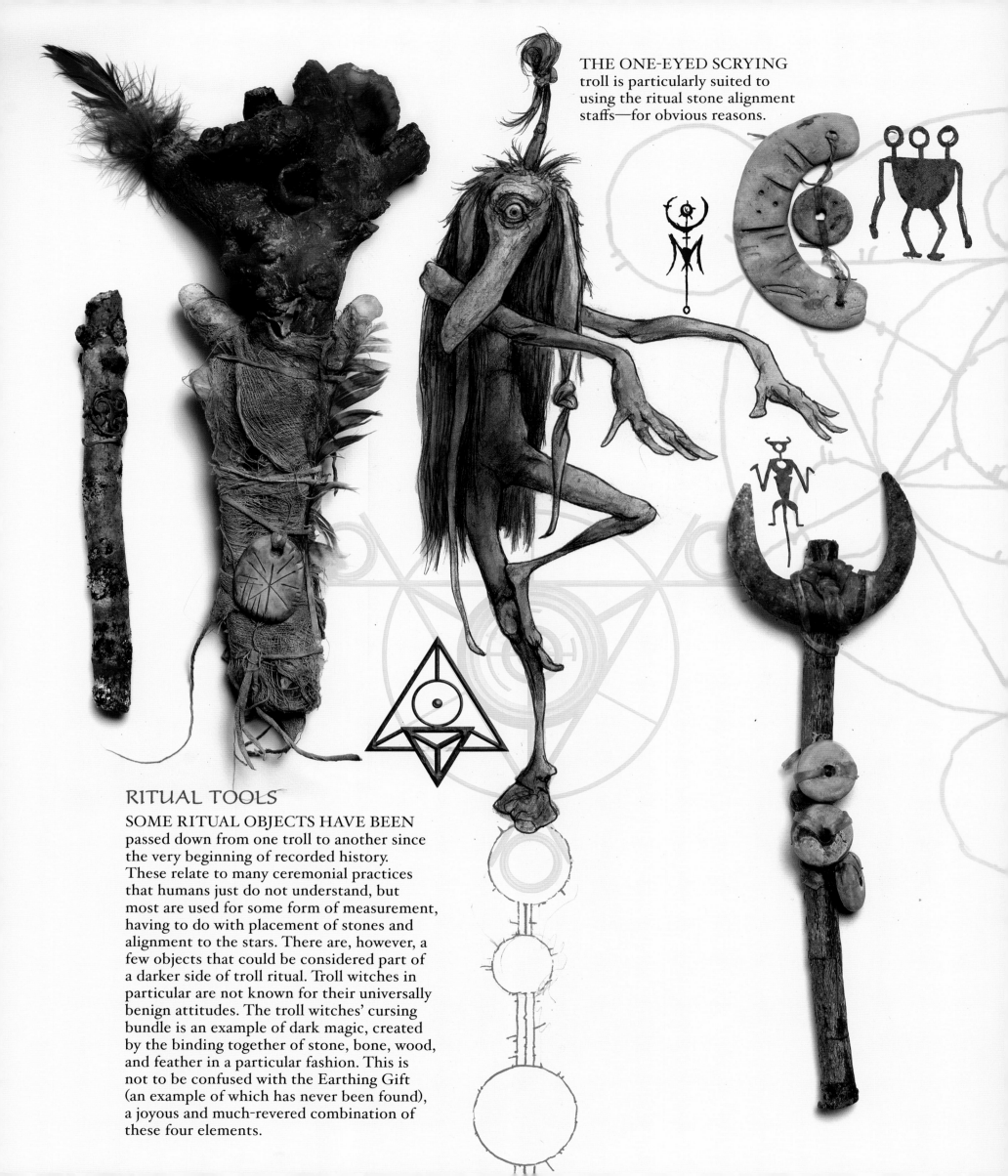

THE ONE-EYED SCRYING troll is particularly suited to using the ritual stone alignment staffs—for obvious reasons.

RITUAL TOOLS

SOME RITUAL OBJECTS HAVE BEEN passed down from one troll to another since the very beginning of recorded history. These relate to many ceremonial practices that humans just do not understand, but most are used for some form of measurement, having to do with placement of stones and alignment to the stars. There are, however, a few objects that could be considered part of a darker side of troll ritual. Troll witches in particular are not known for their universally benign attitudes. The troll witches' cursing bundle is an example of dark magic, created by the binding together of stone, bone, wood, and feather in a particular fashion. This is not to be confused with the Earthing Gift (an example of which has never been found), a joyous and much-revered combination of these four elements.

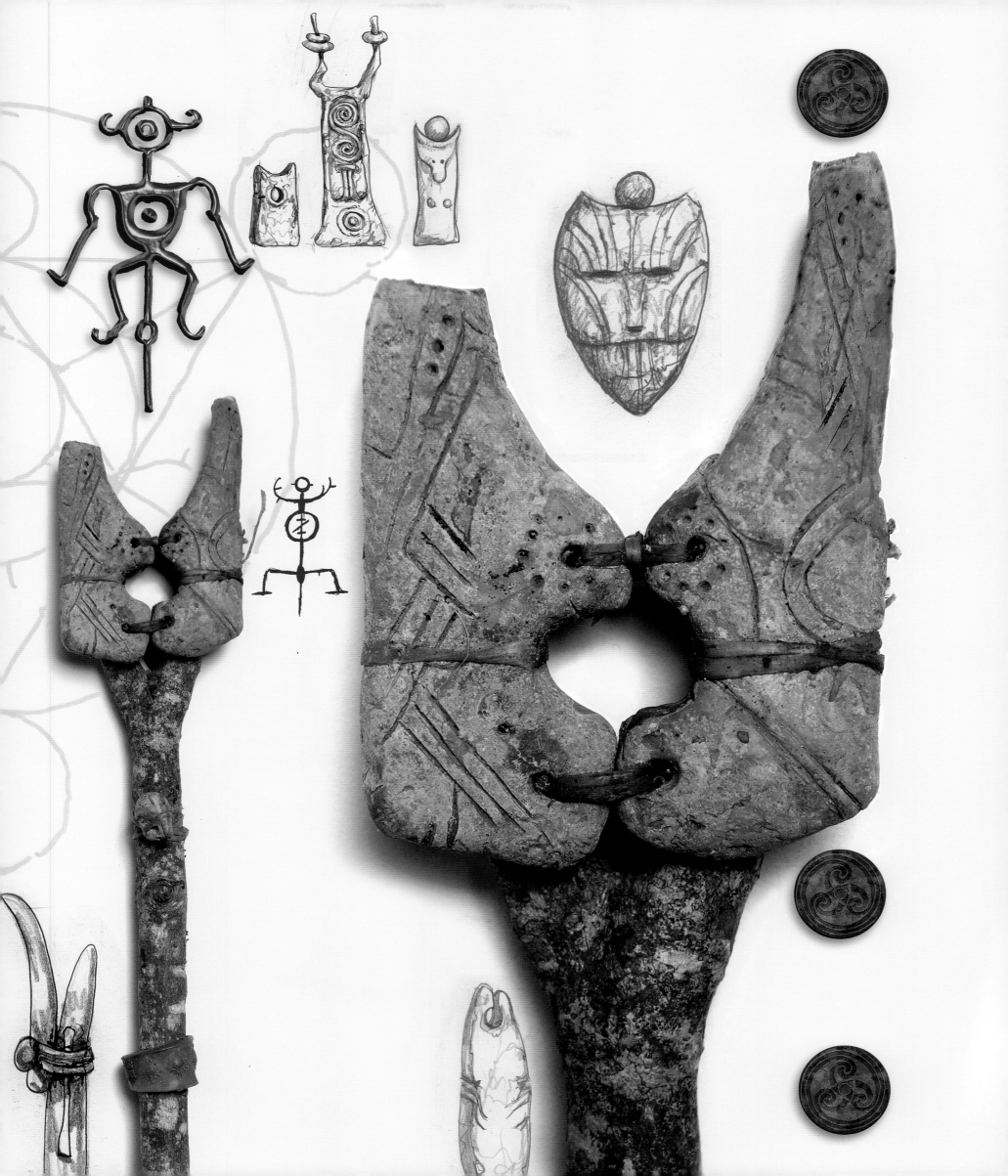

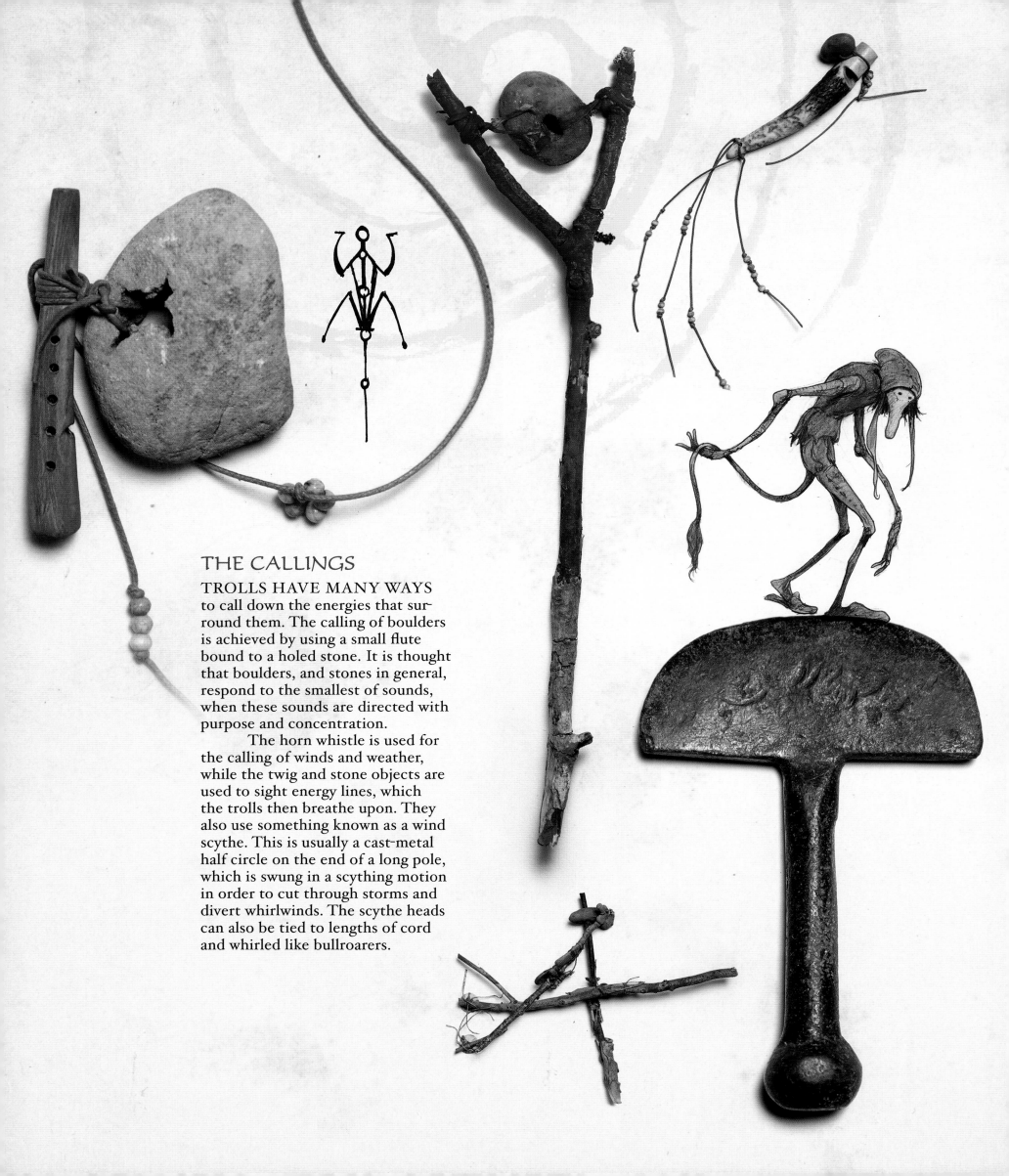

THE CALLINGS

TROLLS HAVE MANY WAYS
to call down the energies that sur-
round them. The calling of boulders
is achieved by using a small flute
bound to a holed stone. It is thought
that boulders, and stones in general,
respond to the smallest of sounds,
when these sounds are directed with
purpose and concentration.

The horn whistle is used for
the calling of winds and weather,
while the twig and stone objects are
used to sight energy lines, which
the trolls then breathe upon. They
also use something known as a wind
scythe. This is usually a cast-metal
half circle on the end of a long pole,
which is swung in a scything motion
in order to cut through storms and
divert whirlwinds. The scythe heads
can also be tied to lengths of cord
and whirled like bullroarers.

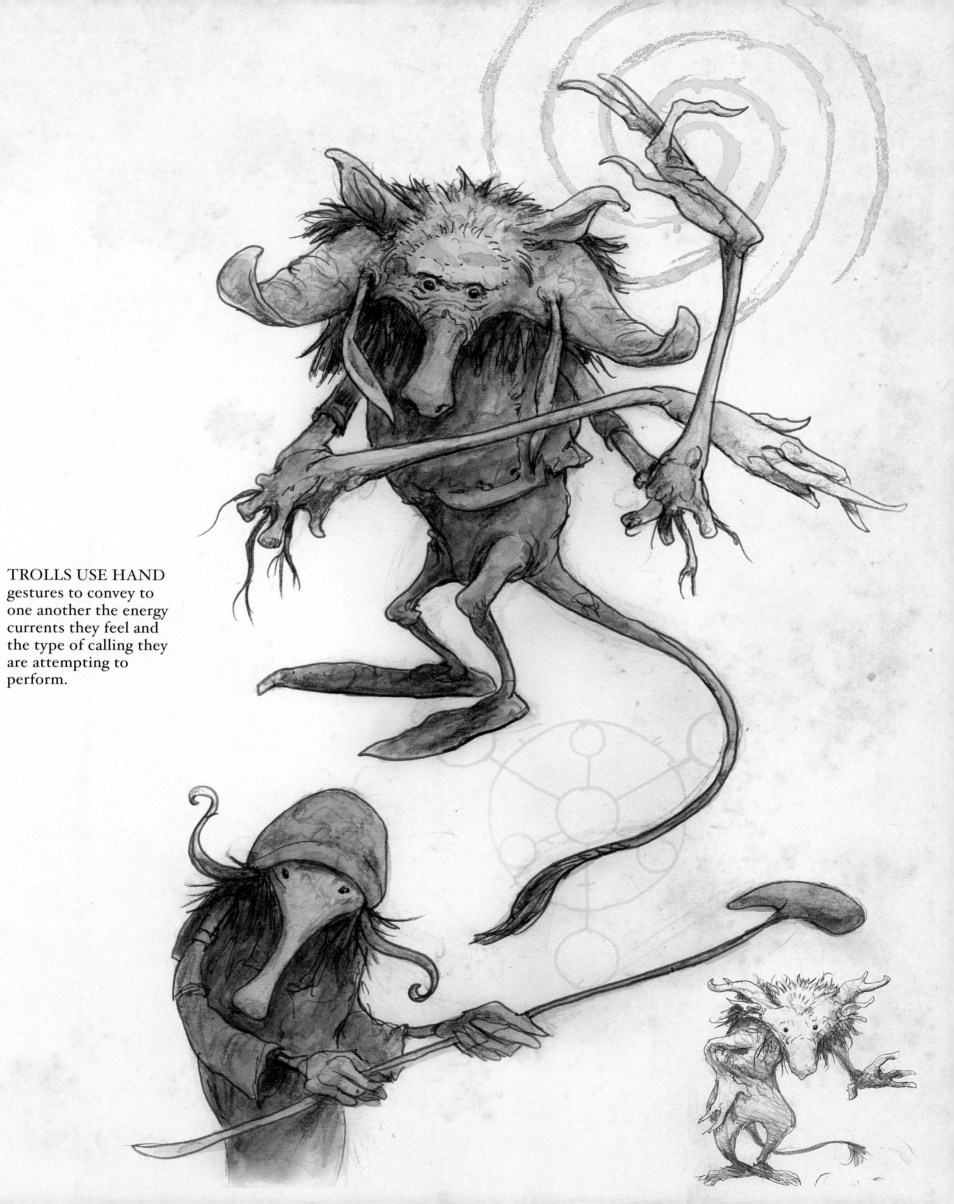

TROLLS USE HAND gestures to convey to one another the energy currents they feel and the type of calling they are attempting to perform.

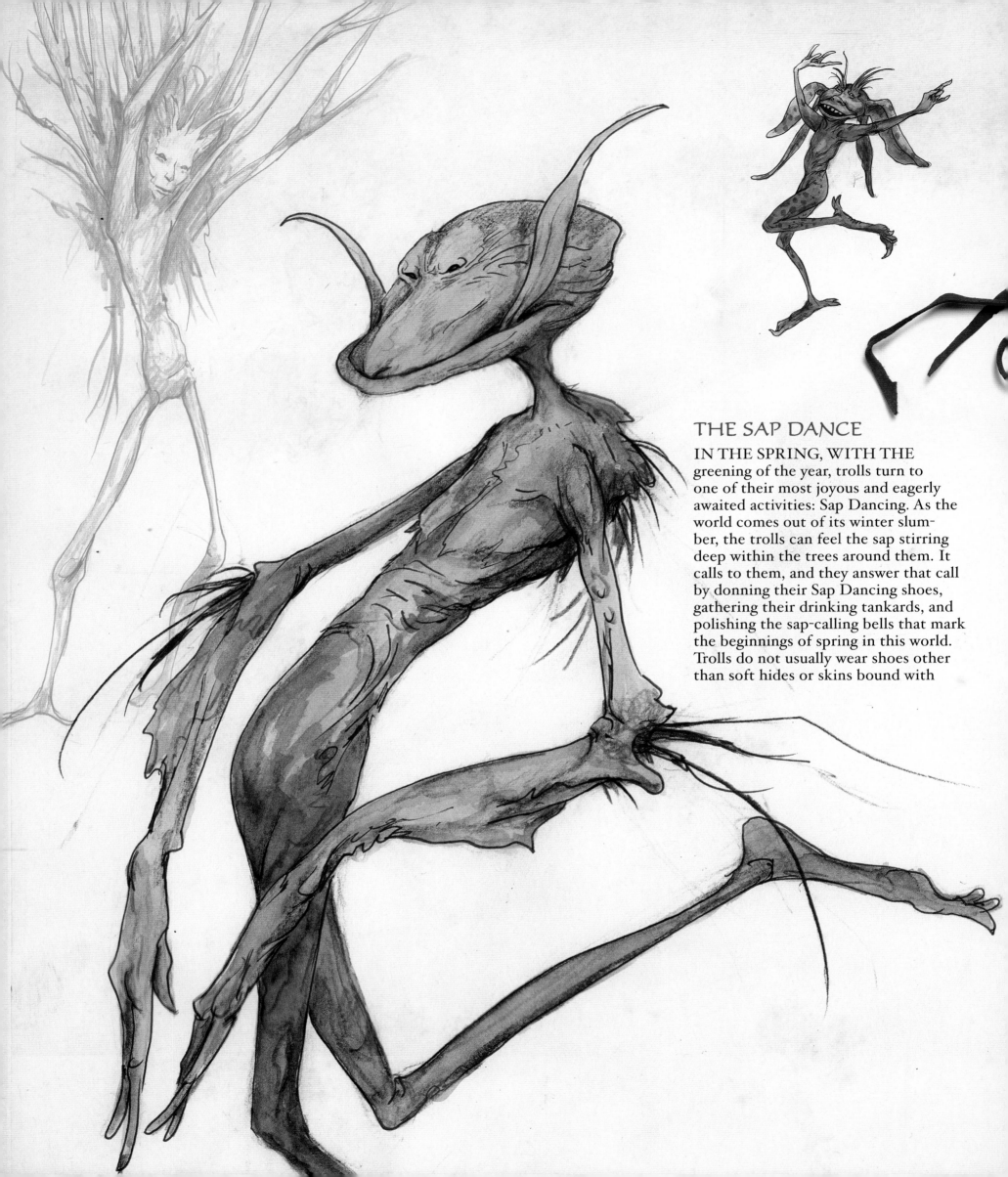

THE SAP DANCE

IN THE SPRING, WITH THE
greening of the year, trolls turn to
one of their most joyous and eagerly
awaited activities: Sap Dancing. As the
world comes out of its winter slum-
ber, the trolls can feel the sap stirring
deep within the trees around them. It
calls to them, and they answer that call
by donning their Sap Dancing shoes,
gathering their drinking tankards, and
polishing the sap-calling bells that mark
the beginnings of spring in this world.
Trolls do not usually wear shoes other
than soft hides or skins bound with

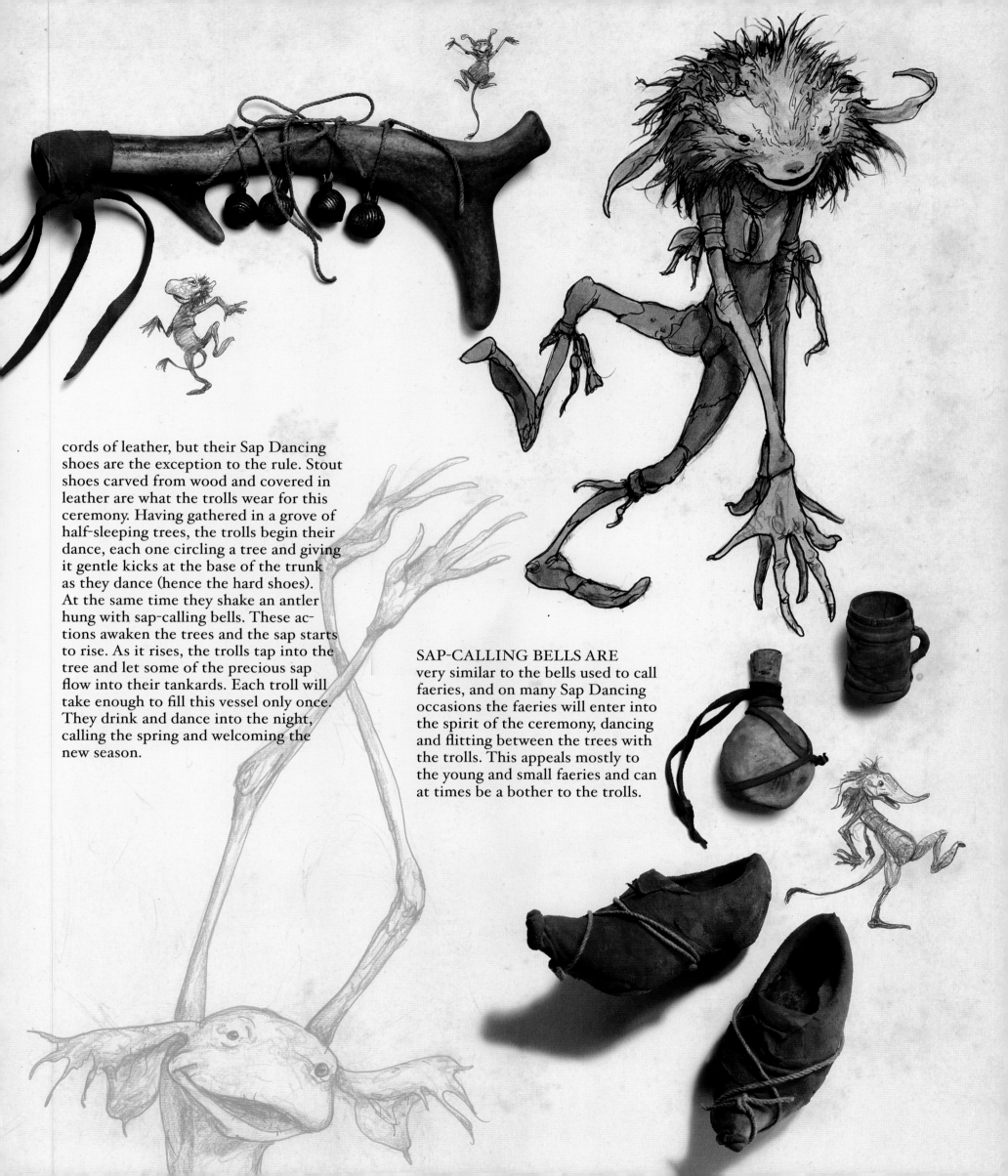

cords of leather, but their Sap Dancing shoes are the exception to the rule. Stout shoes carved from wood and covered in leather are what the trolls wear for this ceremony. Having gathered in a grove of half-sleeping trees, the trolls begin their dance, each one circling a tree and giving it gentle kicks at the base of the trunk as they dance (hence the hard shoes). At the same time they shake an antler hung with sap-calling bells. These actions awaken the trees and the sap starts to rise. As it rises, the trolls tap into the tree and let some of the precious sap flow into their tankards. Each troll will take enough to fill this vessel only once. They drink and dance into the night, calling the spring and welcoming the new season.

SAP-CALLING BELLS ARE very similar to the bells used to call faeries, and on many Sap Dancing occasions the faeries will enter into the spirit of the ceremony, dancing and flitting between the trees with the trolls. This appeals mostly to the young and small faeries and can at times be a bother to the trolls.

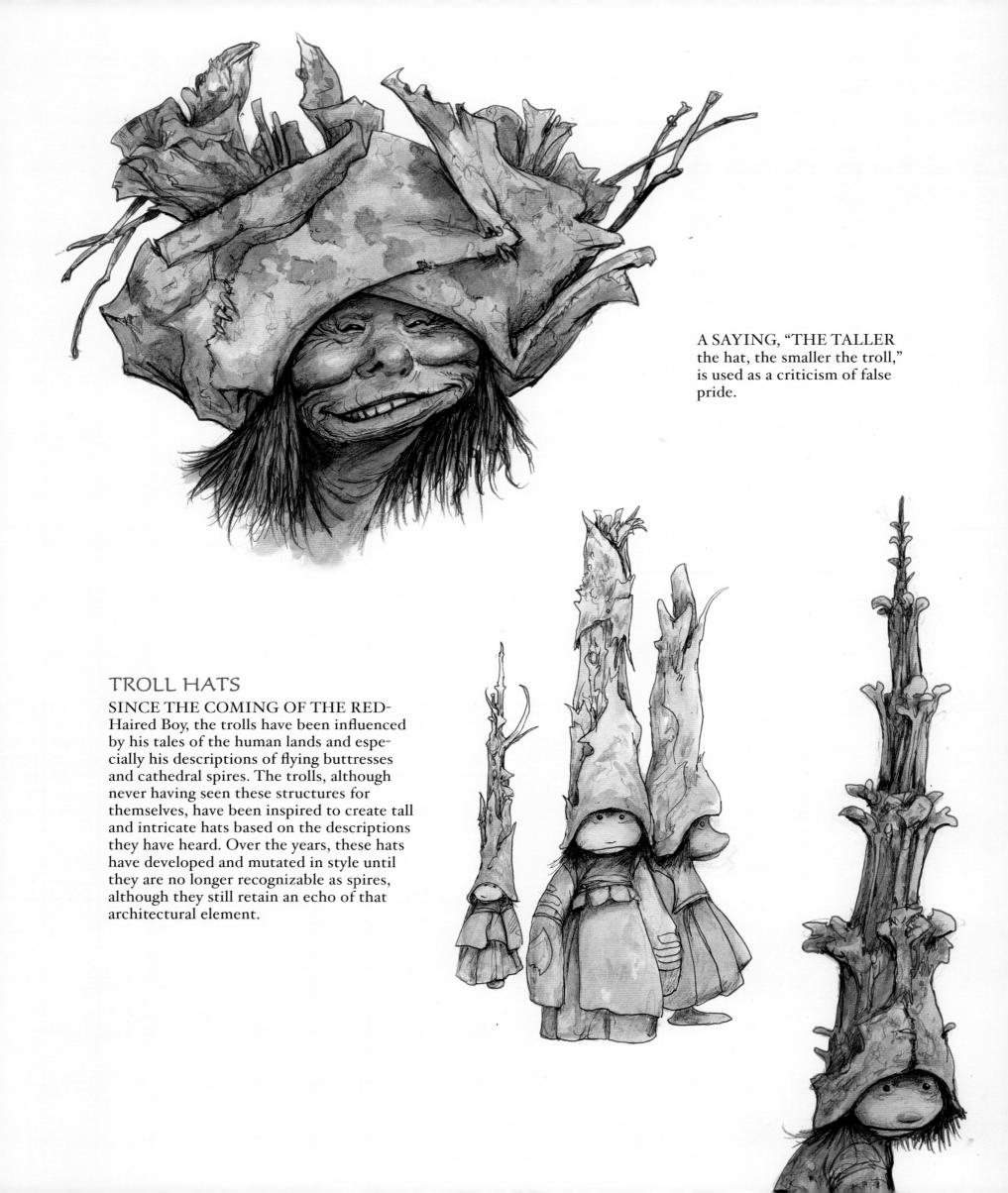

A SAYING, "THE TALLER the hat, the smaller the troll," is used as a criticism of false pride.

TROLL HATS

SINCE THE COMING OF THE RED-Haired Boy, the trolls have been influenced by his tales of the human lands and especially his descriptions of flying buttresses and cathedral spires. The trolls, although never having seen these structures for themselves, have been inspired to create tall and intricate hats based on the descriptions they have heard. Over the years, these hats have developed and mutated in style until they are no longer recognizable as spires, although they still retain an echo of that architectural element.

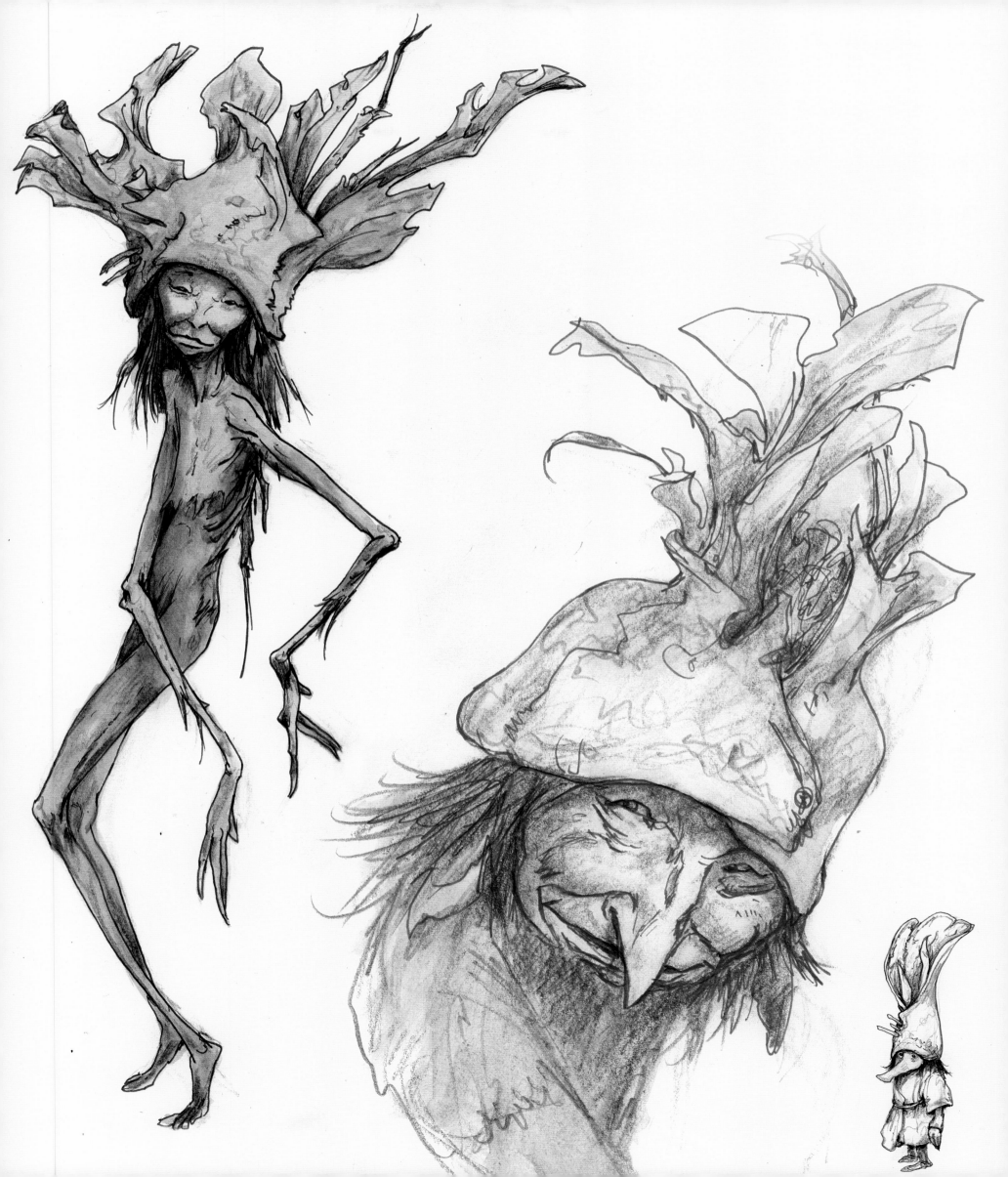

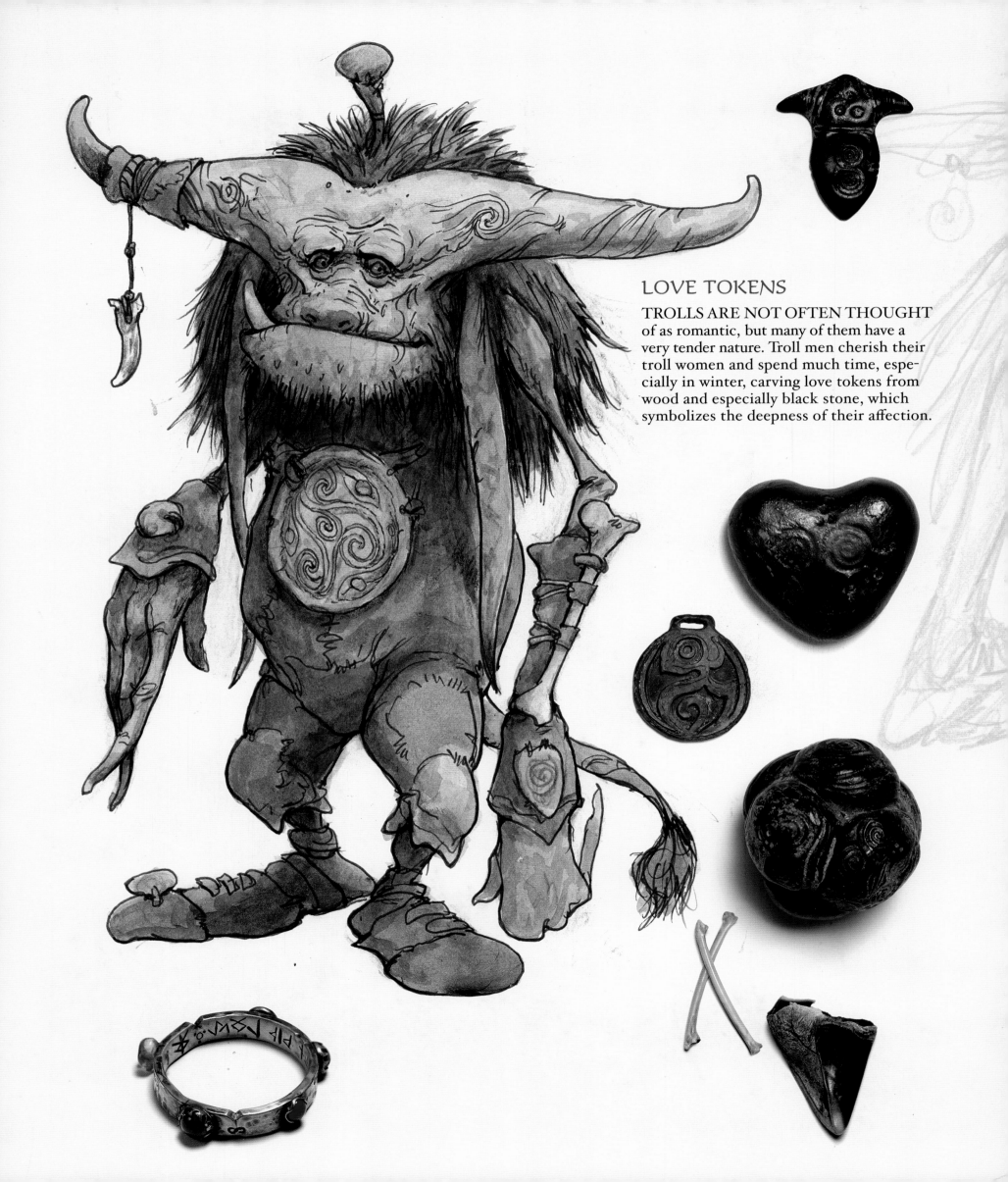

LOVE TOKENS

TROLLS ARE NOT OFTEN THOUGHT of as romantic, but many of them have a very tender nature. Troll men cherish their troll women and spend much time, especially in winter, carving love tokens from wood and especially black stone, which symbolizes the deepness of their affection.

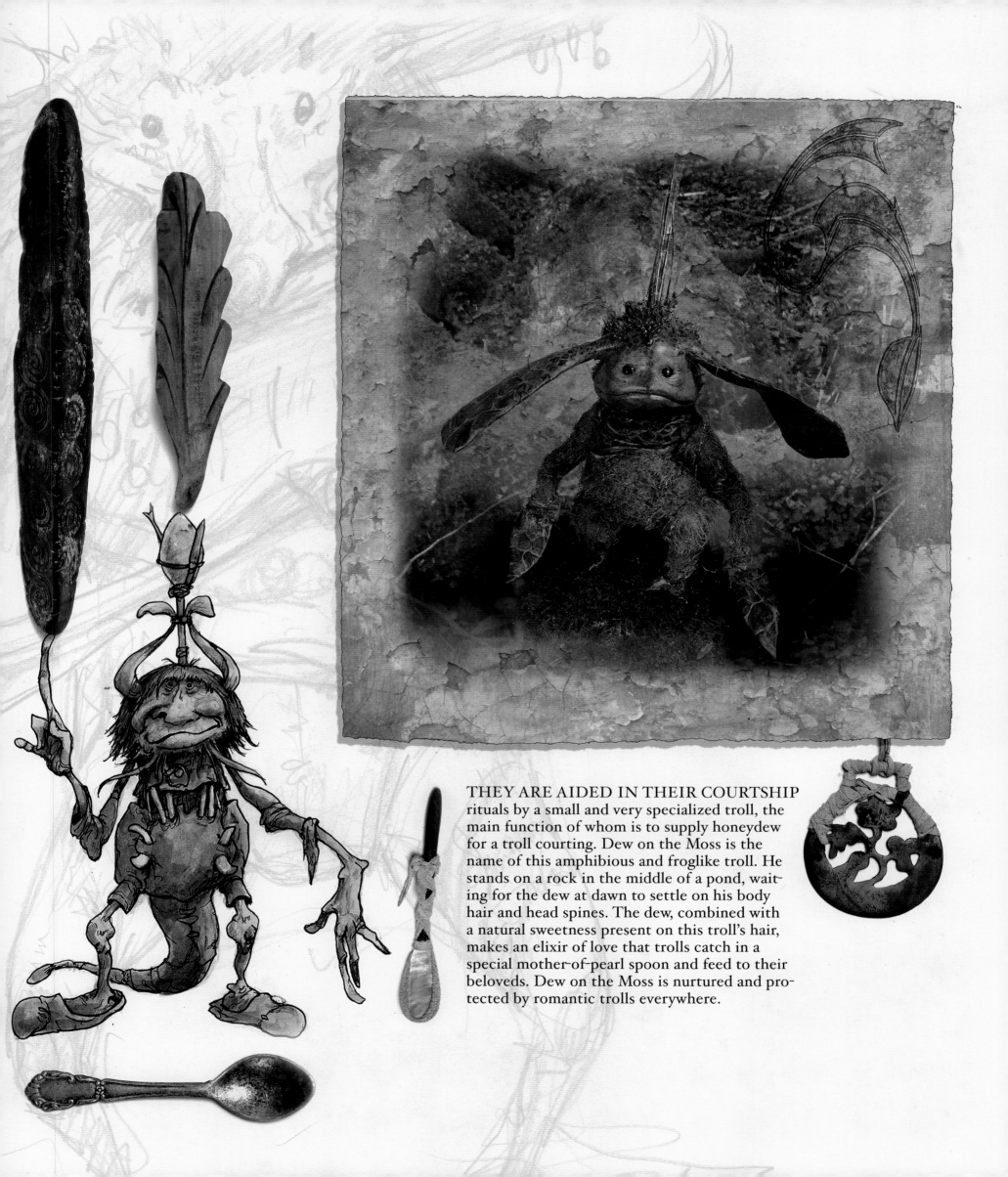

THEY ARE AIDED IN THEIR COURTSHIP rituals by a small and very specialized troll, the main function of whom is to supply honeydew for a troll courting. Dew on the Moss is the name of this amphibious and froglike troll. He stands on a rock in the middle of a pond, waiting for the dew at dawn to settle on his body hair and head spines. The dew, combined with a natural sweetness present on this troll's hair, makes an elixir of love that trolls catch in a special mother-of-pearl spoon and feed to their beloveds. Dew on the Moss is nurtured and protected by romantic trolls everywhere.

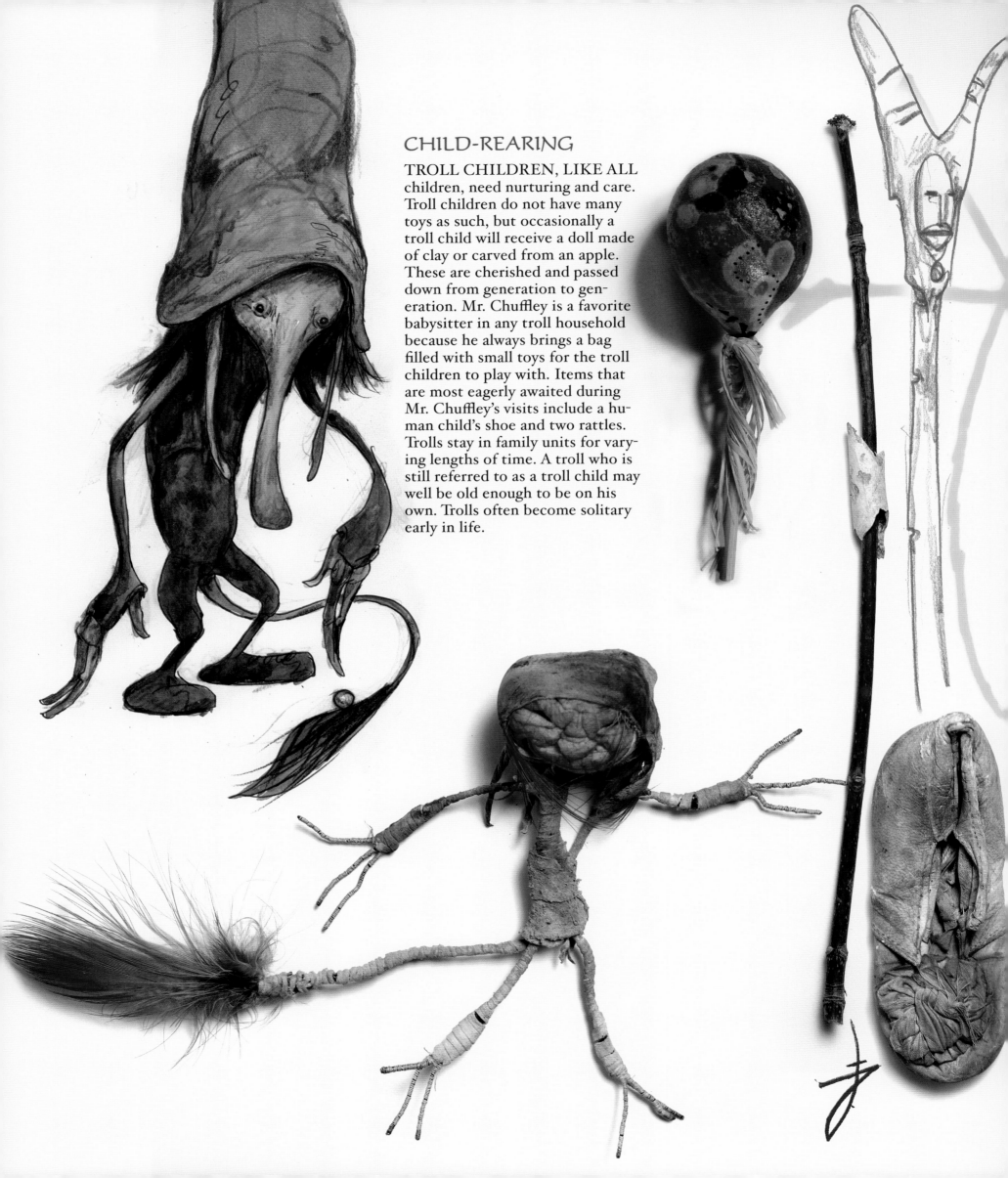

CHILD-REARING

TROLL CHILDREN, LIKE ALL children, need nurturing and care. Troll children do not have many toys as such, but occasionally a troll child will receive a doll made of clay or carved from an apple. These are cherished and passed down from generation to generation. Mr. Chuffley is a favorite babysitter in any troll household because he always brings a bag filled with small toys for the troll children to play with. Items that are most eagerly awaited during Mr. Chuffley's visits include a human child's shoe and two rattles. Trolls stay in family units for varying lengths of time. A troll who is still referred to as a troll child may well be old enough to be on his own. Trolls often become solitary early in life.

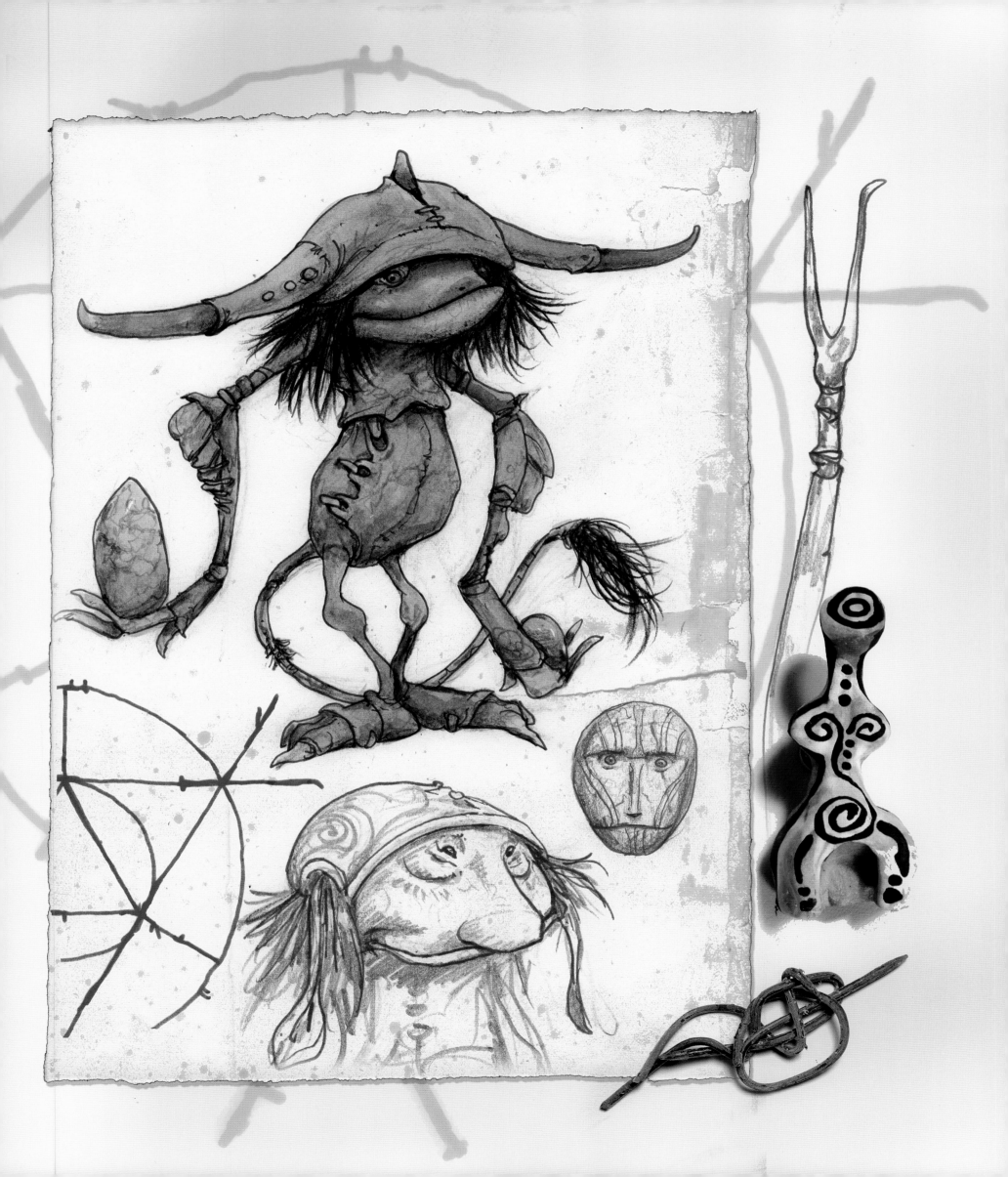

TROLL DOMESTICITY

TROLLS ENJOY THEIR FOOD, AND WHEN THEY CAN,
they will choose to eat from bowls that tell stories of the food they
are eating. Bowls for soup, bowls for stew, each one has a tale incised
in the clay—a tale of gathering, storing, cooking, and eating. The
trolls can eat their food and feel the tale with their fingers at the
same time. Drinking cups and plates are also decorated in this
manner, adding to the enjoyment of any meal.

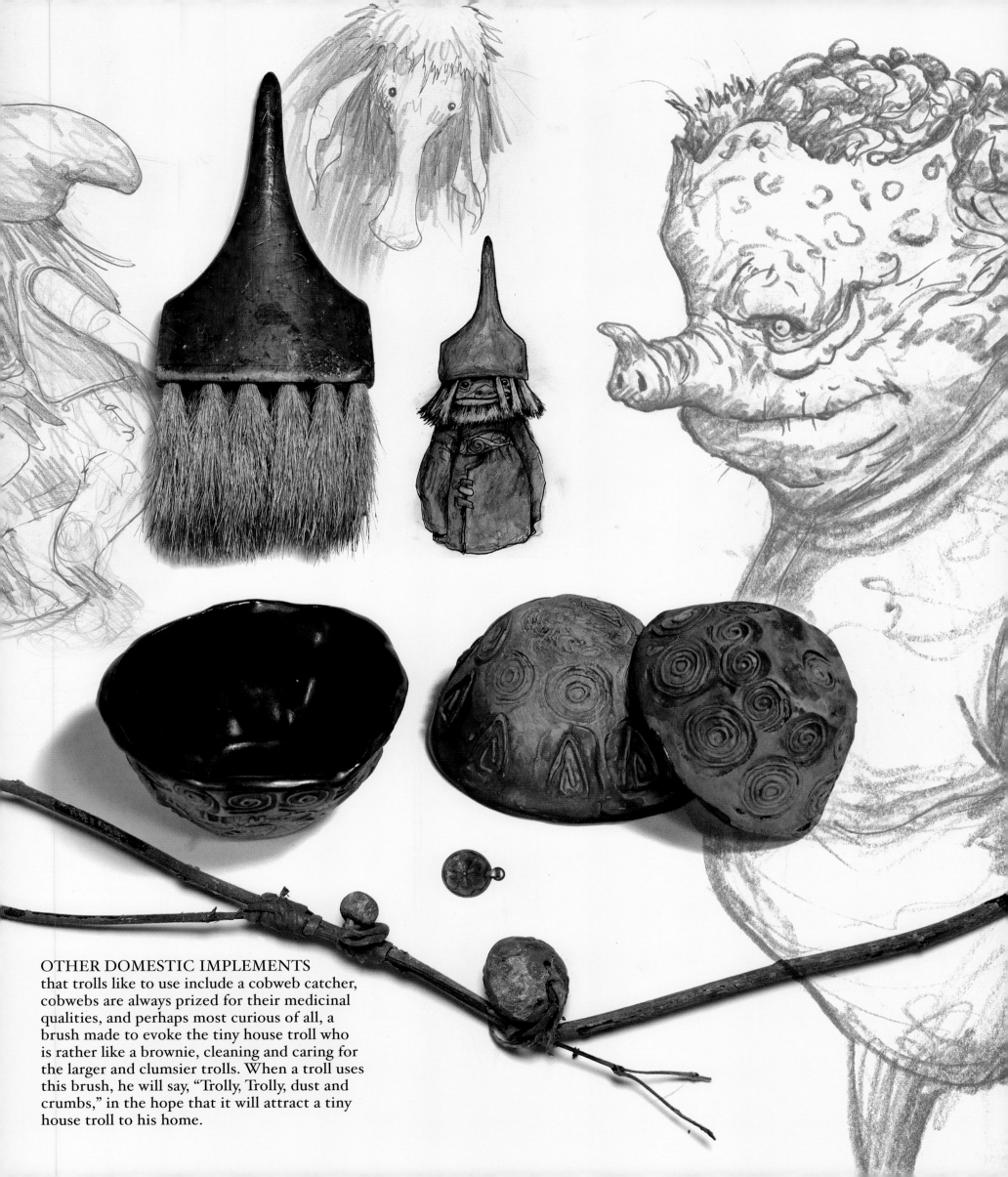

OTHER DOMESTIC IMPLEMENTS

that trolls like to use include a cobweb catcher, cobwebs are always prized for their medicinal qualities, and perhaps most curious of all, a brush made to evoke the tiny house troll who is rather like a brownie, cleaning and caring for the larger and clumsier trolls. When a troll uses this brush, he will say, "Trolly, Trolly, dust and crumbs," in the hope that it will attract a tiny house troll to his home.

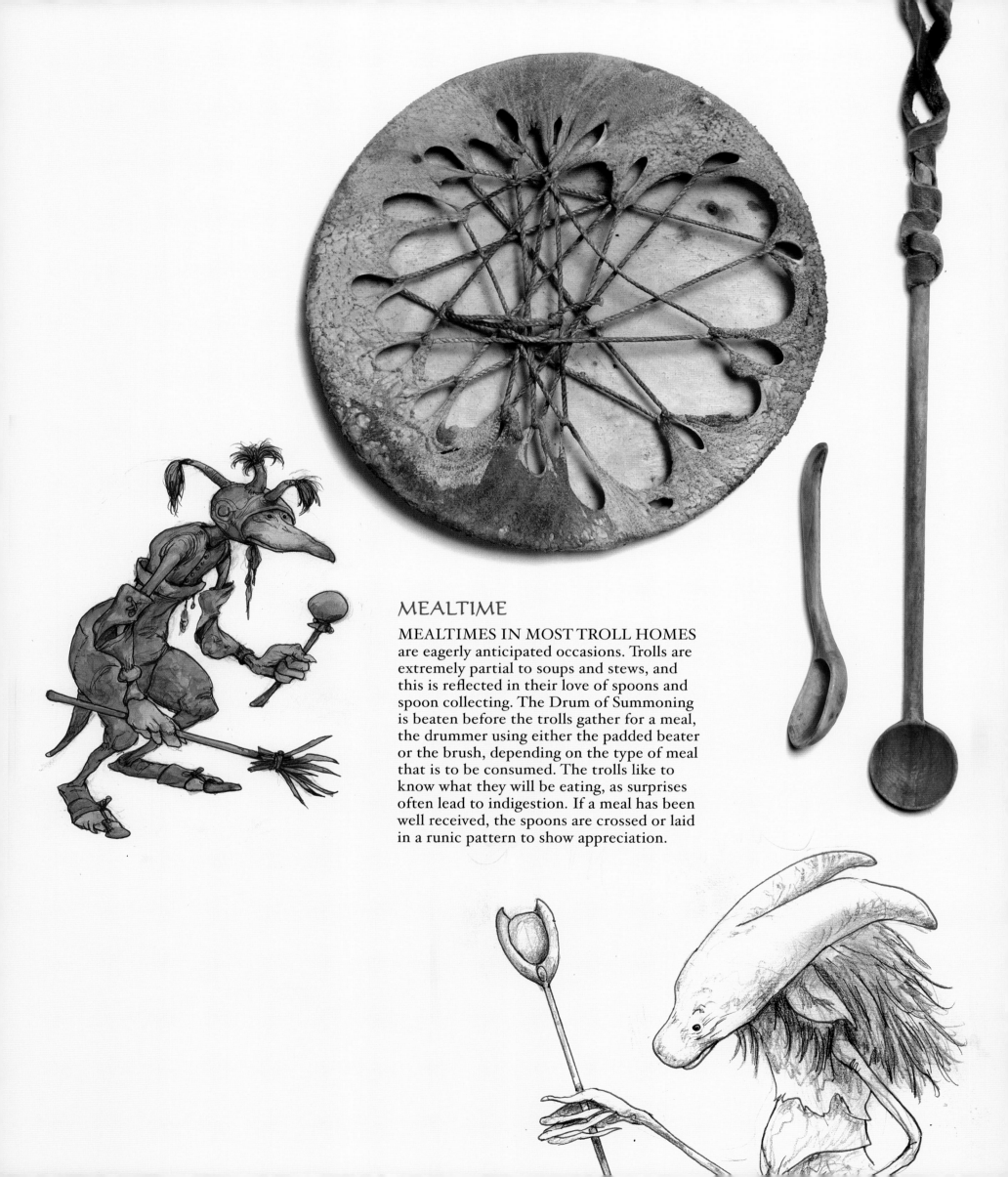

MEALTIME

MEALTIMES IN MOST TROLL HOMES
are eagerly anticipated occasions. Trolls are
extremely partial to soups and stews, and
this is reflected in their love of spoons and
spoon collecting. The Drum of Summoning
is beaten before the trolls gather for a meal,
the drummer using either the padded beater
or the brush, depending on the type of meal
that is to be consumed. The trolls like to
know what they will be eating, as surprises
often lead to indigestion. If a meal has been
well received, the spoons are crossed or laid
in a runic pattern to show appreciation.

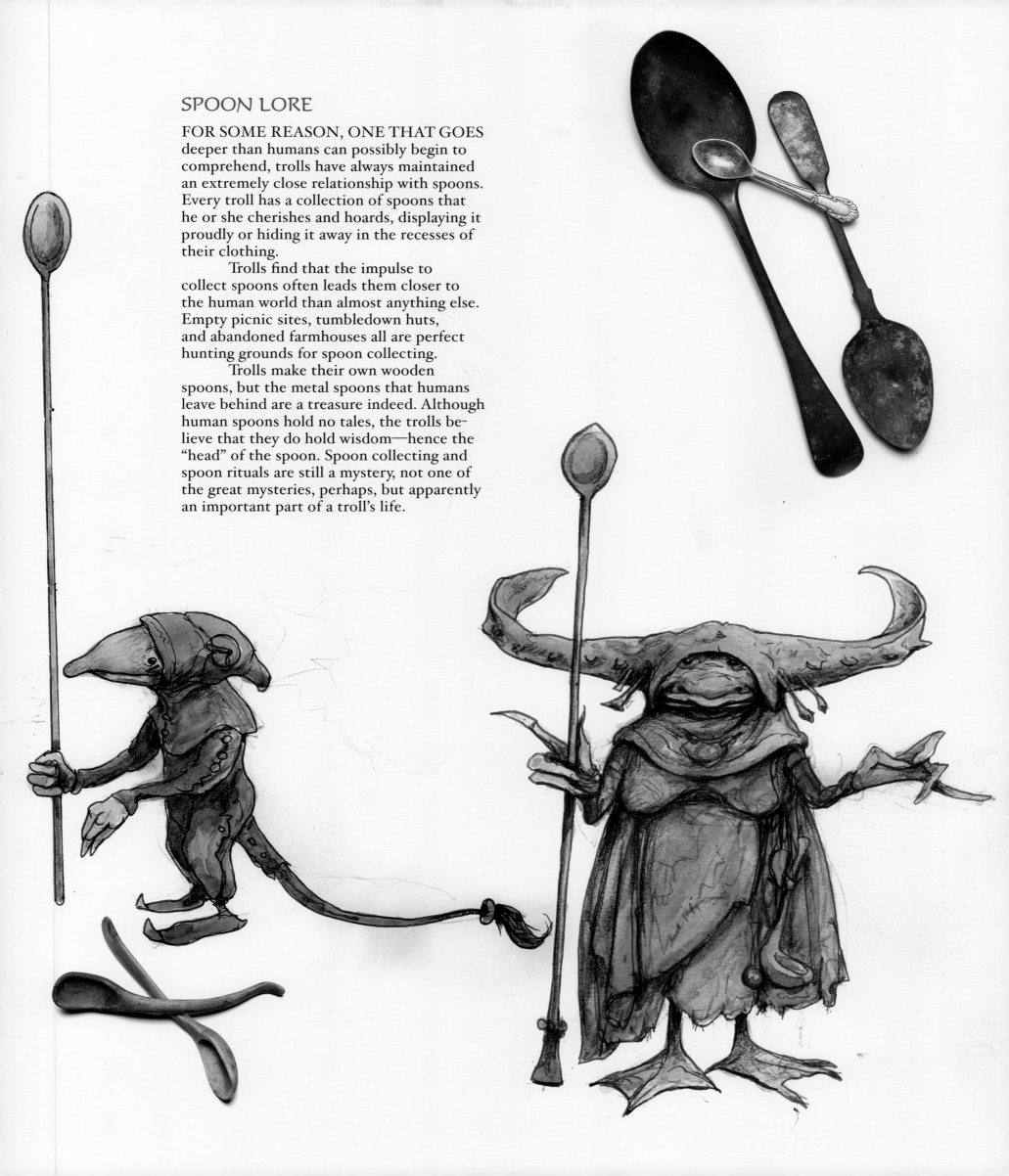

SPOON LORE

FOR SOME REASON, ONE THAT GOES deeper than humans can possibly begin to comprehend, trolls have always maintained an extremely close relationship with spoons. Every troll has a collection of spoons that he or she cherishes and hoards, displaying it proudly or hiding it away in the recesses of their clothing.

Trolls find that the impulse to collect spoons often leads them closer to the human world than almost anything else. Empty picnic sites, tumbledown huts, and abandoned farmhouses all are perfect hunting grounds for spoon collecting.

Trolls make their own wooden spoons, but the metal spoons that humans leave behind are a treasure indeed. Although human spoons hold no tales, the trolls believe that they do hold wisdom—hence the "head" of the spoon. Spoon collecting and spoon rituals are still a mystery, not one of the great mysteries, perhaps, but apparently an important part of a troll's life.

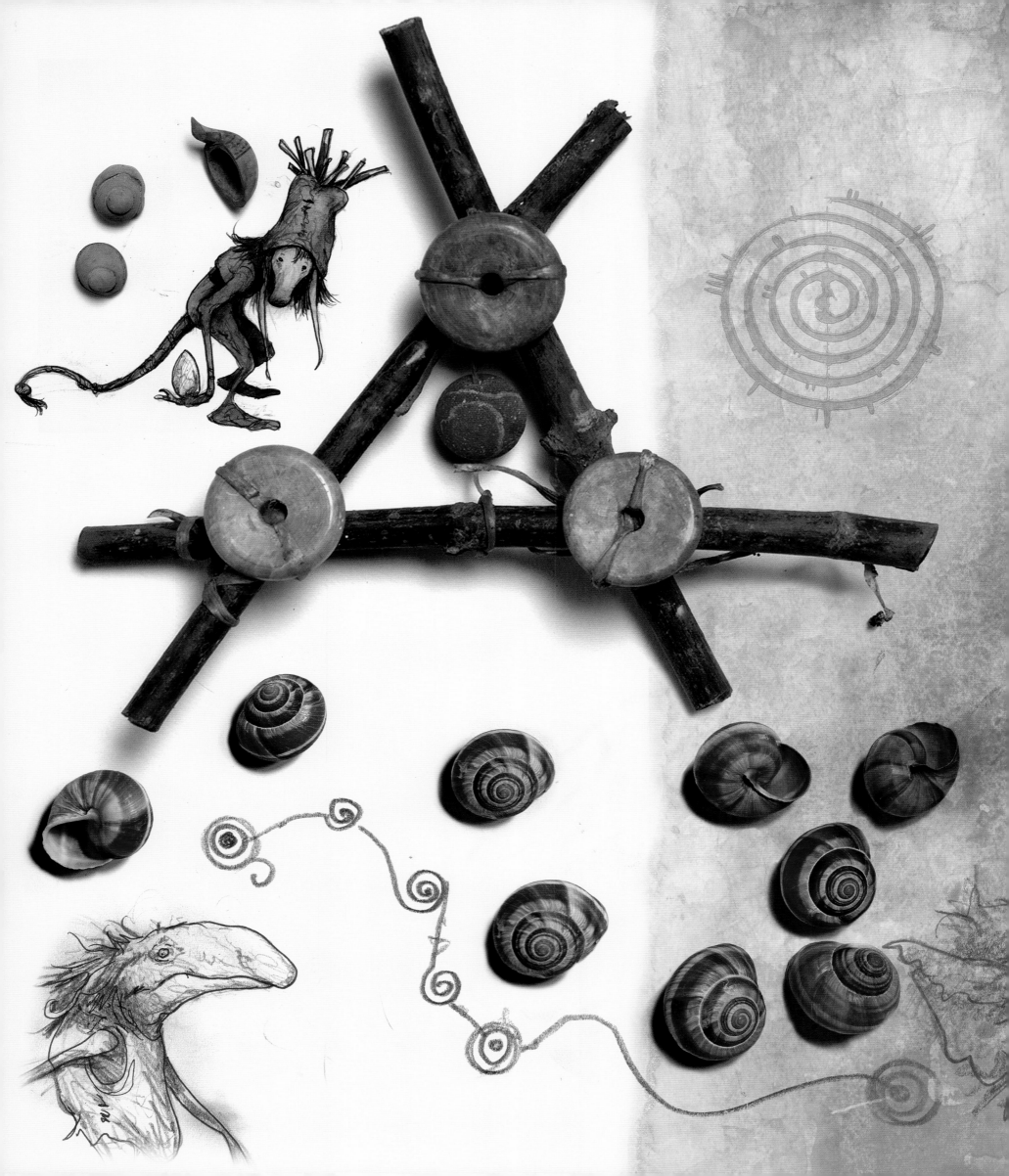

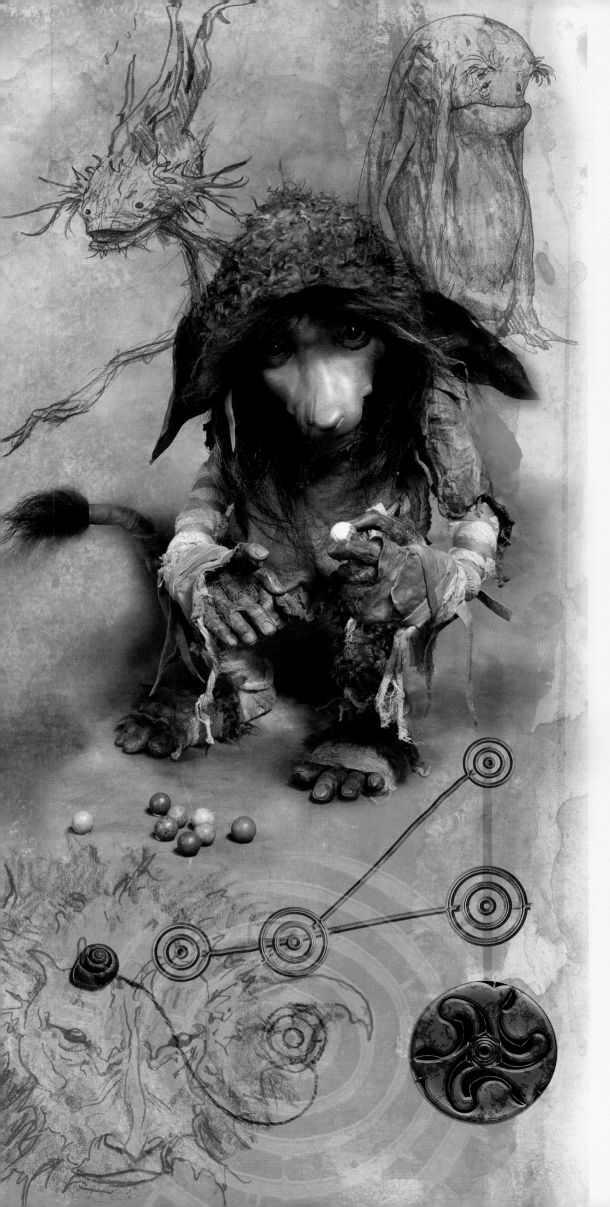

THE TELLING OF TALES

THE TELLING OF TALES IS SOME-
thing that all young trolls are taught at
some point in their lives. Of course, not
all of them become tellers of tales—it is a
skill and a gift that many never develop—
but all troll children learn the basic skills
of looking and feeling and making con-
nections. They do this with small stones,
some round as planets, others flat and tied
to twigs. They learn to see the stories in
snail shells and bones. If we were trolls,
and could read the shells and twigs on
this page, they would begin to tell a tale
rather like this:

THE ROAD WENT ON FOREVER,
or so it seemed to the boy. The
village was many miles behind him and
the words of the wise man grew fainter
with each passing step. He had never
been this far from home before, but
then, what was home? Gone in the space
of a short day, the village burned and
his family was stolen away—all but the
boy—hidden within the deep recesses
of the oldest oak tree at the edge of the
clearing. He had seen it all and lived to
carry the burden of what he had witnessed.
The village wise man, lying broken on a
fallen cartwheel, had spoken to the boy
as life left him, whispering words in his
ear, his face so close that the boy
could feel the white whiskers on the
old man's chin. "Go to the trolls. Seek
the tellers of tales and they will help you
find your family. The trolls know." And
that was that. The old man died and the
boy was left alone. But how to find the
trolls? The old man hadn't told him this—
and so the boy walked down the road,
mile after mile, until finally here he was.

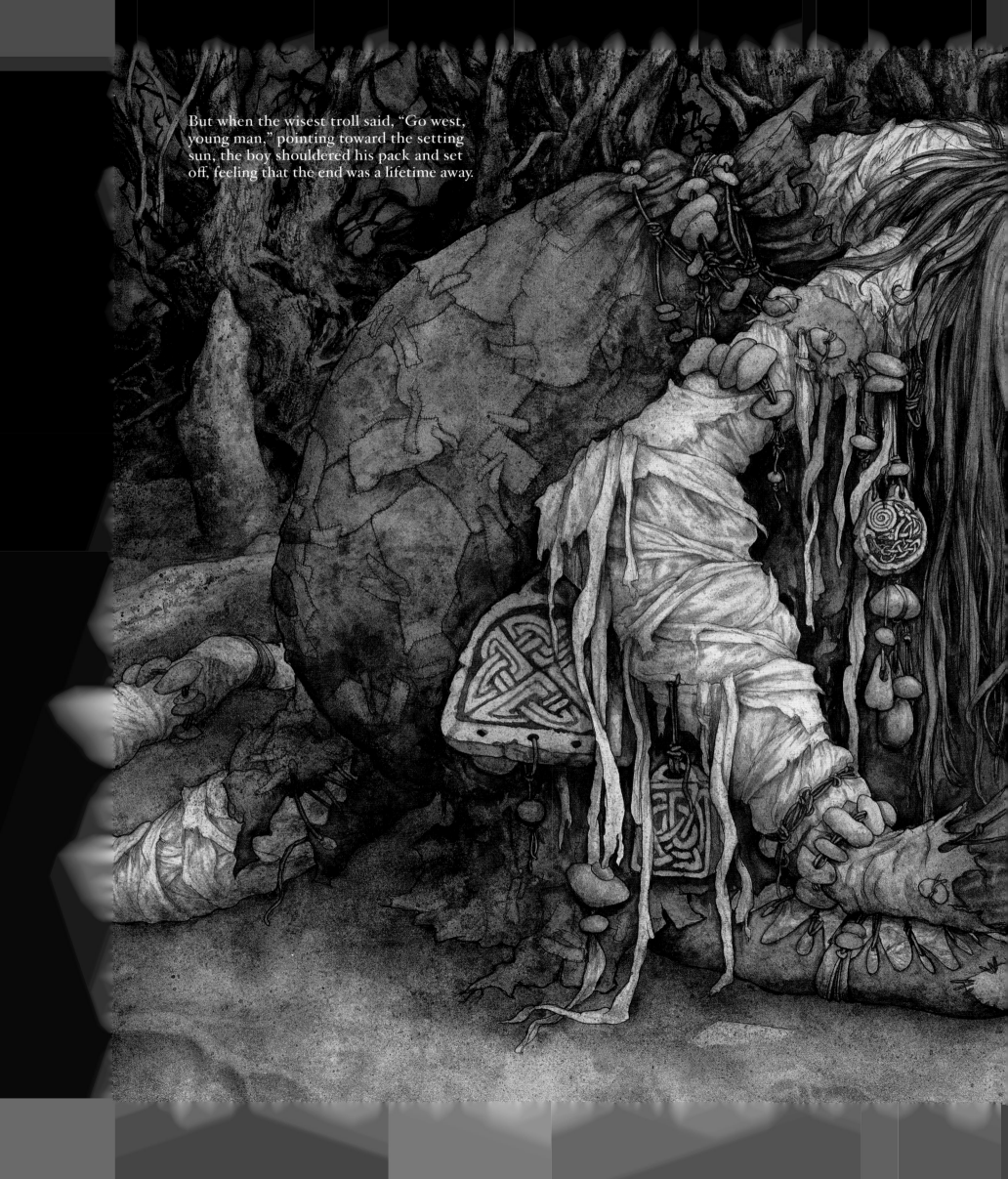

But when the wisest troll said, "Go west, young man," pointing toward the setting sun, the boy shouldered his pack and set off, feeling that the end was a lifetime away.

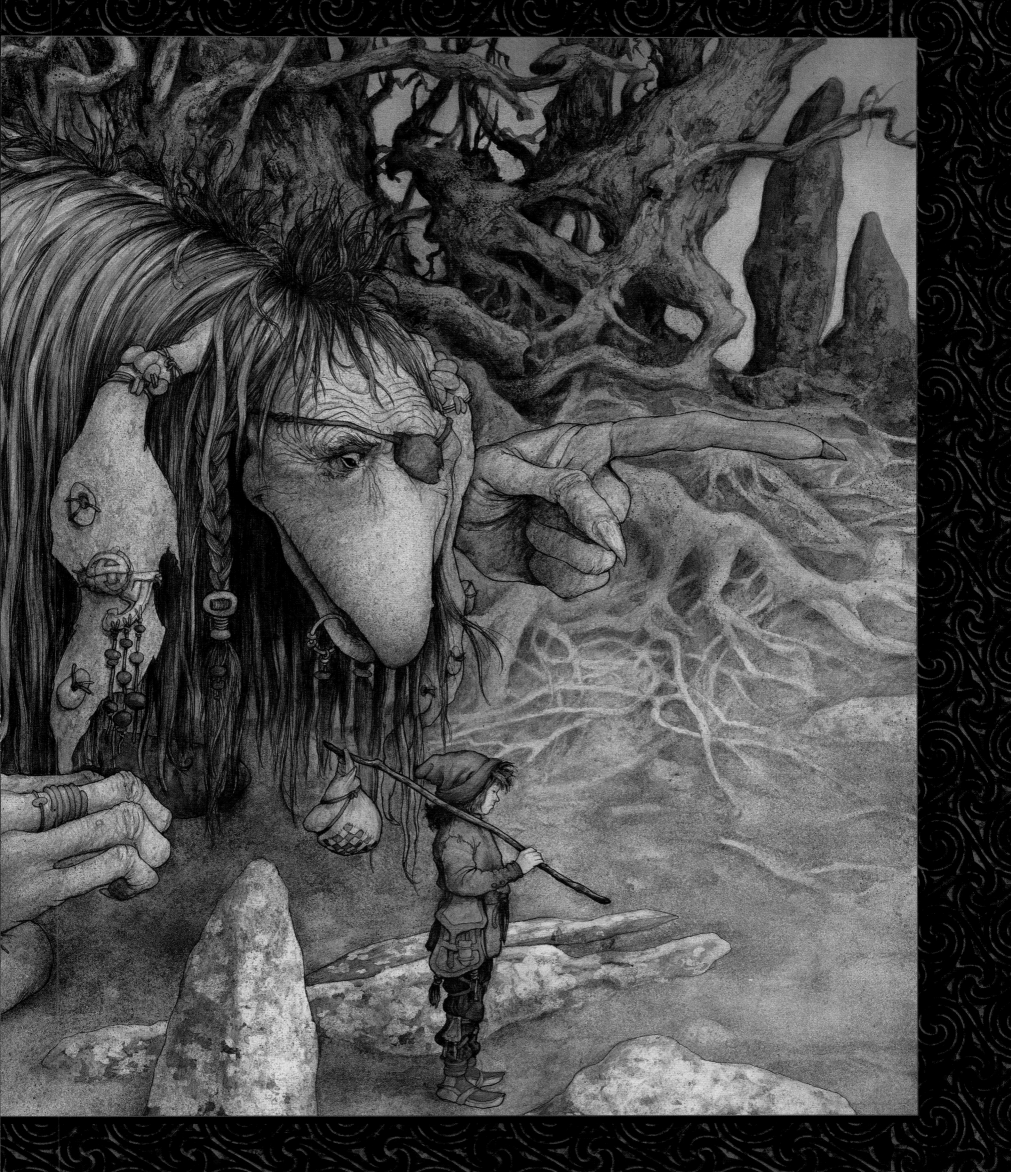

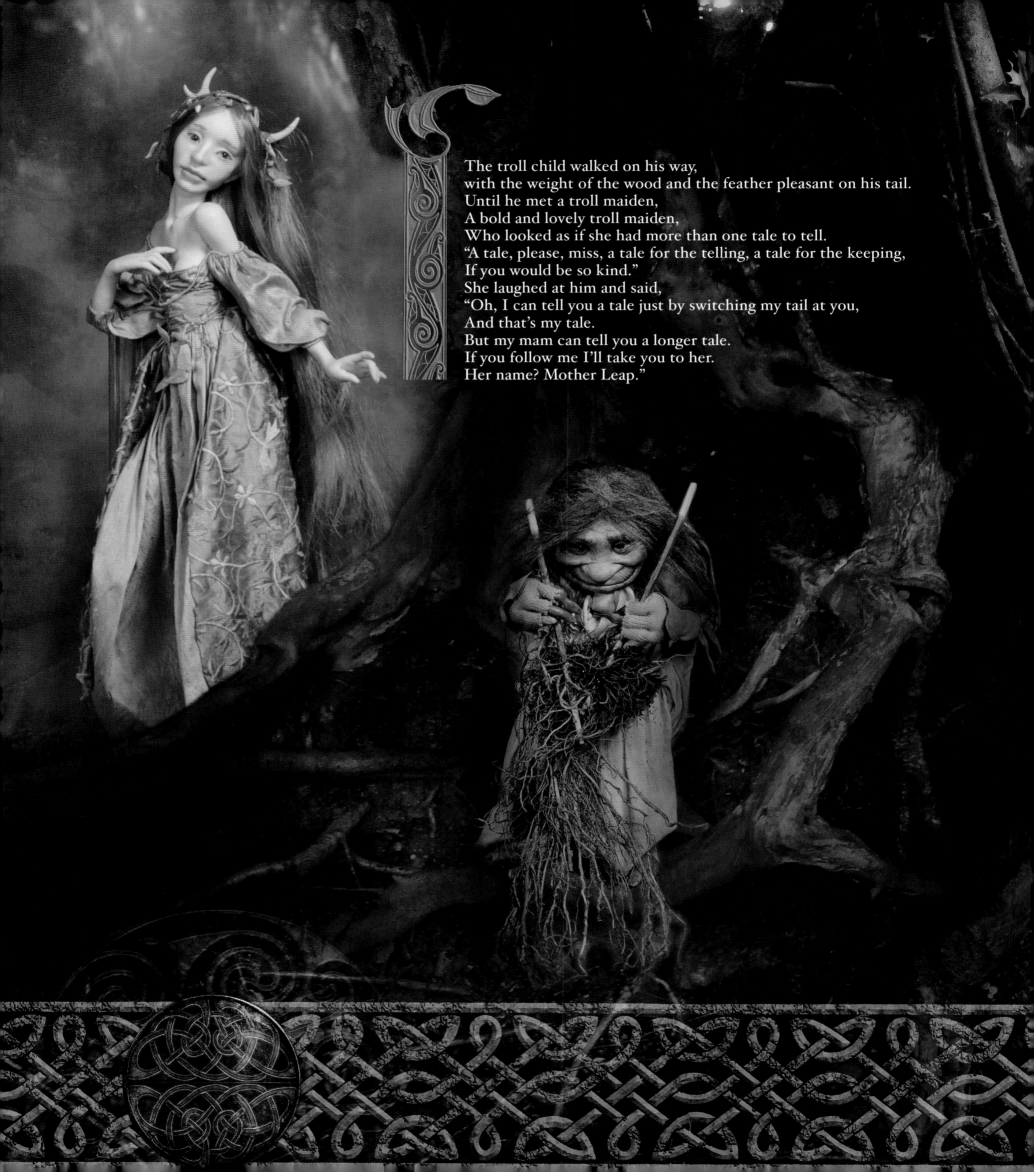

The troll child walked on his way,
with the weight of the wood and the feather pleasant on his tail.
Until he met a troll maiden,
A bold and lovely troll maiden,
Who looked as if she had more than one tale to tell.
"A tale, please, miss, a tale for the telling, a tale for the keeping,
If you would be so kind."
She laughed at him and said,
"Oh, I can tell you a tale just by switching my tail at you,
And that's my tale.
But my mam can tell you a longer tale.
If you follow me I'll take you to her.
Her name? Mother Leap."

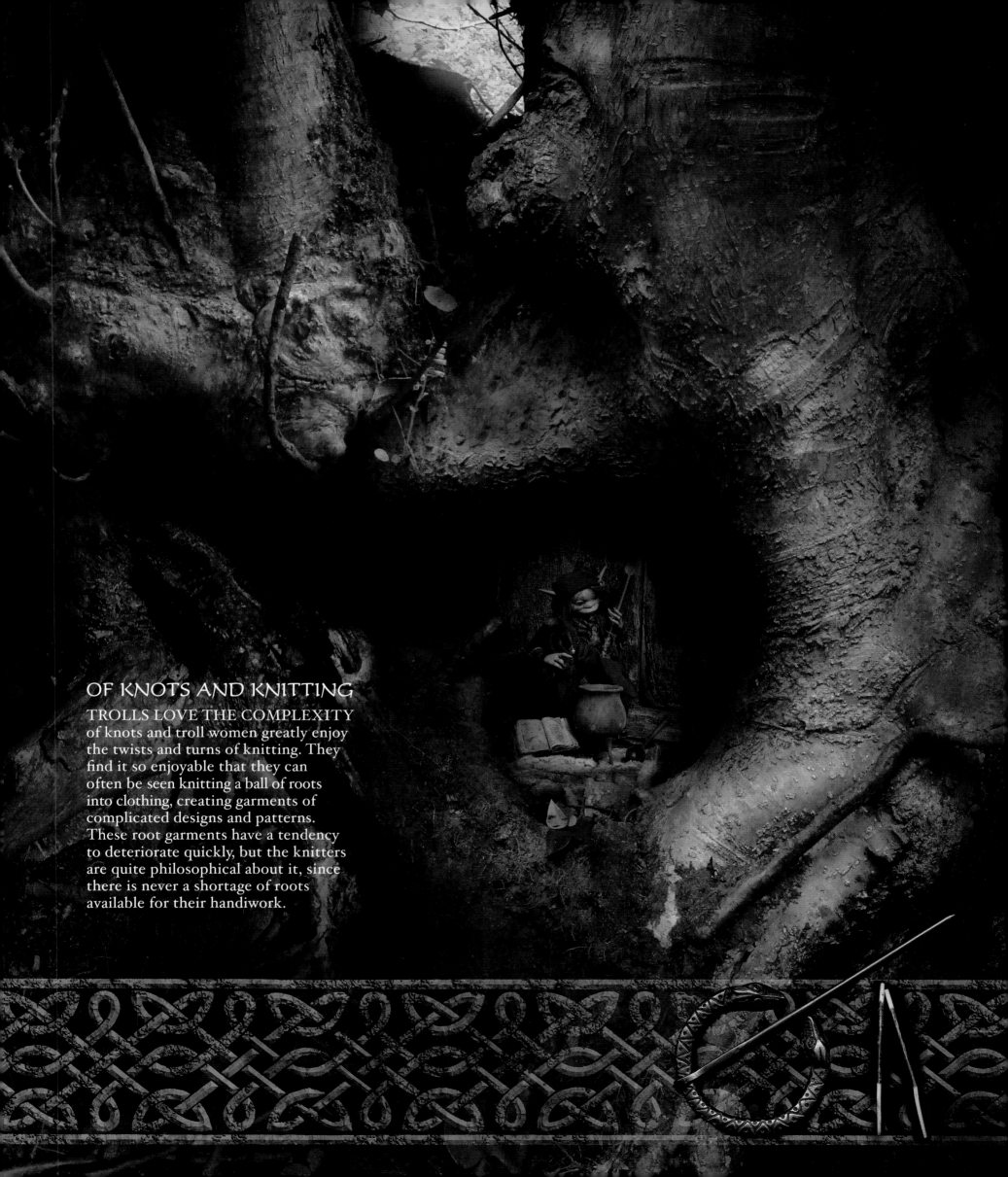

OF KNOTS AND KNITTING

TROLLS LOVE THE COMPLEXITY
of knots and troll women greatly enjoy
the twists and turns of knitting. They
find it so enjoyable that they can
often be seen knitting a ball of roots
into clothing, creating garments of
complicated designs and patterns.
These root garments have a tendency
to deteriorate quickly, but the knitters
are quite philosophical about it, since
there is never a shortage of roots
available for their handiwork.

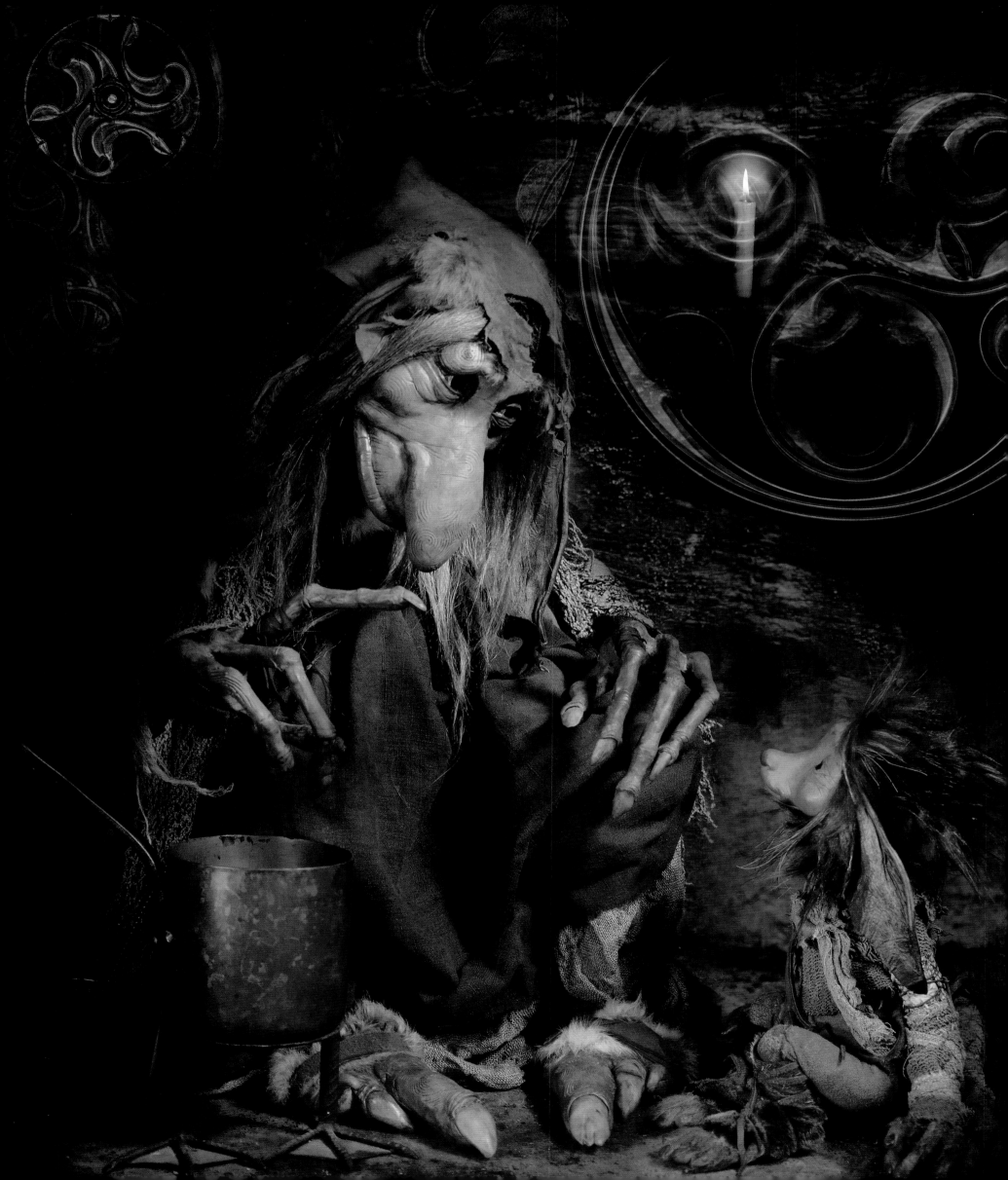

"Oh, my little one, my leveret, my sweeting,
You've come to Mother Leap.
You'll be wanting a tale from Old Mother, then.
And what tale would that be?
What tale can Mother Leap tell to a young one like yourself? I wonder.
I could tell you the tale of—but no,
I believe I'll keep that one safe in my pocket for a time yet.
Now, what tale can Mother give you to have for your very own?
What's that? A question, my little leveret?
Why am I called Mother Leap?
Yes, I hear you asking—you don't have to say the words to Mother.
I'm called Mother Leap because of my dancing and my nimble ways
In the meadows and amongst the grasses.
Mother Leap jumps up and pricks her ears, and look at this!
Now Mother Leap is a hare in the meadow,
Dancing and singing and calling to her children.
And they come.
They always come to Mother.
And just when they're near—when they're dancing in her footsteps,
She catches them and holds them close and snaps their little necks.
Then Mother Leap goes home,
And sits down to a supper of stewed hare and turnip greens.
Mother Leap does have her ways, indeed she does,
And Mother Leap never goes hungry.
Now, my sweeting, sit close to Mother,
I think I know just the tale for you."

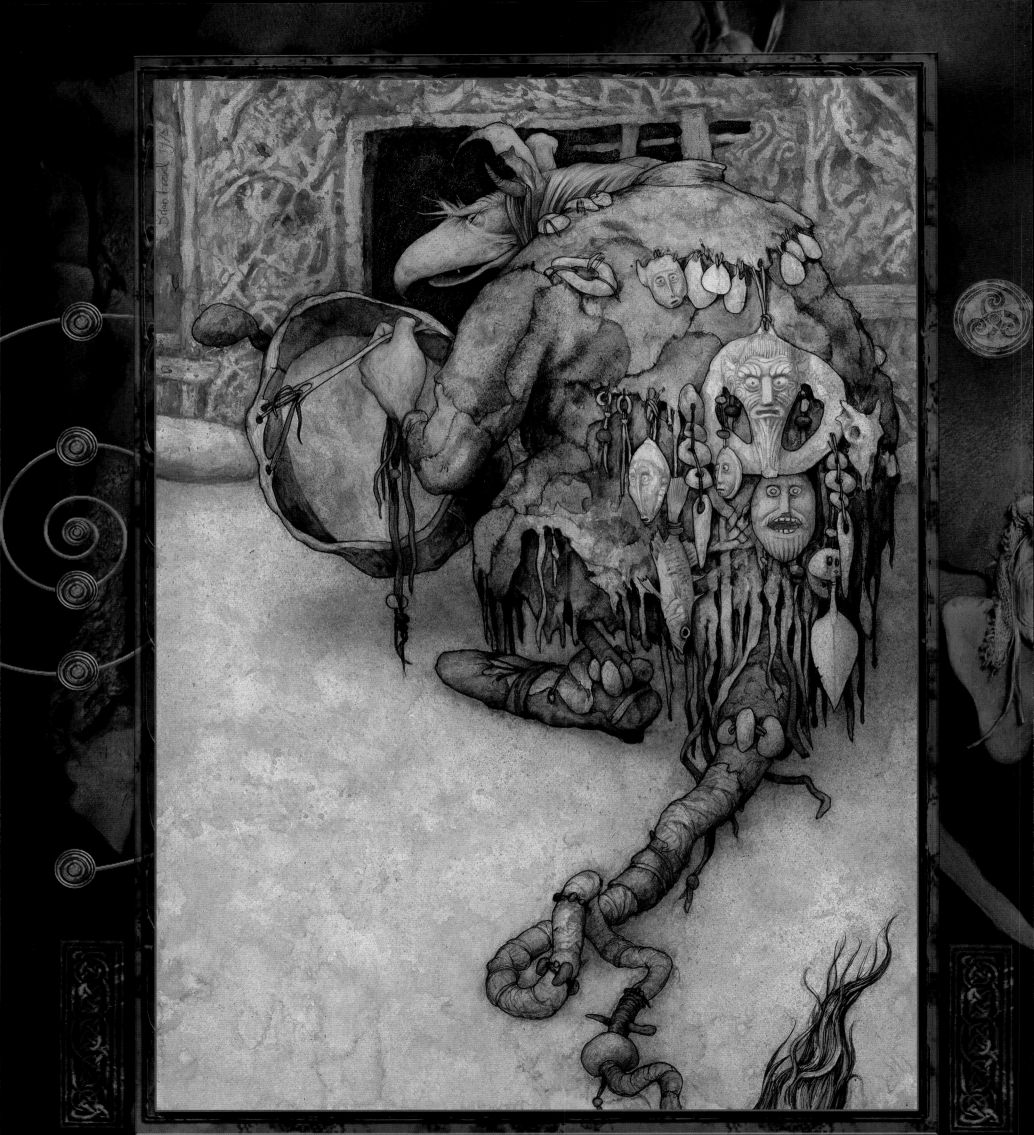

The Tale of Stone

The Pride of Anhold Honeybag

ANHOLD HONEYBAG WAS A RARE thing among trolls. He was prideful. Now, being prideful isn't the same as being proud. Prideful carries a boast in its voice that pride does not. Mind you, Anhold had much to be proud of, if not to be prideful about. Anhold Honeybag had the longest tail of all the trolls that lived on the moor, and this tail was hung with more stones and bones and feathers and twigs than any other tail on the moor, and this meant that Anhold was the keeper of more tales than any other troll on the moor.

Now, trolls are by nature generous with their praise of one another's tails and the tales they tell. They collectively are a proud race of tale tellers—the more tales to be gathered for the Rememberings, the grander their chronicles become and the happier the trolls become as well. Having said this, trolls gathered for the Remembering always listened with sinking hearts whenever it was Anhold Honeybag's turn to relate his tales. For Anhold always, without fail, boasted of the new tales he had collected and how with each new tale, his tail had become almost heavier than he could manage. Anhold laughed and said that maybe he should give a few of his older, smaller tales to the less fortunate trolls who came to the Remembering with perhaps only one small and insignificant tale to tell. But he never did. Anhold carried the weight of his tail with a pridefulness unlike any other troll on the moor.

Year after year, Remembering after Remembering, it was the same. Until the year when Anhold journeyed to the gathering followed by his grand tail, which was being held aloft by three young and very small trolls, each one carrying the weight of a third of that magnificent appendage. Anhold the Prideful settled into his place in the circle of trolls and opened his mouth to begin his telling, and the gathering as one heaved a sigh.

The tale he told that fateful year was, it had to be admitted, a most entertaining tale of goblin foolery and how Anhold had outsmarted and (there was only one word for it) tricked the goblin court out of its most precious possession—the Great Holed Stone of Grimspound. This was no ordinary holed stone—although as everyone knows, no holed stone is ordinary—this was the most magical of holed stones. It had graced the court of the Grimspound goblins for more years than they

could remember, although to be honest, goblins do not have terribly long memories, so it may not have been very long at all. This particular holed stone, when peered through, would show the seeker exactly what he was hoping to see. Goblins hope for many things, most of them having to do with food or drink or something that smells bad. The stone passed from hand to hand and eye to eye, showing each goblin an especially fine piece of putrid meat, its surface glowing with iridescent maggots, or a magnificent hollow log filled to the brim with stagnant water, frogspawn, and insect carcasses. The goblins spent endless hours gazing upon these delicacies.

The Great Holed Stone of Grimspound was their dearest treasure. Now, with the stone gone, tricked out of their keeping by one extremely self-satisfied troll, the goblins followed Anhold to the gathering of the Remembering, hiding just out of sight, and heard his newest tale, their tale, told with a prideful voice and a turn of phrase that made the goblins appear very foolish and easily bested by a clever troll. They did not like what they heard. They did not like it at all. They planned, they revised, and, finally coming up with the perfect strategy, they hunkered down together and plotted their revenge. As the Remembering moved on to another troll's tale, they crept back to their court at Grimspound and waited.

The Remembering was a long-drawn-out affair. The trolls all told their tales and spent many hours discussing, evaluating, and mulling over each tale and each telling. By the time the last troll had spoken and the last tale had been appreciated, the season had turned and winter was blanketing the moorland with a dusting of snow and a thin layer of ice on the standing pools of water.

Anhold had been the first troll to speak and the most impatient to depart and resume his searching. He left as the farewells were still rumbling on and, followed by his three small tail carriers, began his journey home over the snow and ice, swaying slightly with the weight of the tail and the extra weight of the small trolls hanging on and sliding behind him. Eventually his path took him nearer and nearer to Grimspound and the waiting goblins—the foolish goblins—the easily tricked goblins.

The goblins heard the heavy foot-steps of the troll and knew it was time to set their trap. Just off the path, just to the right of a circle of standing stones, they placed their offering: their magnificent, irresistible offering for prideful Anhold Honeybag. What was this amazing offer-

ing? It was something trolls search all their long lives for—something so rare and so beautiful that any troll, and especially a troll such as Anhold, would risk his very life to own. This was an Earthing Gift—a talisman of great power and wisdom, made in times long past and almost forgotten and very, very occasionally discovered by an exceptionally lucky troll (of course, having first been discovered by perhaps some not-so-foolish goblins). Anhold was that lucky troll. He could hardly believe his eyes. Here, just to the right of the last stone circle, nestled in a hollow in the ground, was an Earthing Gift made of stone and bone, wood and feather—a gift that held within it not one tale but many, many tales of each sort—the longest tales of stone, the bone tales of passings, the wooden tales of birthings, and the rarest feather tales of laughter—all combined in this one great piece of troll magic.

Anhold quivered from his ears to the very tip of his precious tail and reached out to touch the Earthing Gift. It vibrated with tales just waiting to be told. He grasped it with both hands and lifted. It was heavy. It was extremely heavy, but surely, once it was attached to his tail, he would, with the help of his three small trolls, be able to manage the carrying of it. The gift was already wrapped with a beautiful knotted cord, and under Anhold's stern direction, the little trolls dutifully tied the amazing gift to the middle of his tail, pushing aside lesser stones and bones, twigs and feathers, to make room for it. Delighted with his luck and his new addition, Anhold told the young trolls to take a firm grip on his tail and move on the count of three. Anhold moved, the little trolls moved, but the tail didn't budge. "Again," Anhold said, and again they lifted, and again the tail stayed exactly where it was. The Gift was far, far too heavy for one tail, even with the help of the three little trolls. What to do? Anhold tried dragging it, pulling it, and pushing it, but nothing moved the tail.

Finally and very reluctantly, he decided that the only thing to be done was to untie the Gift and leave it in the hollow to be collected later with the help of a few of the trolls who were still no doubt saying farewell at the Remembering. "Untie the Gift," Anhold said, the melancholy tone of his voice echoing his disappointment—but try as they might, the little trolls could not untie it. The beautiful, knotted cord held fast and would not be undone.

It was dark. Anhold was tired and distressed and frustrated and as close to being angry as a troll ever gets. The only

thing he could do was stay there tied to his Gift while the little trolls ran for help. It would be a long wait. Anhold was very tired and soon fell fast asleep in the hollow by the stone circle.

Now, the goblins had waited patiently for this moment. They crept out of hiding and unsheathed a small, silver knife that they had found with the Earthing Gift. Slowly and quietly they crept closer until they were near the tail and the Great Holed Stone of Grimspound but as far from the rest of Anhold as possible. The little silver knife cut the knotted cord like butter. Soon the goblins had the Great Holed Stone safely back where it belonged.

But the goblins didn't just rescue the Great Holed Stone of Grimspound—not while they had a chance to cause much more mischief and teach a troll a well-deserved lesson. They carefully and deftly cut away every stone, bone, feather, and twig that Anhold had so lovingly collected over the years and the centuries, and carried them all away, never to be seen again, for these objects meant nothing to the goblins—the fun had been in the stealing of them. They buried the holed stones and ate the bones and burned the wood and blew the feathers away on the wind. All, that is, except the Earthing Gift. They left that tied to Anhold's tail and left Anhold asleep in the hollow with the little silver knife visible but just out of reach.

In the morning Anhold awoke and stretched and found that he felt strangely light. Trolls never feel light. The heaviness of the tales they carry is intrinsic to them, imparting a comforting weight to any movement they make. "Heavy as a troll's trousers" is one of their favorite expressions. Well—Anhold did not feel the least bit heavy. He sat upright and then rose to his full walking height with a quickness and grace he had never before experienced. He moved to the left and right and did a little dance where he stood. Having for the moment forgotten exactly why he was waking up in a hollow on the moor, he began to walk away in search of a bit of breakfast.

He had taken just a step or two in the direction he thought seemed most appropriate when he was pulled up short and stopped outright by something that was holding him quite fast by the tail. He turned and saw to his horror the thing he had forgotten about during the night—the Earthing Gift, knotted tightly to his tail and allowing him to move not a step farther. Nonetheless, he still felt a strange lightness, and looking farther along his tail and turning right around to see his back,

Anhold saw—nothing. Not a stone, bone, twig, or feather tied anywhere on his leather clothing or on his extremely bare tail. Every tale had vanished. Every reminder of his long life had disappeared without a trace. Anhold was a troll with nothing.

He sat down suddenly with a thump. He thought he might as well never get up again, for what is a troll without his tales? He is just a creature with nothing to say and nothing to remember. Sunk deep in despair, Anhold had just decided that he would stay there forever, slowly turning himself into a boulder, which is something trolls can do, when all of a sudden he saw the knife. He leapt to his feet and reached for it, but found that no matter how hard he stretched, he couldn't reach the knife. With a sob he sat back down. Then he heard a noise—quite a bit of noise. Anhold looked over the moor along the pathway he had taken yesterday evening, which now seemed like such a long time ago, and he saw the three little trolls coming back toward him, bringing with them a line of four trolls—four of the trolls who had been at the Remembering the day before.

Anhold had left in such a hurry that the trolls were still there saying their good-byes when the three little trolls burst back into the clearing to impart their dreadful news of Anhold and the Earthing Gift. The trolls, being trolls, had not come immediately to the rescue but had spent the remainder of the night remembering similar tales of the past (although there were no truly similar tales to be remembered) and discussing what was to be done that next morning—and now, having come to their decision, they were here to rescue Anhold.

Anhold cringed at the thought of the trolls coming to rescue him, Anhold, the troll who, over the many years, many centuries, had been the most eloquent, most revered teller of tales that the trolls of Dartmoor had ever known. Anhold the Prideful. Anhold the Shamed.

The trolls gathered in a circle around him and looked at his bare tail, and the Earthing Gift still tied tightly to it. The oldest troll looked at the little silver knife lying on the ground just out of Anhold's reach. He picked it up, saying "Anhold. I shall cut the Earthing Gift free of your tail, but what will happen then? Shall we all share in the beauty of this wonderful thing or will you find a way to carry it off alone?"

Anhold hung his head in shame. "I will gladly give the Earthing Gift to all the trolls of Dartmoor to share at the Rememberings for all the years to come. I know I have been a prideful troll and a selfish troll

and a greedy troll—but I am no longer those things. I am a troll without tales— a troll with nothing. I will travel the moors and tors and valleys searching for new tales to bring to the Rememberings, and maybe centuries from now I will once again have a tail to be proud but NOT prideful of."

The trolls heard Anhold and took pity on his emptiness. The oldest troll again spoke for them all, saying, "Anhold, you have learned a hard lesson—but no troll should walk through life taleless. We will each give you a small tale so that you will start your journey with something to remember." Then the troll took the little silver knife and cut through the knotted cord, and the Earthing Gift came away from Anhold's tail. He then cut a small stone from his own tail and tied it to Anhold. The next troll cut a small bone, the third cut a twig, and the fourth, a wren's feather. Each one tied his offering to Anhold's bare tail until he once again had the beginnings of his tail of tales.

Anhold thanked the trolls for their kindness and bid them farewell, watching as they carried the Earthing Gift off between them, for it was an easy job for four strong trolls (and three little ones). Then Anhold began his solitary journey over the moor, and as he walked, he felt the same lightness he had felt earlier that morning. It was not an unpleasant sensation, and as Anhold climbed the hill just past the last stone circle near the path, he did a little dance.

When Mother Leap had finished,
When the tale was told and done with,
And tied securely to the troll child's tail,
Mother looked him in the eye and said,
"Time to be off now, child,
Mother can hear her children running
in the meadow,
And Mother is hungry."

The troll child hurried away,
Not looking back at Mother Leap,
Afraid to see her capering in the grasses,
Her children following, bright-eyed,
All in a row.

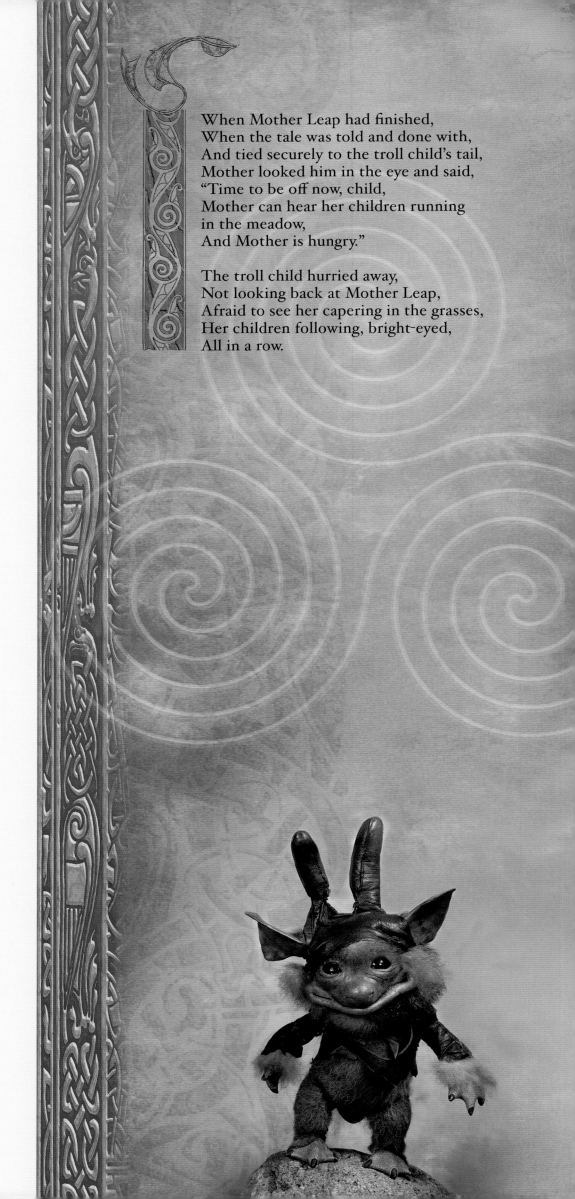

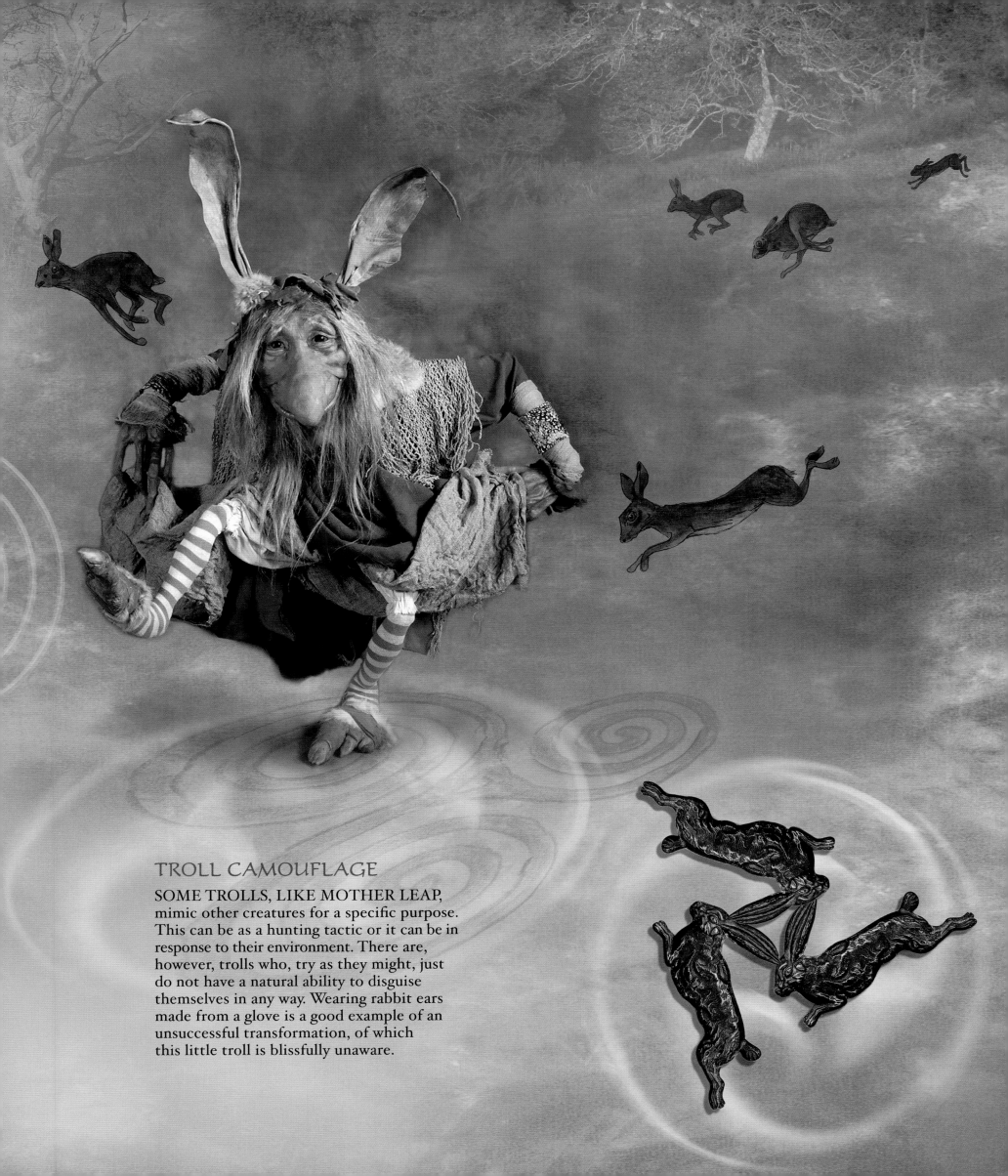

TROLL CAMOUFLAGE

SOME TROLLS, LIKE MOTHER LEAP, mimic other creatures for a specific purpose. This can be as a hunting tactic or it can be in response to their environment. There are, however, trolls who, try as they might, just do not have a natural ability to disguise themselves in any way. Wearing rabbit ears made from a glove is a good example of an unsuccessful transformation, of which this little troll is blissfully unaware.

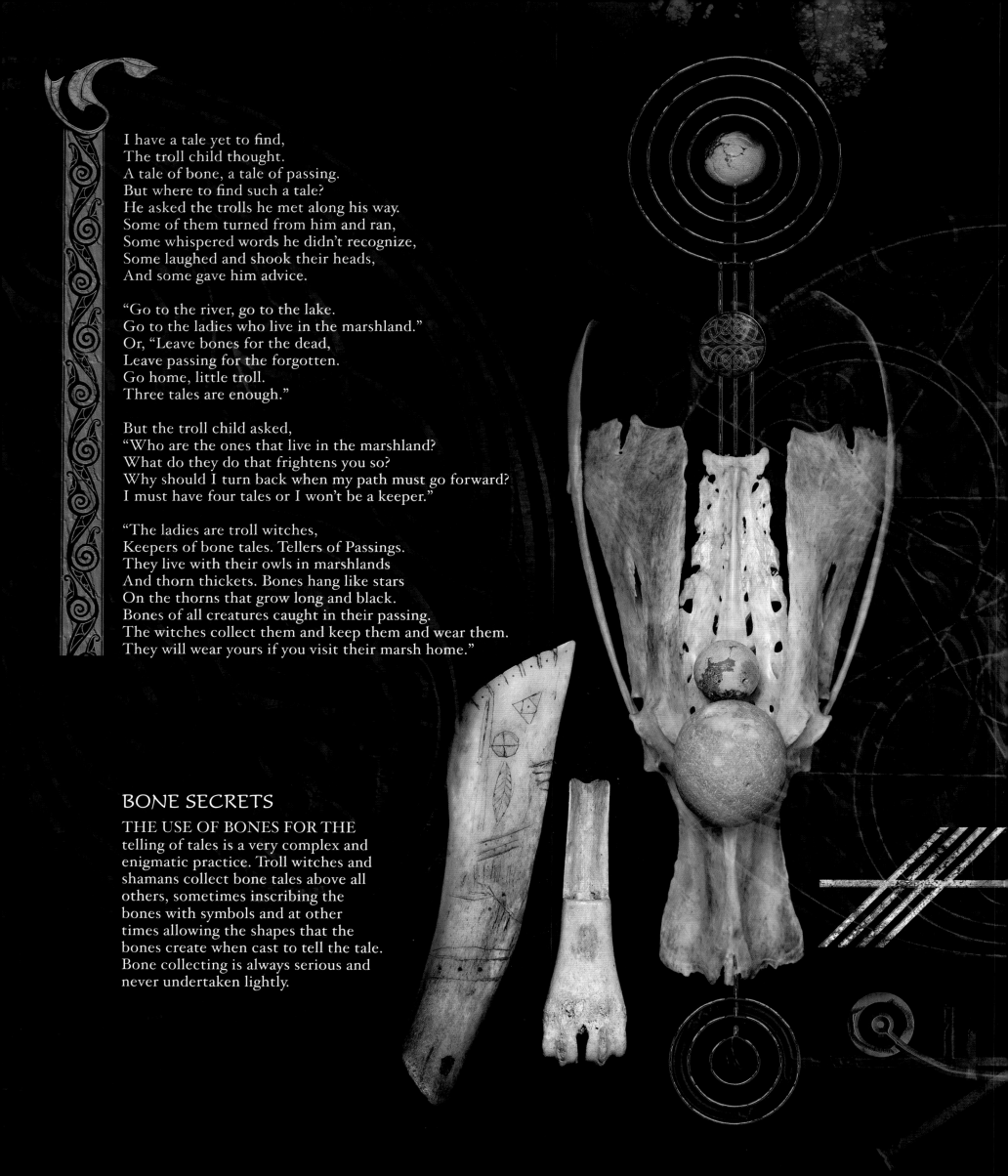

I have a tale yet to find,
The troll child thought.
A tale of bone, a tale of passing.
But where to find such a tale?
He asked the trolls he met along his way.
Some of them turned from him and ran,
Some whispered words he didn't recognize,
Some laughed and shook their heads,
And some gave him advice.

"Go to the river, go to the lake.
Go to the ladies who live in the marshland."
Or, "Leave bones for the dead,
Leave passing for the forgotten.
Go home, little troll.
Three tales are enough."

But the troll child asked,
"Who are the ones that live in the marshland?
What do they do that frightens you so?
Why should I turn back when my path must go forward?
I must have four tales or I won't be a keeper."

"The ladies are troll witches,
Keepers of bone tales. Tellers of Passings.
They live with their owls in marshlands
And thorn thickets. Bones hang like stars
On the thorns that grow long and black.
Bones of all creatures caught in their passing.
The witches collect them and keep them and wear them.
They will wear yours if you visit their marsh home."

BONE SECRETS

THE USE OF BONES FOR THE
telling of tales is a very complex and
enigmatic practice. Troll witches and
shamans collect bone tales above all
others, sometimes inscribing the
bones with symbols and at other
times allowing the shapes that the
bones create when cast to tell the tale.
Bone collecting is always serious and
never undertaken lightly.

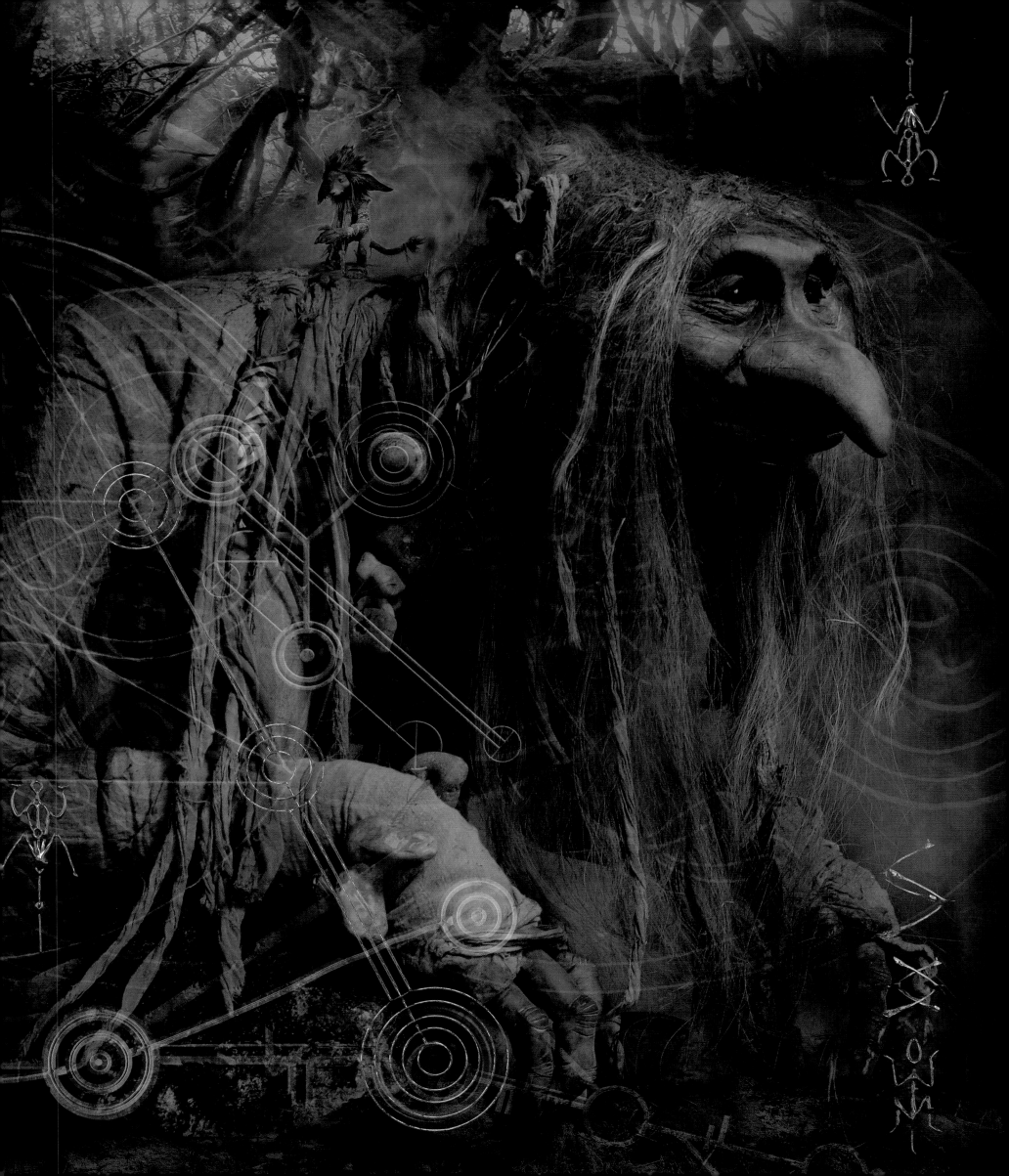

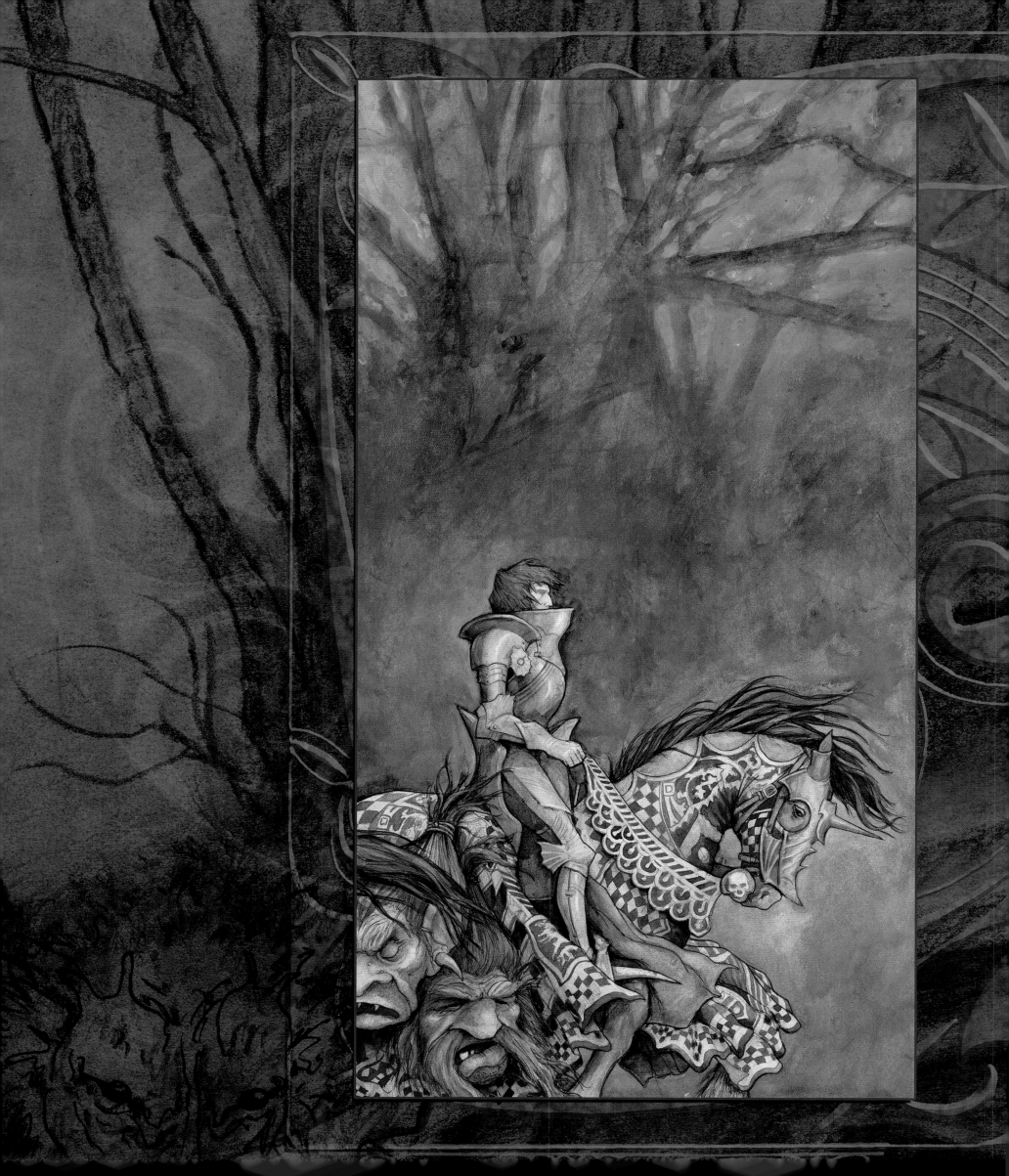

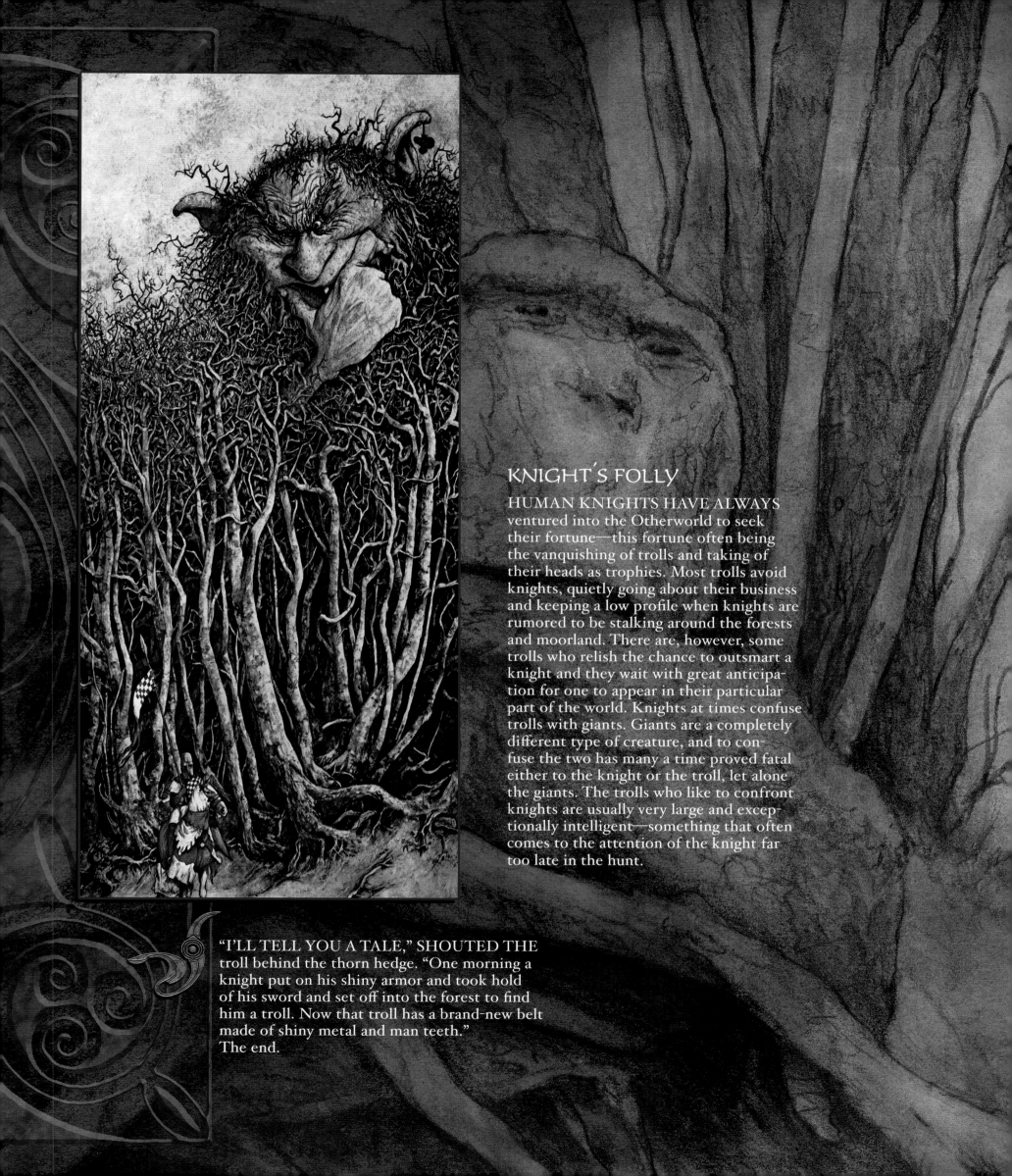

KNIGHT'S FOLLY

HUMAN KNIGHTS HAVE ALWAYS ventured into the Otherworld to seek their fortune—this fortune often being the vanquishing of trolls and taking of their heads as trophies. Most trolls avoid knights, quietly going about their business and keeping a low profile when knights are rumored to be stalking around the forests and moorland. There are, however, some trolls who relish the chance to outsmart a knight and they wait with great anticipation for one to appear in their particular part of the world. Knights at times confuse trolls with giants. Giants are a completely different type of creature, and to confuse the two has many a time proved fatal either to the knight or the troll, let alone the giants. The trolls who like to confront knights are usually very large and exceptionally intelligent—something that often comes to the attention of the knight far too late in the hunt.

"I'LL TELL YOU A TALE," SHOUTED THE troll behind the thorn hedge. "One morning a knight put on his shiny armor and took hold of his sword and set off into the forest to find him a troll. Now that troll has a brand-new belt made of shiny metal and man teeth."
The end.

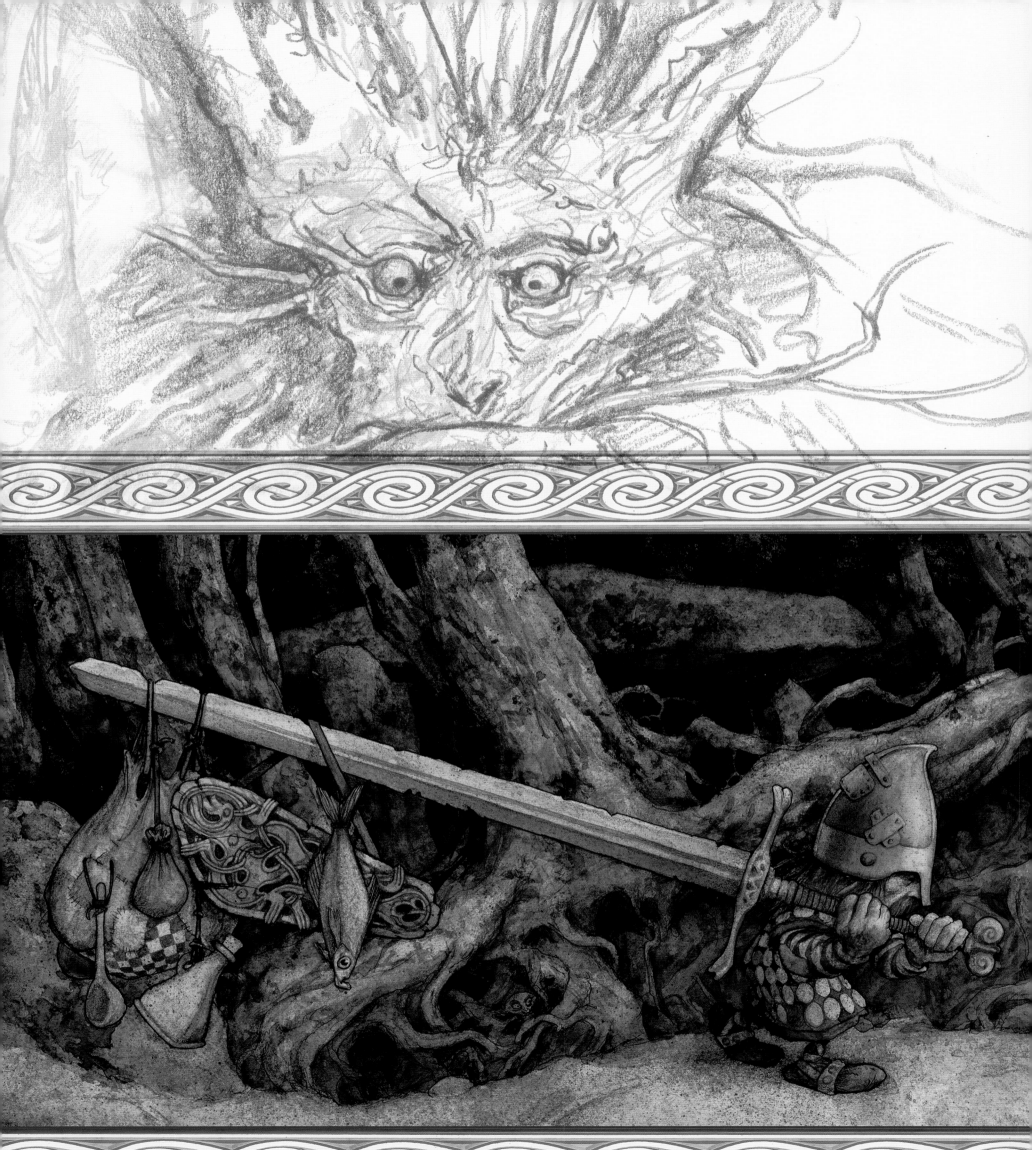

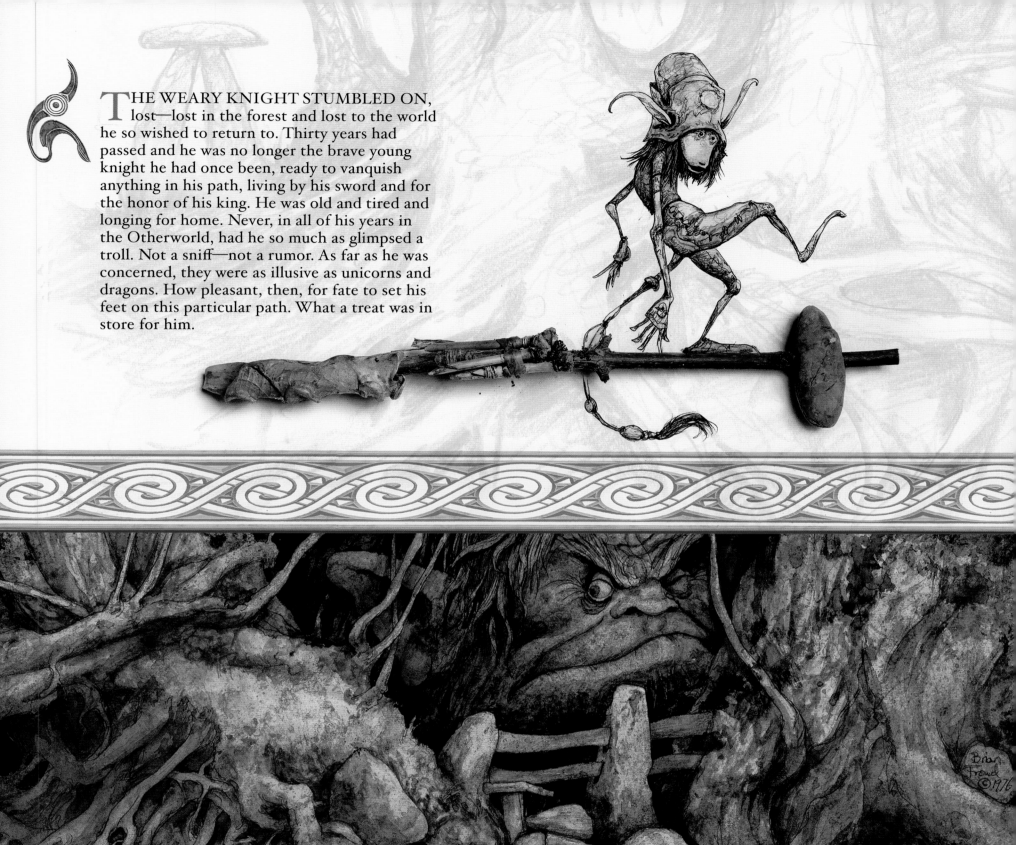

THE WEARY KNIGHT STUMBLED ON, lost—lost in the forest and lost to the world he so wished to return to. Thirty years had passed and he was no longer the brave young knight he had once been, ready to vanquish anything in his path, living by his sword and for the honor of his king. He was old and tired and longing for home. Never, in all of his years in the Otherworld, had he so much as glimpsed a troll. Not a sniff—not a rumor. As far as he was concerned, they were as illusive as unicorns and dragons. How pleasant, then, for fate to set his feet on this particular path. What a treat was in store for him.

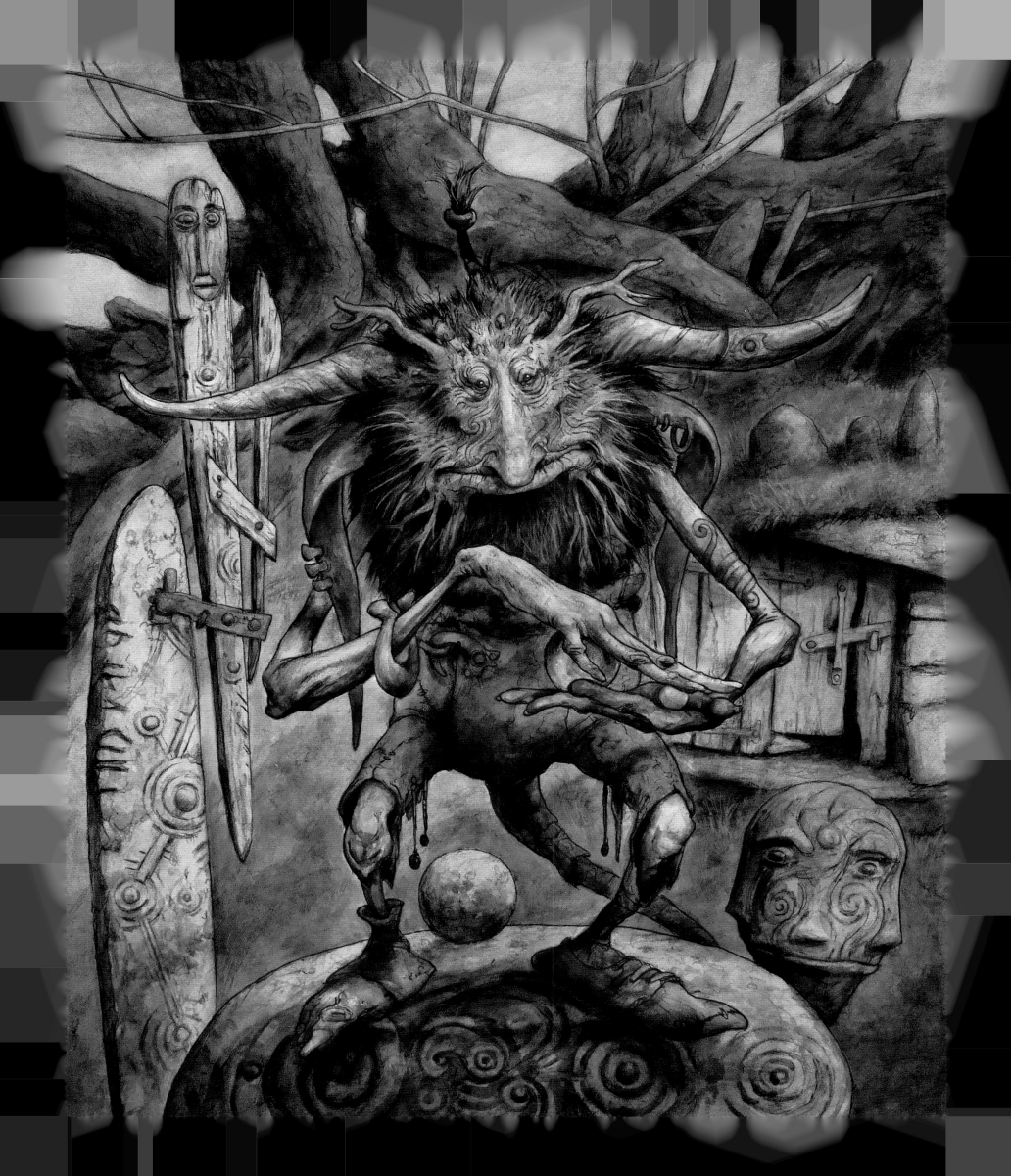

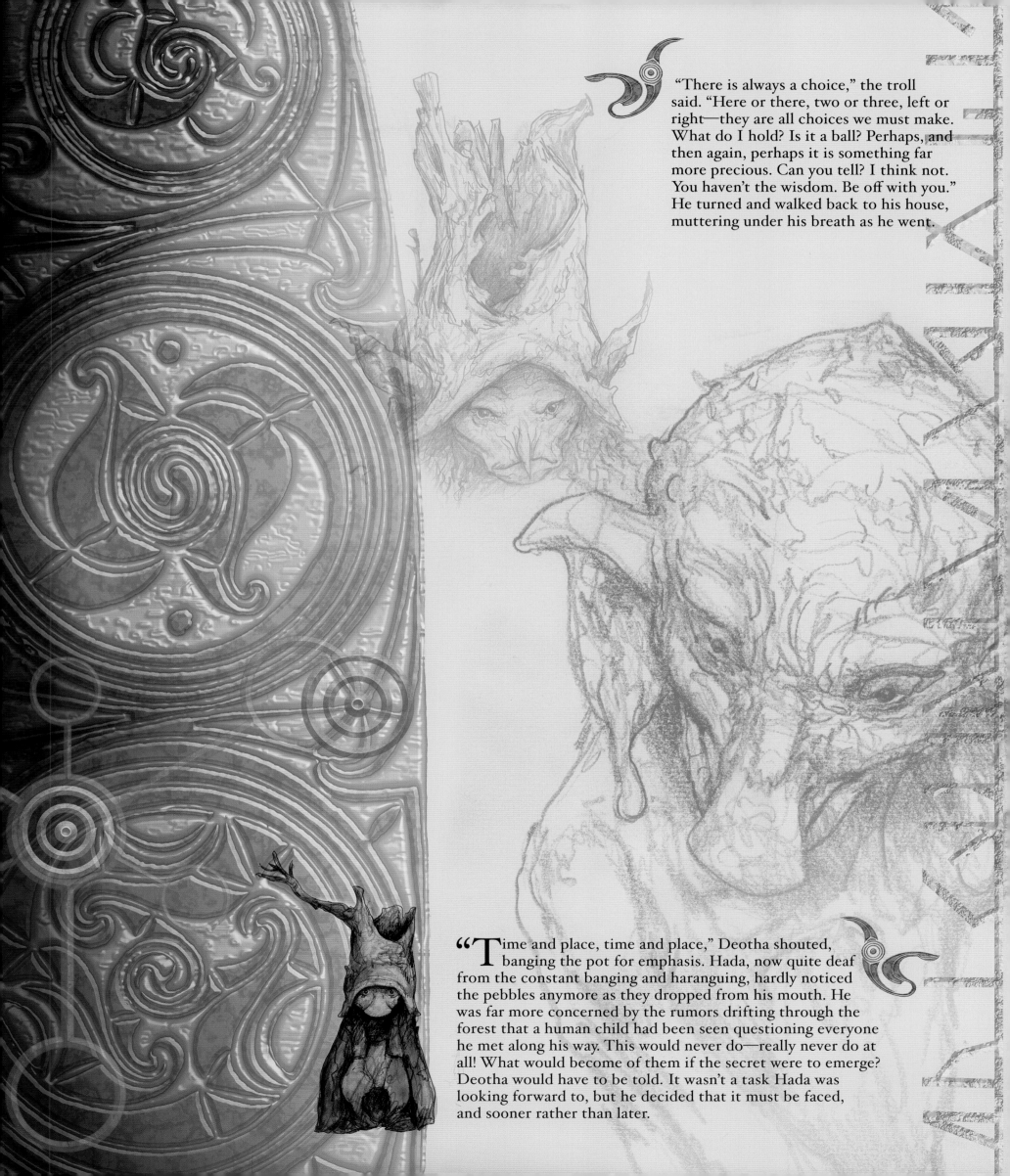

"There is always a choice," the troll said. "Here or there, two or three, left or right—they are all choices we must make. What do I hold? Is it a ball? Perhaps, and then again, perhaps it is something far more precious. Can you tell? I think not. You haven't the wisdom. Be off with you." He turned and walked back to his house, muttering under his breath as he went.

"Time and place, time and place," Deotha shouted, banging the pot for emphasis. Hada, now quite deaf from the constant banging and haranguing, hardly noticed the pebbles anymore as they dropped from his mouth. He was far more concerned by the rumors drifting through the forest that a human child had been seen questioning everyone he met along his way. This would never do—really never do at all! What would become of them if the secret were to emerge? Deotha would have to be told. It wasn't a task Hada was looking forward to, but he decided that it must be faced, and sooner rather than later.

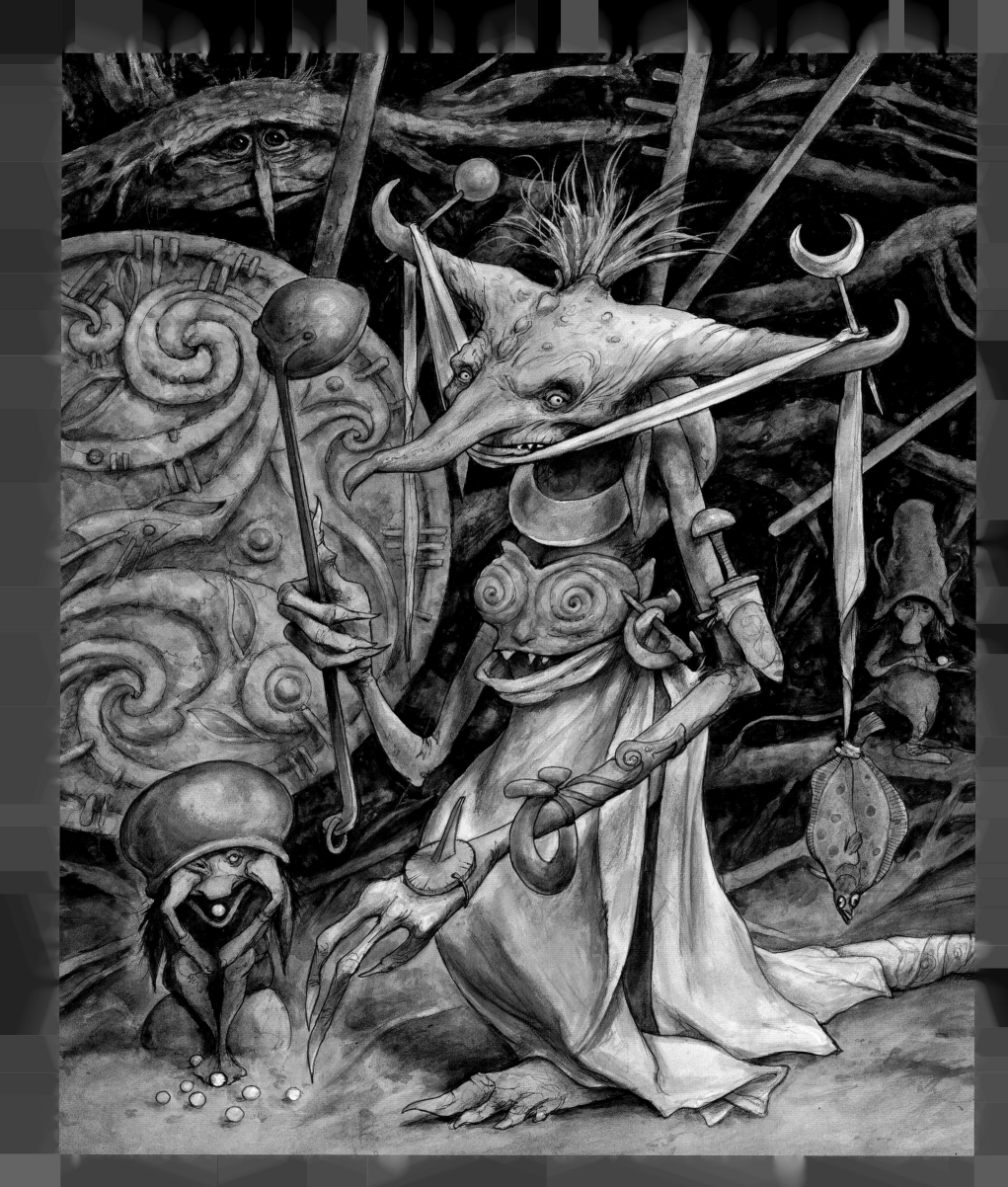

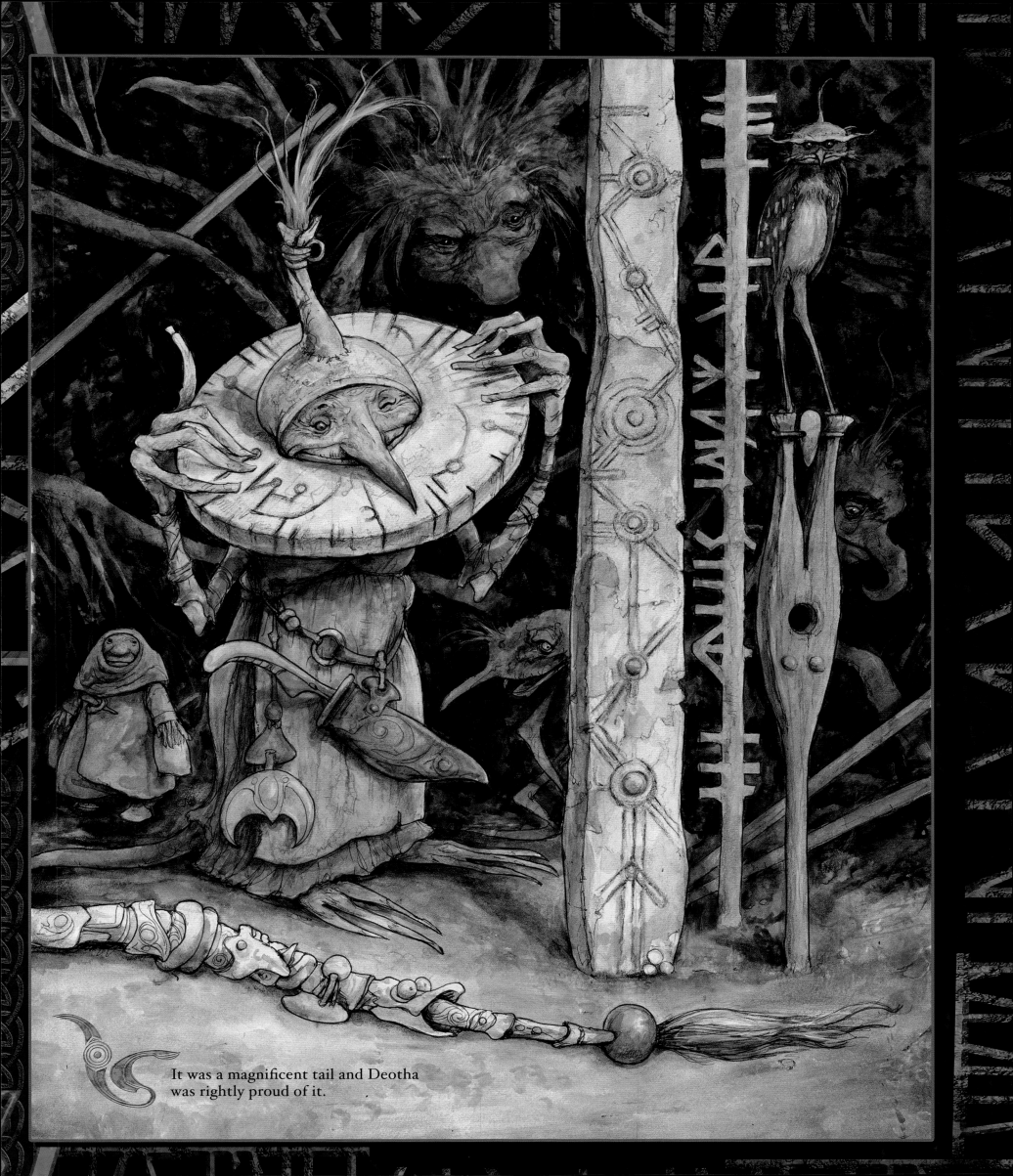

It was a magnificent tail and Deotha
was rightly proud of it.

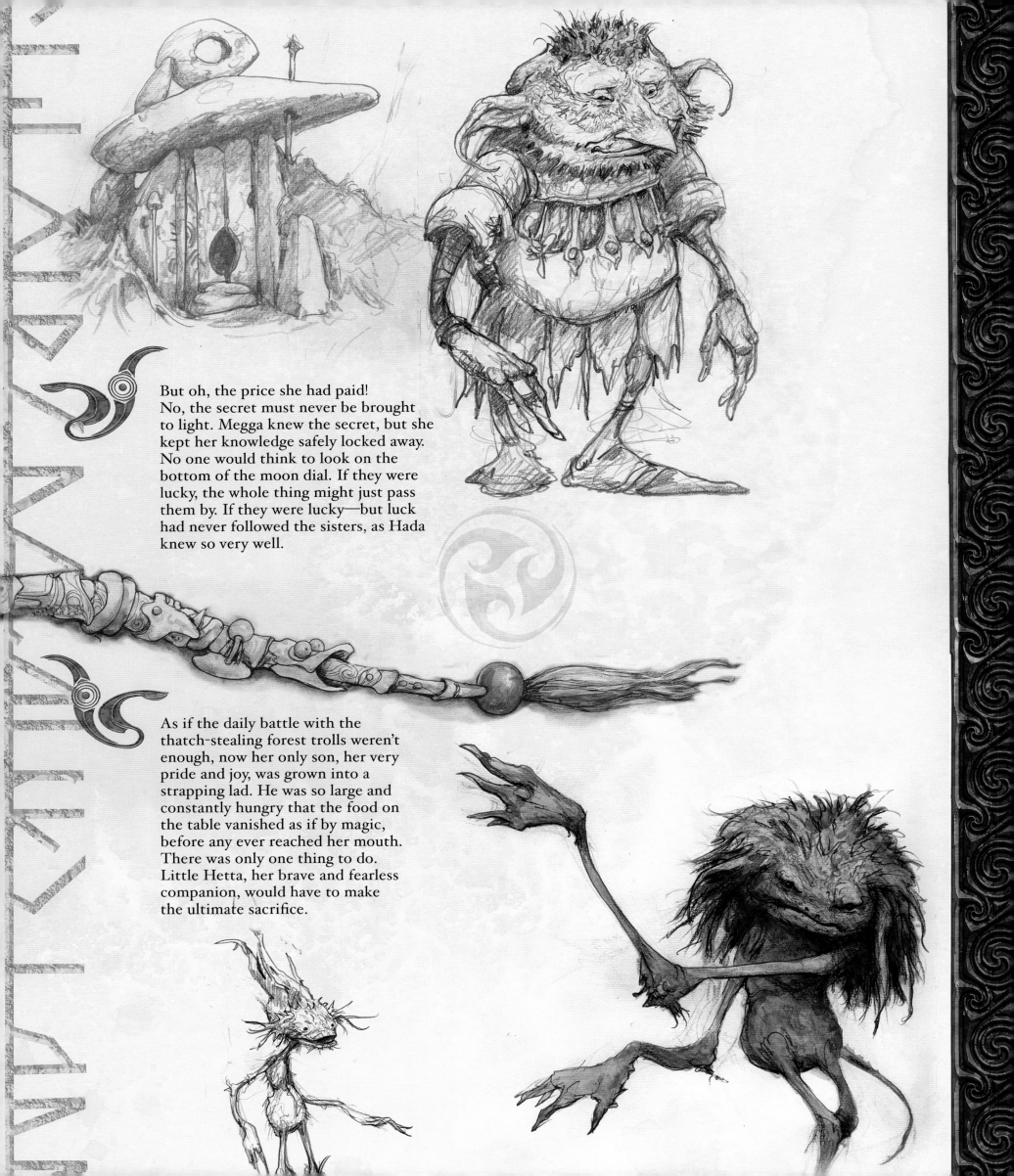

But oh, the price she had paid!
No, the secret must never be brought
to light. Megga knew the secret, but she
kept her knowledge safely locked away.
No one would think to look on the
bottom of the moon dial. If they were
lucky, the whole thing might just pass
them by. If they were lucky—but luck
had never followed the sisters, as Hada
knew so very well.

As if the daily battle with the
thatch-stealing forest trolls weren't
enough, now her only son, her very
pride and joy, was grown into a
strapping lad. He was so large and
constantly hungry that the food on
the table vanished as if by magic,
before any ever reached her mouth.
There was only one thing to do.
Little Hetta, her brave and fearless
companion, would have to make
the ultimate sacrifice.

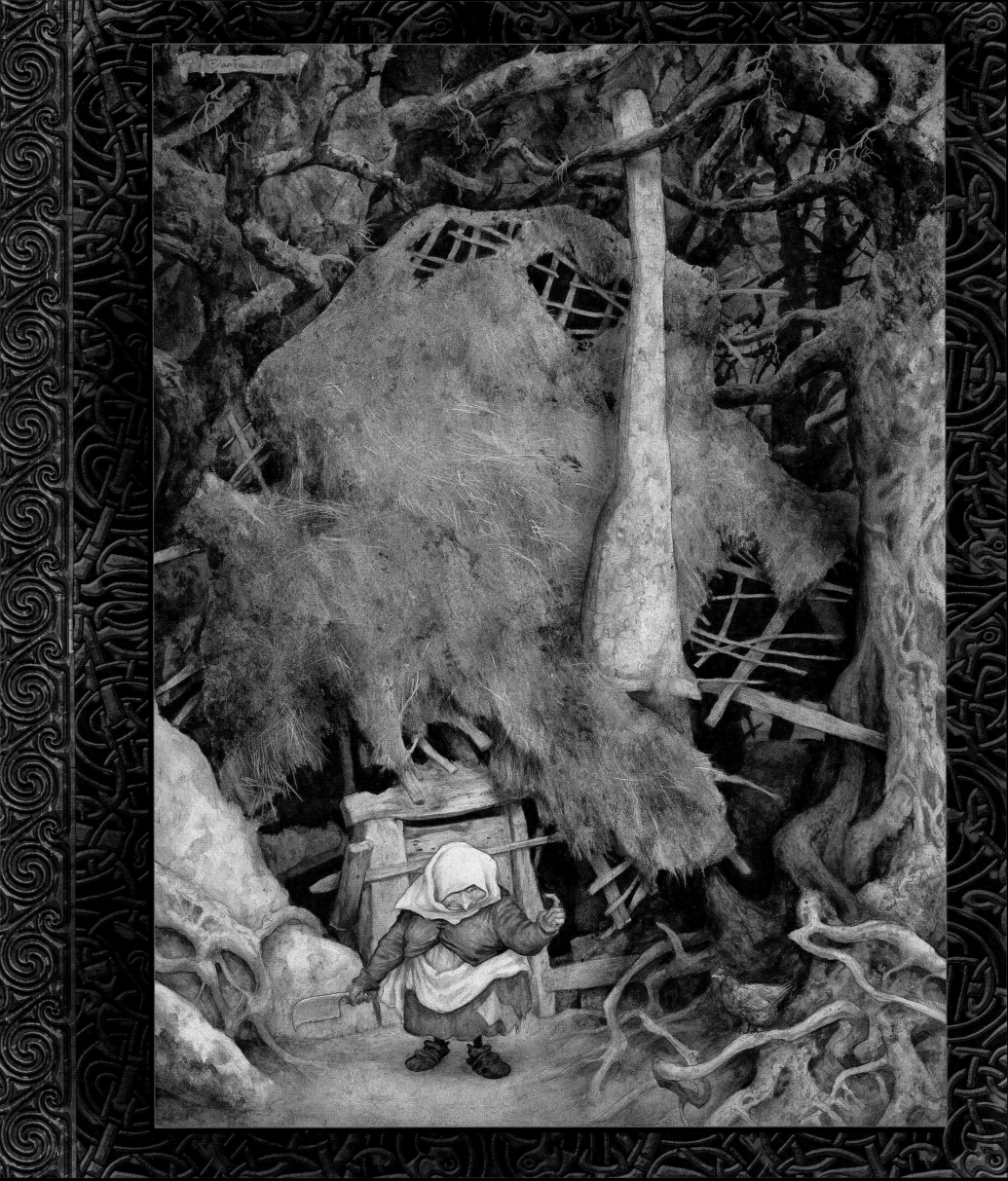

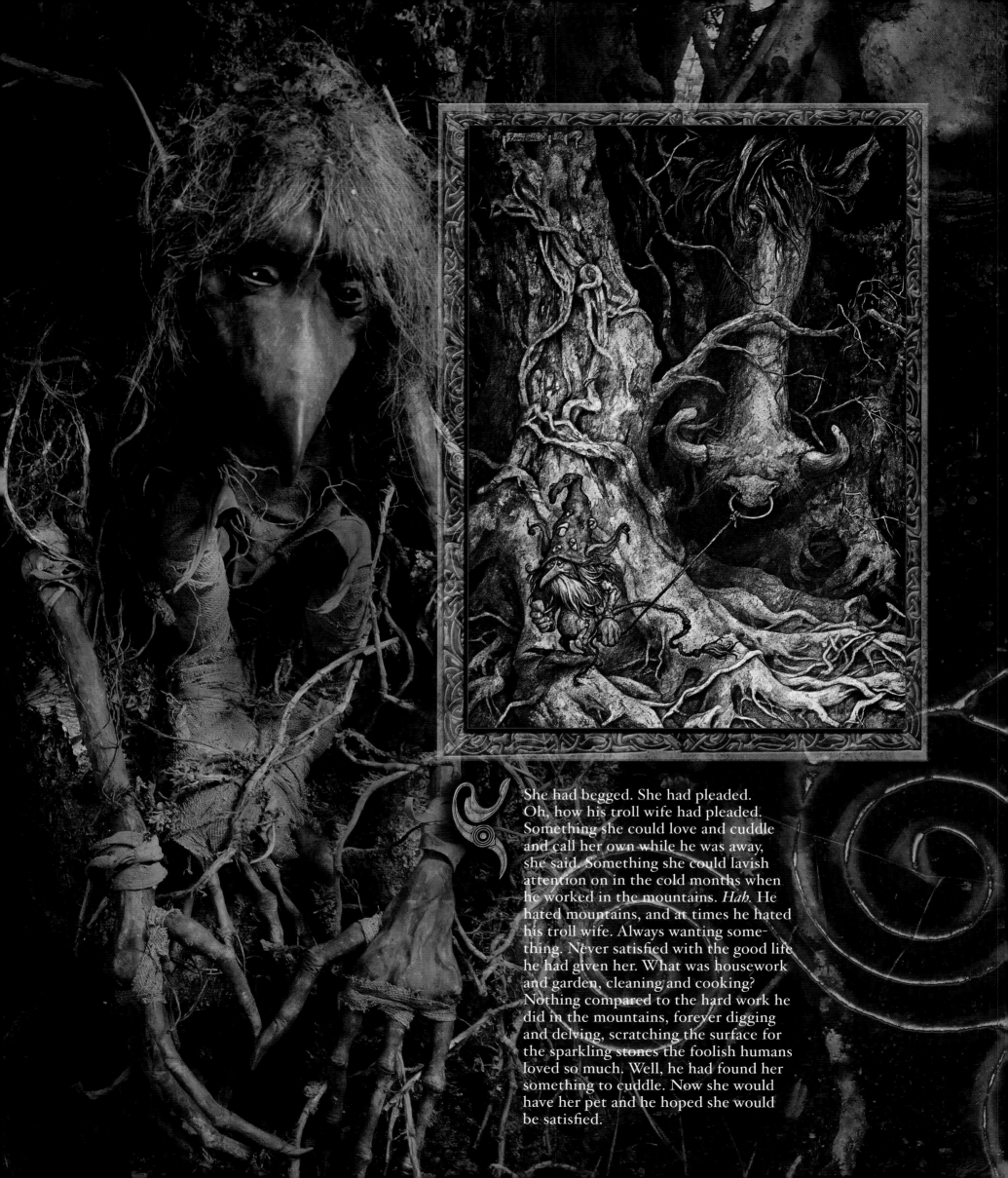

She had begged. She had pleaded.
Oh, how his troll wife had pleaded.
Something she could love and cuddle
and call her own while he was away,
she said. Something she could lavish
attention on in the cold months when
he worked in the mountains. *Hah.* He
hated mountains, and at times he hated
his troll wife. Always wanting some-
thing. Never satisfied with the good life
he had given her. What was housework
and garden, cleaning and cooking?
Nothing compared to the hard work he
did in the mountains, forever digging
and delving, scratching the surface for
the sparkling stones the foolish humans
loved so much. Well, he had found her
something to cuddle. Now she would
have her pet and he hoped she would
be satisfied.

The troll child sat,
And sat, and thought.
"How can I finish my task if the troll witches eat me?" he wondered aloud.
A voice by his feet said, "Maybe they won't."
The troll child looked down, and there, by his left foot,
The smallest troll he had ever seen
Stood looking up at him.

"Maybe they won't," the tiny troll said again.
"And maybe they will," said the troll child.
"True enough, but maybe, just maybe,
There's a way through the thorns
And a way through the marshland
And a way to the heart of a troll witch as well."

"And what would that be?" asked the troll child.
"All things long for something," said the tiny troll.
"All things have a place in their heart that is empty
And yearns to be filled.
All things wish and want and wait for an answer."

"I must ask them," said the troll child.
"I must ask what they yearn for,
And hope that they answer before I am eaten.
And if I can help them, a tale may be mine
For the asking."

"I'll go with you," said the tiny troll,
"I'm not afraid of troll witches,
Besides, I'm so tiny they'll never see me."
"Hah," said the troll child,
"You may be the size of a wren,
But I'd think you would hang on a black thorn
Just as easily as I would."

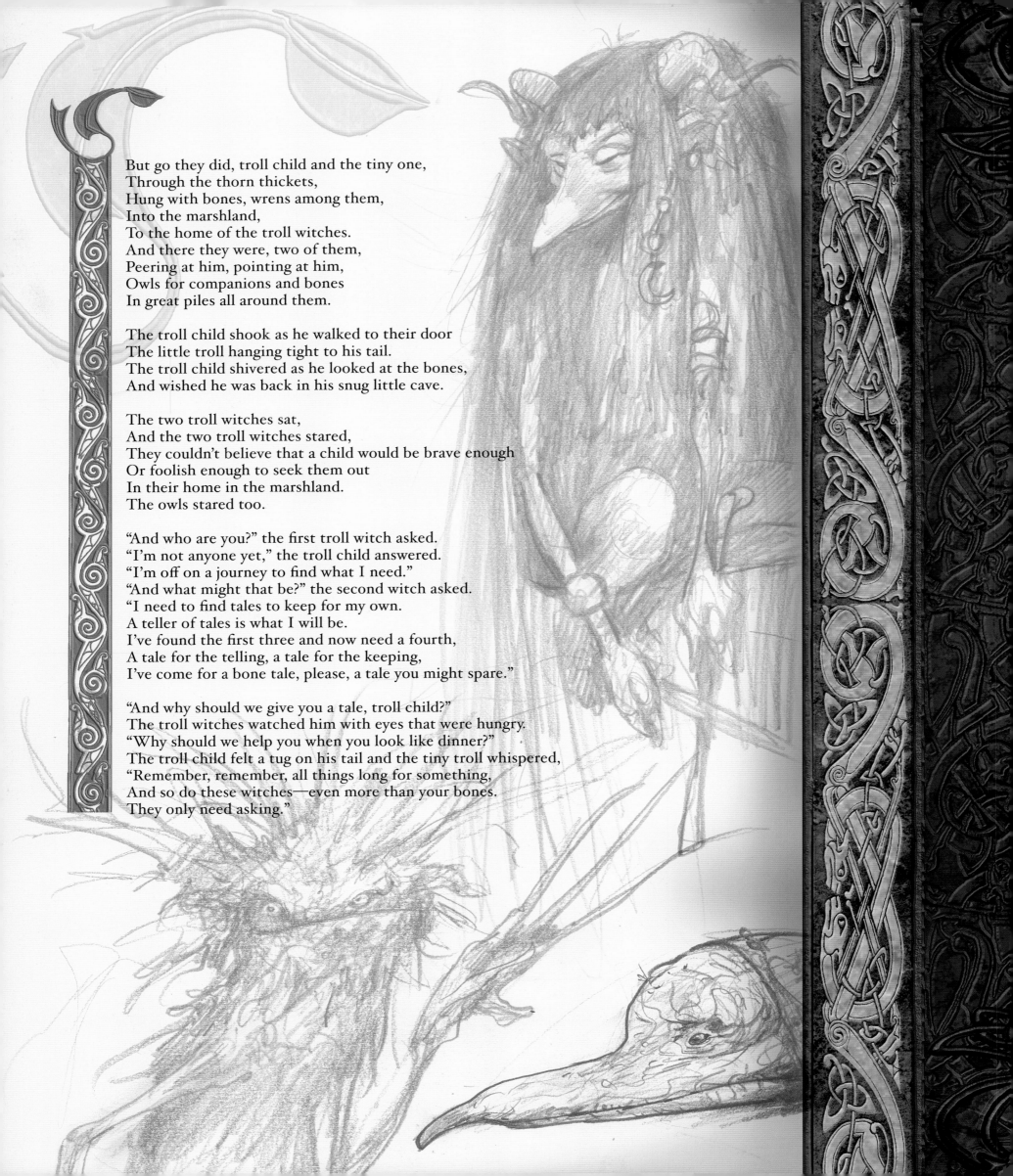

But go they did, troll child and the tiny one,
Through the thorn thickets,
Hung with bones, wrens among them,
Into the marshland,
To the home of the troll witches.
And there they were, two of them,
Peering at him, pointing at him,
Owls for companions and bones
In great piles all around them.

The troll child shook as he walked to their door
The little troll hanging tight to his tail.
The troll child shivered as he looked at the bones,
And wished he was back in his snug little cave.

The two troll witches sat,
And the two troll witches stared,
They couldn't believe that a child would be brave enough
Or foolish enough to seek them out
In their home in the marshland.
The owls stared too.

"And who are you?" the first troll witch asked.
"I'm not anyone yet," the troll child answered.
"I'm off on a journey to find what I need."
"And what might that be?" the second witch asked.
"I need to find tales to keep for my own.
A teller of tales is what I will be.
I've found the first three and now need a fourth,
A tale for the telling, a tale for the keeping,
I've come for a bone tale, please, a tale you might spare."

"And why should we give you a tale, troll child?"
The troll witches watched him with eyes that were hungry.
"Why should we help you when you look like dinner?"
The troll child felt a tug on his tail and the tiny troll whispered,
"Remember, remember, all things long for something,
And so do these witches—even more than your bones.
They only need asking."

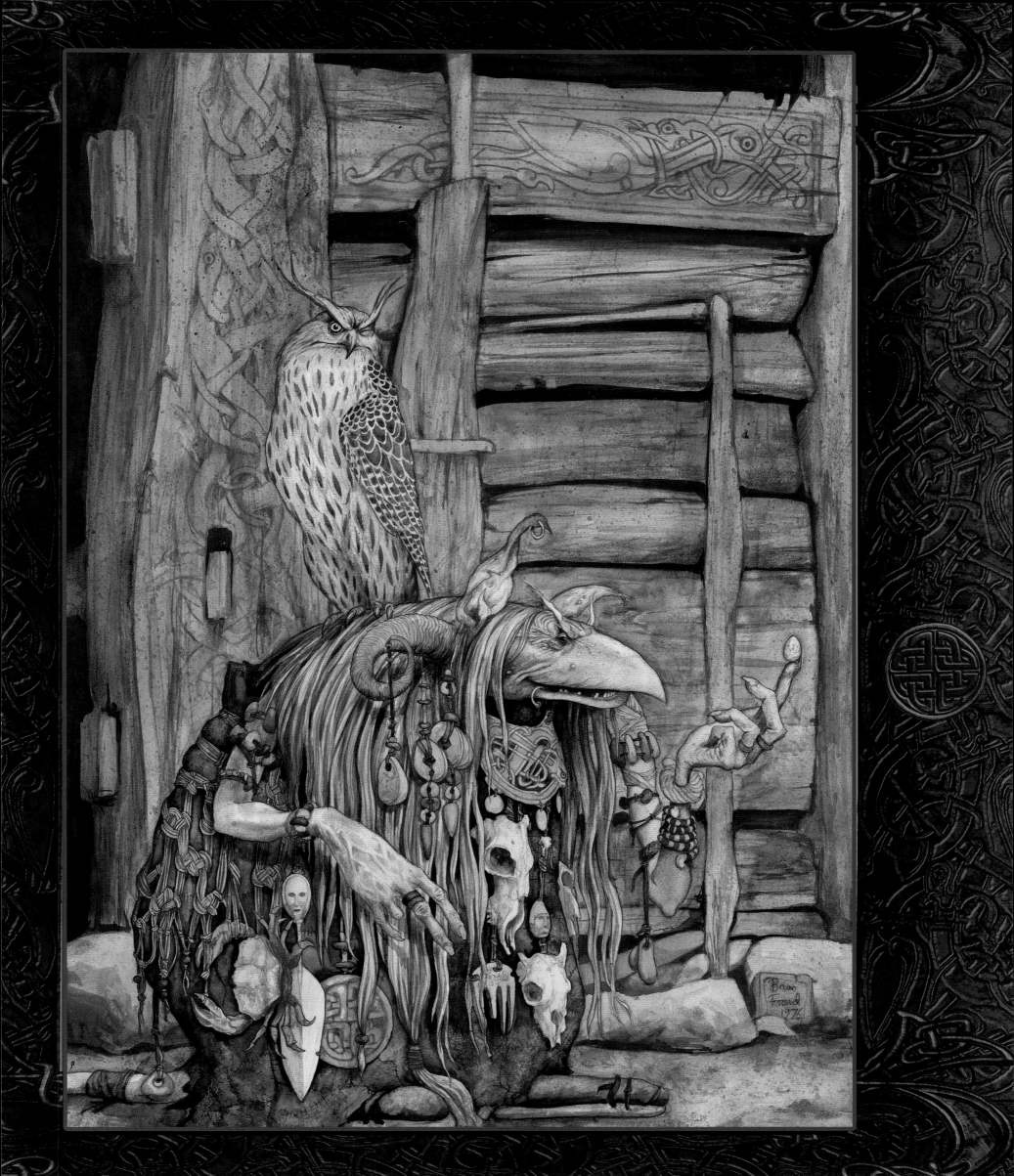

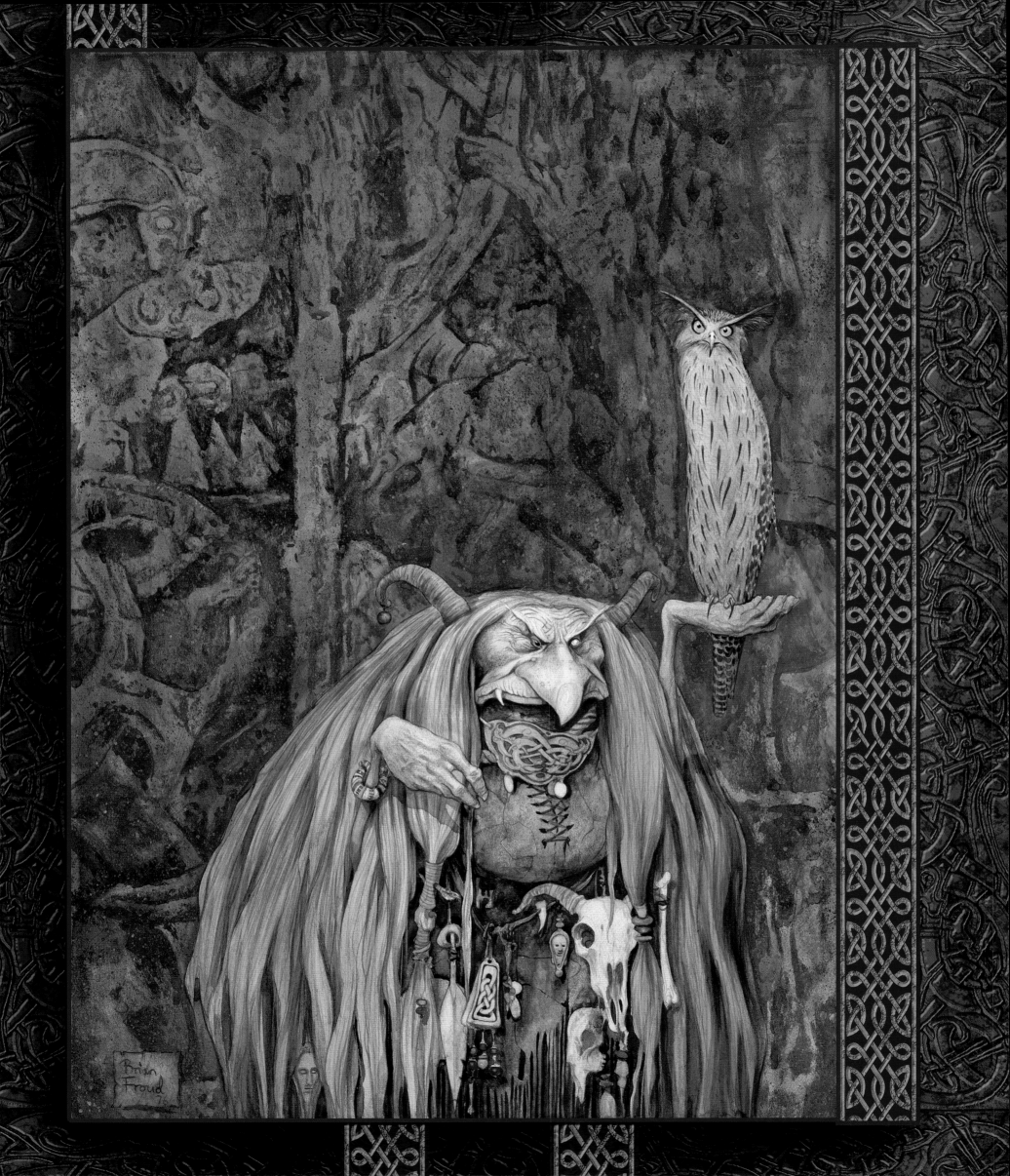

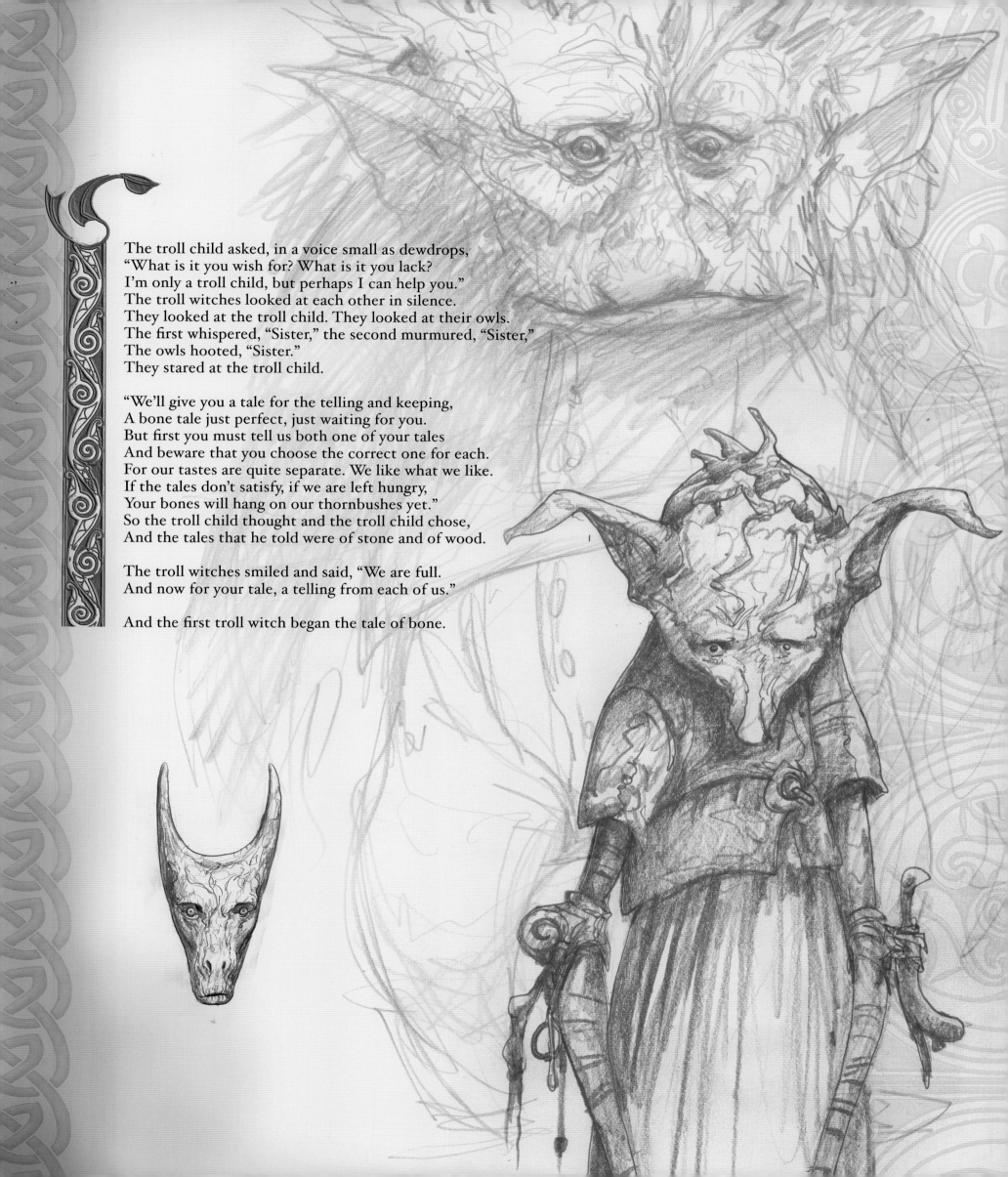

The troll child asked, in a voice small as dewdrops,
"What is it you wish for? What is it you lack?
I'm only a troll child, but perhaps I can help you."
The troll witches looked at each other in silence.
They looked at the troll child. They looked at their owls.
The first whispered, "Sister," the second murmured, "Sister,"
The owls hooted, "Sister."
They stared at the troll child.

"We'll give you a tale for the telling and keeping,
A bone tale just perfect, just waiting for you.
But first you must tell us both one of your tales
And beware that you choose the correct one for each.
For our tastes are quite separate. We like what we like.
If the tales don't satisfy, if we are left hungry,
Your bones will hang on our thornbushes yet."
So the troll child thought and the troll child chose,
And the tales that he told were of stone and of wood.

The troll witches smiled and said, "We are full.
And now for your tale, a telling from each of us."

And the first troll witch began the tale of bone.

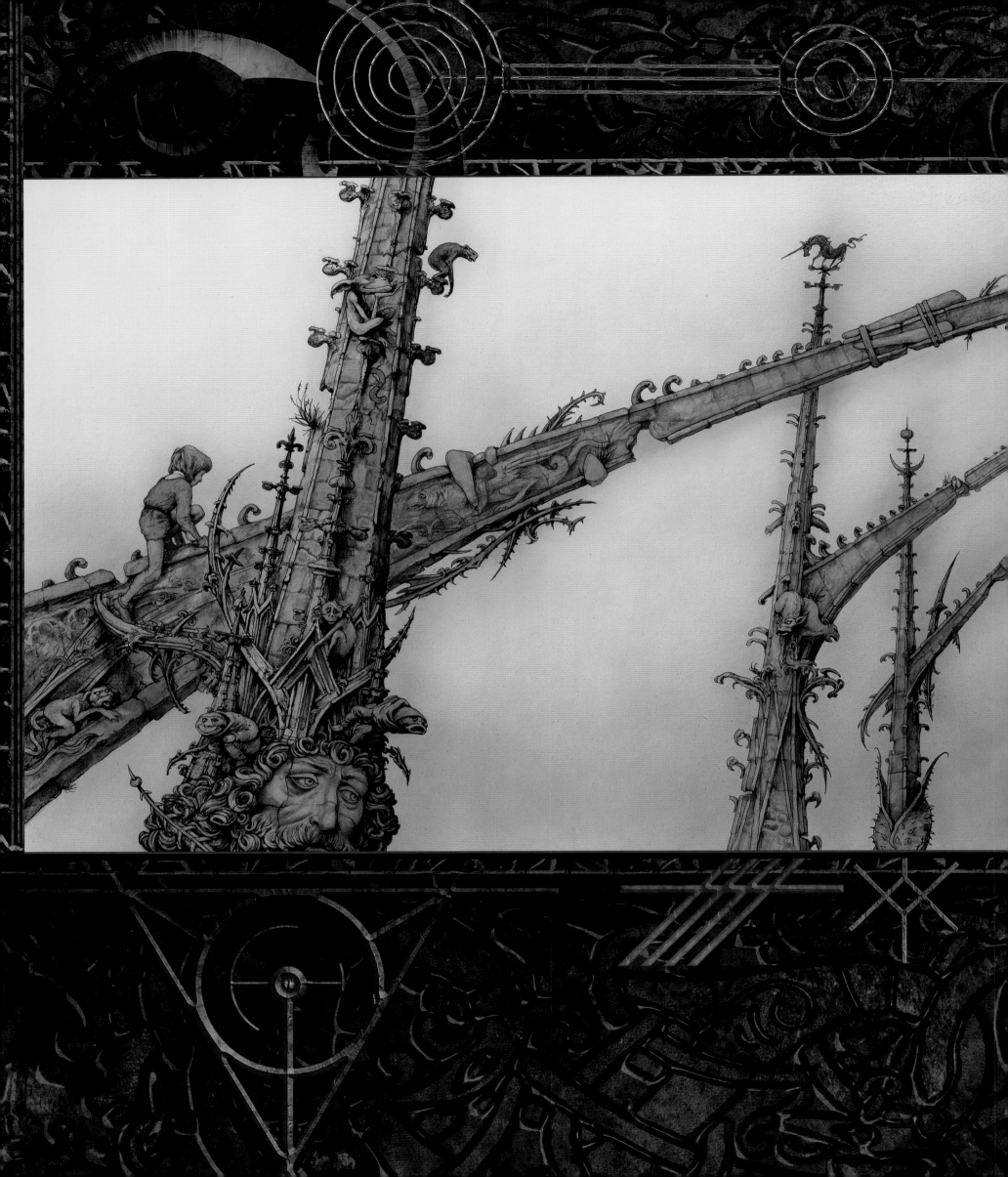

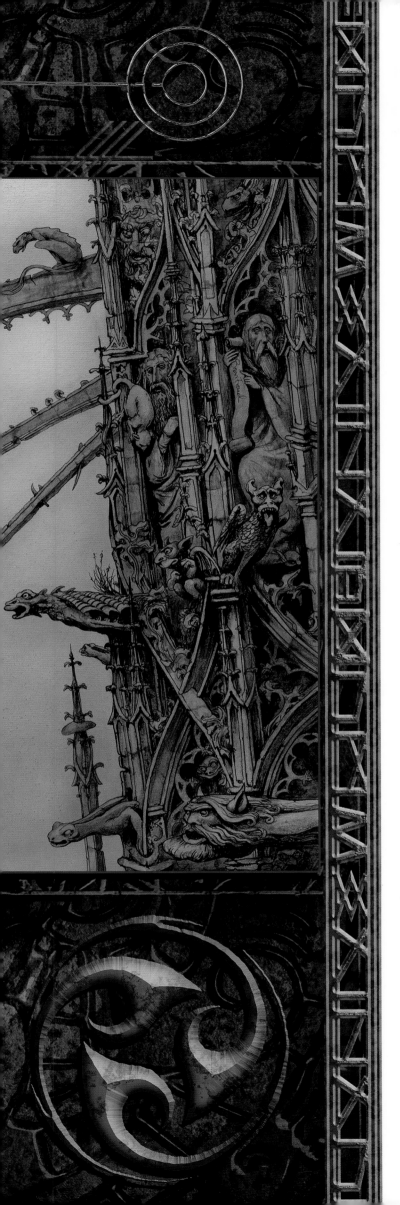

The Tale of Bone

The Red-Haired Boy

ONCE LONG AGO, OR PERHAPS only yesterday, there was a Red-Haired Boy—a human boy—a boy from beyond the edge of the world. This boy lived in what the humans called a city, and at the center of this city the biggest building the humans had ever seen was being built, slowly rising toward the sky. It was called a cathedral. It was the house of God. Strange as it might seem to trolls, the god of the humans lived in huge dwelling places that had been especially built for that purpose. And the more the building was decorated and decked in fine stone carvings, the more important that dwelling place was.

The Red-Haired Boy had a fine and talented father. Indeed he was the finest stonemason in all the land, and it was his responsibility to make sure that the stone—the stone hewn and cut, lifted from deep within the earth itself—was carved and shaped and turned into magnificent creatures never before seen in that world. The father was a proud and hard man, and the Red-Haired Boy—whose name was Will—worshipped him and wished to be just like him. There was only one problem: Will was lazy when it came to stone and never spent time learning the trade of a stonemason, let alone the skills it took to become a great sculptor. He could read and write, draw and figure, all thanks to the monks who had taught him well—but for all that he loved his father's sculptures, it was the final result, far more than the time spent achieving it, that appealed to Will.

But what Will *did* like to do was observe—and the place that Will chose to do this was the cathedral rooftop, amongst the flying buttresses and the fantastical creatures carved there. Every day Will could be found astride a great outstretched arm of stone, sketching what he saw from his rooftop aerie, writing down his impressions of all that was spread out below him, for Will was a recorder of things. He kept a sheaf of parchment (stolen from the cathedral architect's table) to write and draw and record everything he saw. Still, what he truly wished to be was a carver of stone. He just didn't have the patience to learn.

One day, Will was again nestled in the stone arms of the flying buttresses when he looked far, on to the horizon. This was a horizon he had stared at hundreds of times—a horizon broken by great mounds of rock called tors, rising from the moorland that surrounded the city. On this particular day, with the sun low in the sky, casting beams of light down the great stone arms, Will looked along a buttress, straight as an arrow, right through the hole in the carved finial at the end of it. Through this little hole he saw a shimmer of something strange on the rocks and tors in the distance. What this was, Will had no idea, but being curious (and determined to prove he wasn't just a lazy dreamer as his father thought), he decided to follow his fortune all the way to the moor and the rocks and the shimmering tor and not to come home until he had discovered what there was to discover.

And the second troll witch then took up the tale and added her voice:

Will walked and walked over the farmlands and heath lands and moorlands until he found what he was looking for, and of course what he found was the edge of the human world and the edge of the Otherworld all bound up together in a shimmer as thin as a breath, that divided them one from the other. Will stepped over and between and through the shimmer until he emerged like a butterfly in the Otherworld—the green world of moss and rocks, trees and grasses, rivers, streams, moors, and marshlands. This new land delighted Will and he quickly made friends with everyone he met, and he met many creatures—trolls and goblins, faeries and sylphs—but trolls . . . well, trolls were the most wonderful and wondrous of all.

Trolls—creatures of wood and stone, bone and feather—appreciated and loved the nature of things just as Will did. The trolls were happy to share everything they knew, delighted that a human boy could understand and enjoy the things they themselves did. So Will recorded all that they told and showed him. He drew their pots and pans, their clothing and houses, their collec-

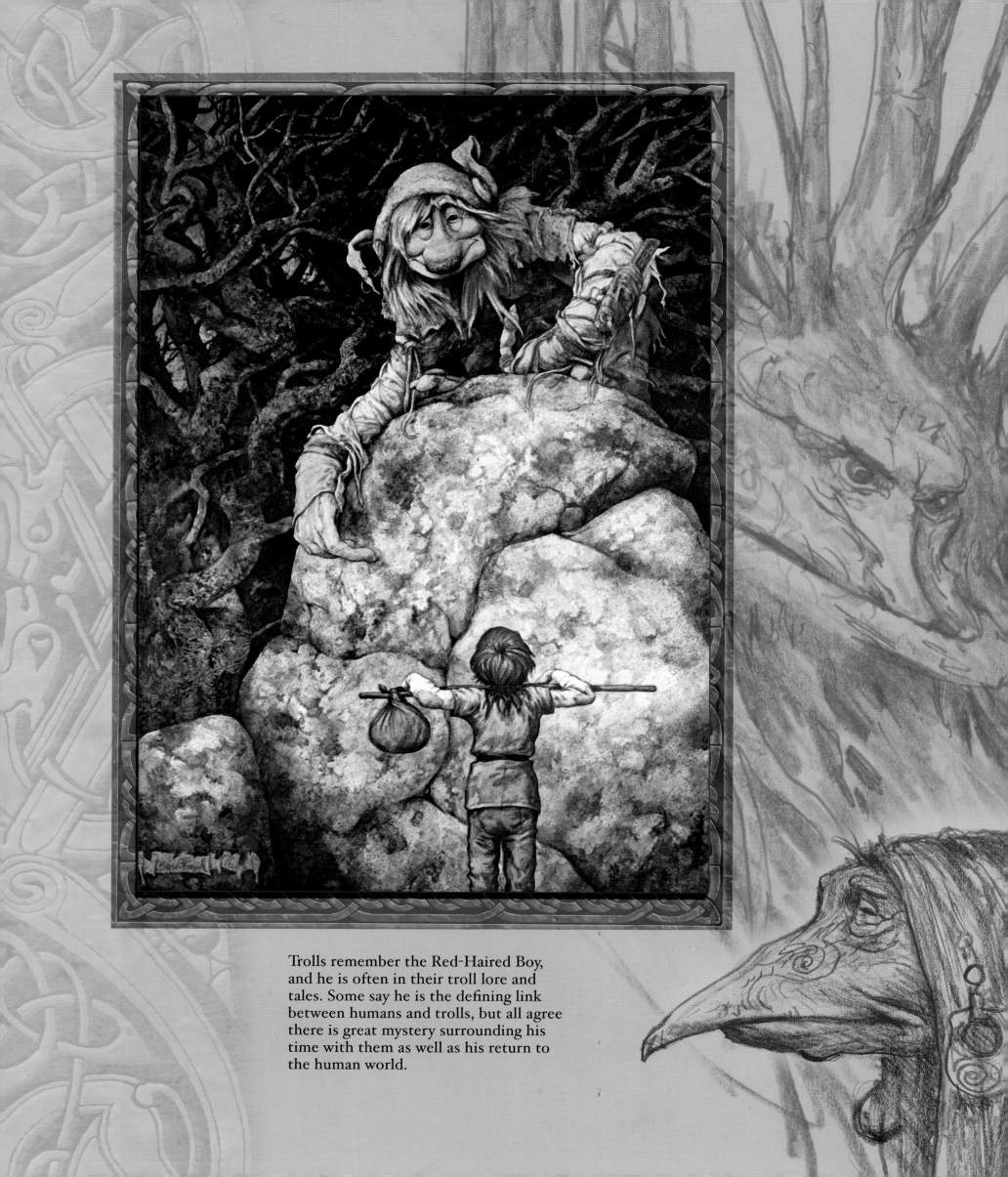

Trolls remember the Red-Haired Boy, and he is often in their troll lore and tales. Some say he is the defining link between humans and trolls, but all agree there is great mystery surrounding his time with them as well as his return to the human world.

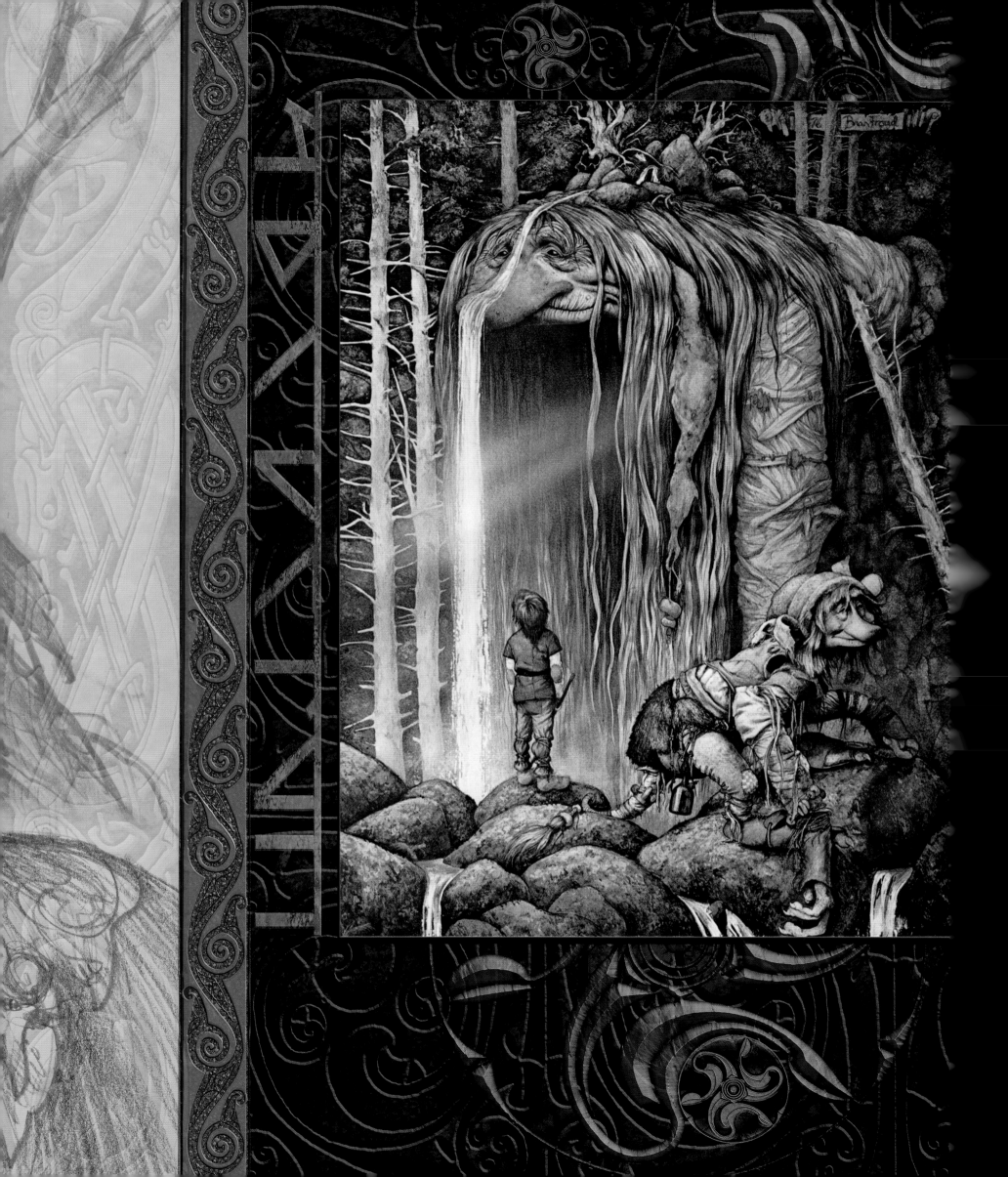

tions and hoardings. He drew them all. And then he wrote about their dreams and songs, their tales and tellings, their ins and outs. Everything. Will wrote it all down—sketched it all out—and the trolls, being tellers of tales and Keepers of Secrets and Wisdom, shared what they knew with Will, the Red-Haired Boy, their very own human!

Will spent long hours listening and watching, and sometimes, not often but occasionally, he picked up a troll object and quietly placed it in his bundle until that bundle was full to bursting. He never thought of this as stealing, for he took only small things—things he knew the trolls wouldn't miss and things that looked like nothing so much as a bunch of twigs, a stone with a hole in it, or a few feathers tied with red cord. Well, the trolls didn't notice, and perhaps even if they did, they overlooked his stealing because they enjoyed his company so very much. For you see, trolls love the lightness and quickness of humans. It isn't the lightness of the faeries or sprites; it isn't the nimbleness of elves or goblins. It is something quite, quite different, and that very difference, that "humanness," was what attracted the trolls.

Will could make the young trolls laugh and they loved him for it. Capering and singing, he danced circles around his young friends. He could mimic the fusty old trolls who lived in the hills and he could imitate the strange troll witches who lived in the marshes. Will became the beloved leader of three young trolls of the moor, encouraging them to secretly tease and taunt the elders as he did, all in fun, of course. And so they did— teasing and taunting and laughing as the young will do. The three young trolls soon became as bold as Will himself, taunting and teasing the troll witches and especially the one-eyed troll witch who lived with her two sisters in the marshlands.

Now, the old troll witch soon tired of their mimicry and decided to teach both Will and the young trolls a well-deserved lesson. She found Will alone one day and began to fill his head with ideas. She told him secrets and gave him advice, and finally, when she had him hooked well and truly like a brown trout, she offered him a gift.

"Come to me when the moon is full and I'll give you something to fulfill your dearest dream." Will's dearest dream was to be the most famous sculptor in all the man lands (without having to work for it), and if the troll witch could help him achieve this, then he would willingly come to her on the full moon. And so he did.

Will met the troll witch in a clearing close to where his three young troll friends waited, and when he arrived, she stepped aside, revealing an enormous hunting horn. "Will," she said, "when you blow this horn, any troll who hears it will willingly follow you wherever you wish to go—even into the man lands, for it is time for you to return and become all you CAN become and do all you NEED to do to fulfill your dream." She looked hard at Will, and as he looked in her eyes, he understood exactly what she meant by these words. She put her fingers in her ears and he blew the horn and the three young trolls appeared.

Will smiled and said, "Follow me, my friends," and the Red-Haired Boy and the three young trolls walked out of the Otherworld and into the man lands and never returned.

"But the tale is unfinished," the troll child said. "I can't tie this tale on if I don't know the ending."

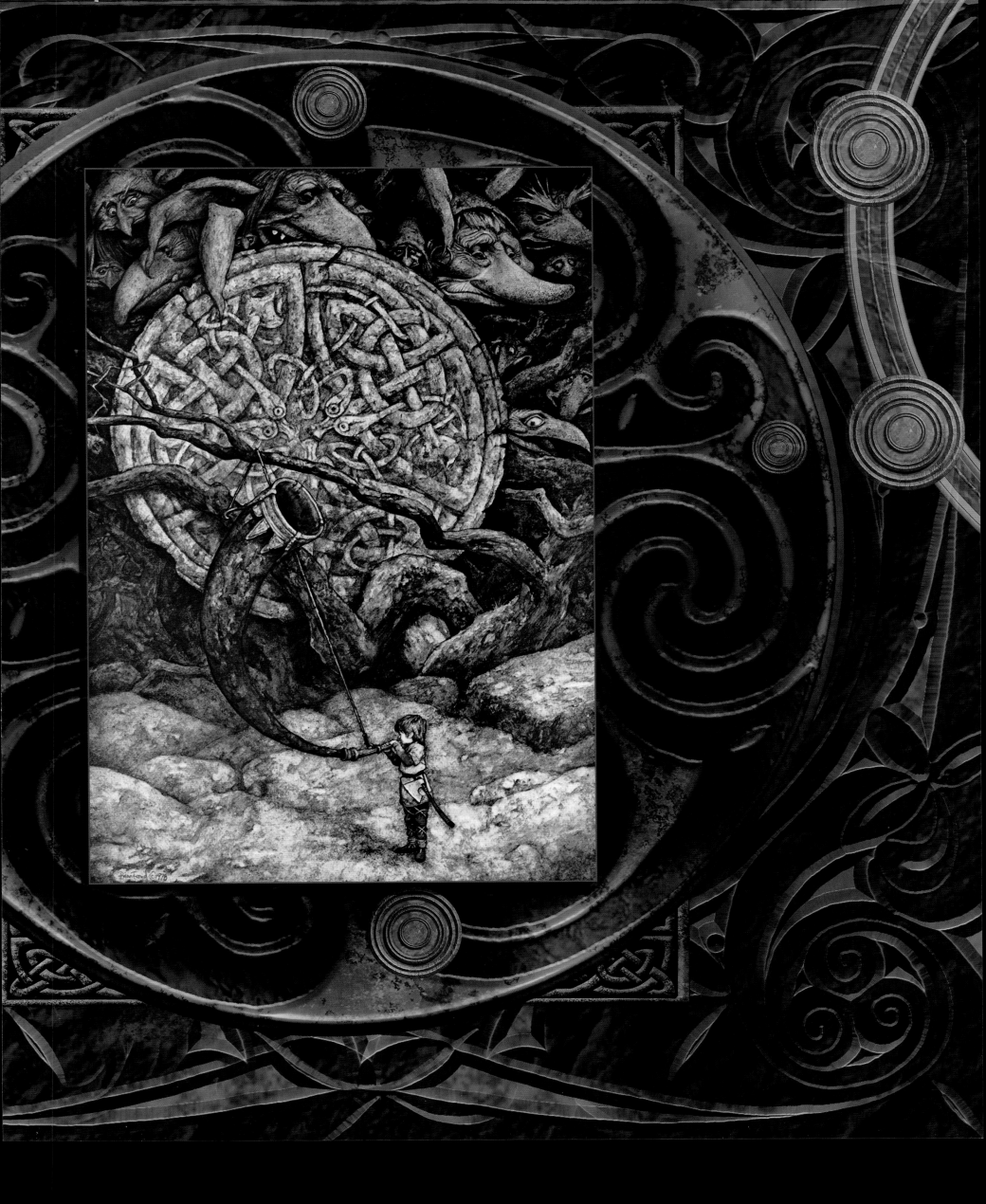

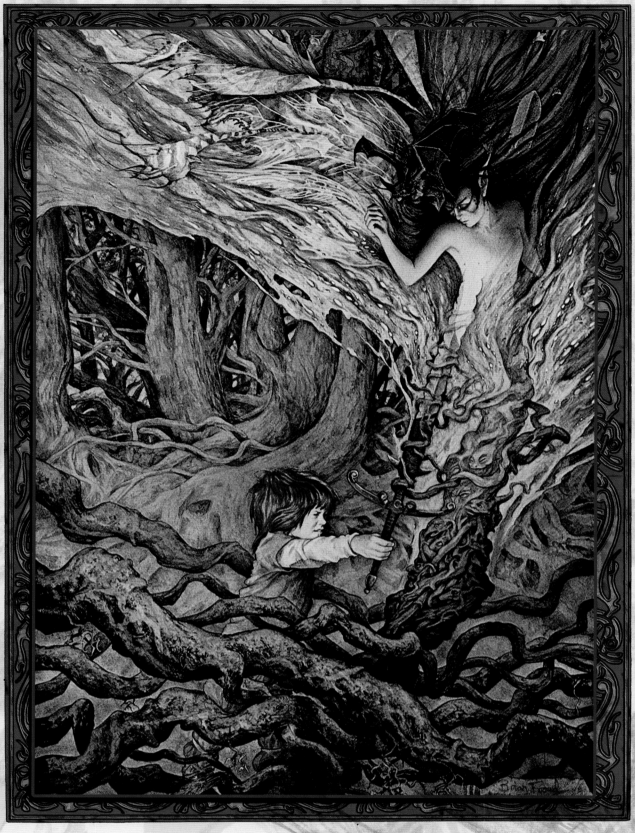

 The sword was far too big for him, and as he staggered under the weight of it, it seemed to take on a life of its own, slashing through the vine-covered tree with the lightness of a feather. With the first stroke he heard a great crack and the tree shivered and split, releasing—what? The Red-Haired Boy knew it wasn't a troll, but before he could actually see what it was, it disappeared in a gust of wind and a swirl of magic.

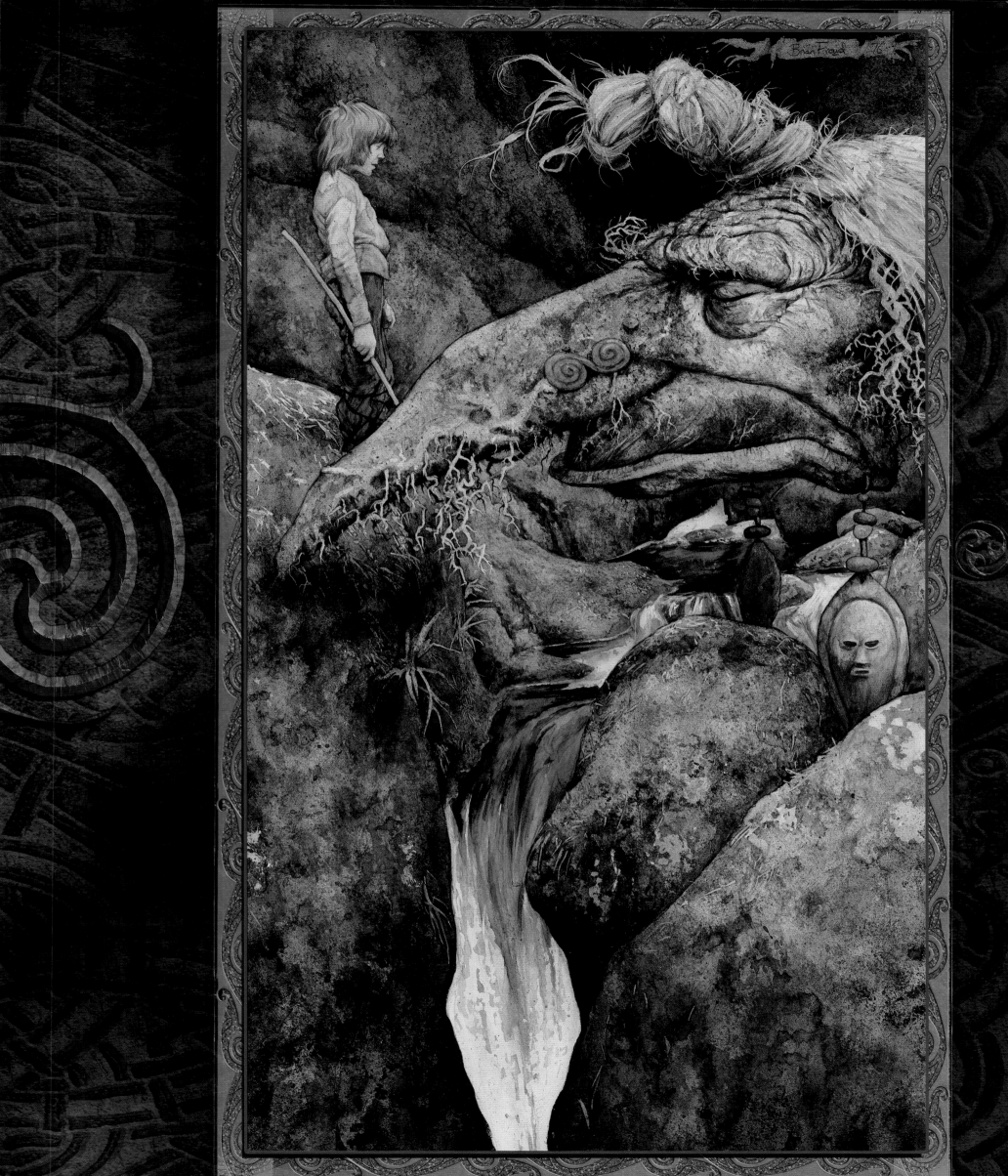

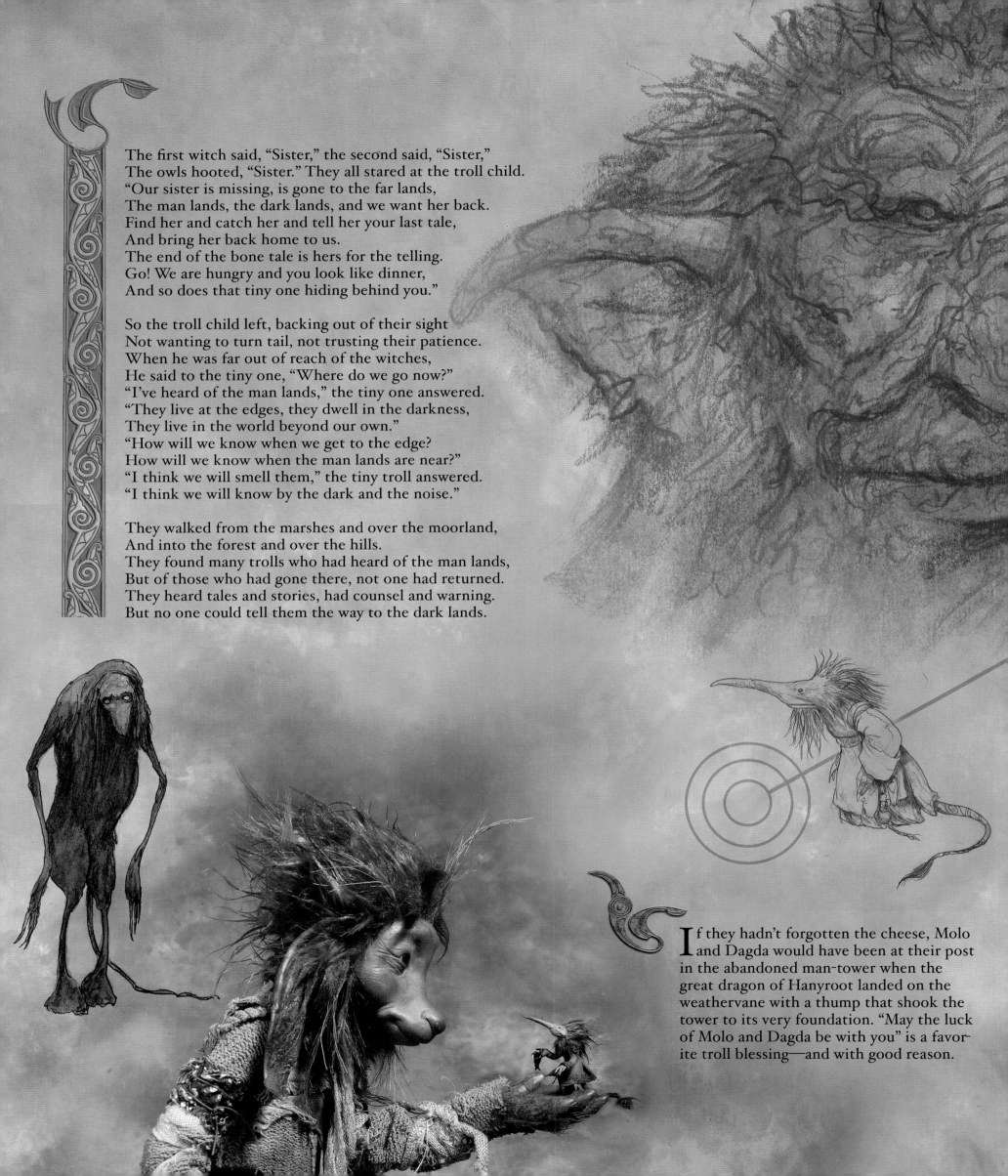

The first witch said, "Sister," the second said, "Sister,"
The owls hooted, "Sister." They all stared at the troll child.
"Our sister is missing, is gone to the far lands,
The man lands, the dark lands, and we want her back.
Find her and catch her and tell her your last tale,
And bring her back home to us.
The end of the bone tale is hers for the telling.
Go! We are hungry and you look like dinner,
And so does that tiny one hiding behind you."

So the troll child left, backing out of their sight
Not wanting to turn tail, not trusting their patience.
When he was far out of reach of the witches,
He said to the tiny one, "Where do we go now?"
"I've heard of the man lands," the tiny one answered.
"They live at the edges, they dwell in the darkness,
They live in the world beyond our own."
"How will we know when we get to the edge?
How will we know when the man lands are near?"
"I think we will smell them," the tiny troll answered.
"I think we will know by the dark and the noise."

They walked from the marshes and over the moorland,
And into the forest and over the hills.
They found many trolls who had heard of the man lands,
But of those who had gone there, not one had returned.
They heard tales and stories, had counsel and warning.
But no one could tell them the way to the dark lands.

If they hadn't forgotten the cheese, Molo
and Dagda would have been at their post
in the abandoned man-tower when the
great dragon of Hanyroot landed on the
weathervane with a thump that shook the
tower to its very foundation. "May the luck
of Molo and Dagda be with you" is a favor-
ite troll blessing—and with good reason.

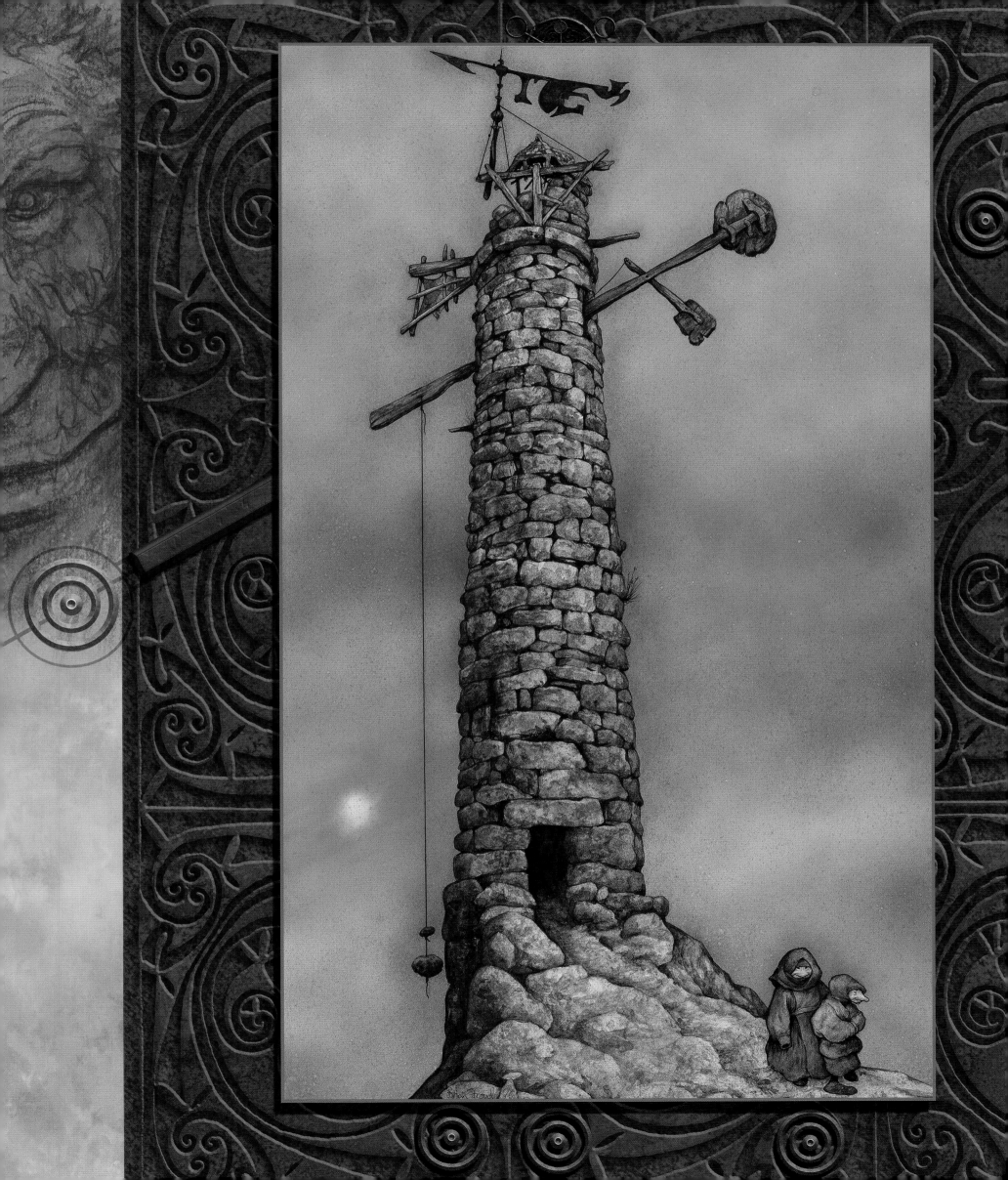

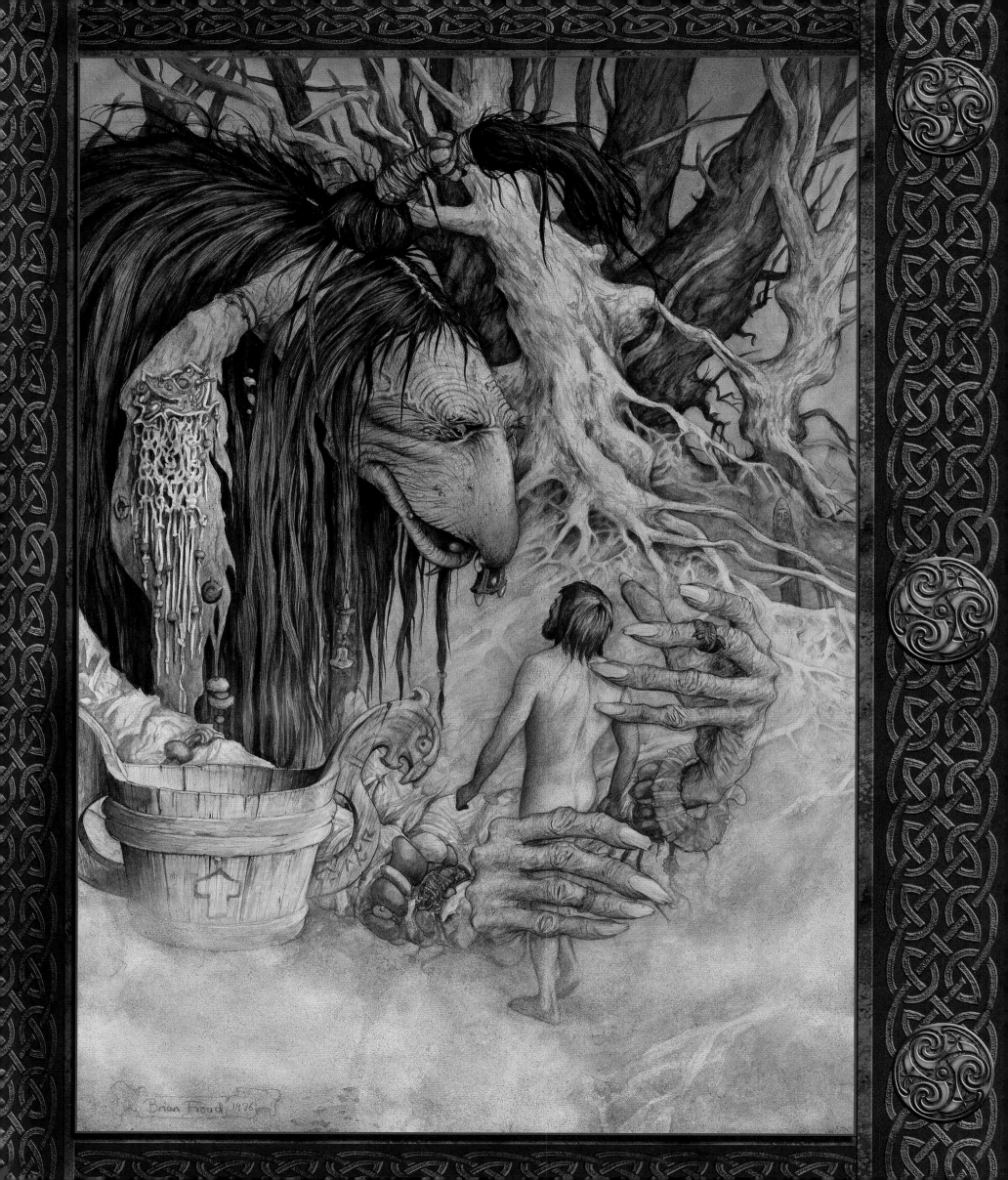

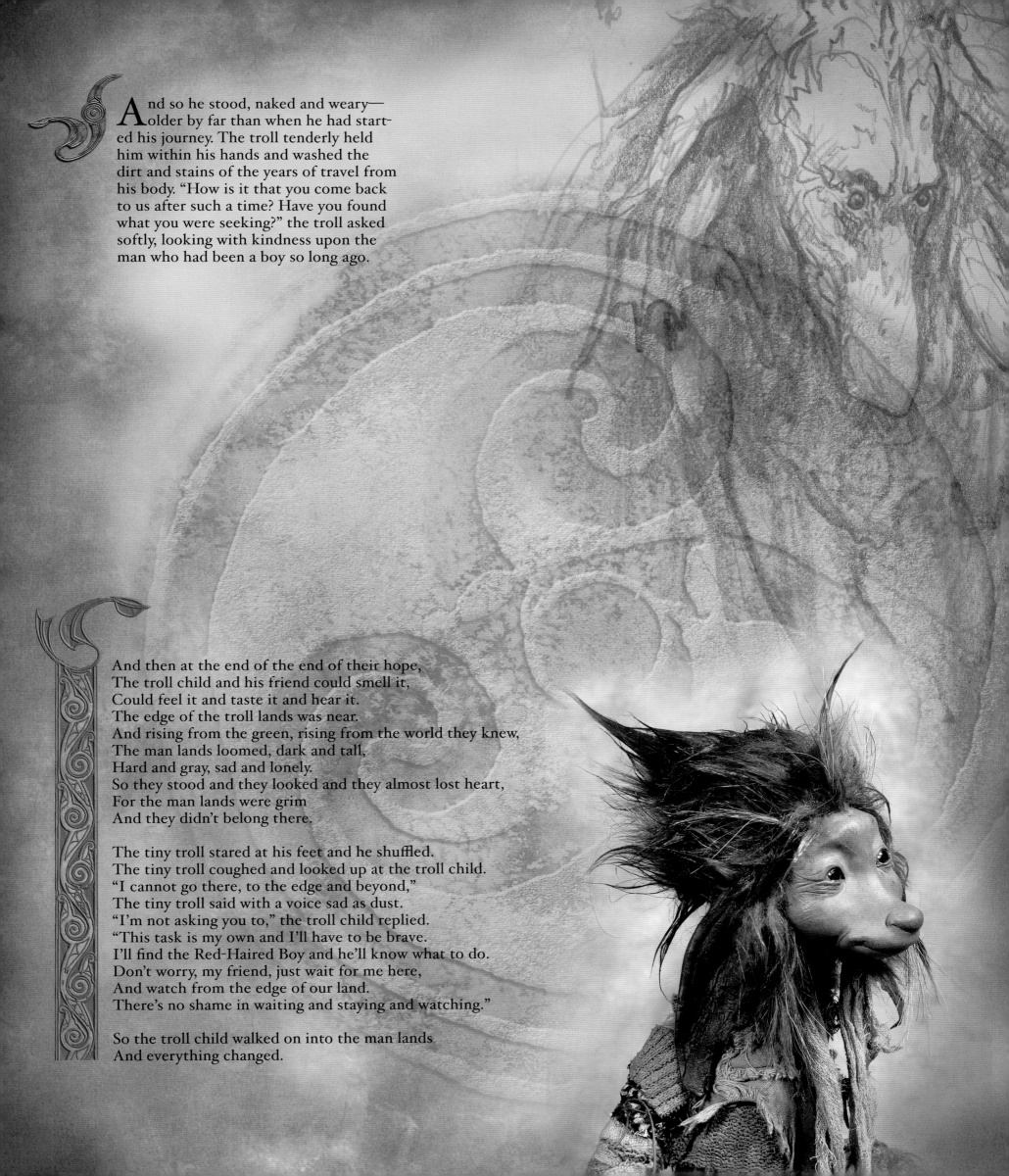

And so he stood, naked and weary—older by far than when he had started his journey. The troll tenderly held him within his hands and washed the dirt and stains of the years of travel from his body. "How is it that you come back to us after such a time? Have you found what you were seeking?" the troll asked softly, looking with kindness upon the man who had been a boy so long ago.

And then at the end of the end of their hope,
The troll child and his friend could smell it,
Could feel it and taste it and hear it.
The edge of the troll lands was near.
And rising from the green, rising from the world they knew,
The man lands loomed, dark and tall,
Hard and gray, sad and lonely.
So they stood and they looked and they almost lost heart,
For the man lands were grim
And they didn't belong there.

The tiny troll stared at his feet and he shuffled.
The tiny troll coughed and looked up at the troll child.
"I cannot go there, to the edge and beyond,"
The tiny troll said with a voice sad as dust.
"I'm not asking you to," the troll child replied.
"This task is my own and I'll have to be brave.
I'll find the Red-Haired Boy and he'll know what to do.
Don't worry, my friend, just wait for me here,
And watch from the edge of our land.
There's no shame in waiting and staying and watching."

So the troll child walked on into the man lands
And everything changed.

When the troll child took the first step between the worlds—from his world to ours—everything he knew tilted sideways and inside out. Everything he thought he knew grew gray and fuzzy and his head felt like it had been wrapped in hay and muffled until he could no longer hear the sounds that meant home to him. He could no longer hear the trees whispering gently to one another and the grasses laughing in skittish waves. The rocks and hills were silent. No tales were whispered in the air. No songs floated on the wind. The man lands had no voice. At least that was how he felt as he walked farther in to the gray world that spread out before him in a strange and towering landscape.

The troll child was used to seeing a cottage or farm every once in a while—those dwellings straddled the worlds and were at home in both—but here the buildings were taller than trees, taller than hills, cold and hard. There were people walking in this dark and muffled land—lots and lots of people. The troll child walked among them as invisible as a thought. They could no more see him than they could hear the trees talking or see the faery folk dancing on the flowers.

But as the troll child walked he realized that HE could still hear and see those familiar beings—just—if he really tried. Faintly, faintly the sound of the world he knew came back to him as he walked on. It was a comfort to know that even if it was so terribly distant, it was still possible to hear and see the things he knew and loved. He just had to look harder and listen more carefully. And the people? They never looked or listened at all, never knew that there was anything else to hear besides the roar and growl of the man lands. He wandered from one street to the next, whispering to himself the tales he carried as he went—and as he passed close to the humans, some of them stopped and lifted their heads as if hearing a faint and distant song on the wind . . . and when they walked on, it was with a lighter step and a smile on their faces, although they wouldn't have been able to say why that was.

As the troll child walked, he looked at the people passing him so quickly on the gray streets and pavements—all colors and shapes and sizes they were, with hair in a hundred shades—red included—but none of them was the Red-Haired Boy from the troll lands. Where to find him? What to do? Then, as he looked and watched, invisible to everyone, he felt someone looking back at him, someone small who was sitting on the steps of the tall building nearest him.

The small person stared at the troll child. The troll child stared back. The small person was certainly human (the troll child could tell as much) and seemed to be a girl. She had black, tangled hair that streamed down her back and looked very much like it had twigs and feathers in it, and that was a comfort to the troll child. She was watching him in a most serious way, as though she wasn't quite sure if she wanted to speak.

The troll child stepped closer and smiled just a little. Slowly the girl stood up and took a step toward him. They were of a similar height, and standing nose to nose, they could look into each other's eyes. "Can you see me?" the troll child asked.

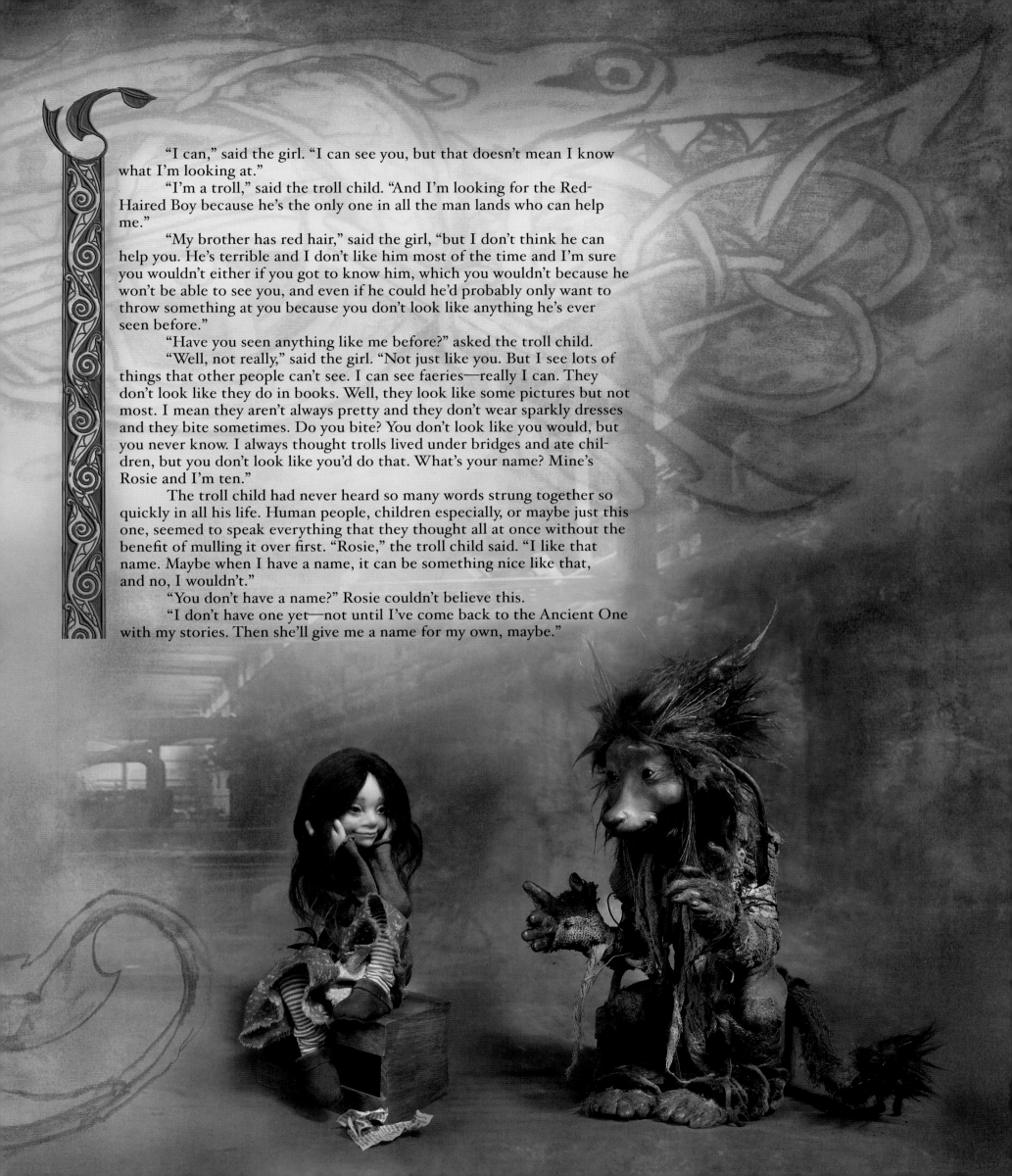

"I can," said the girl. "I can see you, but that doesn't mean I know what I'm looking at."

"I'm a troll," said the troll child. "And I'm looking for the Red-Haired Boy because he's the only one in all the man lands who can help me."

"My brother has red hair," said the girl, "but I don't think he can help you. He's terrible and I don't like him most of the time and I'm sure you wouldn't either if you got to know him, which you wouldn't because he won't be able to see you, and even if he could he'd probably only want to throw something at you because you don't look like anything he's ever seen before."

"Have you seen anything like me before?" asked the troll child.

"Well, not really," said the girl. "Not just like you. But I see lots of things that other people can't see. I can see faeries—really I can. They don't look like they do in books. Well, they look like some pictures but not most. I mean they aren't always pretty and they don't wear sparkly dresses and they bite sometimes. Do you bite? You don't look like you would, but you never know. I always thought trolls lived under bridges and ate children, but you don't look like you'd do that. What's your name? Mine's Rosie and I'm ten."

The troll child had never heard so many words strung together so quickly in all his life. Human people, children especially, or maybe just this one, seemed to speak everything that they thought all at once without the benefit of mulling it over first. "Rosie," the troll child said. "I like that name. Maybe when I have a name, it can be something nice like that, and no, I wouldn't."

"You don't have a name?" Rosie couldn't believe this.

"I don't have one yet—not until I've come back to the Ancient One with my stories. Then she'll give me a name for my own, maybe."

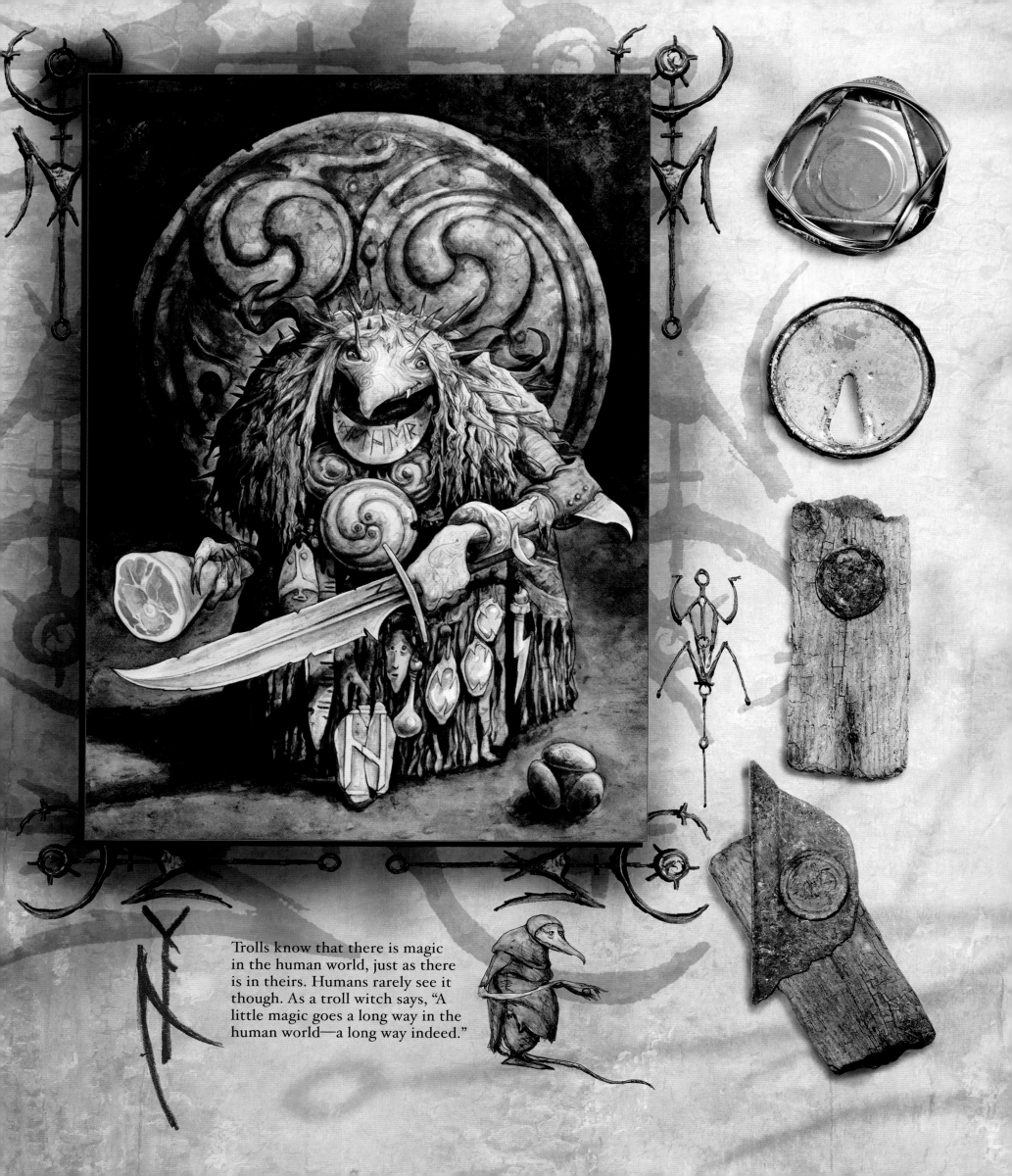

Trolls know that there is magic
in the human world, just as there
is in theirs. Humans rarely see it
though. As a troll witch says, "A
little magic goes a long way in the
human world—a long way indeed."

Rosie thought, and then she said, "Well, I've got to call you something. I think I'll call you Tam. I like that name and you look like a Tam to me."

"Tam . . ." the troll child replied. "I think I like it too. Maybe I'll get to keep it for my own someday." And then he sighed. "The Red-Haired Boy. I need to find him because he can see us and has traveled to the Otherworld, my world, and come back again to the man lands."

"I'm not sure I understand—in fact, I know I don't. I think you should start at the beginning and tell me everything," Rosie said. "I'm awfully good at figuring things out, but I'll have to know what you know first."

So Tam the troll child sat next to Rosie the human child on the front step of her building and told his story. He took his time, and the gray day in the city turned from morning into afternoon, and then as the shadows lengthened and the light began to grow even fainter, Tam finished his tale and looked at Rosie expectantly. "So—what should I do now? How do I find the Red-Haired Boy?"

Rosie frowned. "I'm not sure, but I don't think you actually need to find the Red-Haired Boy. You've got me and I can see you and I think I might just know what you need to do next. And besides, I think, from everything you've told me, that the Red-Haired Boy lived, oh, a long, long time ago and you're not going to find him now no matter how hard you look. Besides, you don't have the rest of the bone tale yet and you don't know what happened to him, do you? If you ask me, he sounds like he might turn into someone you wouldn't want to meet anyway . . . not if you could have me instead?" She said this in a small and hopeful voice. Tam looked at her again and smiled.

"You're right. You're not the Red-Haired Boy, but I think maybe you ARE just what I'm looking for after all," said Tam. "So, now that I've found you, what do we do next?"

"Well," replied Rosie, "the alley behind my building has a strange, strange thing living in it. My mother says it's just a poor old soul who lives on the street and we should be kind but not ever get too close to her, and my brother says maybe we should throw something at her to see what she'll do, and I say that we should just go and talk to her and see if she might be the troll witch you've come to find. I know she's not just an old lady—a human one, that is—I just know it. I can 'see' her inside shape and it's even scarier than her outside one, so I think she might be who you're looking for—and we had better do it now because I have to go in to supper in a few minutes."

So Tam and Rosie crept around to the back of the apartment building and into the alley behind it. The alley was even darker and harder and colder than the streets. Monstrous shadows danced across the brick wall of the building in the gathering twilight, and strange shapes loomed up unexpectedly all around them. Tam and Rosie huddled together and their steps grew smaller and more timid as they made their way farther into the darkness. They heard something rustle and hiss—a strange, rasping sound like a snake trying to speak—and out of the gloom an eye appeared, following them as they cowered against a trash can. The eye was followed by a nose, as sharp and pointed as a beak. There was only the one eye, a nose, and a mouth that the children just knew was full of pointed teeth. Then the whole head emerged, covered in long, stringy hair that snaked over the creature's shoulders and down her back. It was a "her" as far as they could tell. As she shuffled out of the shadows, they could see that she had dressed herself in rags and bags and tatters and things the troll child had never seen before.

However, Rosie, being a city child, and human, knew they were black plastic bags and old tin cans and perhaps the skins of rats or feral cats. The children saw her "outside" and "inside" shapes as she came closer—a human shape and a troll shape merging into something that was at home neither in this world of men nor the Otherworld.

The troll witch watched them with her one eye. She hissed. She spoke. "What can I see? What stands before me? Why do I know you? Why have you come here?" She had not said so much in all the years she had been in the man lands, and it left her silent and waiting, longing for something she couldn't remember.

The troll child found his voice and said, "I bring greetings from your sisters in the marshland."

"Sisters? Sisters? I have no sisters. I have no one. I have nothing," the troll witch whispered.

"But you do," said Tam. "You have two sisters who live in the marshland and want you and need you and miss you most greatly."

"Sisters," the troll witch said again.

"And owls," added Tam. "They miss you too."

The troll witch dragged herself closer to the children and tilted her head so her one eye was level with theirs. "Tell me a story," she said, in a voice as grim as the streets of the city. "I have nothing but bees in my head and dead mice and cabbage peelings. I would have a tale instead, so, little one, tell me a tale or I'll swallow you up for good and for all."

Tam trembled and his voice skittered far away from him and hid in the shadows. The troll witch breathed and creaked and shifted. Tam felt as if he had been turned to stone. There was but one tale left to tell and it was the tale of laughter. Not a tale to tell this troll witch. Not a tale for this dark place.

Rosie poked him hard with her elbow. "Tell her! Tell her the tale. You have no choice. There is no other and you have to tell her something. Maybe it will be enough—just maybe."

Tam took a deep breath, and pulling his voice back from where it had been hiding, he began: "Once there was a troll . . ." and he told the tale of feathers from beginning to end. Then he stopped and his voice ran back to the safety of the shadows.

Rosie and Tam looked at the troll witch and tried to see if the story had had any effect on her at all. She squatted there, still as stone, grim as plague. And then, from the very middle of her inside shape, her troll shape, she began to laugh. Her shoulders shook and her hair whipped around her face and she threw her head back and howled with laughter. It was a strange sound, the laugh of a troll witch, but it was a laugh nonetheless, and the more she laughed the more she changed until, as the laughter shook her, her rags and tatters, skins and black plastic bags, fluttered and flapped, turned into feathers, and flew away on the wind. And there stood the troll witch, just as she had been when she first came to the man lands.

"Well, my little ones," she said, with a smile that was nearly as frightening as her frown, "you've made me remember. The bees are all flown, the mice turned to dust, and the cabbages gone. Sisters! My sisters! Hah! And the owls. Yes, now I remember."

The children waited and finally Tam said, "Will you come to the troll lands with me? Return to your sisters? Return to the owls?"

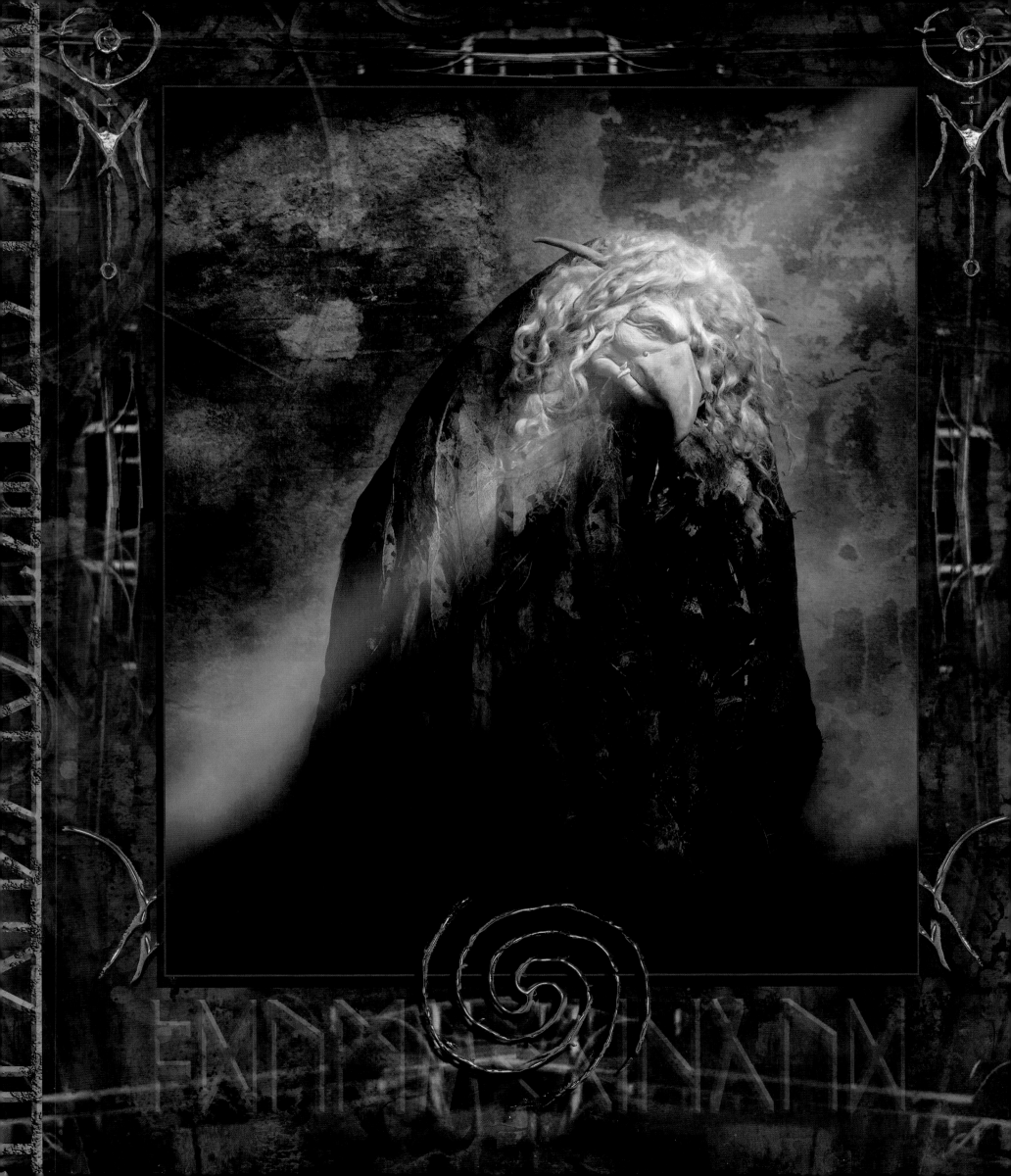

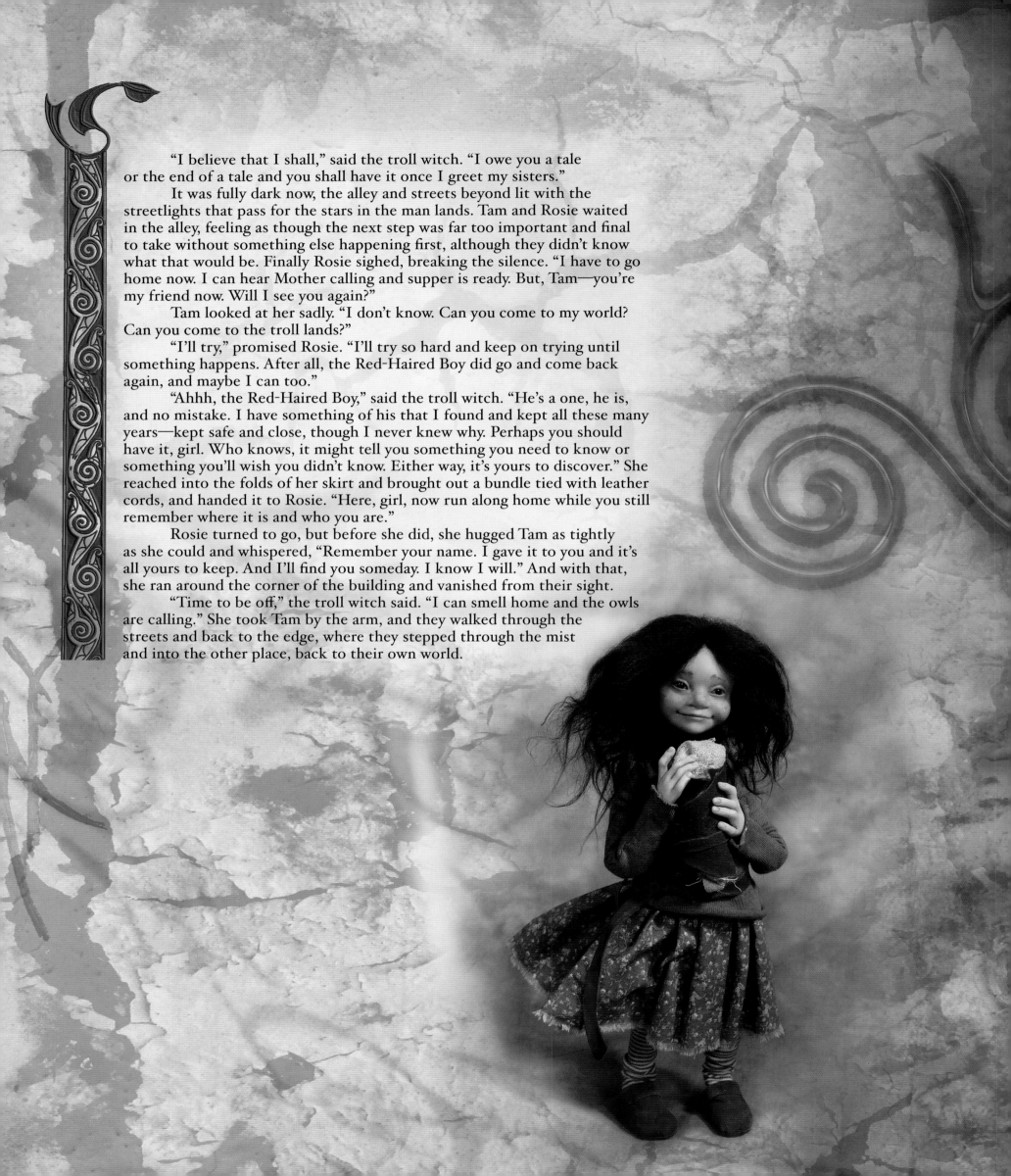

"I believe that I shall," said the troll witch. "I owe you a tale or the end of a tale and you shall have it once I greet my sisters."

It was fully dark now, the alley and streets beyond lit with the streetlights that pass for the stars in the man lands. Tam and Rosie waited in the alley, feeling as though the next step was far too important and final to take without something else happening first, although they didn't know what that would be. Finally Rosie sighed, breaking the silence. "I have to go home now. I can hear Mother calling and supper is ready. But, Tam—you're my friend now. Will I see you again?"

Tam looked at her sadly. "I don't know. Can you come to my world? Can you come to the troll lands?"

"I'll try," promised Rosie. "I'll try so hard and keep on trying until something happens. After all, the Red-Haired Boy did go and come back again, and maybe I can too."

"Ahhh, the Red-Haired Boy," said the troll witch. "He's a one, he is, and no mistake. I have something of his that I found and kept all these many years—kept safe and close, though I never knew why. Perhaps you should have it, girl. Who knows, it might tell you something you need to know or something you'll wish you didn't know. Either way, it's yours to discover." She reached into the folds of her skirt and brought out a bundle tied with leather cords, and handed it to Rosie. "Here, girl, now run along home while you still remember where it is and who you are."

Rosie turned to go, but before she did, she hugged Tam as tightly as she could and whispered, "Remember your name. I gave it to you and it's all yours to keep. And I'll find you someday. I know I will." And with that, she ran around the corner of the building and vanished from their sight.

"Time to be off," the troll witch said. "I can smell home and the owls are calling." She took Tam by the arm, and they walked through the streets and back to the edge, where they stepped through the mist and into the other place, back to their own world.

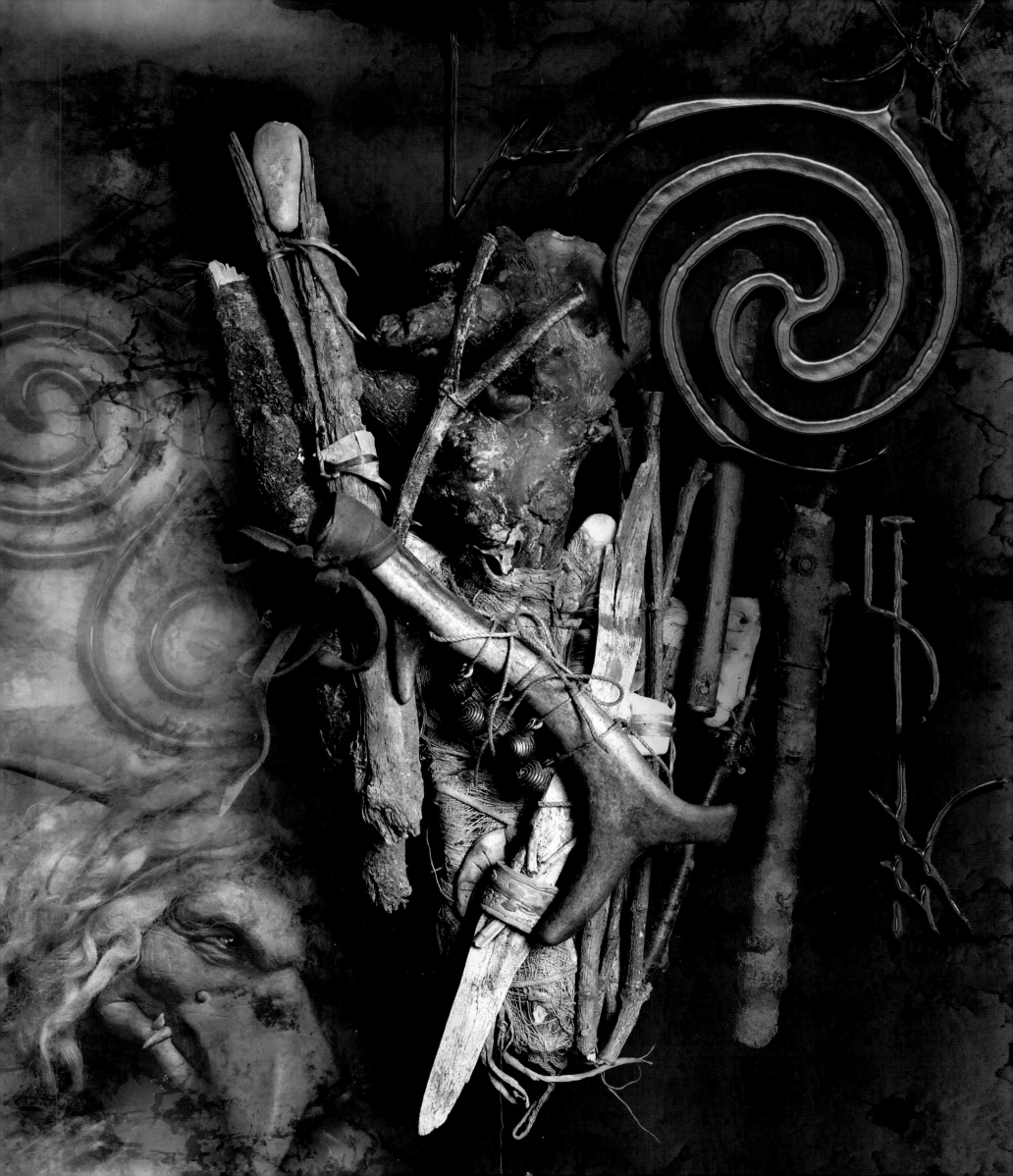

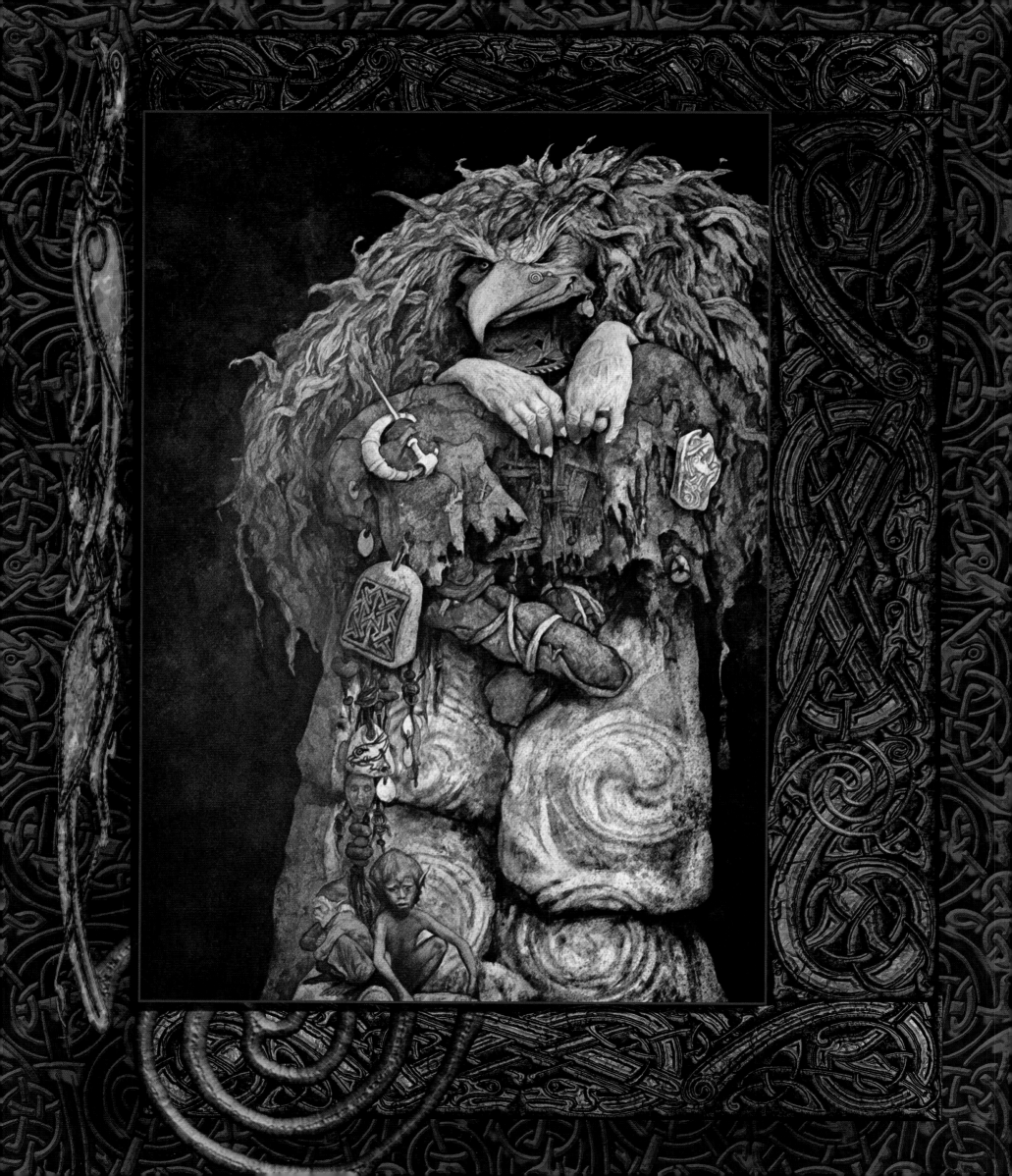

The troll child blinked and looked all around him.
He looked at the troll witch,
Who stared back with one eye.
He felt a small tug on his tail,
And turning around to see what it was,
He found the tiny troll just where he'd left him,
Waiting and watching for the troll child's return.
And the voices of trees and flowers and rocks,
The voices of hills and mountains and tors,
Came back to the troll child all clear, bright, and shining.
And "home" found its song and the troll child smiled,
As his time in the man lands grew distant and vague.

Together the three traveled over the moorland
And back to the marshland and back to the sisters.
And troll witch and troll witch and troll witch were gathered
In one huge embrace, all clanking with bones,
All smothered in owls.
And the three witches smiled,
And the three witches laughed,

Which still was unsettling, the troll child thought.

"And now for your tale; for the end of your tale.
Let us see what the Red-Haired Boy has become."
And the lost troll witch sister got down to the telling,
And this is the end of the bone tale she told:

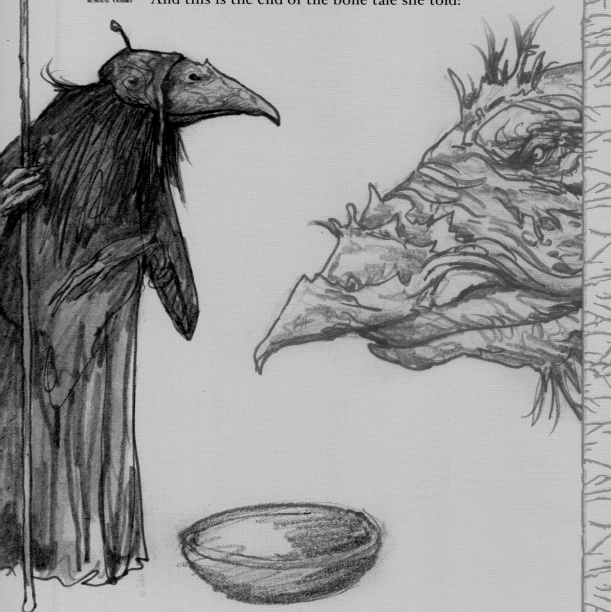

The troll witch watched the young ones leave, following behind Will, who carried the bundle of drawings and objects he had found. But the troll witch soon began to regret her mischief making. She thought for a long time and pondered the right and wrong of the thing, her conscience giving her little pokes and prods, and finally decided that she must venture into the man lands and fetch the young trolls back. She said farewell to her two sisters and made her way into the man lands and into the city and right up to the enormous cathedral in the center. And what did she see there?

She saw an old man, white-haired and prosperous-looking, chisel in hand, sculpting in stone. At his feet was a bundle. And what did she see when she looked up? High, high above, perched on the flying buttresses, the troll witch saw the three young trolls, all turned to stone and become statues, staring back to the far, far hills of their homeland—trapped by the stolen magic of the Otherworld . . . trapped by Will, now grown old and famous, the most famous sculptor in all the man lands.

Looking at Will, the troll witch now understood the secret of the lightness of humans. It is their brief, passionate lives and their swift flight of passing that make them so attractive to the beings of the Otherworld. Human time and human frailty are the true barriers between the worlds. She sighed and stumped toward the old man.

The troll witch passed by the people of the city, invisible to them, invisible to everyone except Will, who turned and, staring at her in horror, hurried away as fast as his old legs could carry him. In his haste he left behind the bundle—the bundle full of magic and writings, drawings and tales, that he had carried and cherished all these many years, and the troll witch picked it up and put it under her arm. The bundle tingled with magic, spilling onto her fingers and curling like smoke in her hair.

And as she turned back toward home, her memories began to fade. In her head she heard a buzzing and a mumbling . . . and just like that—all of her thoughts, all of her wishes, and all of her Rememberings of the Otherworld faded and fluttered and drifted away and were gone from her head, for the magic was wild and unstable in this world. The troll witch was trapped by the passing of time, rushing like wind, sweeping away her very trollness, leaving her hollow and empty.

The troll witch covered herself in rags and tatters and rat skins and hid herself away, becoming something that the humans could see, but nothing the humans wished to look at.

And so she stayed there in the city, in the narrow streets behind the tall buildings, and she waited year upon year, century upon century, and she never remembered what she waited for and she never remembered why she was there or who she was. And that was the end of the tale until the troll child and Rosie found her.

And the Red-Haired Boy? What of Will? He died a man of much fame and some fortune as well. His sculptures were known far and wide, for he was indeed a marvelous carver of stone—but for all of the many wonderful things he carved, it was acknowledged by everyone that the first three figures he created, the very first pieces that had so amazed his father, were still to this day the very best work he ever did.

"Well," said the troll child, "now I understand.
And a good thing it is that I never could find him."
"Well, there's a wise thought," the troll witches said.
"Now off with you! Hurry, before we are hungry.
You've had your adventure, you carry our tales,
Run away quickly, for you are looking like supper.
You and the little one, go while you can."

So the troll child ran and the little one followed,
Hanging fast to the end of his tail.
And when they were out of the marshes and thorn thickets,
The troll child stopped and sat down and thought.
And try as he might, the thought wouldn't come.
His time in the man lands was fading and faint.
He remembered a girl child, a troll witch, and darkness.
But something was missing, was hiding and lost.

The troll child walked on with the tiny one trailing
Until once again they were back where they met.
The tiny one said, "I'll be leaving you now.
I can hear my home calling. My family is waiting."
So the trolls said good-bye and the troll child continued.
He followed his footsteps, remembered his path.
And all through his journey the missing thought hovered
And flitted above him just out of his reach.

And suddenly he knew. It wasn't so very difficult now that she had pointed it out to him. "A little magic goes a long way in the human world, boy—a long way indeed."

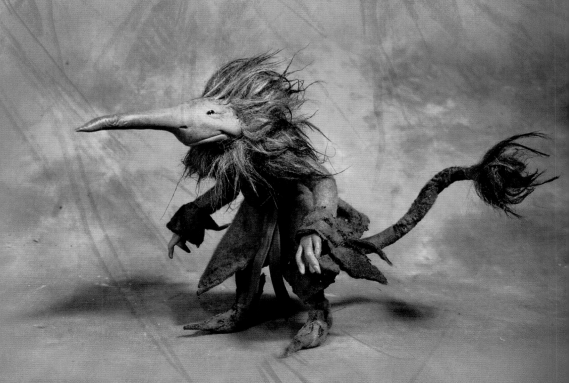

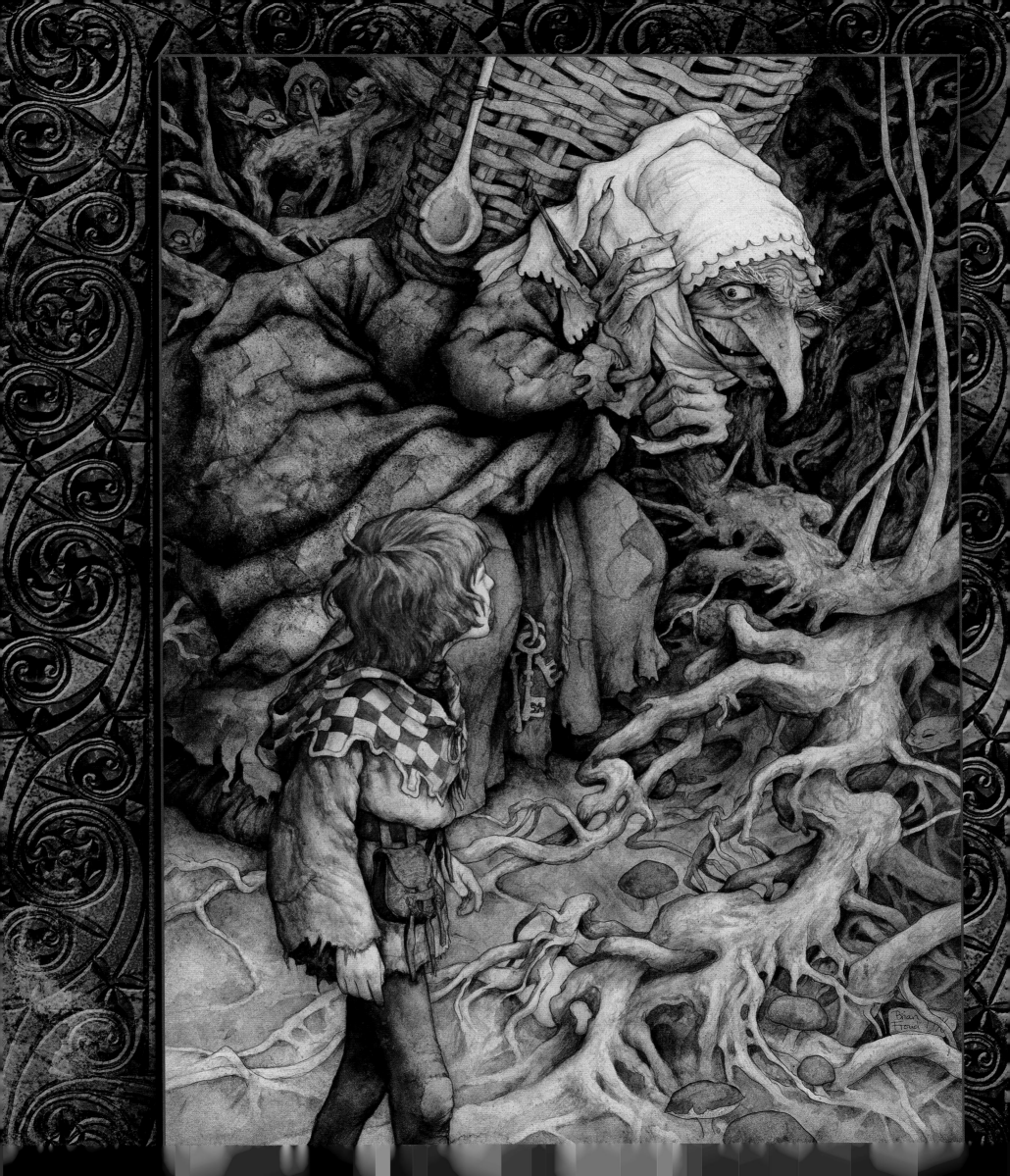

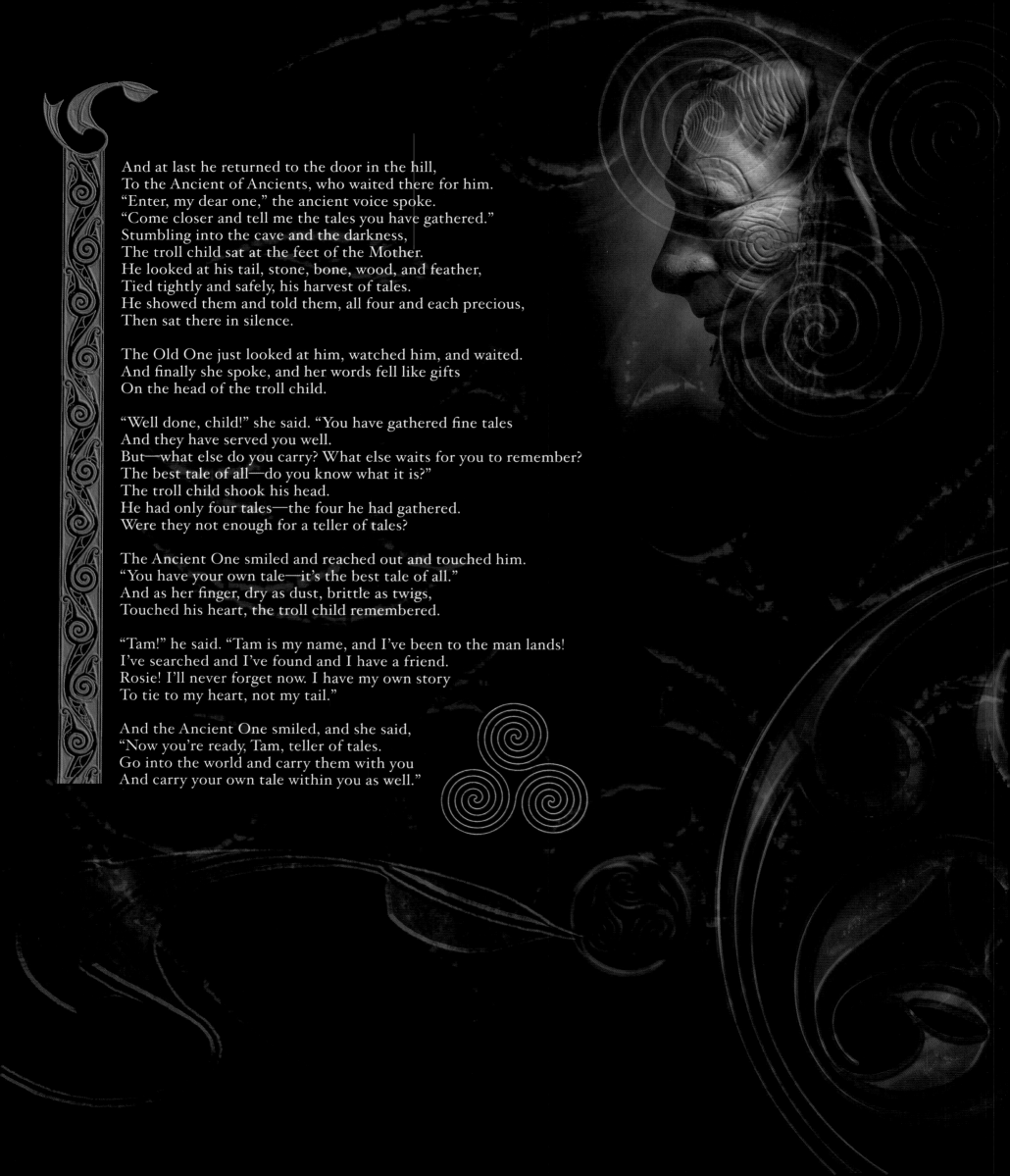

And at last he returned to the door in the hill,
To the Ancient of Ancients, who waited there for him.
"Enter, my dear one," the ancient voice spoke.
"Come closer and tell me the tales you have gathered."
Stumbling into the cave and the darkness,
The troll child sat at the feet of the Mother.
He looked at his tail, stone, bone, wood, and feather,
Tied tightly and safely, his harvest of tales.
He showed them and told them, all four and each precious,
Then sat there in silence.

The Old One just looked at him, watched him, and waited.
And finally she spoke, and her words fell like gifts
On the head of the troll child.

"Well done, child!" she said. "You have gathered fine tales
And they have served you well.
But—what else do you carry? What else waits for you to remember?
The best tale of all—do you know what it is?"
The troll child shook his head.
He had only four tales—the four he had gathered.
Were they not enough for a teller of tales?

The Ancient One smiled and reached out and touched him.
"You have your own tale—it's the best tale of all."
And as her finger, dry as dust, brittle as twigs,
Touched his heart, the troll child remembered.

"Tam!" he said. "Tam is my name, and I've been to the man lands!
I've searched and I've found and I have a friend.
Rosie! I'll never forget now. I have my own story
To tie to my heart, not my tail."

And the Ancient One smiled, and she said,
"Now you're ready, Tam, teller of tales.
Go into the world and carry them with you
And carry your own tale within you as well."

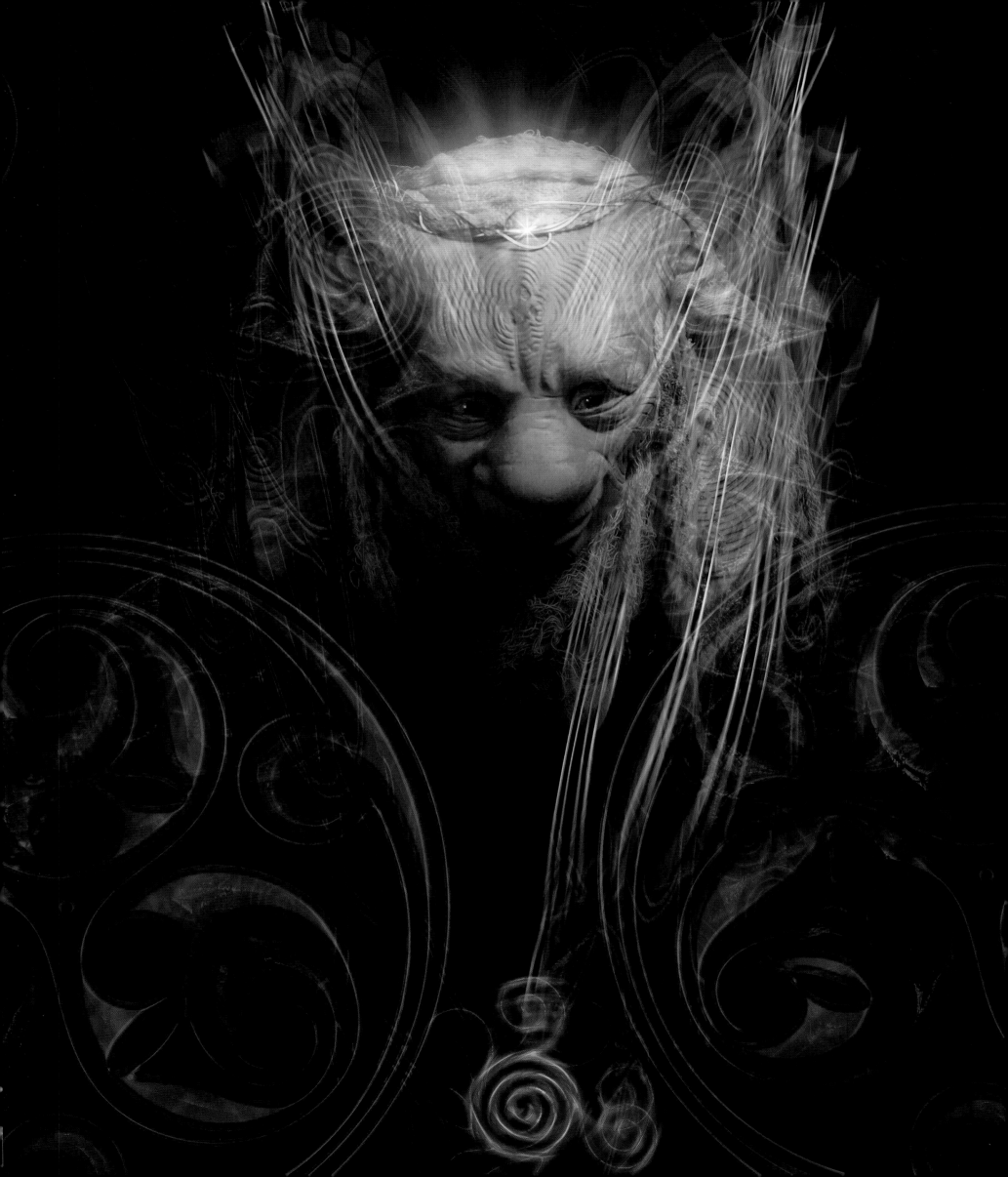

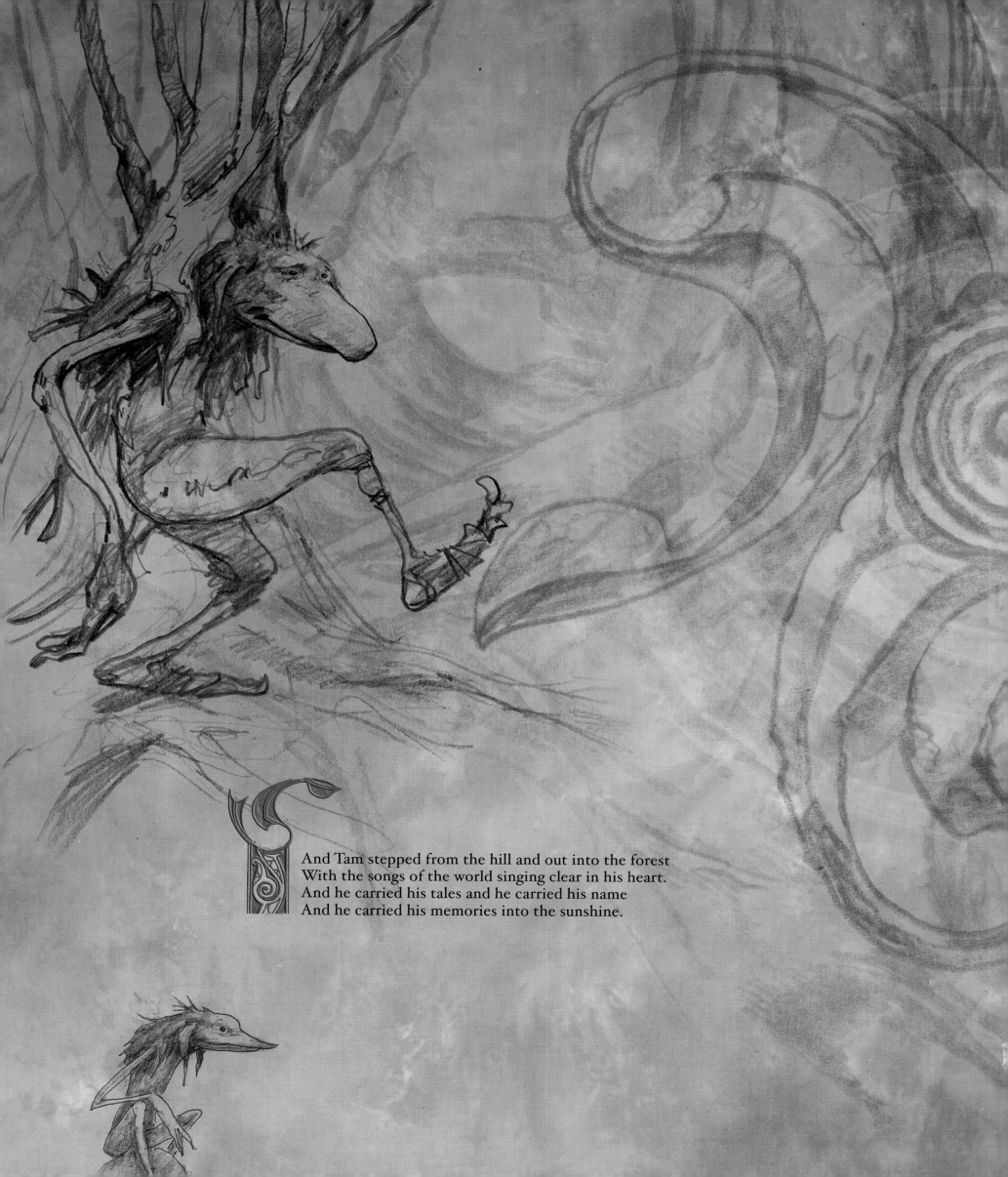

And Tam stepped from the hill and out into the forest
With the songs of the world singing clear in his heart.
And he carried his tales and he carried his name
And he carried his memories into the sunshine.

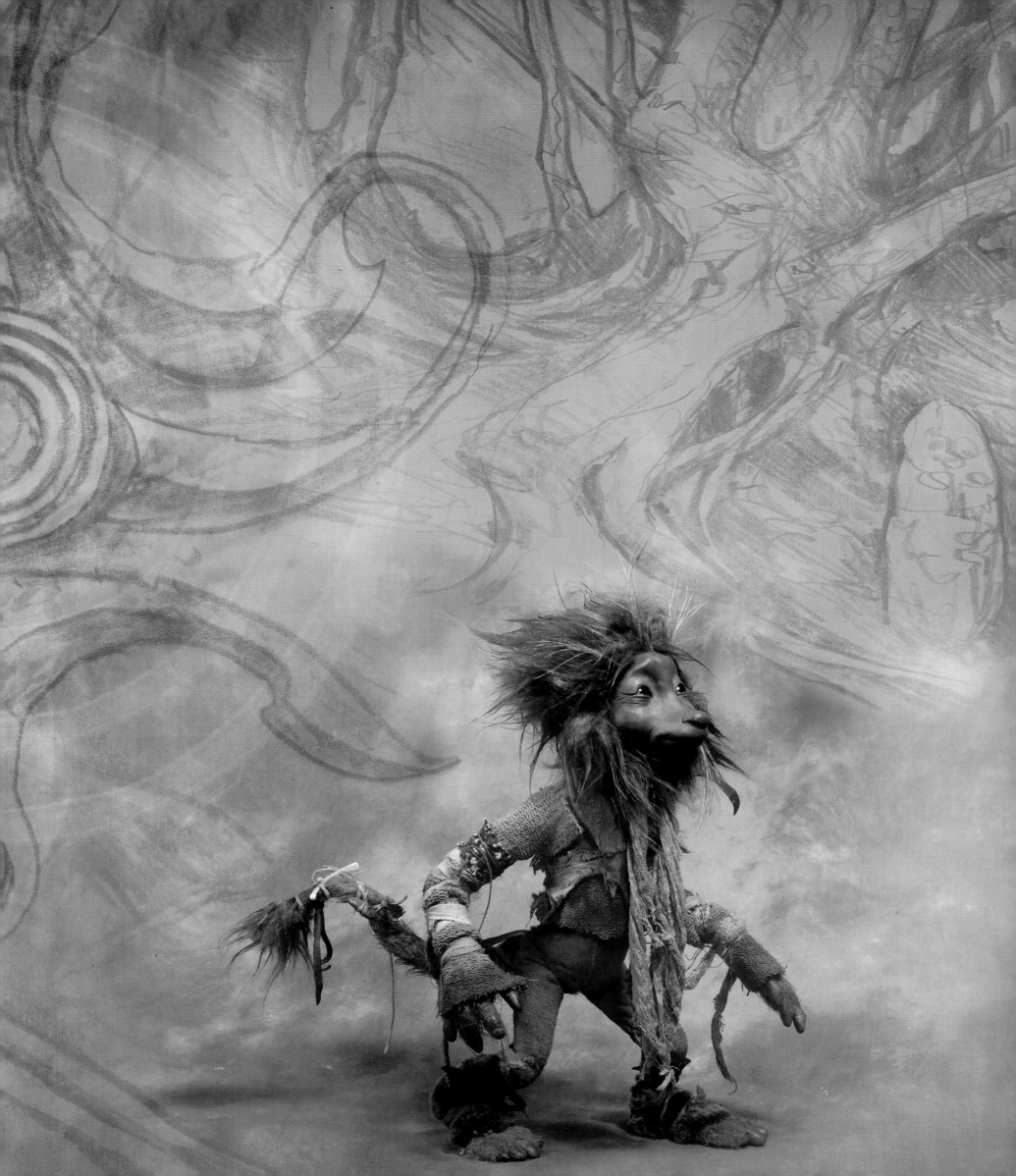

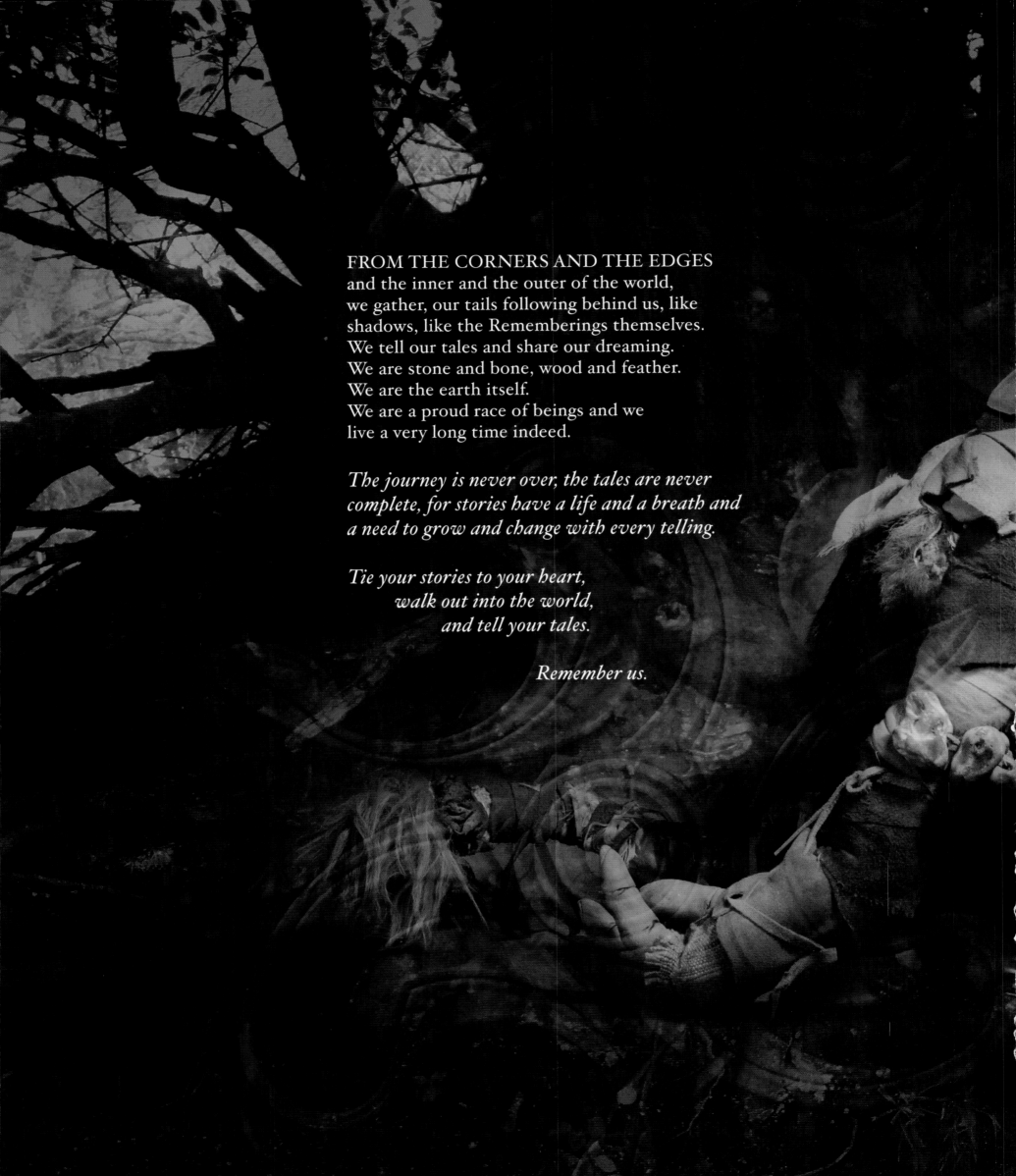

FROM THE CORNERS AND THE EDGES
and the inner and the outer of the world,
we gather, our tails following behind us, like
shadows, like the Rememberings themselves.
We tell our tales and share our dreaming.
We are stone and bone, wood and feather.
We are the earth itself.
We are a proud race of beings and we
live a very long time indeed.

*The journey is never over, the tales are never
complete, for stories have a life and a breath and
a need to grow and change with every telling.*

*Tie your stories to your heart,
walk out into the world,
and tell your tales.*

Remember us.

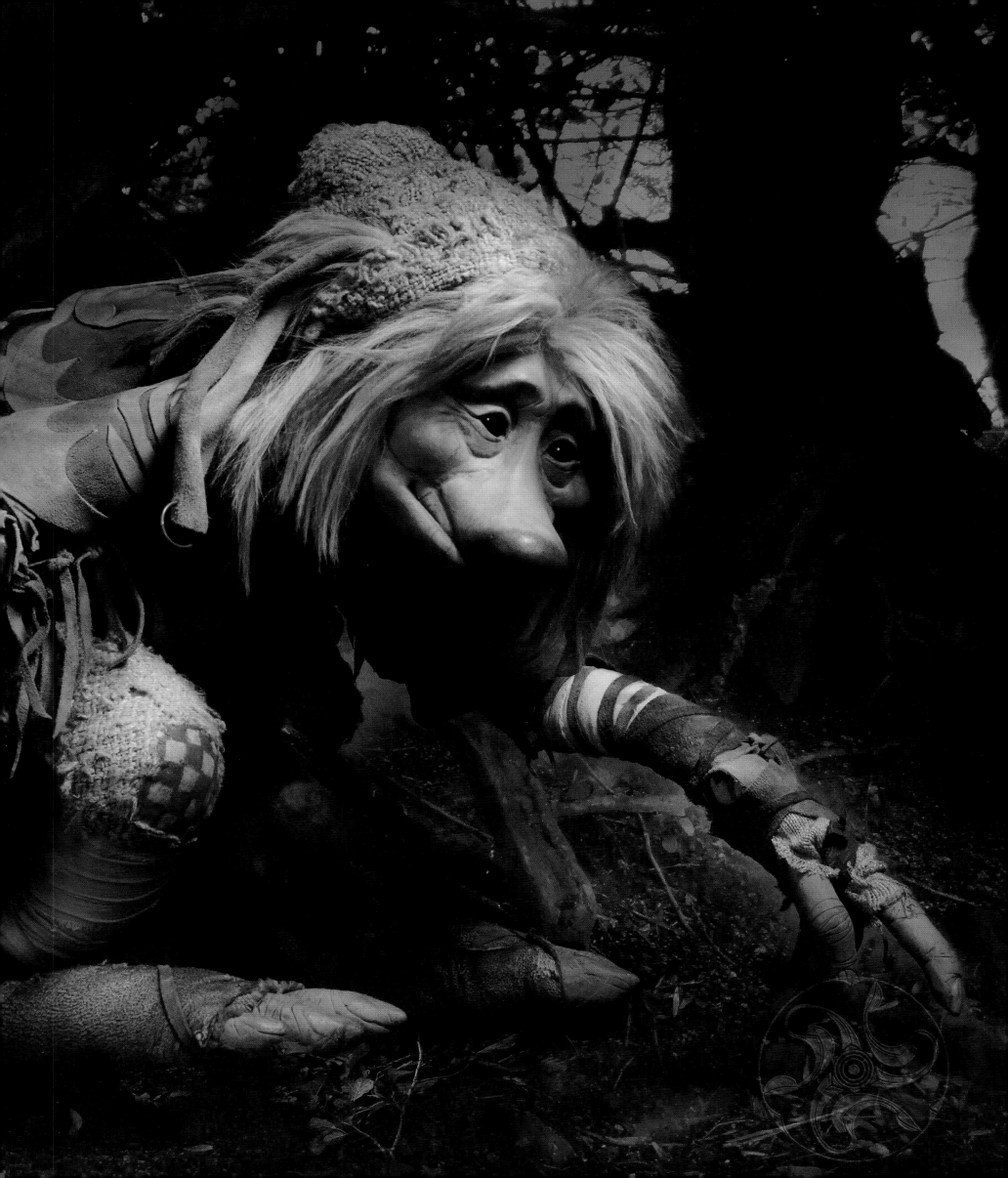

For Jim Henson, who said, "Let's do it,"
and for Robert Holdstock, fellow traveler between the worlds
—B.F. and W.F.

My special thanks to Terri Windling, who gave me the confidence to speak for the trolls
—W.F.

Brian and Wendy would also like to thank the following people for their unfailing support,
encouragement, good humor, and all other forms of help that they have given us
in making this book a reality. We truly appreciate it!

Robert Gould, for his support and encouragement throughout the many years
of developing this book, and for his great help in guiding its vision;
Howard Reeves, our brilliant editor at Abrams, who made it work!;
Stephanie Lostimolo and Emilio Miller-Lopez for their Imaginosis design contributions;
Guy Veryzer, for making great "troll ceramics";
and, finally, the trolls themselves, who allowed us to explore their world
and put our findings in this book.

Editor: Howard W. Reeves
Art Direction: Brian Froud
Production Manager: Ankur Ghosh

Library of Congress Cataloging-in-Publication Data

Froud, Brian.
Trolls / Brian and Wendy Froud.
p. cm.
ISBN 978-1-4197-0438-3 (hardcover) — ISBN 978-1-61312-401-7 (ebook)
1. Froud, Brian—Themes, motives. 2. Trolls in art. I. Froud, Wendy, 1954– II. Title.
NC978.5.F76A4 2012
741.6'4092—dc23
2012008313

Printed and bound in China

10 9

Abrams books are available at special discounts when purchased in quantity for premiums
and promotions as well as fundraising or educational use. Special editions can also be created
to specification. For details, contact specialsales@abramsbooks.com or the address below.

ABRAMS The Art of Books
195 Broadway, New York, NY 10007
abramsbooks.com